Frontier America: The Far West

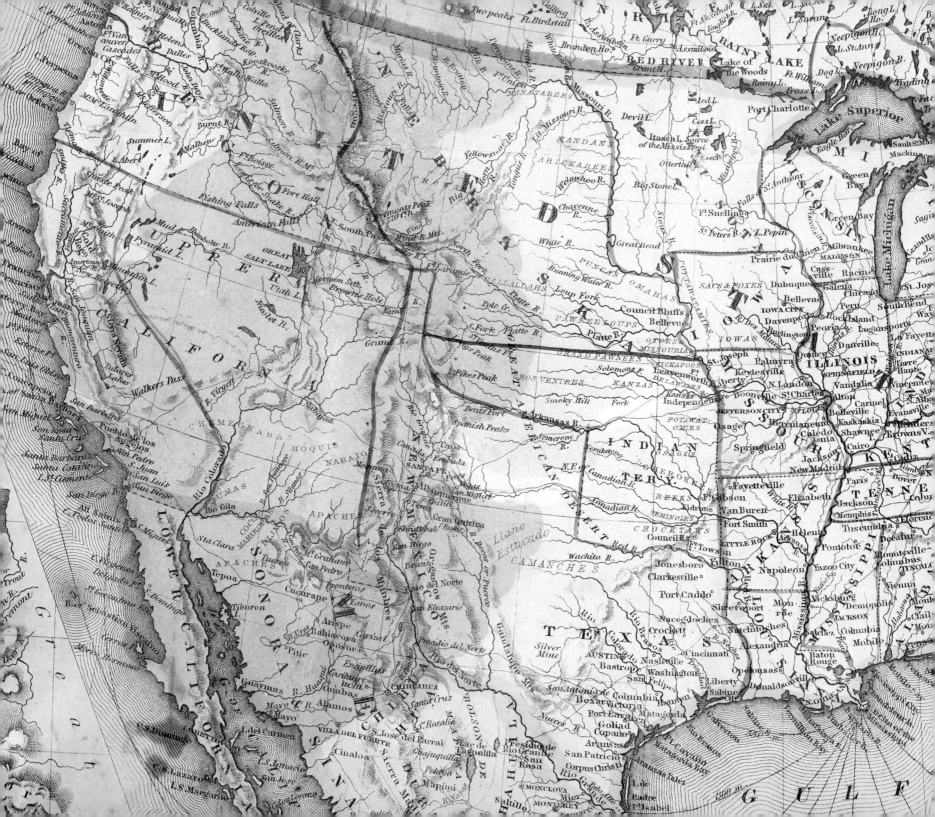

Frontier America: The Far West

Department of American Decorative Arts and Sculpture

Museum of Fine Arts, Boston

Contributors to the Catalogue

JONATHAN L. FAIRBANKS,
Curator

ROLAND F. DICKEY

FREDERICK J. DOCKSTADER

JOHN C. EWERS

ANNE FARNAM

ELISABETH SUSSMAN

WILLIAM H. TRUETTNER

GILIAN S. WOHLAUER

Museum of Fine Arts, Boston

This exhibition is sponsored through
matching grants from
the National Endowment for the Arts
and Philip Morris Incorporated
on behalf of Marlboro.

Typeset by Dumar Typesetting,
Dayton, Ohio
Color separations by Techno-colour Co.
Inc., Montreal
Printed by The Leether Press, Boston
Designed by Carl F. Zahn

Photographs by Richard Cheek
with the exception of numbers 15, 24, 26,
27, 28, 29, 38, 40, 41, 43, 44, 45, 48, 54, 58,
59, 65, 69, 74, 76, 77, 79, 80, 82, 87, 89, 94,
95, 96, 108, 110, 111, 112, 115, 120, 129, 156,
157, 159, 161, 162, 167, 185, 214, 227, 231,
237, 292, 297, 313, 314.

Cover design:
adapted from detail of no. 241
Pie safe, ca. 1875
Southwestern Colorado

Frontispiece: J. Calvin Smith
Map of North America (detail)
Published by J. Disturnell, New York,
1850
(Courtesy of Goodspeed's Book Shop,
Inc., Boston)

Dates of the exhibition:

Museum of Fine Arts, Boston
January 23-March 16, 1975

Denver Art Museum
April 19-June 1, 1975

The Fine Arts Gallery of San Diego
July 2-August 17, 1975

William Rockhill Nelson Gallery of
Art, Kansas City
September 17-November 2, 1975

Milwaukee Art Center
December 5-January 18, 1975

Contents

Foreword

For many Americans, the western frontier has seemed more a part of legend than of reality. But the frontier did exist, and it helped forge the American character.

Through "Frontier America: The Far West," we experience the frontier's reality. The art, artifacts, and crafts of the men and women who struggled with nature in the vast area between the Missouri and the Pacific express the cultural evolution that is uniquely American.

No culture has wider roots. The Far West was initially settled from the East by the descendants of English and Scottish tobacco farmers in Virginia, Kentucky, Tennessee, and the Carolinas, from the South by Spanish colonizers, from the Southeast by blacks, and from the North by French fur traders. Long before that the great cultures of the American Indian tribes were thriving, and they too take their proper place in the exhibition.

Conceived and produced by the Boston Museum of Fine Arts, the exhibition will not end in Boston. It will tour American cities and, during our nation's bicentennial year of 1976, it will travel overseas to some of the European countries that have contributed to the pluralistic nature of American life.

The exhibition reveals the robust spirit, the driving energy for discovery, and the rich diversity of creative expression that were characteristic of the early settlers of the West despite the hardships and deprivations of frontier life.

Those qualities were fundamental to the emerging American culture, and it is appropriate that we reflect on them as we commemorate our two hundred years as a nation.

GEORGE WEISSMAN
Vice Chairman of the Board
Philip Morris Incorporated

Preface

"Frontier America: The Far West" is the prologue to a series of exhibitions celebrating the Bicentennial of American Independence at the Museum of Fine Arts, Boston. This exhibition concerns the people and their popular arts in the western half of the United States before the age of industrialization. The theme of the Far West is firmly rooted in our image of self and closely related to the symbols of a growing nation: abundant natural resources, boundless energy, and vast spaces. These symbols have often been explored in pictures, books, and films; but only recently have objects from the Far West—as distinct from symbols— been scrutinized as an important part of the record. Boston, which in the seventeenth century was a vital part of another nation's frontier in the early America, later played an important role in the course of the western growth of our own country when the trading ship *Columbia,* out of Boston, skirting the Pacific Coast, gave the United States a claim to the Oregon country by sailing up the Columbia River in 1792. In a continuing spirit of exploration, the Department of American Decorative Arts and Sculpture of the Boston Museum, with the assistance of outside scholars, has re-examined the nature of western culture. Both the exhibition and the accompanying catalogue are the result of cooperative efforts stemming from many sources. More than three hundred and fifty paintings, drawings, and photographs, as well as decorative and utilitarian objects have been assembled from private and public collections. Among these are forty paintings and drawings from the M. and M. Karolik Collection in the Boston Museum.

Through the generosity of the lenders it has been possible to bring together the arts and crafts of the Far West in wide variety. The project could not have been realized without matching grants from the National Endowment for the Arts and Philip Morris Incorporated on behalf of Marlboro. For these contributions we express our gratitude.

MERRILL C. RUEPPEL
Director, Museum of Fine Arts, Boston

The Academy of Natural Sciences of Philadelphia

Amon Carter Museum

Archives of the Oregon Province of the Society of Jesus

Arizona State Museum

Aurora Colony Historical Society

The Beinecke Rare Book and Manuscript Library, Yale University Library

Boston Public Library

Brigham Young University

Mrs. Charles L. Bybee

The Church of Jesus Christ of Latter-day Saints

The College of Eastern Utah

Colonial Society of Massachusetts

Colorado Springs Fine Arts Center

The Cooper-Hewitt Museum of Decorative Arts and Design, Smithsonian Institution

de Saisset Art Gallery and Museum

The Denver Art Museum

Denver Public Library

Dr. and Mrs. Avard T. Fairbanks

The Fine Arts Museums of San Francisco

Fogg Art Museum, Harvard University

Rell Francis

Mrs. Georgeanna Greer

The Heard Museum

Jefferson National Expansion Memorial Historic Site

Robert Quill Johnson

Kennedy Galleries, Inc.

Selma Klatt

Oscar Krauskopf

The Library of Congress

Marion Koogler McNay Art Institute

Walter Nold Mathis

Maxwell Museum of Anthropology

Dr. and Mrs. Ward Alan Minge

Montana Historical Society

Mr. and Mrs. Harvin Moore

Museum of the American Indian, Heye Foundation

Museum of Northern Arizona

Museum of Fine Arts, Boston

National Archives

National Collection of Fine Arts

Natural History Museum of Los Angeles County

Nebraska State Historical Society

Leona Will Nelson

New Hampshire Historical Society

The Oakland Museum

Oregon Historical Society

Peabody Musem of Archaeology and Ethnology, Harvard University

Phoenix Art Museum

Pioneer Craft House, Salt Lake City

Pioneers' Museum

Pioneer Museum and Haggin Galleries

Royal Ontario Museum

San Antonio Museum Association Collection

Horace Sorensen

Southwest Museum

State Capitol Museum, Olympia, Washington

The State Historical Society of Colorado

Stuhr Museum of the Prairie Pioneer

Texas Pioneer Arts Foundation

Texas Memorial Museum, University of Texas

Mr. and Mrs. Andrew Z. Thompson

U.S. Department of Parks and Recreation, Salt Lake City, Utah

Utah Pioneer Village

Vose Galleries of Boston, Inc.

Washburn Gallery

Nelson Wadsworth

West Point Museum, United States Military Academy

William Rockhill Nelson Gallery of Art

Wyoming State Archives and Historical Department

Yale University Art Gallery

Zion's Cooperative Mercantile Institution

Acknowledgments

Only a few years ago this exhibition would not have been possible. Even as late as the 1960's many of the works of art had not yet been discovered. But through the inspiration and interest of many persons, it has been possible to gather together these handsome and instructive materials from and about the American frontier. Those who generously lent their treasures to this show are listed above. But mention in a list is hardly sufficient acknowledgment for the effort expended by the lenders. For institutions as well as private lenders, the loan of choice works often involves some adjustment and sacrifice and obligations such as the gathering of background information useful to the exhibition catalogue. For this assistance and for many other services volunteered by the lenders we express our gratitude.

Work on the exhibition was a cooperative effort of great complexity. After an outline of objectives was developed, four field assistants were assigned to locate works within their region appropriate to the exhibition. James Abajian, former librarian, California Historical Society; Roland Dickey, president of the State Historical Society of New Mexico; Peter Myer, gallery director, Brigham Young University; and Gilian Wohlauer, former assistant to the curator, Department of American Decorative Arts and Sculpture, Museum of Fine Arts, Boston, were those who assisted in the initial gathering of objects for inclusion in the show. Sorting the mass of data submitted, Elisabeth Sussman, assistant for "Frontier America," developed further the guidelines for selection with advice from Richard Ahlborn, curator, Division of Ethnic and Western Cultural History, the National Museum of History and Technology; Ray Billington, Huntington Library and Art Gallery; Bainbridge Bunting, University of New Mexico; John Ewers, senior ethnologist, National Museum of Natural History; John Harrison, University of Sussex; Robert Hine, University of California, Riverside; Howard Lamar, Yale University; Richard Metcalf, Yale University; and Wallace Stegner, Stanford

University. Further generous help was given during the planning of "Frontier America" by Eleanor Adams, Harold Allen, Robert Athearn, Stephen Baird, Mrs. Arthur L. Beeley, Elizabeth Bates, Dale Berge, Richard Bushman, Jay Cantor, Bobbi Carey, Everett Dick, Ralph Ehrenburg, Elliot Fairbanks, Alan Fern, Gilbert Fite, Rell Francis, Archibald Hanna, Charles Hammond, Charles Hanson, Florence Jacobsen, Milton Kaplan, Merrill Mattes, Lynette Miller, Charles Peterson, Charles Poitras, Eleanor Reichlin, R. Henderson Schuffler, Fran Silverman, Roger Stein, William Truettner, Ronnie Tyler, Nelson Wadsworth, Diggory Venn, Elisabeth Walton, Joan Washburn, C. Malcolm Watkins, Rosita Whirl, and Stephen Williams.

Special thanks are due to others who have assisted in locating objects for the exhibition. Frederick Dockstader, Director of the Museum of the American Indian, Heye Foundation, New York, offered Indian artifacts from this collection that would be appropriate. Peter Corey, former research consultant, Peabody Museum of Archaeology and Ethnology, Harvard University, made similar suggestions. We are particularly indebted to Jack McGregor, director, and Don Stover, Cecilia Steinfeldt, and Claudia Eckstein, staff members of the San Antonio Museum Association, for the significant contribution they have made to this exhibition. Their catalogue *Early Texas Furniture and Decorative Arts* was an invaluable source of information, and their help in arranging for loans and transportation of works from Texas is greatly appreciated.

Interpretative essays and catalogue entries were contributed by Roland Dickey, William Truettner, Frederick Dockstader, John Ewers, Elisabeth Sussman, Gilian Wohlauer, Anne Farnam, and Jonathan Fairbanks. Anne Farnam coordinated catalogue texts and compiled a checklist of the exhibition. Beth Carver, Eleuthera DuPont, Deborah Emerson, Deborah Gieringer, Joyce Goldberg, Barbara Jobe, and Nancy

Webbe, of the Department of American Decorative Arts and Sculpture, assisted in the preparation of the catalogue and the exhibition in various ways.

We are grateful for the advice and help given by members of other departments at the Museum of Fine Arts. Thanks are due to Clifford Ackley, of the Department of Prints and Drawings, and Laura Luckey and Lucretia Giese, of the Department of Paintings. The curator of textiles, Larry Salmon, assisted in the care, cataloguing, and displaying of all textiles in the exhibition. Laura Luckey, curatorial assistant in the Department of Paintings, traveled to several western museums to view materials for the exhibition. In technical analysis and conservation William Young and his staff of the Research Laboratory at the Museum of Fine Arts provided analytical assistance. Repairs and restoration of furniture were performed by Vincent Cerbone. The complexity of travel arrangements, loan requests, insurance, and innumerable details were handled by registrars Linda Thomas and Allison Gulick. Design and installation of the exhibition were in the care of Tom Wong and Mary Anne Dulude. For kind assistance and advice graciously given we thank the editor of this catalogue, Margaret Jupe. The majority of photographs in this catalogue are the excellent work of Richard Cheek. For the behind-the-scenes support essential to the development of a project such as "Frontier America" we are indebted to the museum's administrative officers. Finally, we are grateful to Caroline Goldsmith, Vice President of Ruder & Finn Fine Arts, for her support and encouragement.

JONATHAN L. FAIRBANKS
Curator

ELISABETH SUSSMAN
Special Assistant, "Frontier America"

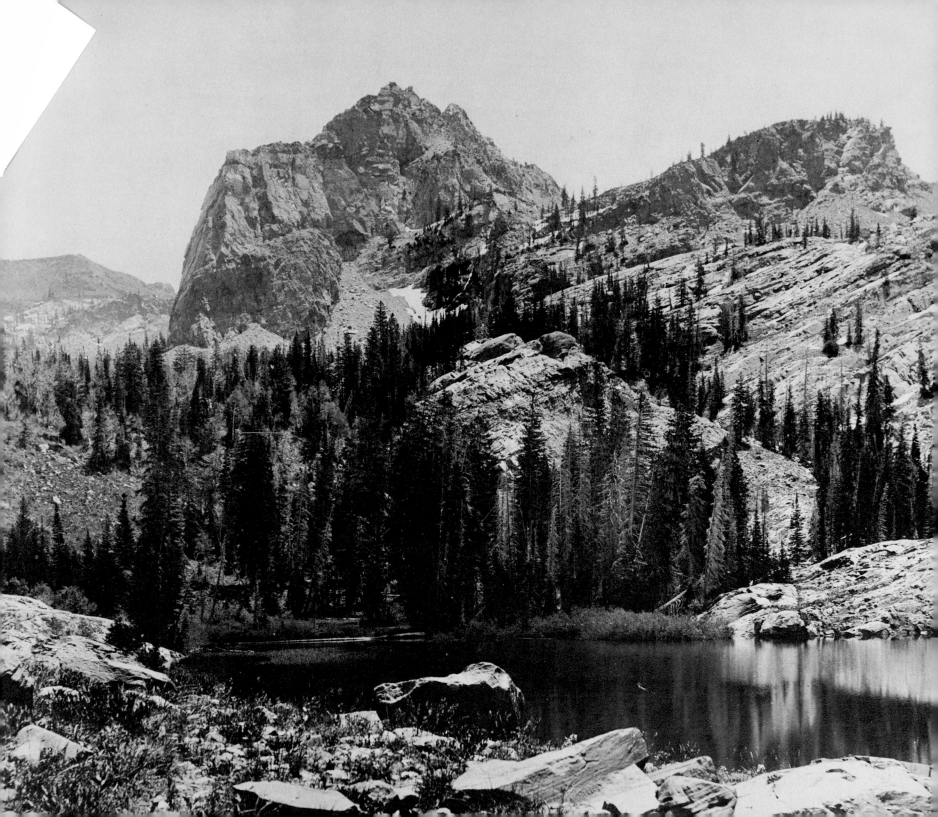

Introduction

Far more than a place or time, the frontier was an attitude. It was a state of mind adopted by those who chose or were forced to live somewhere between the remote wilderness and the borders of well-established cities. For many Americans, this restless condition prompted search for opportunities and expansion westward. Even today, the excitement of new growth is still felt as an echo from the pioneering past. It is timely, therefore, that in an era of dwindling resources, we re-examine a period when there seemed enough of everything for all Americans beyond the thousandth generation.

The focus of this exhibition is the western part of the United States, from the Missouri to the Pacific Coast, as it was in the nineteenth century. Life in this area before urbanization is presented through pictorial, decorative, and functional arts. Written accounts and pictorial records give us a clear image of the settlers who accepted the challenge of life in the Far West, but none of these can impart the physical understanding conveyed by the objects actually made and used by these people. Like the varied western landscapes themselves, the objects are full of contrasts: strong and delicate, sophisticated and naïve, brutal and tender —expressions of an era now often misunderstood.

These materials are examined here for two reasons. First, little serious attention has been given to many of the crafts of the early West, even though these works possess compelling qualities. Secondly, traditional collections of American art seem to gravitate toward high-style works made for the upper classes. While this is a natural pattern for art museums, it does exclude a large and important part of American material culture, without which it is hard to understand the wide acceptance of popular and functional arts in this country today.

This study of the not-so-remote past of the common man also offers a chance to better understand the evolution of earlier frontiers in America of which there are now few tangible remains. America has always

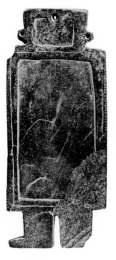

1
Palette
Ca. A.D. 700-900; Hohokam, Kinishba
Ruin, southern Arizona.

had frontiers, constantly moving and involving dramatic change for both settlers and the rest of the nation. As soon as the first footholds on the brink of the Atlantic were secured, the edge of settlement started to move westward, gaining momentum with each wave of immigration or new generation. Even before the American Revolution, when many persons were moving beyond the Allegheny Mountains, the Far West was also being explored and settled from the Spanish South. Far from being an ordered progression, the frontiers of America were extended through exploration and trade in a crazy quilt pattern along rivers, across prairies, and from the Pacific Coast into the most remote corners of the continent. Reflecting this diversity, with a selection of objects from widely separated and different cultures, this exhibition attempts to capture the variety of life when not only the individual was tested but the whole nation was savoring its destiny.

The plan of this exhibition is chronological, showing the development of the arts during the colonization of the West a century ago. First were the native or Indian arts, profoundly influenced by contact with the white man, through conflict as well as through trade. The second major stage of the arts began with settlement of large numbers of immigrants. Many brought with them furnishings and utensils from their place of origin in an attempt to fashion a way of life that was familiar to them. Supplies of these goods eventually became exhausted, and as settlements were often in relative isolation, the third stage resulted during which objects were made by hand for home use—a trend that continued until transportation improvements changed the character of the West altogether. By the end of the century the new technology that prevailed in the East was easily "imported" to the Far West. At the same time, self-conscious "Westerners" began to export their "western" art to a consuming public in the East. With this cultural homogenization of East and West, frontier life disappeared.

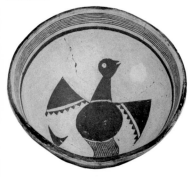

15
Bowl
Ca. A.D. 1000-1200; Mogollon culture, Mimbres Valley, southwest New Mexico.

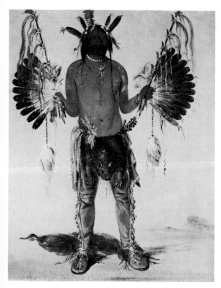

32
George Catlin, 1796-1872
Old Bear, A Mandan Medicine Man
1832.

Although the sequence of and variations on these phases of life and the arts in the Far West are developed in detail by the individual essays in the catalogue, it may not be out of place to single out here some of the major aspects. The first part of the exhibition is devoted to a selection of Indian arts from prehistoric times to the beginnings of Spanish colonization (nos. 1-23). The works selected serve as a reminder that the European settlers moved into a land that already possessed a rich culture. The forms, for the most part, are composed of durable materials. There is sophisticated pottery made by the Mogollon and Anasazi cultures of the Southwest (nos. 14-21). Smooth steatite animals from southern California (nos. 8-10) carry the story to the Pacific. From the Pacific Northwest comes a monumental stone figure (no. 2), pecked and painted for reasons unknown to us by prehistoric Indians of the Columbia River area. As with most prehistoric art, the meaning and original functions of these objects are not well understood, yet their formal qualities have an immediate visual appeal for us in the twentieth century.

More readily understood by the twentieth century viewer are the depictions of the Far West (nos. 24-113) by artists, explorers, and photographers who made the often difficult journey west long before large-scale immigration took place. Quick to realize that the frontier was an evanescent moment, George Catlin, Samuel Seymour, Titian Ramsay Peale, and other explorer-recorders felt compelled to search the early West in a quest for the source of creation. The unspoiled wilderness had a strong magnetic attraction for many artists during the early years of the romantic nineteenth century. It drew westward those who recognized cosmic forces in the primitive life and in the unparalleled immensities of land and sky. While Catlin discovered a primeval force in the Indian (no. 32), others, like Alfred Jacob Miller, found the Indian an archetypal descendant of the noble Roman (nos. 38-42). Other artists with a more scientific approach recorded fact, not fancy, in an effort to

26
Samuel Seymour, 1797-1822
"View near the base of the Rocky Mountains"
1820.

140
Cross
Ca. 1890; Cheyenne; Oklahoma.

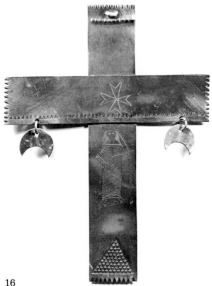

understand the Far West. One of these was Samuel Seymour, who, as a member of the Long expedition, made the first view of the Rocky Mountains to be reproduced in the East (no. 26). Details of Indian costume captured the attention of the Swiss artist-traveler Peter Rindisbacher (no. 29), who painted with a stiffly accurate style becoming to one in search of unusual visual facts.

Conflict in the West is a theme often repeated in novel and film. In this exhibition two views of this conflict are offered: that of the Indian and that of the white (nos. 117-125). Since both cultures had a long tradition of warfare even before coming into contact with each other, it is not surprising that, with the burgeoning of the immigrant population in the nineteenth century, incidents of conflict increased. The defeat of Colonel George A. Custer at the Battle of the Little Big Horn in 1876 was a victory for the Sioux, Cheyenne, and Arapaho much celebrated by Indian artists (nos. 131-132). Battle art, which had a long tradition in Indian life, remained linear in treatment just as it had been practiced in ancient times on rock and skin surfaces. With the coming of the white man, the Indian quickly adopted cloth and paper (no. 118) for his paintings in place of hide.

The effect of the white man on Indian crafts is first seen in the use of manufactured goods brought by traders, trappers, mountain men (nos. 126-152) in exchange for furs and other resources of the western territories. Bright scarlet cloth, blankets, dyestuffs, trade beads, knives, axes, guns, ammunition, coffee, tobacco, and other objects calculated to appeal to the fancy or need of the Indian were shipped west. Goods were carried by caravans or boats to distant outposts and from there along remote trails to rendezvous points where the trappers and traders concluded every year's toil with wild debauch. Contrasting with this careless abandon is the thought employed by the Indian in refashioning what were to him precious trade materials for his own purposes.

132
White Bird
Custer's Last Fight. The Battle of
Little Big Horn
1894-1895; Northern Cheyenne,
Wyoming.

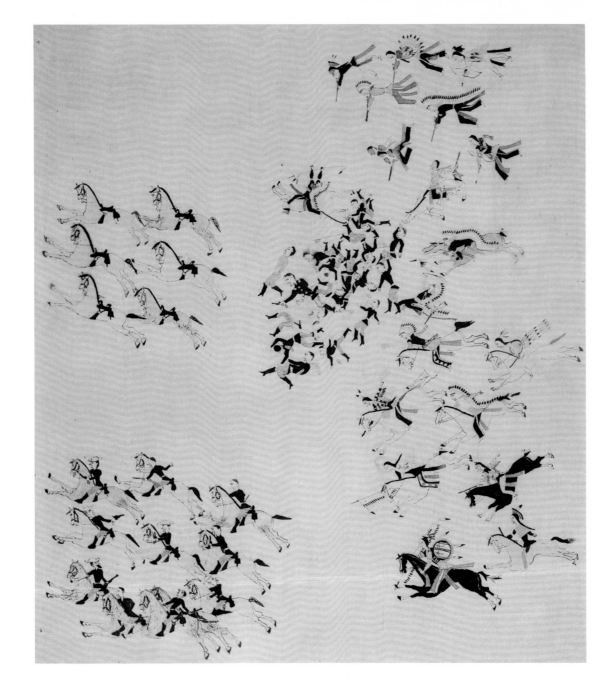

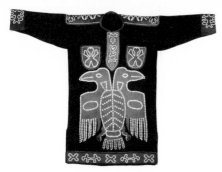

129
Man's shirt
19th century; Tlingit, Alaskan coast.

143
Courting flute, made from a gun barrel
Ca. 1900; White Mountain Apache;
Cibique, Arizona.

The Tlingit man's shirt from the Northwest Coast (no. 129) is a prime example of brilliant designs utilizing trade materials. Red stroud cloth, a favorite woolen brought to the Indians, is found mixed with feathers and other animal parts on a calumet, or pipe, from Oklahoma (no. 127). Trade cloth and iron for the tips of arrows are found on the Indian relics (no. 128) brought back to Boston by Francis Parkman after his stay with the Sioux in the 1840's while he prepared for his book *The Oregon Trail*. Silver ornament, a mark of distinction among Indians, is represented in the exhibition by three pieces. Two are of German silver and were owned by Indians in Oklahoma (nos. 140-141). One is a silver United States peace medal (no. 142) bearing the portrait of James K. Polk, who was responsible for expanding the boundaries of the nation into Mexican territory. Beads were the most common materials of trade with the Indian. And although they were of trifling value to the white man, in the hands of skilled Indian craftsmen, they became beautifully arranged or strung on buckskin fringe, as seen on an Apache burden basket (no. 147). Whenever the Indian reshaped to his needs goods obtained through trade, the transformation was remarkable. With freshness of eye and deftness of hand, he created works that sometimes have a poetic irony, such as the gun barrel fashioned into a courting flute (no. 143).

Objects from the settlements form the most extensive part of the exhibition. In these (nos. 153-286) the viewer can witness the development of domestic crafts. Those who were lured westward by tales of rich natural resources and exaggerated claims of land agents were not always disappointed. Competing nations and companies enticed some who expected to gain profit from Indian lands. Others went west seeking gold. Rare views of the gold country (nos. 156-158) and the cities that boomed as a result of the population growth (nos. 162-165) clearly show the rapidity with which temporary settlements became permanent.

Land was the greatest single attraction in the West. Hope of estab-

lishing new orders of community life free of rigid social structures also drove many people west. Emigrants from overpopulated European countries found the American West a place of opportunity, where one could succeed because of ability rather than by credentials or birth.

Since the land was settled in so many different ways by people from many varied backgrounds, it was decided that this exhibition would select three characteristically different groups that were representative of others. Collected in some quantity here are furniture and decorative works made by people of the Spanish Southwest (nos. 179-219), German-Texas settlers (nos. 273-281) who, for the most part, came directly from abroad, and Mormon pioneers (nos. 266-267, 284), who immigrated to the Far West from earlier frontiers of Illinois and Ohio. Added to these three groups are objects from settlements in Oregon (nos. 230-231), Montana (nos. 227-229), Colorado (no. 241), and Nebraska (nos. 226, 269, 285).

For orderly presentation the Spanish Southwest has been treated first. Even though some of this material is not chronologically the earliest, the style of life that produced it was of an older order. Carved six-board chests (nos. 189-190) and rigidly framed armchairs (no. 185) continued a style that was two hundred years out of current fashion in urban centers. In the remote circumstances of the Spanish Southwest, it is understandable that the popular arts developed individualistic local traditions and practices. Representative of these arts developed in relative isolation is the colcha (nos. 210-211). As trails to the East opened in the nineteenth century, so the style of life in the Spanish Southwest slowly changed. A camape, or daybed (no. 186), a side chair (no. 263), and a tin frame (no. 198) provide evidence of the influence and change wrought by contact between the people of the Spanish Southwest and the East.

Decorative arts on the frontier reveal the dynamics of settlement. Household objects were brought from the homeland to newly estab-

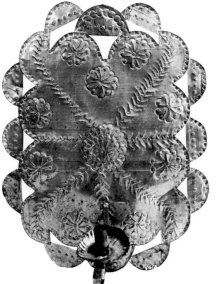

196
Sconce
Ca. 1870; Cabezon, New Mexico.

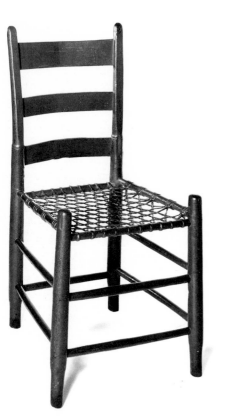

220
Dominicus and Polly Miner Carter
Slat-back side chair
Ca. 1851; Utah.

lished communities (nos. 220-224). But since the communities were often isolated and transportation was limited, most settlers were soon obliged to manufacture their own shelter and furniture. Grappling with conditions of climate and environment that were often harsh, settlers had to learn how to make their own buildings, furniture, and clothing out of available materials. Adobe houses, stick furniture, and buckskin clothes were frequent choices. Familiar craft practices from the past were simplified through the use of tools at hand. With hand, axe, and adze, earlier forms in furniture were transformed by the pioneering experience. But traditions held fast, and stick, or slat-back, chairs (nos. 220, 232-237), which had enjoyed centuries of use elsewhere, persisted on the frontier. With seats of woven rawhide or gut, or stretched hide, these chairs became the most ubiquitous form of seating throughout the West.

Functionalism was one of the prime requisites of frontier furniture. The simple lines that form a kitchen table (no. 245) are surprisingly modern looking. With a certain pride in neatness of workmanship, economy of means, and rapidity of execution, the frontier craftsman shaped his art with memories of style lingering from his homeland. But for all his efforts to reproduce his past, a new rough-hewn strength asserted itself, as may be seen in several pieces in this exhibition. A sapling rocking chair from Nebraska (no. 225) with bark still left on, a rough-hewn pedestal table, left unpainted, from the Texas frontier (no. 262), and a stained bed with coarsely shaped posts (no. 256) suggest the utilitarian nature of much initial settlement furniture made for home use.

As organized settlement grew and offered opportunity for the specialized craftsman, small craft shops opened. With considerations beyond those of mere survival, the frontier craftsman could perfect his style. In rural Texas, where Germans settled in great numbers between the Colorado and Brazos rivers, there continued through the nineteenth century a love of brilliantly colored massive wardrobes (nos. 277-279).

277
Wardrobe
Ca. 1860-1870; Fayette County, Texas;
marked "C.W." on back in chalk.

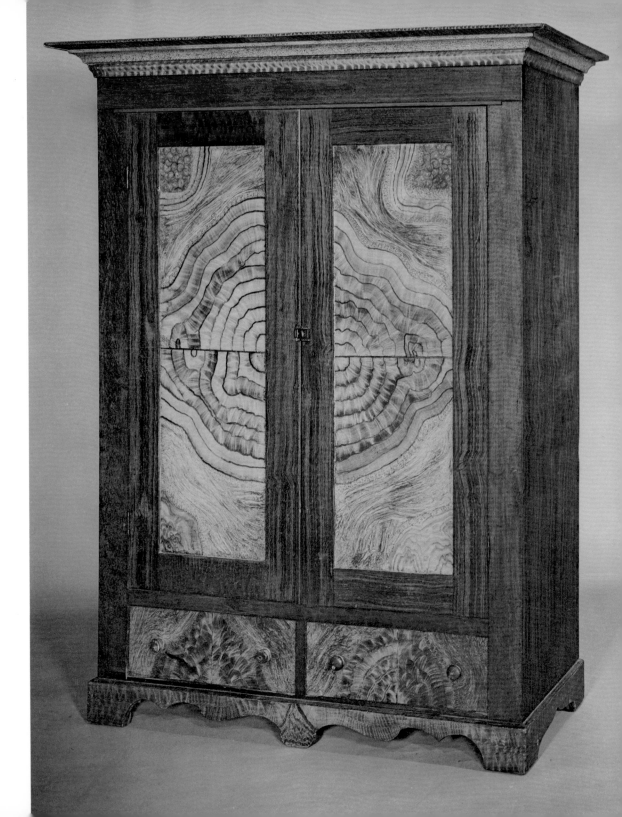

Wooden surfaces with shimmering patterns to the grain also delighted Germanic taste in this area (nos. 273-274). Contrasting with the furniture produced by German immigrants are the works of those who traveled overland to the West from previous frontiers. Typical of the taste of most settlers who moved to California and Oregon are the pieces of furniture produced by Mormons in the 1850's, before the arrival of the transcontinental railroad in 1869. A side chair and bed (nos. 266, 268), both probably produced in the Great Salt Lake Public Works established by Brigham Young, exhibit what the frontier craftsman remembered of neoclassicism from the East.

The romanticized versus the real West is to be seen at a glance throughout the exhibition by comparing the painted image with the photographed image. Contrast, for example, the idealized portrait of Brigham Young's family (no. 292), which is supposed to have been taken from life, with the photograph of a less fortunate family by Edward Anderson (no. 298). And in the realm of landscapes, compare the paintings of Bierstadt (nos. 70-73) with photographs by O'Sullivan (nos. 76-85).

As the West matured, and as the frontier became diminished by safe travel for anyone who could afford it, picturesque tour books multiplied and stereopticon views (no. 315) brought the West into eastern parlors. Westerners soon discovered that there was a market for things "western." Frederick Remington traveled west to illustrate an era almost at an end. Charles Russell and a host of others produced paintings that recorded and intensified the image of the cattle frontier as they saw it (no. 166). Horn chairs, which were made from the raw surplus of hunting or ranching (no. 286) became recognized symbols of the Old West and were fabricated with great skill for display at fairs and exportation to hunting lodges in the East.

By the end of the century, the West was celebrating its own past. With the buffalo exterminated and the Indians confined to reservations,

with the direct importation of modern building techniques (no. 294) and manufactured furniture, the frontier ceased to exist. In 1904 St. Louis organized a World's Fair to celebrate the frontier past, the centennial of the Louisiana Purchase, and the expedition of Lewis and Clark. For this fair a bronze Indian was produced (no. 293) by sculptor C. E. Dallin. It shows a Plains warrior with clenched fist raised in the familiar gesture of protest.

Within the lifetime of most pioneers and within the memory of many Indians who had seen the strangers come to their lands, the Far West had passed from a stage where native arts had flourished, through a period of simple pioneering crafts, to become an urbanized society employing the most modern technology.

JONATHAN L. FAIRBANKS

287
Armchair
Ca. 1900, Riverton or Lander, Wyoming.

291
Buffalo robe
Ca. 1890-1900; Utah.

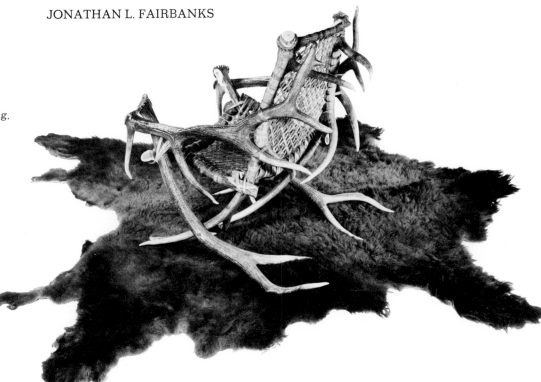

293
Cyrus Dallin, 1861-1944
The Protest
1904.

Facing page:
103
John K. Hillers
*"Ruins of Cliff Dwellings
in De Chelley Cañon."*
1872-1878

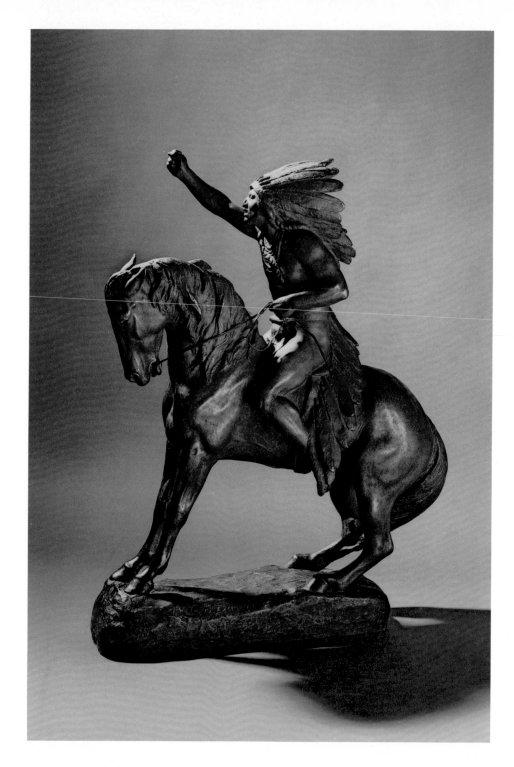

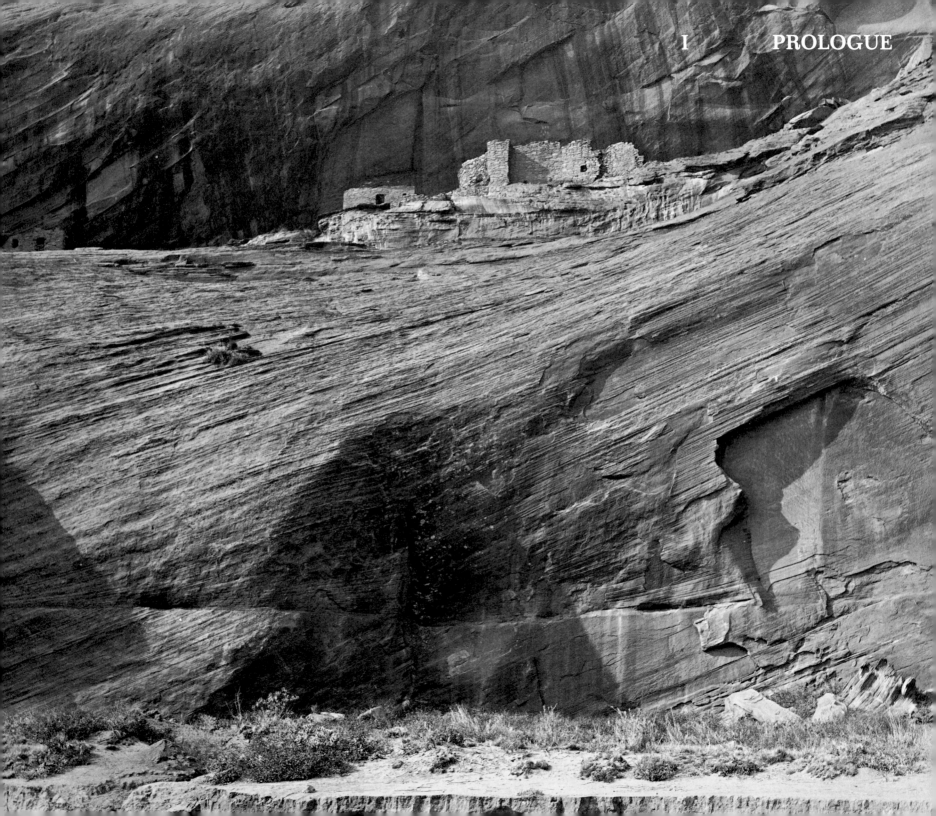

1
American Indians before European Contact

Human beings have inhabited America for more than seventeen thousand years, sharing the postglacial environment of the shaggy mammoth, the American horse and camel, the long-horned bison. Elegantly shaped projectile points, colored pigments, and bone fragments engraved with rhythmic patterns are found in association with these long-extinct animals.

In the fifteen centuries before Europeans invaded the Far West, cultural entities rose and dwindled; techniques of art and survival were acquired, developed, forgotten, and relearned; countless migrations and mixings of peoples took place. American Indian arts and crafts of prehistoric times, like those of today, can be enjoyed for expressive form, subtlety of pattern, and clever manipulation of materials, but each item should be set against its own time and place. The Indian objects shown in this exhibition were made by peoples with cultures and languages as unlike as those of ancient Athens and Peking, some a thousand years and a thousand miles apart, peoples who may have had not the slightest influence upon each other.

What Robert F. Spencer calls the "American Babel," some two hundred Indian languages and a very large number of sublanguages and dialects were spoken north of Mexico at the time of European encounter. Despite "mutually unintelligible languages" and natural barriers of mountains, desert, and sheer distance without any beast of burden but the dog, for centuries these peoples fostered a substantial trade.[1] Such art materials as sea shells, copper, turquoise, obsidian, pigments, and feathers were carried hundreds of miles. Certain practical techniques, religious tenets, ceremonial symbols and practices spread across huge overlapping circles of territory, yet some groups clung fiercely to their own ways, rejecting or ignoring innovations from nearby "enemy" tribes. Human subsistence varied from elementary foraging to community-organized agriculture using irrigation, from big and small game

1. Robert F. Spencer et al., *The Native Americans* (New York: Harper & Row, 1965).

hunting to seacoast fishing, from temporary and portable shelters to multistoried towns.

Among the less perishable evidences of Indian concern with design are the paintings and scribings on boulders and rock walls throughout the continent. Garrick Mallery has observed that these drawings are embodiments of gesture, a kind of sign language, just as the hand motion for "water" is transcribed as a wavy line. Aside from their aesthetic impact, pictographs and petroglyphs tell something of the story of an era through stylized and naturalistic rendering of animal forms, costume, weaponry, battles, and ceremonial events.[2]

Sculpture also had ample expression in stone, bone, clay, wood, and more fugitive materials, such as basketry (nos. 3-7). Copper, not widely distributed and the only metal used, was cut into flat silhouette ornaments in the Mississippi Valley and cast by the *cire perdue* process into small bells in the Southwest. Sleek steatite and bone sculptures were created by West Coast Indians (nos. 2, 8, 9). The Hohokam peoples of Arizona (ca. A.D. 1-1400) carved shallow dishes in the form of lively horned lizards and rattlesnakes in coarse-grained sandstone and lava. Spirited deer, mountain sheep, and feral cats, as well as people and supernatural beings were molded in clay, usually enhanced with paint.[3] Sophisticated "effigy" pots, most commonly in the shape of birds, stylistically decorated, have been recovered in excavations of many Pueblo ruins.

Sculpture reached a high degree of excellence in the big-tree area of the Northwest Coast, where wood was carved and painted in the round and in bas relief for architectural and memorial uses, as well as for sixty-foot seagoing canoes. Sculptural themes echoed the same elegant symbols of beasts and men used in basketry, paint, and costume.

For dances and ceremonies, Indian groups employed several media —masks, costumes, ornaments, and body paint—to transform human

2. Dorothy Dunn, *American Indian Painting of the Southwest and Plains Areas* (Albuquerque: University of New Mexico Press, 1968), 16-17; Garrick Mallery, "Picture Writing of the American Indians," U.S. Bureau of American Ethnology, *Annual Report* no. 10 (Washington, D.C., 1893).

3. Harold S. Gladwin et al., *Excavations at Snaketown: Material Culture* (Tucson: University of Arizona Press for Arizona State Museum, 1965).

figures into gods, animals, and mythological beings. Among the south-western Pueblos, costume, ceremony, and music became elaborate and refined. The thousand-year-old proof of this appears in ceramic draw-ings and in murals. A tradition of painted wooden figures survives in the "kachina dolls" of present-day Pueblos, recording the masks and par-aphernalia of dancers who portray the supernaturals.

The prehistoric inhabitants utilized plant fibers—bark, grasses, yucca, reeds—in basketry and fabrics. Narrow strips from the pelts of small animals were twisted and woven into blankets. The Spanish con-quistadores, arriving in the mid-sixteenth century, met Pueblo Indians whose garments were woven from domestic cotton and decorated with paint. After sheep were brought in by Spanish settlers, southwestern Indians applied ancient cotton techniques to woolen textiles, and to this day Navajo weavers prefer the aboriginal vertical loom to the Old World horizontal type. Basketry was an early craft, and the so-called Basketmakers (ca. A.D. 200-700) wove yucca and other fibers into hand-some vessels, sandals, and clothing ornamented by textural variations and painted designs. The linear patterns natural to weaving—stripe, checkerboard, stairstep, pyramid—influenced geometric conventions in pottery and painting.

Although pottery was known in South America by 2000 B.C., the technique did not reach the southwestern United States until about 300 B.C., already well developed and coincident with the first permanent habitations. As among modern Pueblo artisans, the potter's wheel was not used, vessels being constructed by several methods and combina-tions of these: hand building, shaping with a paddle against a rounded anvil, coiling, finishing with scrapers, and polishing with a smooth stone. Ornament could involve coil rhythms, clay slips, indenting, carving, and painting with minerals and plant juices. Without a kiln, clay was fired to a maximum of 750° C., too low a temperature for complete fusion, leav-

4. Kenneth M. Chapman, *The Pottery of San Ildefonso Pueblo* (Albuquerque: University of New Mexico Press for School of American Research, 1970), 10.

ing the finished pottery slightly porous.[4] Remarkable strength, thinness, and symmetry characterized many wares, and storage jars large enough to hold fifteen gallons of corn have been found.

Dozens of Indian ceramic styles are recognized by specialists, mainly on the basis of well-established profiles and decorations. A few areas produced wares equal to the best of the Old World's ancient potters. Complex geometric patterns, painted with remarkable balance and precision and differing clearly from one area to another, were widely employed. Some groups developed sophisticated abstract symbols for natural and mythological themes. A few, notably the Hohokam in Arizona and the Mimbres in New Mexico (nos. 11, 15), had a flair for zoomorphic forms. Their yucca brushes caught moments from daily life and recorded characteristics of the wild creatures in their environment.

The most impressive aboriginal architecture in the United States is in the Southwest. The so-called Great Pueblo era reached its peak between A.D. 1050 and the end of the thirteenth century. This culture was characterized by large fortified communities; fields of corn, squash, and beans irrigated from diverted streams; specialization of labor skills; elaborate ritualistic duties supporting multiple religious structures (kivas); well-developed trade; and a healthy proliferation of the arts.

Of the several communal buildings in Chaco Canyon, New Mexico, the most spectacular is four-story, eight-hundred-room Pueblo Bonito. According to H. M. Wormington, "It has been estimated that it could have sheltered 1200 inhabitants, and it was the largest 'apartment house' in the world until a larger one was erected in New York in 1882." Pueblo Bonito was constructed during the tenth and eleventh centuries, with walls of flat stones, carefully fitted but not "cut" in the accepted sense of stonecutting. Roofs were of dressed logs and poles, sealed with fiber matting and earth. The Chaco artisans produced a handsome white pottery painted with bold geometrical patterns (archaeologists un-

5. H. M. Wormington, *Prehistoric Indians of the Southwest* (Denver: Denver Museum of Natural History, 1959), 76-107.

covered many ceremonial pieces in "mint" condition) and a treasury of turquoise and shell bead and mosaic ornaments (nos. 16, 17).[5]

Of the Indian artist of earlier times, Dorothy Dunn has observed: "The individual was never singled out as the producer, recipient, or subject of painting. There were no portraits because the individual man was less important than the plants and animals and the powers necessary to existence, which indirectly *were* man. It never would have occurred to a Pueblo artist to sign his name to a work or to be thought of as an artist. He did, however, expect remuneration for his art as a part of the general beneficence of nature toward the entire pueblo. In this respect, his painting was a religious art."[6]

6. Dunn, *American Indian Painting*, p. 110.

ROLAND F. DICKEY

Titles of pictorial works in quotation marks are those assigned by the artist or photographer. For drawings and watercolors, description of paper is given only when it is other than white. Dimensions are to the nearest one-eighth inch.

1

Palette

A.D. 700-900; Hohokam, Kinishba Ruin, southern Arizona; slate, h. 7 in., w. 3 in.
Arizona State Museum, Tucson

The Hohokam, along with the Anasazi and the Mogollon Indians, were the earliest dwellers of the Southwest. They inhabited the desert region of central and southern Arizona, which they farmed by constructing irrigation canals. This stone palette, of anthropomorphic shape, was used for compounding pigments, traces of which remain on the surface. It may have been a Hohokam trade item.

2

Stele

Prehistoric; Sauvie Island, Columbia River, Oregon; granite with traces of red and white paint, h. 30 in., w. 11 in., d. 9 in.
Oregon Historical Society, Portland

The Pacific Northwest was an important center for the early development of stone sculpture. Found in 1874 on Sauvie Island, near the site of present day Portland, this crowned figure with semiabstract face and ribbed torso, was carved by pecking the large stone surface with harder stones.

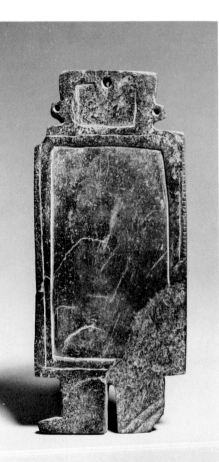

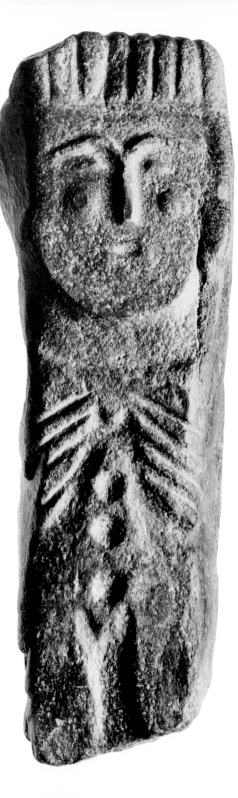

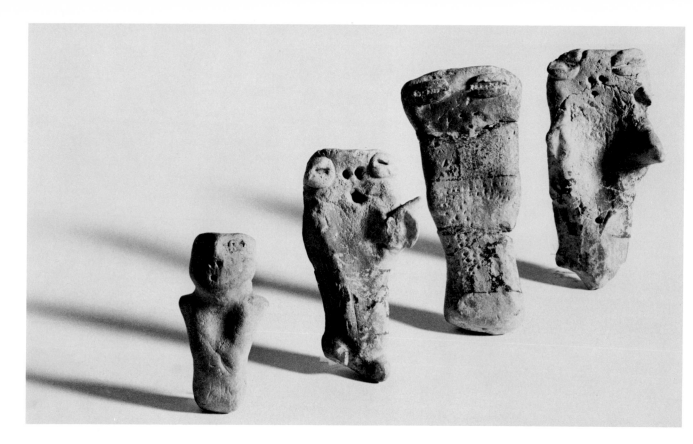

3-6

Four figurines
Ca. A.D. 1000; Fremont-Provo culture area, Hinckley Farm site, Utah Lake; unbaked clay, h. 3⅜ in., 3¼ in., 2¾ in., 2⅛ in.
Brigham Young University, Provo, Utah

A number of clay figurines from the Fremont culture have recently been found in several sites in central and eastern Utah. Desert peoples, who lived by farming and hunting, produced these figures probably for a religious use. The broad shoulders and narrow waist are characteristic of three-dimensional figures and petroglyphs from the same region.

Ref.: Dee F. Green, "The Hinckley Figurines as Indicators of the Position of Utah Valley in the Sevier Culture," *American Antiquity* 30 (1964), 74-80.

8

Pelican
Ca. A.D. 800-1000; southern California Indian; steatite, h. 3½ in., w. 2¼ in., d. 2½ in.
Southwest Museum, Los Angeles

Made by Indians living on the mainland shore and offshore islands near the sites of present day Santa Barbara and Los Angeles, simplified representations of sea creatures such as this were perhaps used in fishing ceremonies.

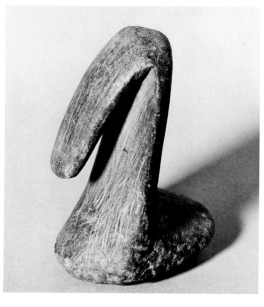

7

Figurine in cradle

Ca. A.D. 950-1200; Fremont-Provo culture area, Wayne County, Utah; bark strands, reeds, clay, skins, cloth, and twine, h. 5 in., w. 9 in., l. 16½ in. Church of Jesus Christ of Latter-day Saints, Salt Lake City

The culture of the Indians of southern Utah was stimulated by that of the Anasazi of Arizona. This unbaked clay figurine, wrapped in cloth and resting in a plain twined rod cradle, was found in a cliff dwelling. The additions of nineteenth century cloth and twine suggest that this figure had ceremonial usage over several generations.

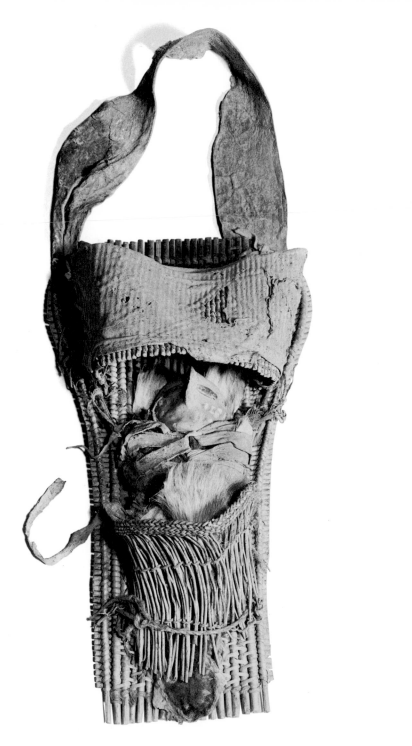
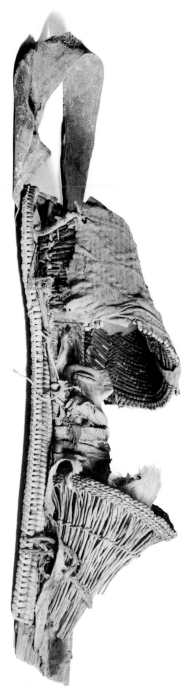

9

Whale

Ca. A.D. 800-1000; southern California Indian; steatite, h. 4¼ in., w. 6⅜ in., d. 2¼ in.

Peabody Museum of Archaeology and Ethnology, Harvard University

11

Jar

Ca. A.D. 900-1200; Hohokam, Snaketown site, Arizona; red earthenware with red and white slip, h. 5 in., diam. (top) 7½ in.

Arizona State Museum, Tucson

Hohokam pottery was made by the piling up of broad coils, which were then shaped and smoothed with a wooden paddle and mushroom-shaped anvil of hard clay. The design on this jar is in the natural color of the baked clay and is outlined in red.

15

Bowl

Ca. A.D. 1000-1200; Mogollon culture, Mimbres Valley, southwestern New Mexico; red earthenware, white and black slip, h. 3½ in., diam. (top) 7¾ in.

The Denver Art Museum

The Mimbres Indians lived in villages of clustered masonry rooms in southeastern Arizona and southwestern New Mexico. Their pottery vessels are distinguished by the superior technique of the brushwork and their bold, black and white interior decoration (which sometimes paled to rusty red in the firing) of whimsical animal and human motifs. This pot, which was used primarily for funerary purposes, had a center "kill" hole (filled during restoration) inflicted in the bowl upon the owner's death so that his spirit could be released.

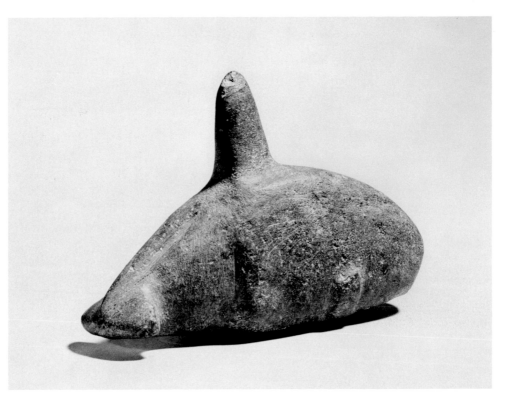

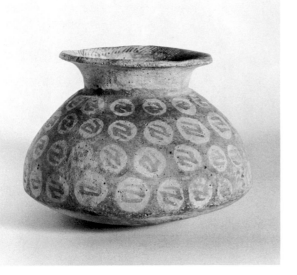

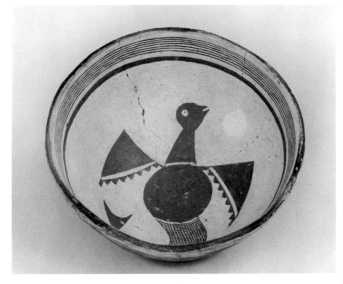

16

Vessel in human form
Ca. A.D. 1050-1350; Anasazi culture,
Pueblo III, Chaco Canyon, New Mexico;
gray earthenware with white and black
slip, h. 7¼ in., w. 4½ in., d. 5 in.
Peabody Museum of Archaeology and
Ethnology, Harvard University

*This vessel in the form of a seated man,
decorated in black and white paint,
may have been used for religious
purposes.*

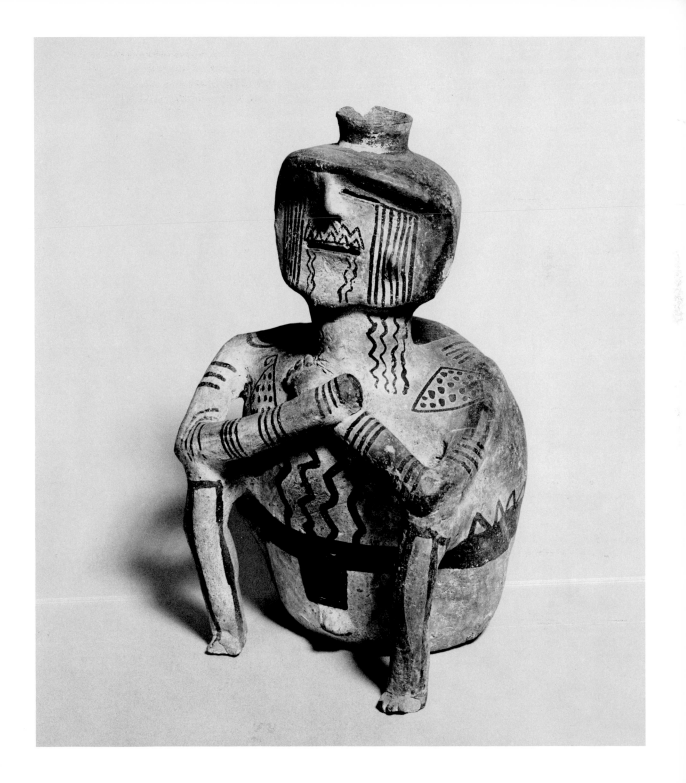

18
Blade
Ca. A.D. 1050-1350; Anasazi culture,
Pueblo III, Poncho House, Utah,
Kayenta region; limestone, inlaid with
turquoise, h. 4½ in., w. 2¼ in.
Peabody Museum of Archaeology and
Ethnology, Harvard University

*The art of mosaic was used in the
Southwest for plaques and ornamental
objects such as this blade. Colorful tur-
quoise, known to the southwestern
Indians from the earliest times, is still
incorporated in their jewelry and
ornaments.*

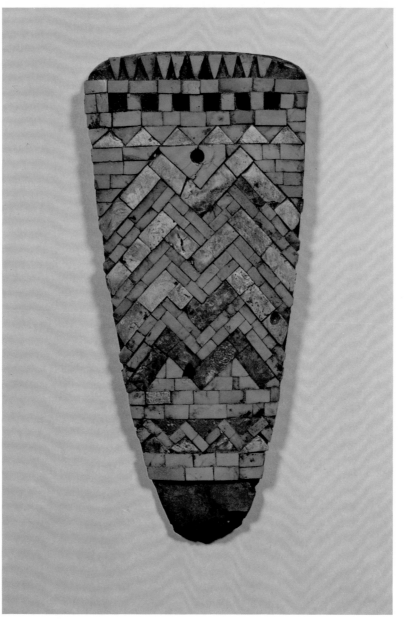

Facing page:
80
Timothy O'Sullivan, 1840-1882
Sand Dune near Sand Springs, Nevada
1867

2
Natural History and the Natural Man: Art and Science in the West

1. George Catlin, *The Manners, Customs, and Condition of the North American Indians* (London, 1841), vol. 1, pp. 14, 15.

Two thousand miles up the Missouri River, at the mouth of the Yellowstone, the painter George Catlin found the world very much to his liking. "I am now in the full possession and enjoyments of those conditions, on which alone I was induced to pursue the art as a profession," he wrote back to an eastern newspaper in 1832. "My enthusiastic admiration of man in the honest and elegant simplicity of nature, has always fed the warmest feelings of my bosom, and shut half the avenues to my heart against the specious refinements of the accomplished world."[1] Although there is a certain literary affectation about Catlin's remark, reminding us that the appreciation of the wilderness was at first an intellectual and urban pursuit, there is also an honest emotion that reveals why an unspoiled natural environment was of supreme importance to the artist and scientist in the early nineteenth century, and why, indeed, a traveling naturalist, overwhelmed by the beauty of the wilderness, was often both.

Catlin, like many of his contemporaries, saw the Indian as a primitive fulfillment of a natural moral order, just as others had discovered the same qualities in the landscape and its mysterious complement of flora and fauna (nos. 31, 32). The West (and still much of the East north of Massachusetts and west of the Alleghenies) was virgin territory, existing beyond the corrupting influence of an industrial civilization and beyond the Old World, with its decadent and immoral ways. The unsettled portions of this new land represented in the minds of those early painters and scientists the clear indication of God's presence, where they might investigate the very source of creation as a means of determining the future.

This Adamic vision, as it has been called, was a curious blend of innocence, optimism, and frontier enterprise, which by the 1850's could even be linked to Manifest Destiny. But its deepest roots seem to go back to an attitude toward nature developed in eighteenth century England

and Germany and passed on to America in the nineteenth century through such seminal figures as Bryant, Cole, Emerson, and Thoreau. Nature, in their sense, became a scriptural source in which artists and scientists were obliged to read the wonder of God's world and then reveal its meaning to a deeply concerned populace.

William Bartram and Alexander Wilson, who roamed our eastern forests in the late eighteenth and early nineteenth centuries, were two of the first naturalists to respond with awe and enthusiasm to the scenes they witnessed. Bartram wrote a glowing description of a journey he made in the 1770's through the southern states, seeking botanical specimens, and Wilson compiled *American Ornithology* between 1808 and 1814, a nine-volume study that he illustrated with his own skillful drawings. By 1800 Philadelphia had become the institutional center for such natural history studies, with the Academy of Natural Sciences, the American Philosophical Society, and Peale's Museum, the latter a collection of portraits and natural history specimens presided over by the venerable painter Charles Willson Peale. As Peale's contemporary John D. Godman maintained, "to study Natural History, it is only necessary for us to use our eyesight."[2] From this scientific environment came Samuel Seymour and Titian Ramsay Peale of the Long expedition and countless other artists and scientists who observed and recorded the West in the subsequent decades of the century (nos. 24, 26, 28).

Europeans were equally curious about the untouched resources of the American West. Prince Maximilian of Germany ventured upriver to Fort Union a year after Catlin had written his tribute to the Blackfeet and the Crow. With him came the Swiss artist Karl Bodmer, who not only recorded these Indians and their accessories with remarkable precision (no. 36) but left us in addition the finest landscapes of the Upper Missouri painted in the nineteenth century. Alfred Jacob Miller's western views were more fanciful than those by Bodmer (nos. 38, 40, 41), per-

2. Jessie Poesch, *Titian Ramsay Peale, 1799-1885, and His Journals of the Wilkes Expedition* (Philadelphia: American Philosophical Society, 1961), 51.

haps because his patron, the Scotsman William Drummond Stewart, was less a scientist than an adventurer, but the Canadian Paul Kane, the last of these artist-explorers unattached to a survey team, was as methodical as one could wish (nos. 44, 45). Having met Catlin in London in 1843, Kane returned to Canada and began a gallery of Canadian Indians that duplicated the pictorial and written record of the Plains tribes assembled by Catlin between 1830 and 1836.

As a measure of their objective, the artists involved in these early expeditions were primarily concerned with a careful transcription of detail, and when photography became a somewhat portable medium in the 1860's, the western surveys quickly adopted it as a further means of guaranteeing the accuracy called for by Sir David Brewster, inventor of the stereograph. The painter "owes to truth," he wrote in 1856, "the same obligations as the botanist who is to describe . . . plants, or the mineralogist . . . rocks and stones."[3] Thus, the photographs of W. H. Jackson, Timothy O'Sullivan, and Jack Hillers (nos. 76-82, 89, 93, 103) were but another way of analyzing and recording survey information, ethnographic, botanical, or topographical, although the skill of several of these early photographers was such that the medium soon gained an independent aesthetic identity.

Lewis and Clark had scarcely returned from their reconnaissance of the Louisiana Territory when various commercial interests and government agencies began to investigate its practical value. Artists and scientists might be awed by its virgin character, but others more conscious of the destiny of the young nation saw it as a rich new world of furs, minerals, lumber, and farmland waiting to be developed by the compulsive energy of the pioneers. Interest in the Great Plains and the Rockies was generated by numerous descriptive accounts in the 1820's and 1830's, including novels by both Cooper and Irving; and after immigration began in earnest in the early 1840's, army and railroad sur-

3. Sir David Brewster, *The Stereoscope: Its History, Theory and Construction* (London, 1856), 174.

veys explored farther to determine the least difficult routes to the Pacific Coast and to plan effectively for the development of the land. Accompanying these surveys were artists of varying talent, including Seth Eastman (no. 48) and other army officers trained as draftsmen at West Point: John Mix Stanley and William Birch McMurtrie (no. 54), who had previous experience as professional painters; and Gustavus Sohon, James M. Alden, and Joseph Heger, who were at best only amateur topographers (no. 69).

In general, these surveys were staffed with a full complement of engineers, scientists, and cartographers, in addition to artists and photographers. With an impatient populace waiting to expand into the West, the research attitudes of these explorers were perhaps less ideal than those of a generation earlier. Even so, a foundation for southwestern archaeology was begun during this period by R. H. Kern (nos. 52-53) in his reconstruction of pueblo sites (W. H. Holmes later expanded the field); and Eastman and Stanley, the best of these survey painters, lamented, as Catlin had earlier, the inevitable extinction of the Plains tribes.

The army and railroad surveys came to an end with the Civil War and were replaced by the geological surveys of the War Department in the late 1860's and 1870's, operating under Ferdinand V. Hayden, Major John Wesley Powell, Clarence King, and Lieutenant George M. Wheeler. These surveys began to probe areas neglected by the previous groups more concerned with effecting transcontinental migration, and in the process they discovered the most imposing scenery of the American West. Several distinguished landscape painters of the period, Albert Bierstadt (nos. 70-72), Worthington Whittredge, Sanford Gifford (no. 90), and Thomas Moran (nos. 92, 95, 96) came West as guest artists on these surveys; they had no official duties, and they rarely attempted a strictly topographical record of the landscape. Instead they were looked

upon by Hayden, Powell, and others as effective publicizers of survey discoveries, whose glowing visual reports might persuade Congress to continue the annual appropriations for these expeditions.

The artists approached the West with much the same sense of wonder and delight that William Bartram had expressed when exploring the virgin forests of the East almost a hundred years earlier, but now they came charged with a deeper mission to interpret the landscape. Nature was a grand, exhilarating moral influence, to be studied and painted as a means of clarifying spiritual inspiration. "Scenes of majesty and enduring interest," the English critic John Ruskin would have called them, and although he issued a volume of instructions on how to copy geological formations, he also challenged the artist to convey the exalted experience of mountain scenery. Thomas Moran echoed Ruskin when he explained his first major painting of the West: "The motive or incentive of my 'Grand Canyon of the Yellowstone' was the gorgeous display of color that impressed itself upon me. Probably no scenery in the world presents such a combination. The forms are extremely wonderful and pictorial, and, while I desired to tell truly of nature, I did not wish to realize the scene literally, but to preserve and to convey its true impression."[4]

4. George W. Sheldon, *American Painters,* rev. ed. (New York: Appleton, 1881), 125-126.

During the Yellowstone survey of 1871, Jackson and Moran had worked together on countless occasions, selecting subjects and views that would effectively enhance the medium in which each worked. Perhaps Jackson benefited most from this exchange, and his survey photographs are still regarded as masterpieces of the wet-plate process, but the composition of Moran's large picture may have been influenced by Jackson's views of the Yellowstone canyon. Bierstadt and Eadweard Muybridge, and John Henry Hill (no. 87) and O'Sullivan affected each other's work in similar ways, while Thomas Hill and C. E. Watkins often selected the same sites for their dramatic views of Yosemite.

Not all of the painters treated the West on the grand scale of Moran and Bierstadt. Gifford and Whittredge, for example, raised on the Catskills and the White Mountains, seemed hesitant to expand beyond the more pastoral interludes of the western mountains, but they recognized the range and effect of the scenery, and Whittredge has left us an account of a chance meeting with Kit Carson in Santa Fe that conveys a range of emotion as poignant and revealing as any in the history of western travel. Carson for some time had been watching Whittredge sketch a landscape, when finally he asked the artist if he might say a word to him. "He began by describing a sunrise he had once seen high up in the Sangre de Cristo," Whittredge remembered. "He told how the sun rose behind their dark tops and how it began little by little to gild the snow on their heads, and finally how the full blaze of light came upon them, and the mists began to rise from out the deep canyons, and he wanted to know if I couldn't paint it for him. Nature had made a deep impression on this man's mind, and I could not but think of him standing alone on the top of a great mountain far away from all human contact, worshiping in his way a grand effect of nature until it entered into his soul and made him a silent but thoughtful human being."[5]

WILLIAM H. TRUETTNER

5. Worthington Whittredge, *The Autobiography of Worthington Whittredge, 1820-1910*, ed. John I. Baur (1942; reprint ed., New York: Arno Press, 1969), 48.

24

Titian Ramsay Peale, 1799-1855
American Bison Bull
Ca. 1819; watercolor, 6⅛ x 8¼ in.
Kennedy Galleries, Inc., New York

*Titian Ramsay Peale and Samuel
Seymour were the artists attached to
a special scientific corps under Stephen
Harriman Long, which was part of
General Henry W. Atkinson's Yellow-
stone expedition of 1819. The expedi-
tion's purpose was to explore the
territory along the Missouri River to
the source of the Yellowstone and to
establish a series of military posts that
would protect the fur trade and contain
the Indian population. In fact, they
were finally ordered to the Southwest,
where they traveled on the Platte,
Arkansas, and Red rivers.*

*Both Peale and Seymour were Phila-
delphians. Peale's appointment to the
special scientific corps had been en-
couraged by his father, Charles Will-
son Peale, who wished objects brought
back from the expedition to be housed
in Peale's Museum in Philadelphia,
with the Lewis and Clark collections.
As naturalist and artist for the Long
expedition, Titian Peale was instructed
to collect and delineate specimens and
to make sketches indicating the geo-
logical stratifications of rocks, earth,
and mountainsides.*

Refs.: Jessie Poesch, *Titian Ramsay
Peale and His Journals of the Wilkes
Expedition* (Philadelphia: American
Philosophical Society, 1961); William H.
Goetzmann, *Exploration and Empire*
(New York: Vintage Books, 1966).

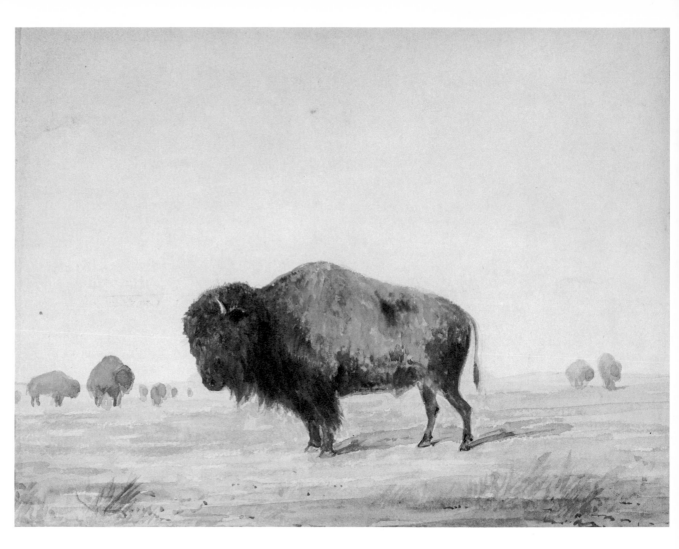

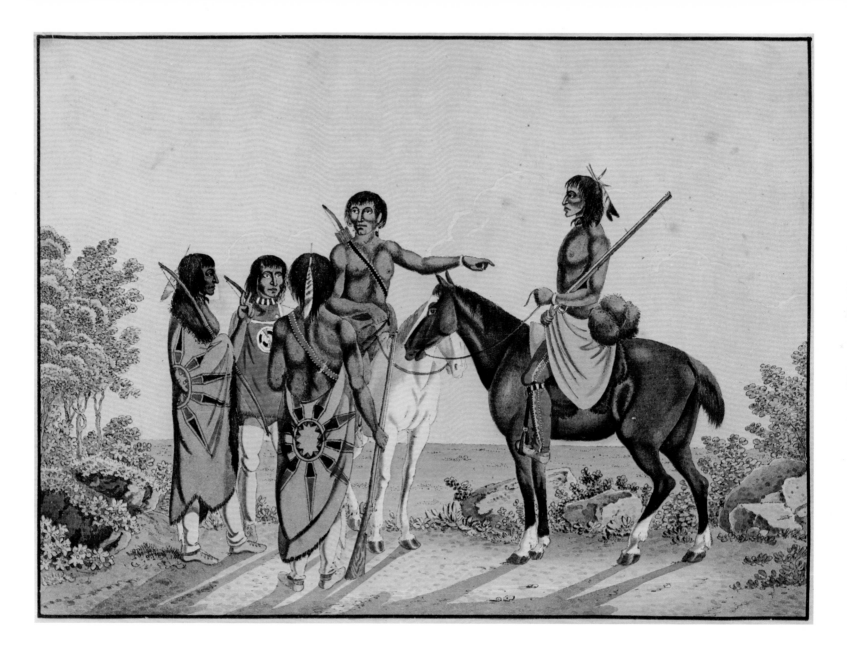

29
Peter Rindisbacher, 1806-1834
"A Party of Indians—Aesseneboines
[sic]"
1821-1824; watercolor, 7⅞ x 9⅞ in.
The Denver Art Museum

Peter Rindisbacher, a Swiss painter,
settled in 1821 with his family at Lord
Selkirk's Red River Colony, near the
site of present day Winnipeg, Mani-
toba. Rindisbacher's pictures of the
Assiniboines are the earliest known

white artist's views of this Plains
Indian tribe. Rindisbacher gives special
attention to details of costume, depict-
ing clearly the feathered-circle decora-
tion on the buffalo robes.

26

Samuel Seymour, 1797-1822
*"View near the base of the Rocky
Mountains"*
1820; watercolor, 5½ x 8¼ in.
The Beinecke Rare Book and Manuscript Library, Yale University
(Shown in Boston only.)

*Samuel Seymour's duties, as indicated
in the official report of the Long expedition, were to "furnish landscapes . . .
miniature likenesses . . . of distinguished Indians . . . exhibit groups of
savages engaged in celebrating their
festivals, or sitting in councils." This is
the first artist's view of the Rocky
Mountains. It was painted in July 1820,
when the expedition crossed the
present state of Colorado from the
headwaters of the Platte to the headwaters of the Arkansas.*

Ref.: John Francis McDermott, "Samuel Seymour: Pioneer Artist of the
Plains and the Rockies," *Annual
Report of the Board of Regents of the
Smithsonian Institution,* 1950, pp.
497-509.

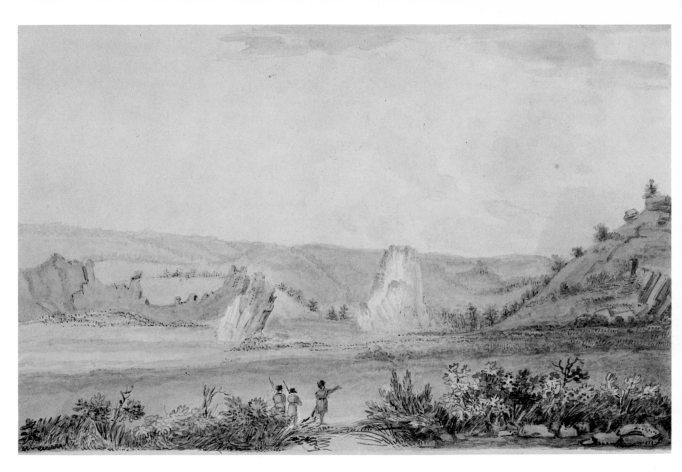

28
Samuel Seymour, 1797-1822
"Kaskaia, Shienne Chief, Arrappaho"
1820; watercolor, 4¾ x 6 in.
The Beinecke Rare Book and Manuscript Library, Yale University
(Shown in Boston only.)

These portraits were sketched in late July of 1820, when Seymour, with several other members of the Long expedition, was detached to proceed eastward along the Arkansas River.

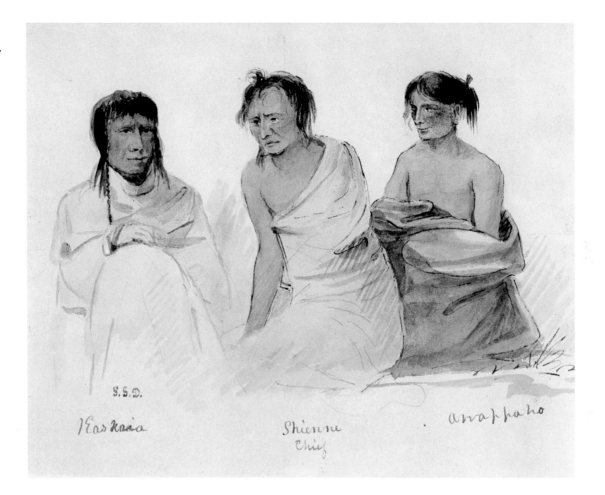

30

George Catlin, 1796-1872
*Big Bend on the Upper Missouri, 1,900
Miles above St. Louis*
1832; oil, 11⅛ x 14⅜ in.
National Collection of Fine Arts,
Washington, D.C.

*This Missouri River view dates from
Catlin's 1832 trip up the Missouri to the
mouth of the Yellowstone as guest of
the American Fur Company. Catlin's
view is an impression of the landscape
of a most generalized sort, unlike the
specifically detailed geological or bo-
tanical drawings by artists accompany-
ing government sponsored western
surveys. Catlin worked in oils in the
field, executing many of his pictures in
a matter of minutes.*

31

George Catlin, 1796-1872
Back View of Mandan Village, Show-ing Cemetery
1832; oil on canvas, 11⅛ x 14⅜ in.
National Collection of Fine Arts,
Washington, D.C.

A self-taught artist, Catlin was an able portraitist and miniature painter who traveled up the Missouri River in 1832 as guest of the American Fur Company. He became primarily known for his portraits of Indians and scenes of ceremonies and cultural practices, such as this view of a Mandan village and burial ground. According to Mandan burial custom, the dead were placed on raised platforms. The Mandans were a small, peaceful tribe, decimated in 1837 by an outbreak of smallpox. Catlin's pictorial record of their life and customs is thus a valuable document of their existence.

32

George Catlin, 1796-1872
Old Bear, a Mandan Medicine Man
1832; oil on canvas, 29 x 24 in.
National Collection of Fine Arts,
Washington, D.C.

*In 1832 the Mandans were located on
the Missouri River in present North
Dakota. After wintering with the tribe
in 1804-05, Lewis and Clark published
accounts of Mandan culture in their
journals, but Catlin's paintings pro-
vided the first visual records of the
tribe.*

36

I. Hurlimann after Karl Bodmer,
1809-1893
Mato-Tope
1842-1844; hand-colored engraving,
16⅝ x 11¾ in. (plate); 23⅝ x 17½
in. (overall)
Museum of Fine Arts, Boston,
M. & M. Karolik Collection
(Shown in Boston, Denver, and San
Diego.)

Prince Alexander Phillip Maximilian of the German principality of Wied-Neuwied on the Rhine River, was a naturalist-scientist who in 1833 journeyed up the Missouri River to its upper reaches in Montana. Karl Bodmer, a twenty-three-year-old Swiss artist, accompanied him. Maximilian's account of his travels appeared in a two-volume work, Travels in the Interior of North America in the years 1832 to 1834, *published at his own expense in his home city of Coblenz in 1839. An elephant folio volume of engravings after Bodmer's paintings accompanied Maximilian's account.*

Mato-Tope, or Four Bears, was the chief of the Mandans, whose portrait also had been painted by Catlin the previous summer. Maximilian's descriptions and Bodmer's paintings of the Mandans, made during the winter of 1833, were the most complete record of the tribe, which was wiped out by smallpox the following year.

Ref.: Bernard DeVoto, *Across the Wide Missouri* (New York, 1947).

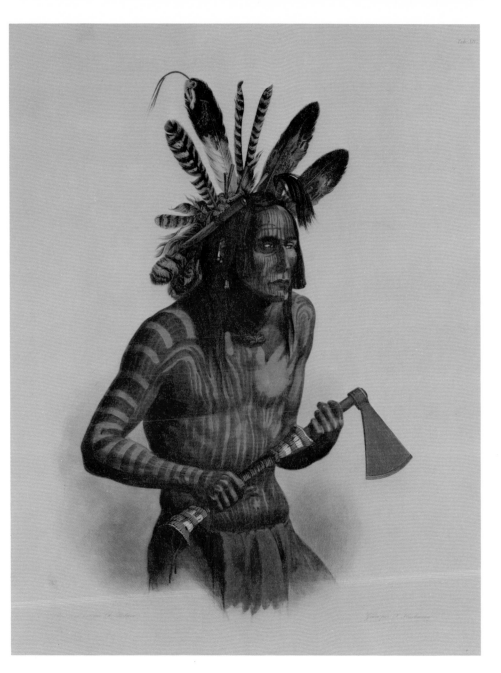

38

Alfred Jacob Miller, 1810-1874
The Indian Guide
1837; pen and ink with gray wash on
buff card, 9 x 11 in.
The Denver Art Museum

*Alfred Jacob Miller, a Baltimore artist
who studied in Europe, was employed
by Sir William Drummond Stewart to
sketch the scenery and incidents of a
journey he would take across the Rocky
Mountains and to make from these
sketches a series of paintings to hang
in Stewart's ancestral home, Murthly
Castle, Perthshire, Scotland. Like other
Europeans of his generation, Stewart
thought of the American West as a
remote and romantic land.*

*Stewart and Miller joined the
American Fur Company's caravan in
1837. In this sketch a Sioux Indian is
shown giving directions to Stewart.*

Ref.: Denver Art Museum, *American
Art from the Denver Art Museum
Collection* (Denver, 1969), 23.

40

Alfred Jacob Miller, 1810-1874
Fort Laramie
1836-1837; watercolor, 7½ x 11⅝ in.
The Beinecke Rare Book and Manu-
script Library, Yale University
(Shown in Boston only.)

*This is the original Fort Laramie, built
in 1834 by the American Fur Company,
eight hundred miles west of St. Louis.
A new Fort Laramie was built of adobe
in 1841. Miller described Fort Laramie
in notes written for William Walters of
Baltimore in 1859-60: "This post . . . is
of a quadrangular form, with bastions
at the diagonal corners to sweep the
fronts in case of attack; over the
ground entrance is a large block house,
or tower, in which is placed a cannon.
The interior is possibly 150 feet square,
a range of houses built against the
palisades entirely surround it, each
apartment having a door and window
overlooking the interior court. Tribes
of Indians encamp here 3 or 4 times a
year, bringing with them peltries to be
traded or exchanged for dry-goods,
tobacco, vermillion, brass, and diluted
alcohol."*

Ref.: Marvin C. Ross, *The West of Al-
fred Jacob Miller* (Norman: University
of Oklahoma Press, 1951), 49.

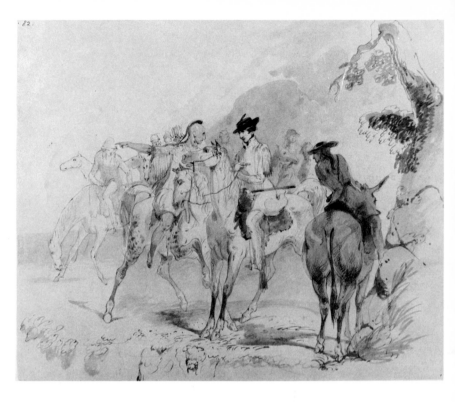

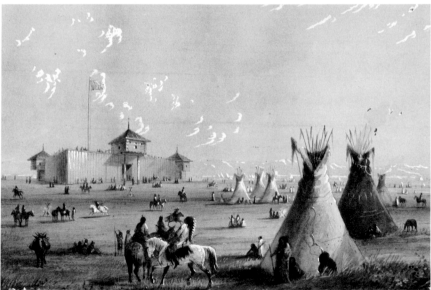

41

Alfred Jacob Miller, 1810-1874
Indians Fording a River, Oregon
Ca. 1837; pencil and brown wash,
6 x 9⅝ in.
Museum of Fine Arts, Boston, M. & M.
Karolik Collection
(Shown in Boston, Denver, and San
Diego.)

*This is one of the few remaining field
sketches that Miller made in 1837 while
in the West. These sketches were in
pencil and ink, sometimes with touches
of watercolor; at other times Miller
used black or sepia washes, or water-
color.*

Refs.: Marvin C. Ross, *The West of
Alfred Jacob Miller* (Norman: Univer-
sity of Oklahoma Press, 1951), xix;
Museum of Fine Arts, Boston, *M. & M.
Karolik Collection of American Water
Colors & Drawings, 1800-1875* (Boston,
1962), vol. 1, pp. 237-239.

43

James William Abert, 1820-1871
*Creek Indian Family on the Upper
Missouri*
1845; wash drawing, 8⅜ x 10½ in.
The Amon Carter Museum.
Fort Worth, Texas

*James William Abert was a member of
the Army Corps of Topographical En-
gineers, a corps whose special task was
to assemble scientific information in
the form of maps, pictures, and narra-
tive reports concerning the American
countryside. Trained in drawing at
West Point by Robert Walter Weir,
Abert made several expeditions into
the West, the reports of which were
illustrated by his own sketches.*
*This sketch of a Creek Indian family
was made in 1845 on a trip Abert made
into the Southwest to gain useful infor-
mation preliminary to the Mexican
War.*

Ref.: William Goetzmann, *Army Ex-
ploration in the American West, 1803-
1863* (New Haven: Yale University
Press, 1959).

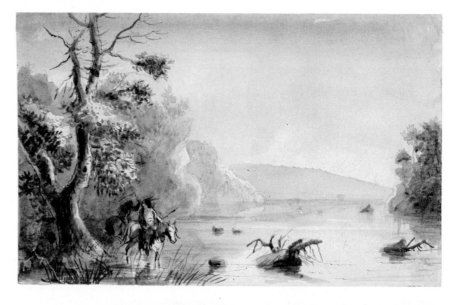

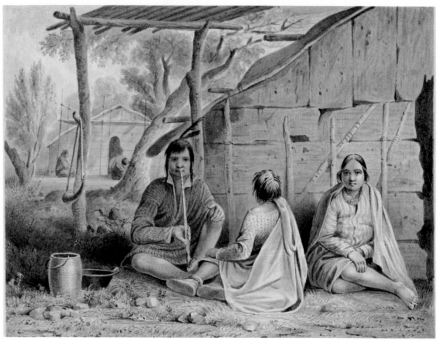

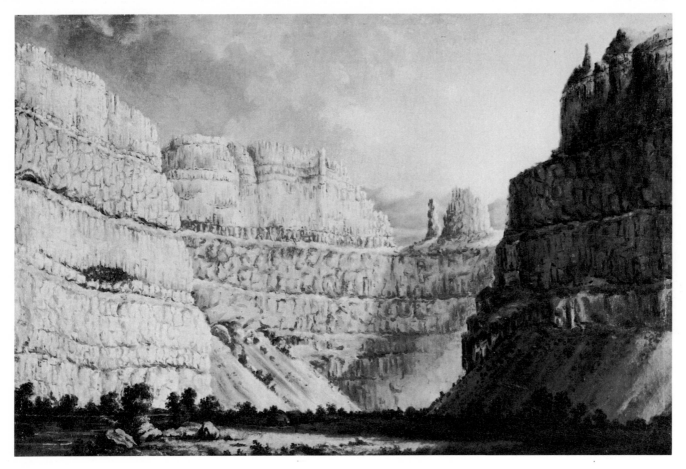

44

Paul Kane, 1810-1871
A Sketch on the Pelouse
1847; oil on canvas, 20¾ x 30 in.
Royal Ontario Museum, Toronto

Paul Kane was an Irishman who settled in British North America in 1819 and returned to Europe for study in Italy and London, where he met George Catlin. Returning to America, Kane traveled from 1846 to 1848 with the spring brigade of the Hudson's Bay Company across the Canadian Plains, over the Rockies, and into the Oregon Territory. He published an account of his experiences in Wanderings of an Artist *(London, 1859), illustrated with twenty-one of his own paintings.*
Kane left Fort Walla Walla on July 13, 1847, to visit the Pelouse River, whose upper and lower falls he found particularly impressive.

Ref.: J. Russell Harper, *Paul Kane's Frontier* (Austin: University of Texas Press for the Amon Carter Museum, Fort Worth, and the National Gallery of Canada, Ottawa, 1971).

45

Paul Kane, 1810-1871
Medicine Mask Dance
1847; oil on canvas, 17½ x 28¾ in.
Royal Ontario Museum, Toronto

Pictured is a dance associated with the Northwest Coastal Indian's Potlatch ceremony, a feast in which one chief gave all his possessions away to his rival, the latter reciprocating on another occasion. The painting was probably made at Fort Victoria, where members of West Coast tribes came as visitors.

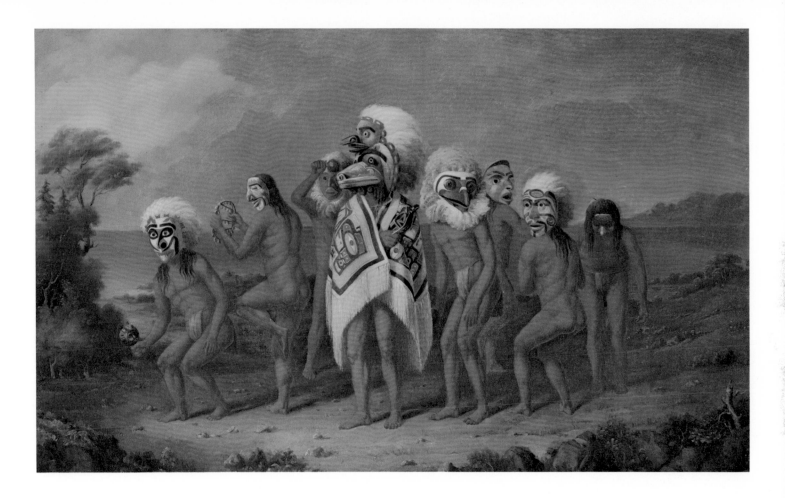

48

Seth Eastman, 1808-1875
"Front View of the Mission Chapel of San José, 5 miles from San Antonio, Texas, Nov., 1848."
1848; pencil on paper, 4¾ x 7¾ in.
Marion Koogler McNay Art Institute,
San Antonio, Texas

Seth Eastman, an 1829 West Point graduate, was detailed for duty as a topographical artist. Sent first to Fort Snelling in Minnesota, Eastman returned to West Point in 1833 as drawing instructor. In 1848, when he marched his regiment through Texas to the Nueces River, Eastman filled his sketchbooks with drawings of the Texas countryside and its architecture. Mission San José, sketched in November 1848, stood in the line of missions built by Spanish colonials in Texas on the northeastern edge of their North American empire. The mission is shown with its original façade, carved doors, statuary, dome, and tower.

Ref.: *A Seth Eastman Sketchbook, 1848-1849,* Introduction by Lois Burkhalter (Austin: University of Texas Press for the Marion Koogler McNay Art Institute, 1961).

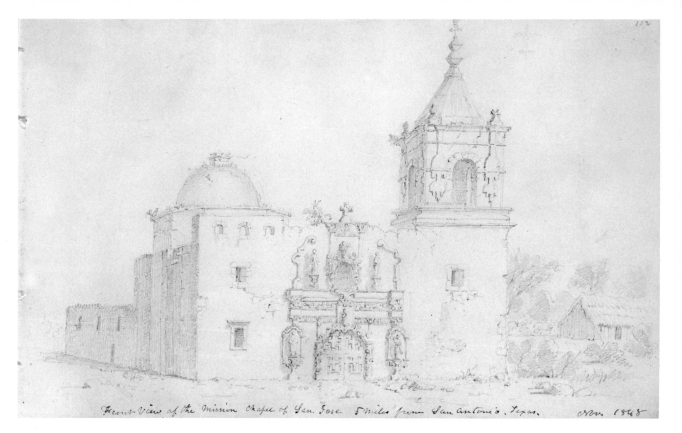

52

Richard Kern, 1821-1853
"North west View of the Ruins of the Pueblo Pintado in the Valley of the Rio Chaco,/No. 1./Aug 26"
1849: ink and wash, 6 x 9½ in.
The Academy of Natural Sciences of Philadelphia

Richard Kern was one of three brothers from Philadelphia all of whom were artists and members of western expeditions. In 1849, he accompanied Lieutenant James Simpson, a topographical engineer attached to the ninth military department in New Mexico, in a raid on the Navaho country. Hos-Ta, the governor of the pueblo at Jémez, New Mexico, described the history of his people to members of the expedition and guided them out of Jémez. Pictured in this sketch are the ruins, called the "Pueblo Pintado" by Hos-Ta, that were situated in the New Mexican canyon country. Kern's sketches and diagrams of ruins observed on Lieutenant Simpson's march often gave their exact dimensions in addition to placing them in their landscape and indicating their state of preservation.

Ref.: William Goetzmann: *Army Exploration in the American West, 1803-1863* (New Haven: Yale University Press, 1959).

53

Richard Kern, 1821-1853
"Ruins of an Old Pueblo in the Cañon of Chelly. Sept 8th"
1849; ink and wash, 9¼ x 5 in.
The Academy of Natural Sciences of Philadelphia

The members of Simpson's military expedition were the first Americans to visit the tribal stronghold of the Navahos at the Canyon de Chelly in New Mexico. Kern's pictures of it were a significant contribution to scientific knowledge.

54

William Birch McMurtrie, 1816-1872
*Mt. Saint Helen's from the Mouth of
the Columbia River*
Ca. 1850; watercolor, 9⅛ x 13 in.
Museum of Fine Arts, Boston, M. & M.
Karolik Collection
(Shown in Kansas City and
Milwaukee.)

*William Birch McMurtrie, son of a
natural history professor in Philadel-
phia, was trained in scientific drawing
by an officer in the Army Corps of
Topographical Engineers. In 1849 he
became a draughtsman for the first
survey of the Pacific Coast and sailed
on the ship* Ewing *around Cape Horn
to the West Coast.*

Refs.: Robert D. Monroe, "William
Burch McMurtrie: A Painter Partially
Restored," *Oregon Historical Quar-
terly,* 60, no. 3 (Sept. 1959), 369; Museum
of Fine Arts, Boston, *M. & M. Karolik
Collection of American Water Colors &
Drawings, 1800-1875* (Boston, 1962),
vol. 1, pp. 233-234.

58

Rudolph Friedrich Kurz, 1818-1871
"Crow Family Crossing the Missouri"
1851; ink and wash drawing,
10 x 14⅛ in.
Museum of Fine Arts, Boston, M. & M.
Karolik Collection
(Shown in Boston, Denver, and San
Diego.)

*From an early age, Rudolph Friedrich
Kurz, a Swiss, had determined to paint
the Indians and primeval forests of
America. Kurz consulted his friend, the
artist Karl Bodmer, who had recently
returned to Europe from a sketching
trip up the Missouri. Leaving for
America in 1846, Kurz first spent some
time in St. Louis. In 1851 he went
further up the Missouri to Fort Bert-
hold, where he received a position as
clerk with the American Fur Company.
This picture of a Crow family crossing
the Missouri was painted near Fort
Berthold in July 1851.*

Refs.: "Journal of Rudolph Friedrich
Kurz," Smithsonian Institution,
Bureau of American Ethnology, *Bulle-
tin*, no. 115, 1937, p. 2; Museum of Fine
Arts, Boston, *M. & M. Karolik Collec-
tion of American Water Colors &
Drawings, 1800-1875* (Boston, 1962),
vol. 2, pp. 31-33.

59

Rudolph Friedrich Kurz, 1818-1871
"Herantsa Children Playing"
1851; pencil and pen, 10½ x 14¼ in.
Museum of Fine Arts, Boston, M. & M.
Karolik Collection
(Shown in Kansas City and
Milwaukee.)

*Kurz's journal entry for July 29, 1851,
describes scenes of Indian life observed
near Fort Berthold: "While I was tak-
ing a walk on the prairie today I met a
number of interesting children playing
in groups near their grazing horses.
Several little girls, who had made a
shelter from the blazing sun with their
blankets, were singing to the rhythm
of drumbeats and tambourines. Their
song practice soon enticed one of the
boys who were also guarding horses,
and he taught a little dwarf to dance. I
saw small boys quite frequently also at
their first shooting practice. With
grass stalks for arrows they aimed at
the leaping frogs and when they hit the
mark, laughed with delight to see the
little white-bellied creatures turn
somersaults in their swift movements
to escape."*

Refs.: "Journal of Rudolph Friedrich
Kurz," Smithsonian Institution, Bureau
of American Ethnology, *Bulletin*, no.
115, 1937, p. 88; Museum of Fine Arts,
Boston, *M. & M. Karolik Collection of
American Water Colors & Drawings,
1800-1875* (Boston, 1962), vol. 2, pp. 31-33.

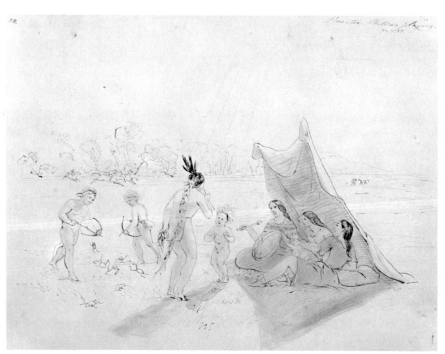

69

Joseph Heger, 1835-1897
"Camp Floyd, Ceder Valley, Utah,
July 1858"
1858; pencil, 5⅞ x 10½ in.
The Beinecke Rare Book and Manuscript Library, Yale University
(Shown in Boston only.)

It was at Camp Floyd in Cedar Valley,
a desolate region midway between Salt
Lake City and Provo, that Colonel Albert Sidney Johnston camped with the
army of Utah from June 1858 until the
outbreak of the Civil War. The original
Camp Floyd, a collection of tents, is
shown in this drawing. Later, tents
were replaced by adobe buildings. Only
traces of Camp Floyd remain today.

Born in Hesse, Germany, in 1835,
Joseph Heger came to America as a
young man and enlisted in the army in
1855. He sketched scenes in Utah and
during the return march to Fort Union
with his regiment, which accompanied
a train bringing supplies to the army
of Utah.

Ref.: Thomas G. Alexander and Leonard J. Arrington, "Camp in the Sagebrush: Camp Floyd, Utah, 1858-1861," *Utah Historical Quarterly* 34, no. 1 (winter 1966), 3-22.

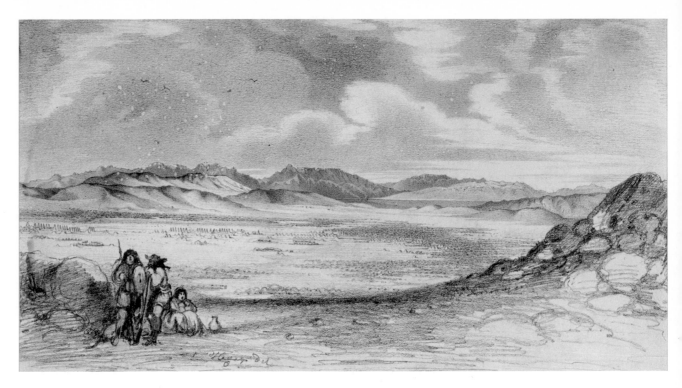

70

Albert Bierstadt, 1830-1902
Indians near Fort Laramie
1859; oil on paper mounted on cardboard, 13½ x 19½ in.
Museum of Fine Arts, Boston, M. & M.
Karolik Collection

After studying and traveling in Europe from 1853 to 1857, Albert Bierstadt returned to America and in 1859 journeyed to the West. Like his fellow American painters Sanford Gifford and Worthington Whittredge, who had also studied in Europe, Bierstadt accompanied the United States surveys of the West, which traditionally included an artist-illustrator on their team.

Bierstadt accompanied Colonel Frederick William Lander's expedition of 1859. Lander's report of the trip referred to the artist's presence: "A. Bierstadt, esq., a distinguished artist of New York and S. F. Frost, of Boston, accompanied the expedition with a full corps of artists, bearing their own expenses. They have taken sketches of the most remarkable of the views along the route, and a set of stereoscopic views of emigrant trains, Indians, camp scenes, &c."

Upon the expedition's arrival at Fort Laramie on June 14, 1859, Bierstadt made studies for Indians near Fort Laramie.

Refs.: Gordon Hendricks, "The First Three Western Journeys of Albert Bierstadt," *Art Bulletin* 46 (Sept. 1964), 333-365. Museum of Fine Arts, Boston, *M. and M. Karolik Collection of American Paintings, 1815-1865* (Cambridge: Harvard University Press, 1949), 74-107.

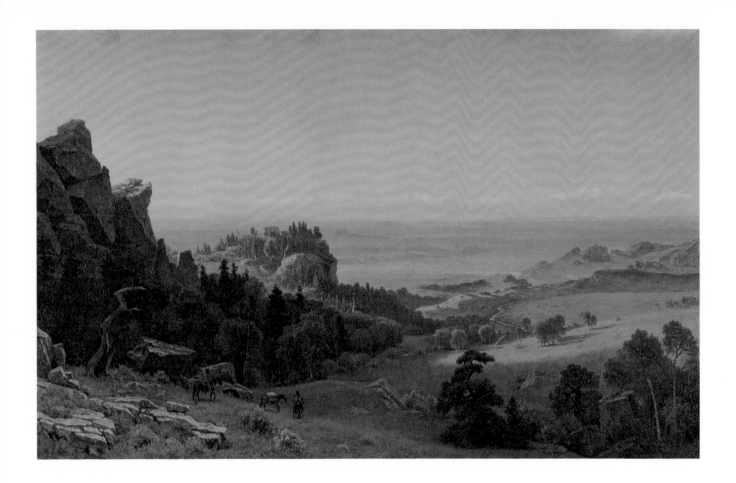

71

Albert Bierstadt, 1830-1902
View from the Wind River Mountains,
Wyoming
1860; oil on canvas, 30¼ x 48¼ in.
Museum of Fine Arts, Boston, M. & M.
Karolik Collection

Sketched from nature, July 1, 1859,
and painted in New York in 1860, this
view was made by Bierstadt on his trip
to the West with Colonel Lander's
expedition.

Ref.: Museum of Fine Arts, Boston,
M. and M. Karolik Collection of Amer-
ican Paintings, 1815-1865 (Cambridge:
Harvard University Press, 1949), 74-107.

72

Albert Bierstadt, 1830-1902
The Rocky Mountains, Lander's Peak
1863; oil on canvas, 44⅜ x 36½ in.
Fogg Art Museum, Harvard University

Executed from studies made on Bier-
stadt's trip accompanying Colonel Lan-
der in 1859, this painting illustrates
what Bierstadt has called Lander's
Peak. To honor the head of the 1859 ex-
pedition, he actually renamed what
many believe to be Fremont's Peak,
near the headwaters of the Green River
in Wyoming.

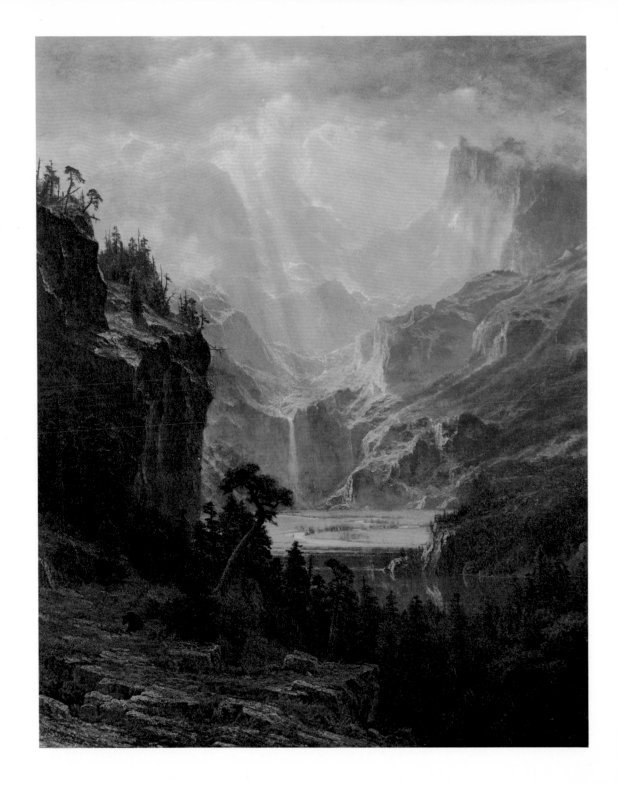

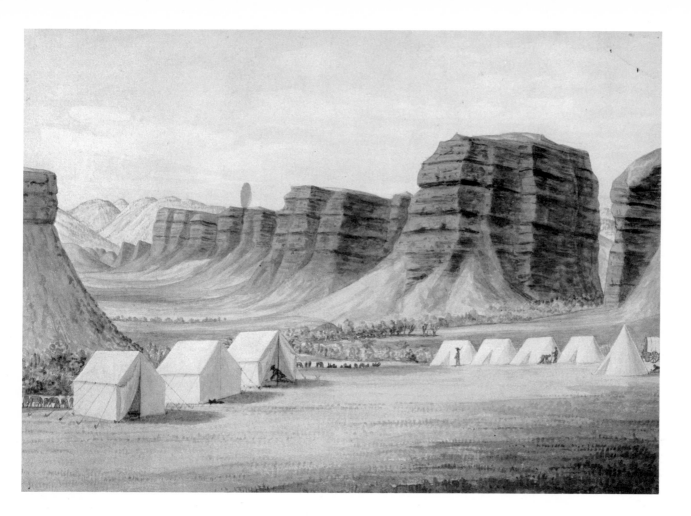

74

Antoin Schonborn
"Red Buttes of Powder River"
Ca. 1859-60; watercolor, 7 x 9⅞ in.
The Beinecke Rare Book and Manuscript Library, Yale University
(Shown in Boston only.)

Antoin Schonborn, a member of Captain William F. Raynolds' expedition of 1859-60 across the northern Plains and into the Wind River Mountains, pictured the group camped en route on the banks of the Powder River in northern Montana and Wyoming. The expedition, led by Jim Bridger, the famous trapper, made an unsuccessful attempt to penetrate the region of the Yellowstone.

Ref.: William Goetzmann, *Exploration and Empire* (New York: Vintage Books, 1966).

76

Timothy O'Sullivan, 1840-1882
Expedition Exploring Boat. Truckee River
Geological Exploration of the Fortieth Parallel. Clarence King Geologist in charge.
1867; photograph, 8 x 10⅝ in. (image), 16¾ x 21¾ in. (overall)
The Library of Congress, Washington, D.C. (Shown in Boston only. Copy print to travel.)

Photographs replaced artists' drawings as scientific illustrations accompanying survey reports of the West after the Civil War. Timothy O'Sullivan, who had worked with Matthew Brady, became, in 1867, official photographer to the U.S. Geological Exploration of the Fortieth Parallel under the leadership of Clarence King. Nettie, the survey party's boat, "the handiwork of an artisan who had built boats for New London fishermen," was navigated through the rapids of the Truckee River to its termination in Pyramid Lake.

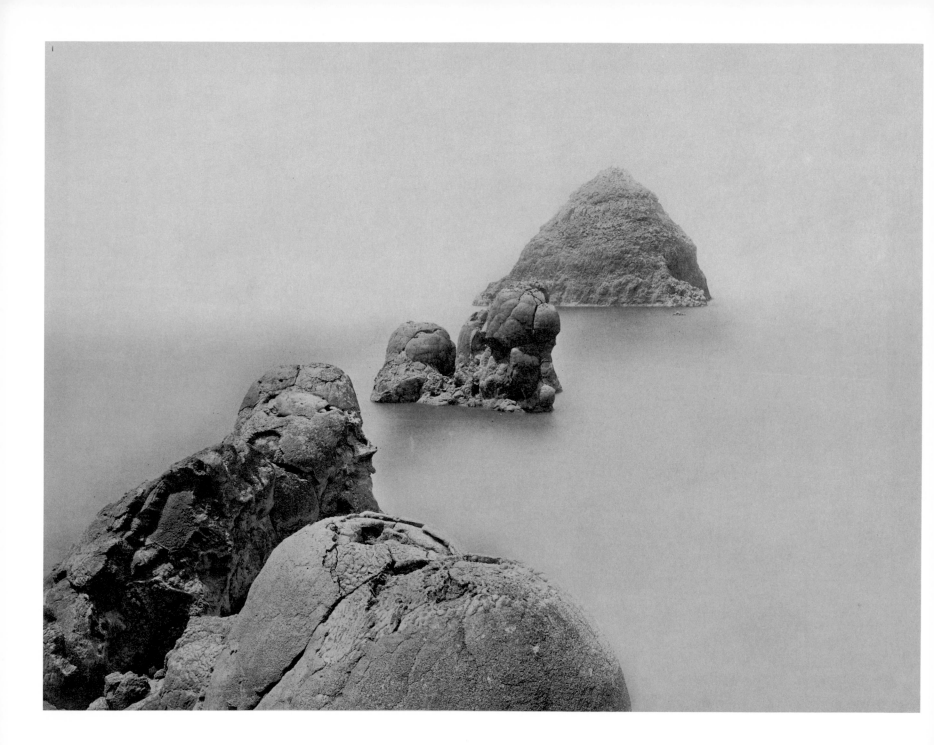

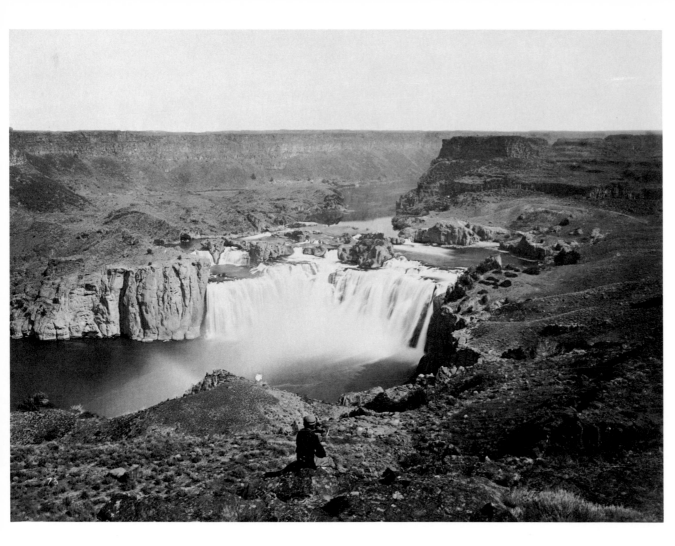

77
Timothy O'Sullivan, 1840-1882
Pyramid Lake, Nevada
U.S. Engineer Department Geological
Exploration Fortieth Parallel
1867; photograph, 7¾ x 10⅝ in.
(image), 18 x 24 in. (overall)
The Beinecke Rare Book and Manu-
script Library, Yale University
(Shown in Boston only. Copy print to
travel.)

*Pyramid Lake derives its name from
the peculiar rock formations arising
from it. The largest "pyramid" rises up
out of the lake to a height of more than
five hundred feet. Members of the King
survey party exploring the rocks found
that they were infested with rattle-
snakes.*

Ref.: T. O'Sullivan [John Sampson],
"Photographs from the High Rockies,"
Harper's New Monthly Magazine 39,
no. 232 (Sept. 1869), 465-75.

79
Timothy O'Sullivan 1840-1882
Shoshone Falls
U.S. Engineer Department Geological
Exploration Fortieth Parallel
1867; photograph, 7¾ x 10⅝ in.
(image), 18 x 24 in. (overall)
The Beinecke Rare Book and Manu-
script Library, Yale University
(Shown in Boston only. Copy print to
travel.)

*Just as Frederick Church had been
captivated by the romantic sublimity
of the Niagara Falls in 1858, O'Sullivan,
the photographer, was impressed by
the great falls of the Shoshone River,
encountered on the King survey in
1867. Delineated earlier, in 1850, by the
artist William Birch McMurtrie, the
falls of Shoshone and the surrounding
barren countryside are here realized
magnificently in the dark tonalities of
the photographic medium.*

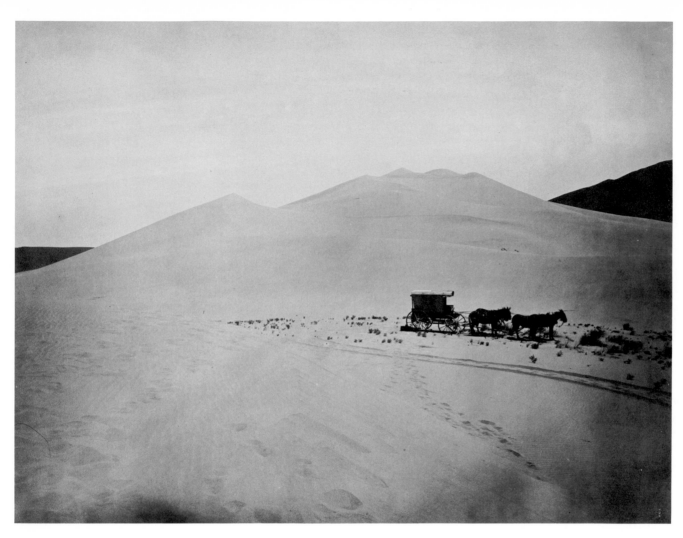

John Henry Hill, son of the painter and engraver John William Hill and grandson of the aquatintist John Hill, traveled west with Clarence King's survey of the Fortieth Parallel. Hill is known to have been in the West with King in 1868 and may also have accompanied him on other field trips of the Fortieth Parallel survey in 1867, 1870, and 1872.

Both John Henry Hill and his father had come under the influence of Ruskin's aesthetic theories and in 1863 had formed a group of men of similar sensibilities, the Society for the Advancement of Truth in Art. Painting exactly and directly from nature was urged by the society. This Hill had the opportunity to do on the King surveys.

Similar views were caught by both artists on the survey, O'Sullivan, the photographer, and Hill, the painter. This view of Yosemite Falls is reminiscent of Ruskin's drawings made directly from nature in the Alps.

To photograph dunes south of the Carson Sink, which towered five hundred feet high, O'Sullivan loaded his photographic equipment into an ambulance drawn by four mules and departed from the King survey party. The ambulance could hold sufficient water supplies to enable O'Sullivan to photograph the shifting dunes in a desert area.

89

William Henry Jackson, 1843-1942
Castellated Rocks on the Chugwater,
S. R. Gifford, artist
1870; photograph, print 8 x 10 in.
Amon Carter Museum, Fort Worth,
Texas
(Courtesy U.S. Geological Survey.)

William Henry Jackson began his
career as a photographer in 1868 in
Omaha. In 1869 he made a photo-
graphic tour of the newly finished
Union Pacific Railroad, and the follow-
ing year he joined Colonel Ferdinand
Vandiveer Hayden's geological survey
of the territories as official photog-
rapher. Other artists on the expedition
were Sanford Robinson Gifford and
Henry Wood Elliott. In his auto-
biography Jackson records that "Gif-
ford, Elliot [sic], and I would go off to
record our respective impressions of a
striking landmark, like Independence
Rock or the Red Buttes."
Jackson's equipment in the field
consisted of "the double barreled
stereo, the 6½ x 8½ . . . the portable
dark room . . . a full stock of chemicals;
and enough glass for 400 plates." This
was transported in either a field am-
bulance or on Jackson's mule, Hypo.

Ref.: William Henry Jackson, *Time*
Exposure (1941; reprint ed., New York:
Cooper Square Publishers, 1970).

90

Sanford Robinson Gifford, 1823-1880
Valley of the Chugwater
1870; oil on canvas, 8¼ x 13⅜ in.
Amon Carter Museum, Fort Worth,
Texas

Sanford Robinson Gifford, the noted
Hudson River landscape painter, had
started on a painting trip to the Rocky
Mountains with Worthington Whitt-
redge and John Kensett when he was
asked by Colonel Hayden to join the
United States Geological Survey of the
Territories. Other artists included on
this 1870 trip were the painter Henry
Wood Elliott and the photographer
William Henry Jackson. The party was
out for two months, passing up the
Lodge Pole, down the Chugwater, up
the Platte and the Sweetwater, through
South Pass, along parts of the Green
River, and the Uinta Mountains and
back to Cheyenne.

(overleaf, page 72)

92

Thomas Moran, 1837-1936
"Beaver Head Canon, Montana
July 4, 1871"
1871; watercolor and chinese white on
yellow-gray paper, 10⅜ x 14⅛ in.
Museum of Fine Arts, Boston,
M. & M. Karolik Collection
(Shown in Boston, Denver, and San
Diego.)

Thomas Moran joined Colonel Hay-
den's official exploration of the upper
Yellowstone in 1871. In July the expedi-
tion, which also included the photog-
rapher William Henry Jackson and the
artist Henry Wood Elliott, reached the
Montana Territory.
Moran is described by Jackson as an
unlikely candidate for a physically
difficult journey: "Prior to 1871 Moran
had never known a true wilderness,
and he was as poorly equipped for
rough life as anyone I have ever
known. But it made no difference—he
had a solution for every problem.
Never had he mounted a horse before
we left the Botelers. And then he did
so with a pillow tucked in over the
cantle of his saddle! Frail, almost
cadaverous, he seemed incapable of
surviving the rigors of camp life and
camp food."

Ref.: William Henry Jackson, *Time*
Exposure (1941; reprint ed., New York:
Cooper Square Publishers, 1970), 200;
Museum of Fine Arts, Boston, *M. & M.*
Karolik Collection of American Water
Colors & Drawings, 1800-1875 (Boston,
1962), vol. 1, pp. 240-243.

(overleaf, page 73)

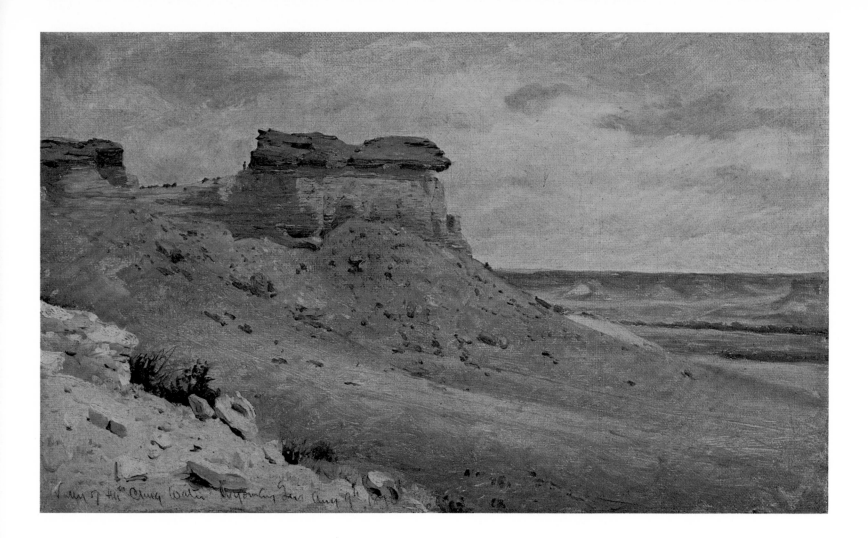

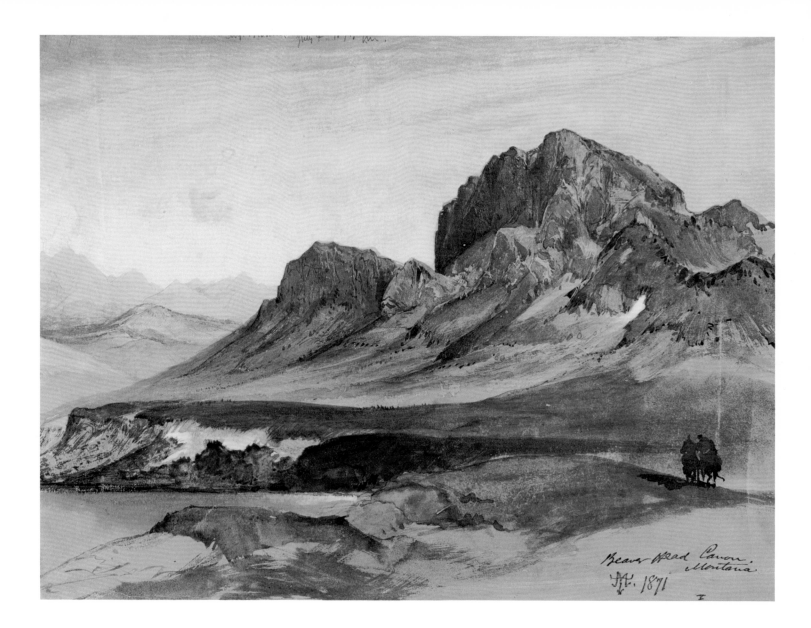

Beaver Head Canon. Montana

1871

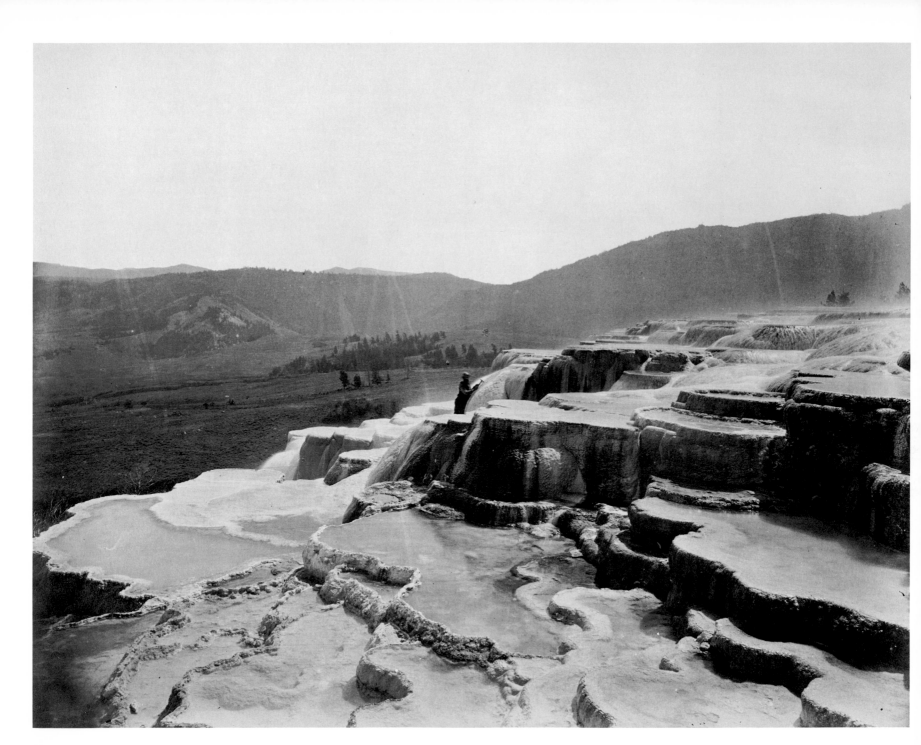

93

William Henry Jackson, 1843-1942
"Mammoth Hot Springs on Gardiner's River"
1871; photograph, 9⅞ x 12¾ in. (image),
16 x 20 in. (overall)
Boston Public Library
(Shown in Boston only. Copy print
to travel.)

94

Henry Wood Elliott, 1846-1930
Yellowstone Lake
1871; watercolor, 10 x 19¼ in.
Kennedy Galleries, Inc., New York

Beginning in 1869 Henry Wood Elliott was an artist with the exploration surveys conducted by Colonel Ferdinand Hayden. This view of Yellowstone Lake dates from Hayden's exploration of the upper Yellowstone of 1871.

95

Thomas Moran, 1837-1936
"The Devils Den, Yellowstone. 1871"
1871; pencil, 4⅞ x 8 in.
The Cooper-Hewitt Museum of
Decorative Arts and Design, Smithsonian Institution, New York

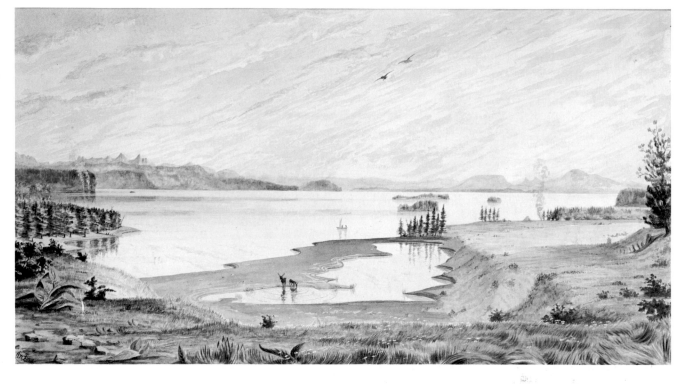

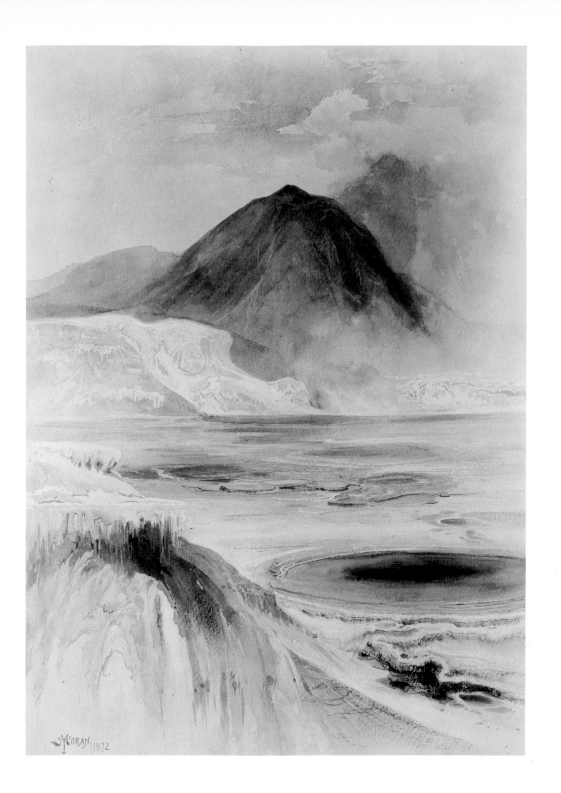

96
Thomas Moran, 1837-1936
Mammoth Hot Springs, Yellowstone
1872; watercolor, 14¼ x 10⅜ in.
National Collection of Fine Arts,
Washington, D.C.
(Shown in Boston only.)

*Moran first saw Mammoth Hot Springs
on July 23, 1871, when the Hayden
party reached the dazzling, multi-
colored pools.*

103
John K. Hillers
*"Ruins of Cliff Dwellings in De Chelley
Cañon."*
1872-1878; photograph, 9¾ x 12⅞ in.
(image), 11 x 14 in. (overall)
Peabody Museum of Archaeology and
Ethnology, Harvard University
(Shown in Boston only. Copy print
to travel.)

*John K. Hillers, a teamster, became the
expedition photographer for the John
Wesley Powell surveys from 1871 to
1878. Powell's interests in ethnology
were reflected in Hiller's photographs,
which proved that the camera could be
the medium for expressing social
realism as well as for recording scenic
and scientific fact.*

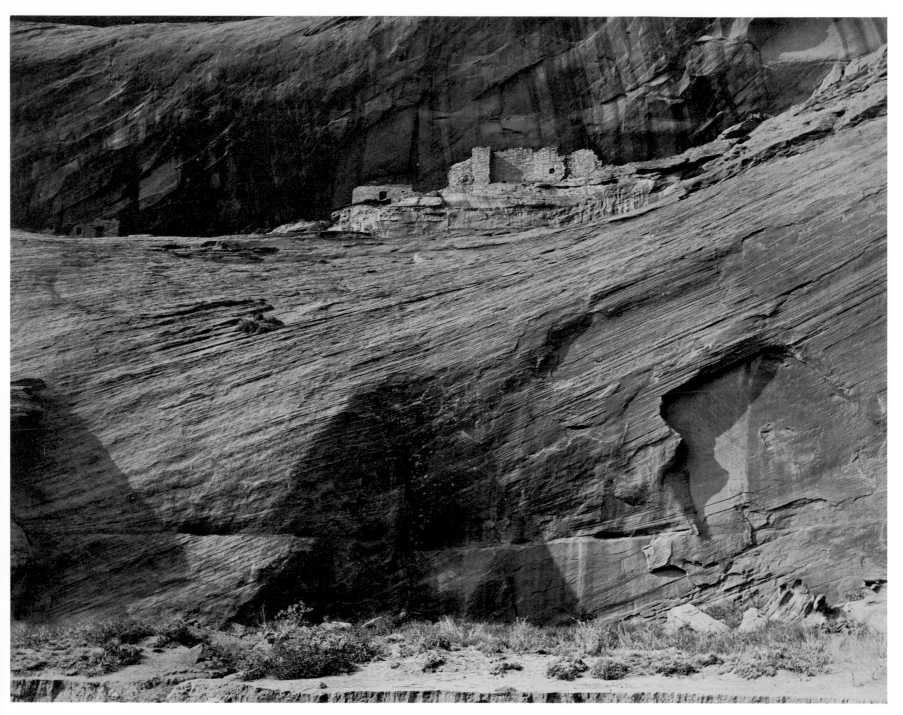

3
The American West as a Theater of Conflict

There were two traditions of military art in the American West, one Indian, the other white. Both help us to visualize the nature and history of conflict in that region. Both reveal the efforts of many artists to interpret that conflict.

On rock surfaces in the Southwest, in the Great Basin and on the High Plains are boldly incised or painted representations of standing warriors carrying primitive shock weapons, their bodies and upper legs concealed by large, circular shields, some of which bear designs doubtless intended to afford magical protection. These heavily armed figures attest to the fact that Indians participated in intertribal warfare long before they acquired horses and firearms from Europeans. Indeed, some of these shield-bearing figures are thought to have been executed by Indians four hundred or more years before the first Spanish conquistadores rode northward from Mexico into the American Southwest.

Other examples of this Indian rock art portray mounted warriors armed with guns, proofs that they were executed within the historic period. Explorers of the Great Plains saw Indian warriors clad in buffalo robes, the skin surfaces of which were embellished with rudely drawn pictorial records of their own heroic deeds in combat with enemy tribesmen. A fine example of the simple, sticklike figures of men and horses employed in that primitive picture writing appears on a buffalo robe collected by Lewis and Clark at the Mandan villages in present North Dakota and sent by them to President Thomas Jefferson in April 1805. It is a Mandan artist's record of a battle his people fought with a neighboring tribe some eight years earlier (no. 117).

Artist-explorers introduced the white man's tradition of more detailed and realistic rendering of men and of horses. Two of those paintbrush pioneers were George Catlin and Karl Bodmer. Both traveled up the Missouri during the early 1830's. Both gained the friendship and painted portraits of Four Bears, second chief of the Mandans. He shared

their interest in art and was proud to picture his own valorous deeds for them. Bodmer provided pencils, watercolors, and paper on which Four Bears portrayed his killing of a Cheyenne chief in a desperate hand-to-hand fight. This earliest-known example of Plains Indian painting in the white man's medium reveals a painstaking concern for bodily proportions and details of anatomy and costume that was lacking in earlier Indian picture writing. Doubtless this concern was inspired by the example of his artist-patron's very realistic renderings of Indians.

By the 1860's many Indians of several Plains tribes were depicting their own and fellow tribesmen's war deeds in ledgers and on sheets of paper obtained from whites. They still created figures in flat perspective against blank backgrounds, but showed mounted men astride running horses with legs outstretched in a rocking-horse pose, which was a departure from their earlier style. Some of their works had very decorative qualities (no. 118). They pictured conflicts with whites as well as with Indian enemies.

Armed conflicts between whites and western Indians began early, with Coronado's attack on the Zuñi pueblo in New Mexico in 1540, but white artists' attempts to record this event were rare prior to the middle years of the nineteenth century. Peter Rindisbacher, a young Swiss artist in Lord Selkirk's colony on the Red River of the North in Manitoba during the 1820's, pictured the killing of a family of Scottish settlers in that region by Sisseton Sioux. Alfred Jacob Miller, a Baltimore artist, heard stirring tales of the trappers' fights with the warlike Blackfeet at their annual rendezvous in Wyoming in 1837 and depicted some of these in his watercolors.

As growing numbers of white emigrants crossed the dry plains in covered wagons to settle on Indian lands beyond the Rockies during the 1840's, the tempo of Indian-white conflict quickened. By midcentury some of America's most talented illustrators and creators of sporting

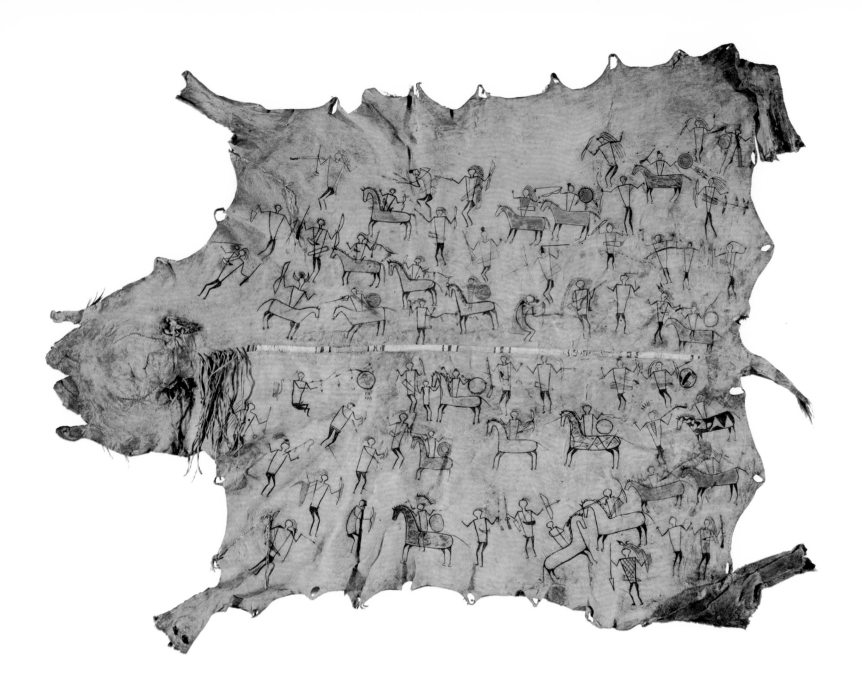

Robe
1797; Mandan, North Dakota; buffalo
hide, 8 x 6 ft. (approx.)
Peabody Museum of Archaeology and
Ethnology, Harvard University
(Shown in Boston only.)

*Deeds of bravery and warfare were
among the traditional subjects of
Plains Indian hide painting, an art
widely practiced at the time of white
contact. Collected from the Mandans
by Lewis and Clark in 1805 and sent by
them to Thomas Jefferson, this robe is
one of the earliest known hide paint-
ings. It is described by Lewis and Clark
in an invoice of April 1805 as "painted
by a Mandan man representing a
battle fought eight years since between
the Sioux and the Ricaras against the
Mandan, the Menitarras and the Ah-
wah-har-ways"; the invoice also men-
tions that the "Mandans &c. were on
horseback." Conventionalized horses
and warriors, outlined and filled in
with color, are pictured in profile
against a blank background. The
battling Indians are armed with spears,
bows and arrows, guns, and toma-
hawks.*

Ref.: Charles C. Willoughby, "A Few
Ethnological Specimens Collected by
Lewis and Clark," *American Anthro-
pologist*, n.s. 7, no. 4 (1905), 633-641.

prints, among them Felix O. C. Darley and Arthur Fitzwilliam Tait, were making very realistic representations of encounters between trappers and Indians and Indian attacks upon wagon trains or isolated frontier settlements (no. 120). Even the title of one popular work, widely circulated as a Currier and Ives print, employed the vernacular of frontier warfare: *A Prairie Hunter. One Rubbed Out.* Yet this work was the creation of Tait and Louis Maurer, New York artists, who learned about the West by reading books and studying Catlin and Bodmer's published pictures in the Astor Library. Charles Wimar's *The Attack on an Emigrant Train* was painted in Düsseldorf and was inspired by his reading of a book of western adventures published in Brussels in 1851. Only *later* did Wimar travel in the western Indian country.

On the other hand, a few white artists participated in the very actions they later portrayed. Theodore R. Davis, a special artist for *Harper's Weekly* on a western assignment, was riding a Butterfield Overland Dispatch coach bound for Denver in the fall of 1865 when it was attacked by a mounted Cheyenne war party near the Smoky Hill stage station in Kansas. His vivid picture of that encounter, published some months later in his magazine, was the prototype for one of the popular themes in western art and motion pictures, the Indian attack on the stage coach.

Two years later Private Hermann Stieffel, Company K, Fifth Infantry, was a member of the escort who repelled a Cheyenne attack upon General Marcy's wagon train near the Arkansas River, September 23, 1867. His panoramic watercolor recreates that action, in which the military escort forms an effective buffer between the circling Cheyenne warriors and the laden wagons (no. 119).

In 1873 William Simpson, special artist for the *Illustrated London News,* became a noncombatant witness to action in the Modoc War. He happened to be in San Francisco when he heard of this conflict. Realizing

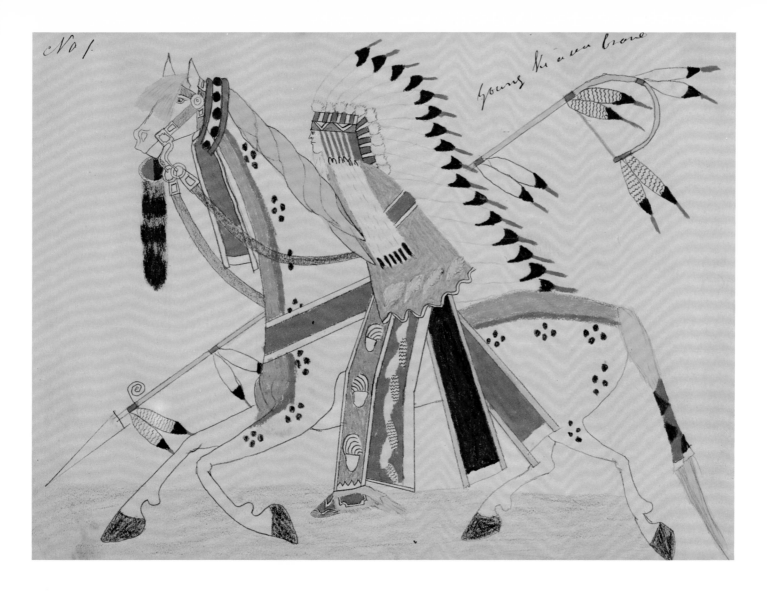

118
Silver Horns
Young Kiowa Brave
Ca. 1887; crayon and pencil,
9¼ x 13¾ in.
Marion Koogler McNay Art Institute,
San Antonio, Texas

This Plains Indian sketch was made on
paper obtained from the white man.

After the mid-nineteenth century
Indians used paper as a substitute for
hide as a surface for painting. A Kiowa
brave is shown here in full dress. The
artist, Silver Horns, was a Kiowa who
participated in the last revolt of the
Kiowa tribe in 1874, which began in
August at an Anadarko agency on
issue day. He later became a medicine

man. He enlisted on August 24, 1891, at
Fort Sill, Oklahoma Territory, as a
private in the United States Cavalry,
from which he was honorably dis-
charged in 1894.

Ref.: Dorothy Dunn, *American Indian*
Painting (Albuquerque: University of
New Mexico Press, 1968).

132

White Bird
Custer's Last Fight, The Battle of Little Big Horn
1894-1895; Northern Cheyenne, Wyoming; painted on muslin, 30 x 26 in.
West Point Museum, United States Military Academy, West Point, New York

Traditionally, paintings by Plains Indians had been executed on shirts, tipis, shields, robes, parfleche bags, and other objects of buffalo hide, deer or elk skin. With the loss of the buffalo, paintings were produced on government-issued cloth. When frame houses began to replace traditional shelters, their walls were hung with paintings on canvas and muslin just as tipis had been decorated with hide paintings. This episode in the Battle of Little Big Horn was painted by White Bird, a Northern Cheyenne, who as a boy had fought against Major General George Custer's troops.

Ref.: Dorothy Dunn, *American Indian Painting* (Albuquerque: University of New Mexico Press, 1968).

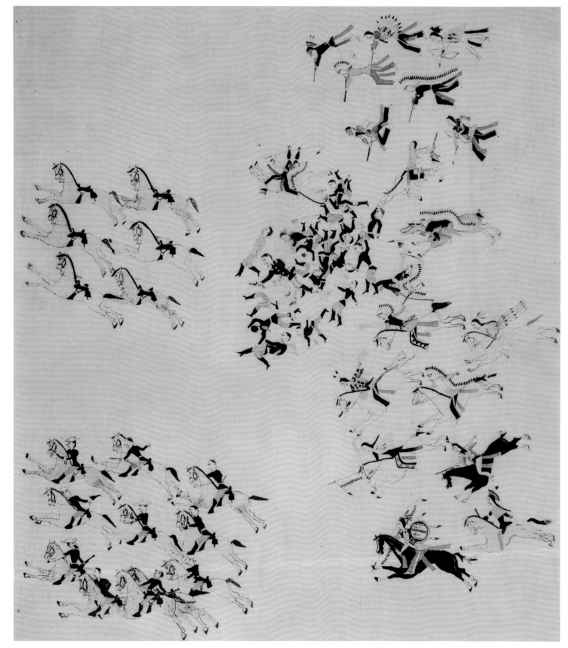

its newsworthiness, he hurried northward in time to see and to picture the doughty Modoc warriors defending their strong positions in the lava beds south of Tule Lake against United States troops (no. 121).

No white artists witnessed the major battles between Indians and soldiers on the Great Plains in which Sioux, Cheyenne, Kiowa, and Comanche chiefs pitted their wits against those of West Point-trained officers. For the Indians the high-water mark of success was reached on June 26, 1876, when Sioux, Cheyenne, and Arapaho allies wiped out George A. Custer's immediate command on the Little Big Horn in Montana. Because there were no white survivors to describe this decisive defeat, soldiers encouraged Indian veterans of the battle to picture their conceptions of the action. Scores of these Indian pictorial records have been preserved on animal skins, paper, or cloth. Among them are three drawings on muslin by the Cheyenne warrior White Bird in the collections of the U.S. Military Academy at West Point (no. 132). A Sioux version of the battle, painted on skin, was owned by President Theodore Roosevelt, author of *The Winning of the West* (1889-1896).

Generations of white artists, intrigued by the mystery as well as the epic character of the Custer battle, have also tried to depict it. Surely the most ambitious of these efforts was a huge, circular painting entitled *Gen. Custer's Last Fight against Sioux Indians at the Battle of the Little Big Horn,* painted by the little-known artist E. Pierpont and six assistants for the Boston Cyclorama Company. It opened to the public March 22, 1889, in a specially designed building at 541 Tremont Street, where an equally large *Battle of Gettysburg* had long been displayed.

Probably the most popular version of this battle over the years was the action-packed lithograph *Custer's Last Fight,* adapted by another little-known artist, Otto Becker, from a painting by Cassilly Adams during the 1890's and reproduced in great numbers by Annhauser-Busch Brewing Company of St. Louis. In many a saloon and barroom this

busily detailed interpretation of the Custer tragedy served as both wall ornament and conversation piece.

Since the Indian wars ended, they have been refought on canvas with vigor and startling realism by some of the most popular painters and illustrators of the western scene, among them Frederic Remington, Charles M. Russell, and Charles Schreyvogel. Some of these works have hung in the White House and in the Metropolitan Museum of Art. Many have become prized possessions of the host of new regional museums established in the West itself since World War II. Remington's *A Dash for Timber* (1889) shows hard-riding cowboys hotly pursued by Indians, so realistically portrayed as to prompt a cavalry officer and veteran of frontier service to comment "his figures dart from the canvas with a life and fullness that causes the observer fairly to stand aside while they dash by."

In our century motion pictures and television have perpetuated and even embellished the image of the Old West as a place of dramatic conflict and exciting action. Even so, we should recognize that that image was substantially formed by generations of artist-creators of still pictures, both Indian and white, before the end of the nineteenth century.

JOHN C. EWERS

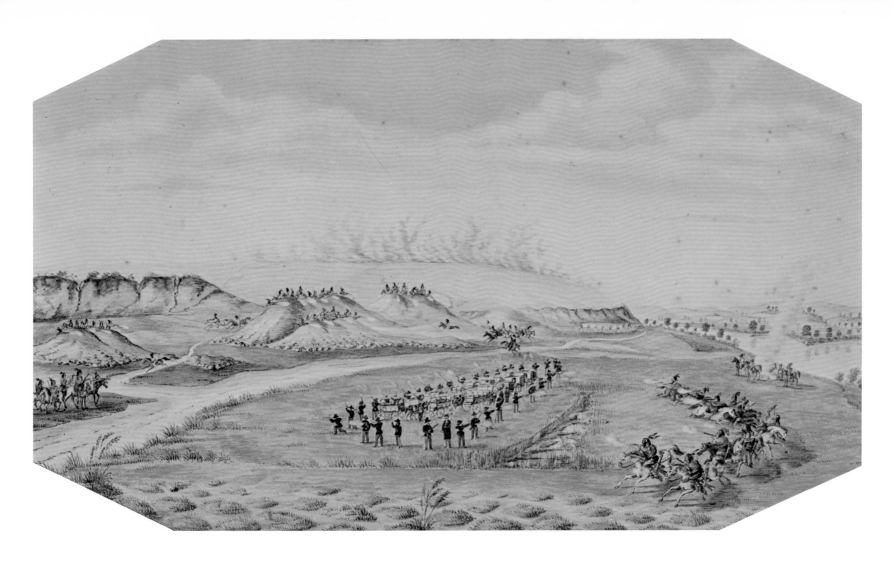

119
Hermann Stieffel, 1826-1882
*"Attack on General Marcy's Train,
escordet by Comp: K 5th U.S. Infantry,
Br. Major Brotherton commanding,
—near Pawne = Fort Kansas, Septem-
ber 23th 1867"*
1867; watercolor, 11½ x 20 in.
The Beinecke Rare Book and Manu-
script Library, Yale University
(Shown in Boston only.)

*Hermann Stieffel was a German born
soldier and artist who joined Company
K of the United States Infantry at
Camp Floyd, Utah, in 1858. In Septem-
ber 1867, Company K went from New
Mexico to Fort Harker, Kansas, in the
Department of Missouri as escort for
Brigadier General R. B. Marcy, who
was acting as inspector general for
troop units west of the Missouri. Stief-
fel has recorded the column near Fort*

*Dodge, Kansas, on the Arkansas River
under attack by a force of Cheyenne
believed led by Black Kettle.*

Ref.: Edgar M. Howell, "Hermann
Stieffel: 'Soldier Artist of the West,' "
United States National Museum,
Bulletin, no. 225, 1960, pp. 3-16.

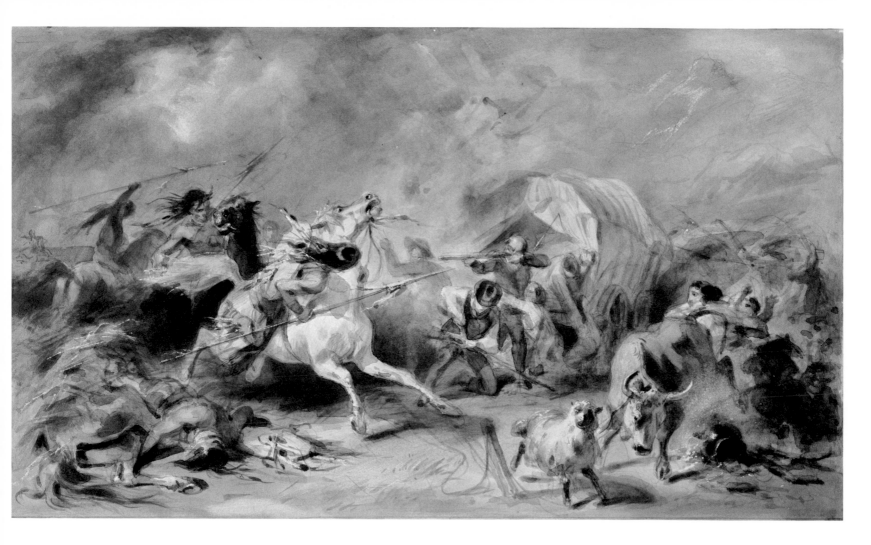

120

Felix Octavius Carr Darley, 1822-1888
Indian Attack on an Emigrant Train
Ca. 1860-1870; water color, 13⅛ x 18⅛ in.
Museum of Fine Arts, Boston, M. & M.
Karolik Collection
(Shown in Kansas City and
Milwaukee.)

Felix Darley, known for his illustra-tions of Rip Van Winkle, The Legend
of Sleepy Hollow, *and Irving's* History
of New York, *sketched this dramatic
scene of confrontation between white
settlers and a band of Indians. There is
no proof that Darley ever witnessed
such a scene at first hand. This sketch
is a study for one of four large draw-ings made for Prince Napoleon, son of
James Bonaparte.*

Ref.: Museum of Fine Arts, Boston,
*M. & M. Karolik Collection of American
Water Colors & Drawings, 1800-1875*
(Boston, 1962), vol. 1, pp. 132-135.

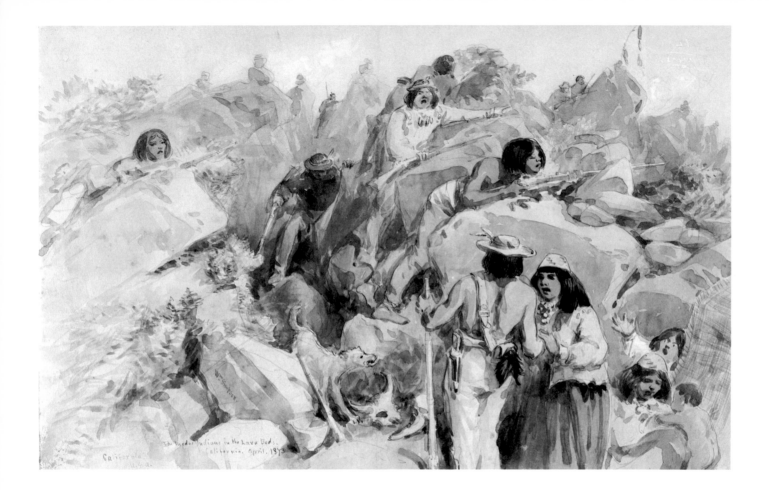

121

William Simpson, 1823-1903
The Modoc Indians in Lava Beds
1873; watercolor, 15 x 21 in.
Peabody Museum of Archaeology and
Ethnology, Harvard University

*William Simpson was witness to the
Modoc Indians' strong resistance to the
white man's control of their land. The
Modoc tribe had ceded their lands in
northern California to the United
States and retired to the Klamath
Reservation in 1864, but, dissatisfied
there, they made attempts to return to
their old lands. The Modoc War began
in 1872 after Kintpuash, a Modoc chief,
took his people back to California and
refused to leave. Finally, the Indians
retreated to the lava beds of northern
California, where for several months
they remained entrenched. At last,
overcome, Kintpuash and five other
leaders were hanged.*

123

Saddle

1880-1900: Navajo, northern Arizona; bone, leather, and wood, h. 15¼ in., w. 14¾ in., d. 21½ in.

Utah Pioneer Village, Salt Lake City

Possession of a saddle was to the Indian's greatest advantage in warfare. Sudden strikes and quick retreats were possible. With the bow and arrow and later the gun as a weapon, and with the hide shield as armor, the mounted Indian was a formidable enemy. By the time the white man came in contact with the Indian in the West, the Indian was mounted. Introduced by the Spanish, horses were acquired by 1539 in the Southwest and by 1682 on the Plains; by 1784 horses were in use throughout the Plains. The form of this Navajo saddle, distinguished by a high pommel and cantle, derives from Spain. It is hide covered, and leather straps, obtained from the white man, are used to form girth and stirrups.

Ref.: Walter Prescott Webb, *The Great Plains* (New York: Grosset and Dunlap, 1931).

293

Cyrus Dallin, 1861-1944
The Protest
1904; bronze, h. 20½ in., w. 17 in.
Museum of Fine Arts, Boston

Francis La Flesche, an Omaha Indian who became an ethnologist at the Smithsonian Institution's Bureau of American Ethnology, admired Cyrus Dallin's ability to capture in his sculpture the accurate rather than the stereotyped image of the American Indian. "His work," said La Flesche, "brings back vividly to my mind the scenes of my early youth, scenes that I shall never again see in reality. This reopening of the past to me would never have been possible had not the artist risen above the distorting influence of the prejudice one race is apt to feel toward another, and been gifted with the imagination to discern the truth which underlies a strange exterior."

A large version of The Protest was executed for the Louisiana Purchase Exposition in 1904 at the end of the period of exploration and expansion into the Far West. The exposition commemorated the centennial of Lewis and Clark's historic journey to the Pacific. The strong gesture of defiance made by the mounted and war-bonneted Indian is unmistakably directed at the white man, whose settlement of the land had destroyed his centuries-old civilization.

Ref.: John C. Ewers, "Cyrus E. Dallin, Master Sculptor of the Plains Indian," *Montana, the Magazine of Western History,* winter 1968, pp. 35-43.

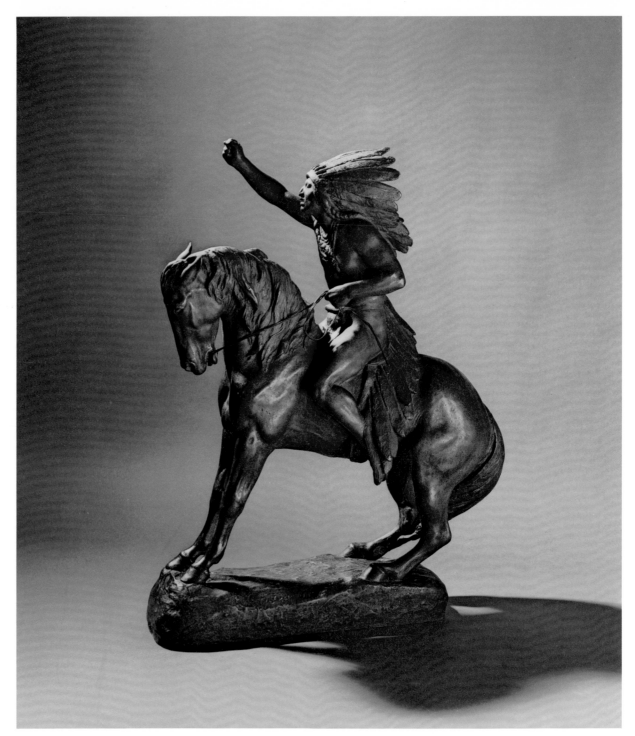

4
The Impact of Trade Goods on Native American Arts

Just as the desire to build a better life through the acquisition of new materials is by no means limited in history, so the exchange of object for object between different cultures, between natives and migrants, has long been in effect. The initial relationship between the native American and the white settler was thus not unusual in that it was based on traditional hospitality, peaceful exchange, and a natural curiosity as to what the other side might have to offer.

The earliest trade between Indian and European was confined to a modest amount of objects brought by the explorers to barter for food and whatever might be available. At first, traders came individually, carrying as much as possible with the aid of a mule or on their own backs. Soon entire caravans were setting out for the West from gathering points such as St. Louis, laden with goods of various types destined for the Indian market. These took the form of manufactured textiles, particularly cloth in bright colors, metal objects such as guns, knives, and axes, beads and jewelry, trade silver, dyes, mirrors, and other objects calculated to please the Indian customer.

It is difficult to fully assess the Indian's attitude toward the trade relationship with the white settler, since we are not certain how much significance he attached to his own resources during the very earliest contacts. We do know that Indian entrepreneurs soon came to realize the importance of their resources and in particular the importance of their location. The alacrity with which the Iroquois recognized the need to control the fur trade and their ability to do so once they had secured guns and gunpowder are indications of this shrewdness. Another example is the control by the Tlingit Indians of the waterways from the interior of Alaska down to the coast. As the demand for resources increasingly exceeded the supply, these attempts at control led both to intertribal wars and to friction between Indian and white.

To estimate the Indian view of the relative importance of trade goods

is also difficult. While metal was on the whole the most desired commodity, the various types of cloth and the brilliant glass beads and similar objects of adornment were probably only slightly less popular. The Indian's attitude toward decoration must be understood to fully appreciate why he eagerly sought after material so much of which in our eyes today appears of little value. Adornment was a preoccupation of the Indian; he took time and pleasure in decorating every portion of his body and his costume. One need only look at the Indian collections in any museum to realize the tremendous range of personal ornamentation common to the tribes of the North American area, particularly those of the Plains region. Many of the objects acquired by the Indian through trade were used by him in ways that differed completely from the purpose intended for them by the manufacturer. Indeed, his inventiveness often created new uses for old objects, making them a colorful asset to his costume. The tribes of the Great Lakes and Central Plains, for example, made artistic use of small scraps of cloth and silk ribbon, working them into gay shawls, dresses, blouses, and leggings (nos. 126, 138). This technique is no less impressive than are the appliqué techniques of the southeastern peoples, again using patches of cotton gingham and broadcloth to form small, colorful geometric designs for their garments. In each instance, these became tribal costumes of such individuality that an ethnologist can recognize them at a glance.

In the field of textiles, the exchange of buckskin for machine-made cloth was certainly quickly established. Trade cloth, commonly called stroud, after the woolen manufacturing center in England where it was produced, was perhaps the commonest and most coveted woven wool textile brought to the West by the European settler (no. 127). Next to it in popularity were cotton products such as gingham and calico, which were used for clothing. With the disappearance of the buffalo from the Plains, government-issued muslin and canvas became so important that

in time they completely replaced hide, even serving as the material on which the Indian artist painted pictures (no. 131).

Various types of dyes and dyed yarns, such as the Germantown wools, were introduced to the Southwest late in the nineteenth century. The vegetable dyes used by the Indians in the weaving of blankets and clothing were supplemented and gradually replaced by the more brightly colored aniline dyes. The dyeing process with the latter was more rapid than that with vegetable dyes and allowed yarns to be prepared for weaving more quickly. These changes in yarns and dyes, combined with the general influence of the white man on native crafts, led to new designs in Indian woven textiles. Silk ribbons and fragments of cotton continued to be used as decoration throughout this period.

Metals brought by the trader, particularly iron, steel, and brass, were considered important for their functional use (no. 139). Copper, a natural resource already familiar to the Indian, was employed in a variety of ways. Tin also served a surprising number of purposes. It was used in decoration: for example, for the small "tinklers" or "jinglers" that gave a musical sound to a costume when they were formed into fringes, and for the brilliant, gleaming eyes of the False Face Society masks made by the Iroquois. Brass was important in its manufactured form as grommets, tacks, and similar equipment, and wire of both brass and copper was used for jewelry (no. 145).

After the middle of the nineteenth century, the introduction of German (or nickel) silver offered the means of providing an inexpensive metal with an attractive luster; it was particularly important in the trade of the Plains area. Silver itself was widely used as a trade commodity; jewelry in a variety of forms, such as religious crosses and brooches, was normally fabricated by silversmiths in London, Paris, Montreal, Boston, or Philadelphia (nos. 140, 141). These pieces are a particularly valuable means of dating trade practices, since they were

126

Needlework case
Ca. 1880; Omaha, northeastern Nebraska; wool and silk, h. 18 in., w. 5½ in. Peabody Museum of Archaeology and Ethnology, Harvard University

Machine-woven cloth and European ribbons, received in trade from the white man, were put to use by the Indian in a variety of imaginative objects. This needlework case of cloth appliquéd with brilliantly colored ribbons in geometric designs is a fine example of the impact of trade goods on Indian art. The case was collected by the Omaha's benefactor, Alice Fletcher. Through her mediation in 1882 the tribe was granted land in compensation for territory ceded to the white man in 1854.

137

Headdress
Ca. 1890; Crow, Montana; eagle feathers, h. 22 in., w. 16 in. (approx.) Museum of the American Indian, Heye Foundation, New York

The feathered headdress, which has become a symbol of the American Indian, was used by the Plains people. This highly colorful bonnet is decorated with material received through trade: brass buttons (which the Indians admired on soldiers' uniforms), silk ribbons, and glass beads. Shell, stone, bone, and seed beads made earlier by the Indians were replaced by European glass beads, which were woven into a wide variety of designs.

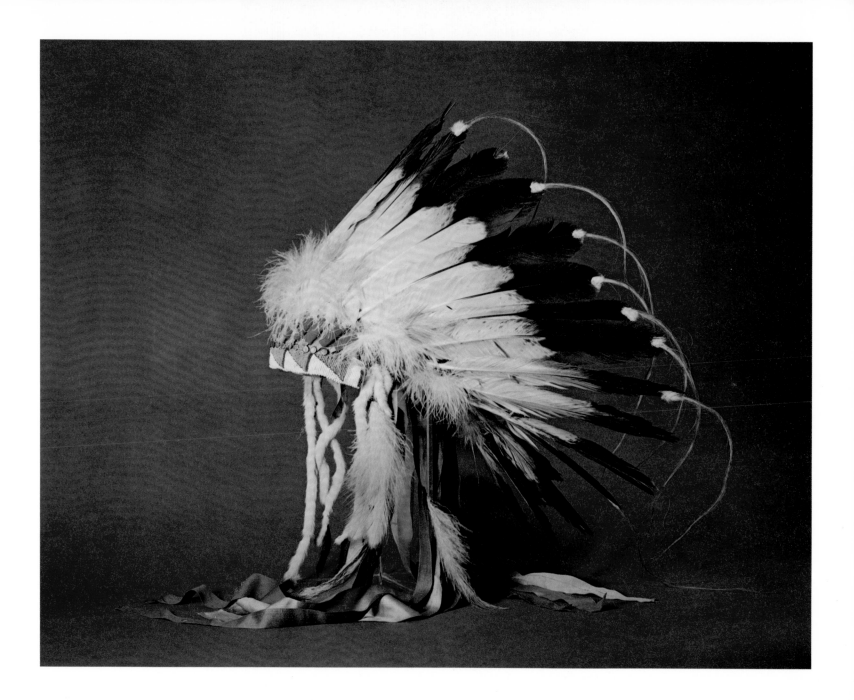

usually hallmarked. The custom of awarding medals to important individuals, early instituted by the French and British political and military leaders, was followed by the Indians until the beginning of the twentieth century. These so-called peace medals again offer a helpful means of dating a given transaction, except where, as is frequently the case, they have been reissued by the federal government (no. 142).

Among metal objects brought by the white man the gun was of paramount interest. Its introduction had a two-fold effect. On the one hand, it allowed the Indian greater success in hunting, while seriously altering the natural balance of the ecology—he could now more readily kill off both food source and predator. On the other hand, the political-military relationship between many tribes was completely and permanently altered. The exhibit includes one novel and incongruous use of a gun, in which the barrel has been transformed into a courting flute by an imaginative and ingenious Apache smith, (no. 143). Knives, whether they served as domestic utensils or as implements of war, were widely traded, as were axes. The latter included the ubiquitous tomahawk, a weapon and cutting tool frequently equipped with a bowl, so that it served in addition as a smoking pipe. The tomahawk became one of the major symbols of "Indian-ness" throughout the United States. These implements were usually made by white blacksmiths in large quantities for Indian trade, and many of them can be traced back to the original maker, whose name was often stamped into the metal.

In the field of miscellaneous objects used for trading there was a tremendous range, from pearl buttons, which were employed on the northwest coast to decorate clothing, to aniline dyes, glass beads, glass mirrors, and related smaller items that were introduced for whatever value the trader or his customer might attach to them (nos. 129, 144). Some of these materials quickly supplanted older, more traditional resources. Perhaps the most familiar is the replacement of dyed porcu-

pine quills by the more brilliant and non-fading glass beads (no. 147).
These beads, made in Italy and southern Europe, were offered to the
Indian in exchange for furs and were quickly seized upon as a most
desirable form of adornment. Used in the decoration of both men's and
women's costumes, they were associated with political, social, or eco-
nomic importance. Designs were varied; geometric patterns predomi-
nated, but floral patterns and free forms were also utilized to make the
most of these brilliant glass decorative elements. The earliest beads,
which were quite large, have been given the name "pony beads" to
distinguish them from the later, smaller beads. The pony beads are
usually blue or white, occasionally red, and less frequently black. Found
throughout the northern Plains and the western territories, they were
introduced in hanks, to be traded mainly for furs. It is quite possible to
date some of the beadwork by the size and type of bead, although this is
not an infallible method, since different beads arrived at varying times
throughout the West. The favorite beads on the northwest coast were
the great blue beads obtained through Russian trading sources. They
were initially given an unreasonably high trading value, which eventu-
ally became more realistic. Even today they still hold a firm place in the
affections of the people of Alaska.

The impact of all these materials on Indian culture was far-reaching.
Many of the traditional crafts were affected: there was a marked change
in design and technique, and, even more important, in economic aspects.
The time factor in determining the trade value of porcupine quill work,
for example, was quite different from that in beadwork, since the latter
did not involve the preliminary steps required in the collecting, dyeing,
and preparation of quills. There was, of course, the time required in ob-
taining furs to trade for the beads, but this was not regarded in the same
light as the tedious process of preparing the quills. As already men-
tioned, use of trade beads carried a certain degree of prestige. Anyone

could wear a costume decorated with porcupine quills, provided, of course, the craftsman had the requisite skill (no. 149). In the case of beadwork, however, economic status was involved; here the wearer had the opportunity to display not only his wealth but also his acumen in obtaining sufficient beads for his purpose.

Inevitably, these attitudes began to have an effect upon the political role of the individual and of the tribe. Those who were able to secure a greater quantity of furs (or whatever was in demand by the white trader) were able to enhance their position through the goods they acquired and occasionally through the demonstration of their superior skill in hunting or other fields. Indians who were in a position of political supremacy were able to dictate terms on which trade could be conducted in their respective areas, thus giving themselves or their people a key role in subsequent negotiations. This was particularly true when vital matters such as access to routes through a given area or even the disposal of land were concerned. And since the Indian tended to associate costume with social status, it is not surprising that the wealthier individuals who were able to provide themselves and their people with unusually well decorated or colorful costumes also achieved a certain political eminence. Although the religious structures of the tribes were also affected by trade with the white settler in various ways, some religious leaders—the more conservative, perhaps—did not make use of the new materials in all instances for their ceremonies but continued to rely on traditional objects. On the other hand, it frequently occurred that a newly introduced material was given a special focus in a religious ceremony. For example, in the Ghost Dance one of the important ceremonial objects was the government-issued muslin shirt worn by the followers of Wovoka, which was said to be magically endowed to ward off the white man's bullets. This was, in essence, turning the white man's materials against him in an effort to defeat his own "magic."

The influence of trade with the white man was also felt in Indian social customs. Since the women did most of the craftwork, their role in bartering was important, and they stressed this importance in no uncertain terms. It was not unknown for the woman to direct the course of a transaction, even though the man was the actual entrepreneur. The woman's role, of course, did not undergo a major change, for in traditional native culture, she enjoyed a level of social and political importance in tribal life. Probably the primary effect of trade on the lives of Indian women was in their craftwork, which in both its technical and aesthetic aspects, was radically altered by the introduction of new materials.

Language was considerably affected, since many of the trade materials were wholly unknown prior to the coming of the European, and terms had to be invented for these, as well as for the transactions themselves, and even for some of the procedures necessary to achieve a desired result. Thus, a new vocabulary was created that was understood and used by both parties in a transaction.

One aspect of the trade relationship between Indian and European can only be surmised: the feelings of superiority on the part of one culture in relation to the other. It is certainly true that in the attitude of the Indian toward possession of a gun there was clear recognition of the superiority of the European product. Yet, the native American was not so naïve that he failed to perceive his advantageous position as supplier of objects eagerly coveted by the white man. The settler's desire for furs and many of the raw materials that the Indian had in ample supply undoubtedly allowed a certain balance in a negotiation. As already observed, it is not possible for us to estimate accurately the view of either side in a given transaction. It must, too, be borne in mind that, since the history of white-Indian relationships has been relatively dominated by non-Indian writers, interpretations of this subject tend to reflect their

point of view; a record of these transactions by Indian writers might well produce some quite different and surprising evaluations. It is quite likely that any intelligent Indian businessman would feel he had the best of the deal when a poorly dressed foreign trader offered him a magnificent sharp-edged tool in exchange for a few animal pelts that he had obtained with ease. Recognition of what he could achieve with the sharp metal blade of an axe or knife as compared with the short-lived edge of a ground-down stone or a flaked piece of quartz (grinding and flaking were both laborious processes) would certainly give him a comfortable feeling of superiority!

The trading system that began with a simple transfer of tools and ornaments for objects that the Indian probably regarded in a similar light eventually changed. These same relatively cheap products were bartered for more valuable objects having some religious, social, or economic importance—and, finally, for land. It was one thing for the white settler to offer a gun, or silver, or beads in exchange for furs, food, or raw materials; but it was quite another matter to offer these for land, particularly when the transfer was viewed by the white man not just as a temporary lease but as a permanent separation of title. Added to general misunderstandings and abuses in transactions, and the intolerance of the white man toward Indian religious beliefs and social customs, this conflicting view on the acquisition of land led to deterioration of the relationship and eventually to warfare between the two cultures.

FREDERICK J. DOCKSTADER

127

Calumet
Ca. 1850; Osage, Oklahoma; wood, duckbill, feathers, horsehair, wool, l. 33½ in.
Museum of the American Indian, Heye Foundation, New York

Red stroud cloth and commercial yarn, trade materials that made their appearance with the advancing frontier, are combined with the traditional fan of eagle feathers and strands of horsehair and duckbill mouthpiece as embellishments for the stem of the calumet, used by North American Indians for ceremonial smoking.

Ref.: George A. West, "Tobacco, Pipes, and Smoking Customs of the American Indians," Milwaukee Public Museum, *Bulletin*, 1934.

129

Man's shirt
19th century; Tlingit, Alaskan coast; wool, l. 44½ in., w. 28½ in.
The Denver Art Museum

Blankets, flannel, and broadcloth were brought by the white settlers to the northwest coast and traded for furs. Dark blue and scarlet were the colors favored by the Indians. From these materials, blankets and shirts with appliquéd designs were created for ceremonial use. These were then trimmed with another trade item, mother-of-pearl, which replaced the traditional abalone or dentalium shells. A shirt such as this, showing clan identification, could be worn with modern trousers.

Ref.: Erna Gunther, *Art in the Life of the Northwest Coast Indians* (Portland: Portland Art Museum, 1966).

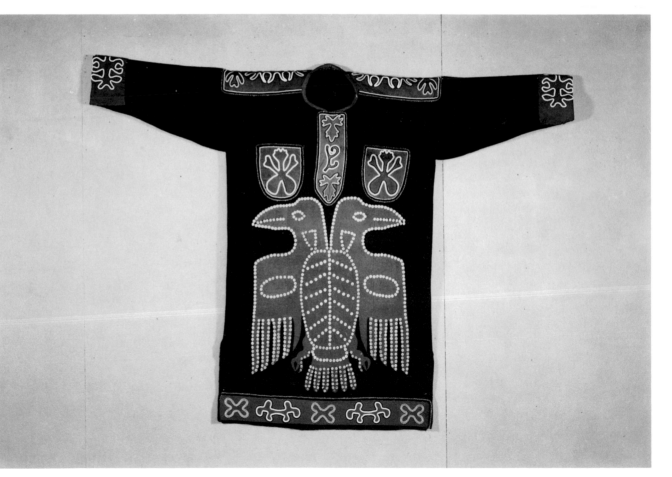

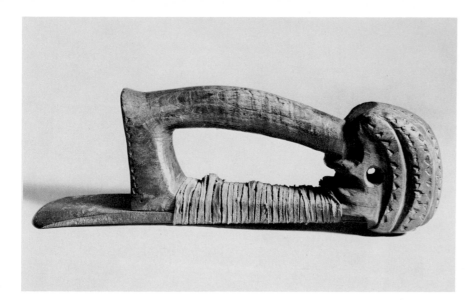

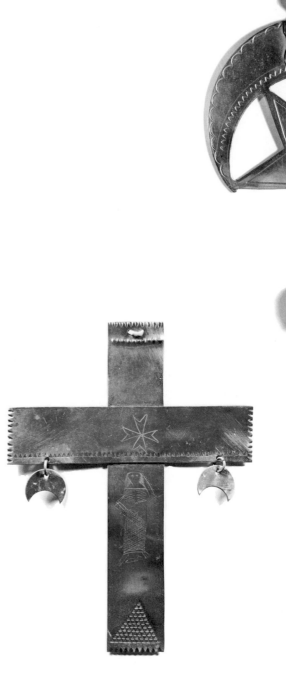

135
Hand adze
Ca. 1890; Cowichan, Vancouver Island,
British Columbia; pine and iron,
h. 3¼ in., w. 10½ in., d. 1¾ in.
Museum of the American Indian,
Heye Foundation, New York

*The nephrite or jadeite blades of adzes
were replaced by iron blades from
reworked files or small axes obtained
from traders. Indians of the northwest
coast, who were fine woodcarvers, took
pride in their tools. The adze was used
for texturing and smoothing planks
and shaping dishes and other small
objects. The wooden handle of this adze
is an abstract carving of an animal
head.*

141
Breast ornament
Ca. 1890; Osage, Oklahoma; German
silver, h. 4½ in., w. 3 in.
Museum of the American Indian,
Heye Foundation, New York

*Ornamented with an applied engraved
United States shield, this breast orna-
ment was probably traded to an Osage
Indian who embellished it further by
attaching two animal paws at the point
of the star.*

140
Cross
Ca. 1890; Cheyenne, Oklahoma;
German silver, h. 8 in., w. 6 in.
Museum of the American Indian,
Heye Foundation, New York

*German silver body ornaments were
popular trade objects. This cross, which
has no hallmark, was in all probability
engraved by an Indian smith, copying
a European or American design.*

142

Peace medal
Ca. 1845; silver, made by the U.S. Mint,
diam. 3 in.
Museum of the American Indian,
Heye Foundation, New York

Before 1760 the French in North America had begun the custom of awarding peace medals to important Indian chiefs as marks of their distinction and to gain favor. After 1760 the presentation of medals was continued by the British and American governments. This large silver medal is engraved with a bust of James K. Polk designed by John Gadsby Chapman on the obverse and clasped hands and the words "PEACE AND FRIENDSHIP," designed by John Reich, on the reverse. It is said to have been presented to Chief Keokuk of the Sauk Indians, Franklin County, Kansas, in 1847. Polk, an outspoken expansionist, was responsible for pushing the frontier west of the Missouri River after 1845.

Refs.: Cornelius Vermeule, *Numismatic Art in America* (Cambridge: Harvard University Press, 1971); Kenneth Failor, *Medals of the United States Mint,* rev. ed. (Washington, D.C.: U.S. Department of the Interior, 1972).

143

Courting flute
Ca. 1900; White Mountain Apache,
Cibique, Arizona; steel, l. 23⅛ in.,
diam. ¾ in.
Museum of the American Indian,
Heye Foundation, New York

The gun was a trade item highly valued by the Indian. The barrel of a gun transformed into a courting flute and ornamented with a design of incised lines illustrates a poetic reuse, intentionally ironic, of white man's materials.

145

Mirror board
Ca. 1890; Caddo, Oklahoma; pine,
h. 11½ in., w. 4⅛ in., d. ¾ in.
Museum of the American Indian,
Heye Foundation, New York

This glass mirror is framed with carved wood and decorated with brass tacks received in trade. The mirror was carried by men participating in ceremonial dances.

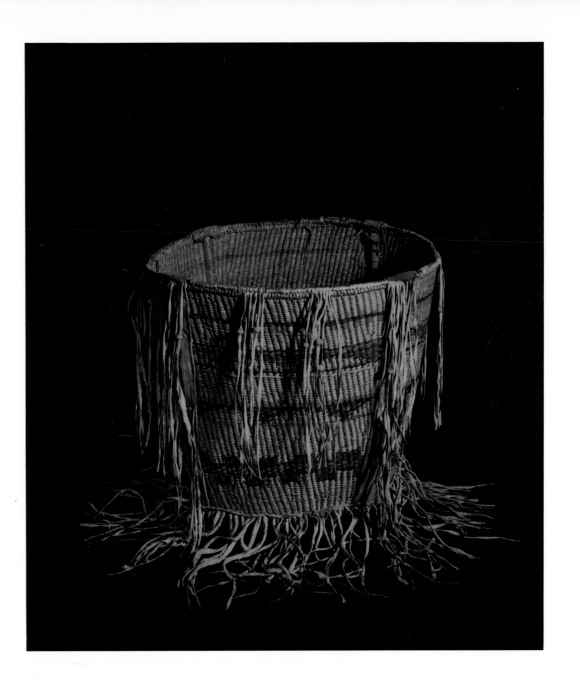

147
Burden basket
Ca. 1850-1900; Apache, Arizona; reeds,
h. 14 in., diam. 17 in.
Heard Museum, Phoenix, Arizona

*Trade beads were used as decoration in
a wide variety of ways. Here, the har-
vest, or burden, basket, which was
carried on the back and usually
attached by a tumpline to the forehead,
is embellished with bright blue beads
strung on buckskin fringes. The basket
is made with a wrapped twine
technique.*

144
Button blanket
Ca. 1910; Kwakiutl, Cape Mudge,
Vancouver Island, British Columbia;
wool, h. 74 in., w. 53½ in.
Museum of the American Indian,
Heye Foundation, New York

*Worn on ceremonial occasions by
wealthy members of the Kwakiutl
tribe, this blue trade blanket has been
transformed by its decoration of red
cloth, black velvet, and pearl buttons
representing a tree and two birds.*

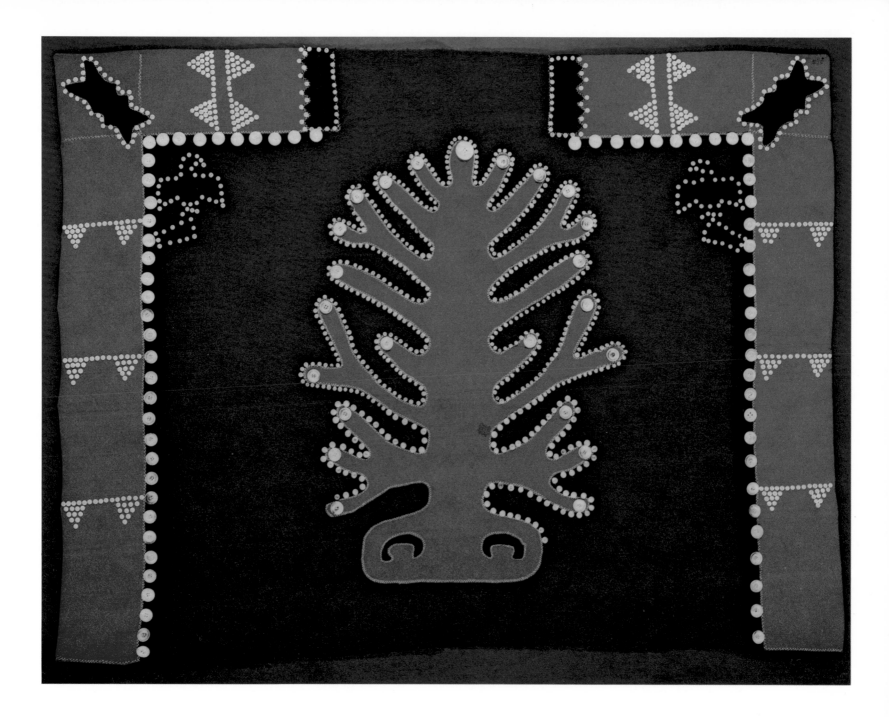

149

Shirt

Ca. 1820-1825; Mandan, North Dakota; buckskin, l. 22 in., w. 20 in. (excluding fringe)

Museum of the American Indian, Heye Foundation, New York

Appliqué of dyed porcupine quills to hide was a traditional Indian art, but when trade beads became available from the fur trader, they replaced the quills. The decoration on this Mandan war shirt combines both quills and beads. Quills dyed orange, red, and blue in a pattern suggesting animal paws decorate the sleeves and front of the garment; beads in abstract patterns appear on the breast flap.

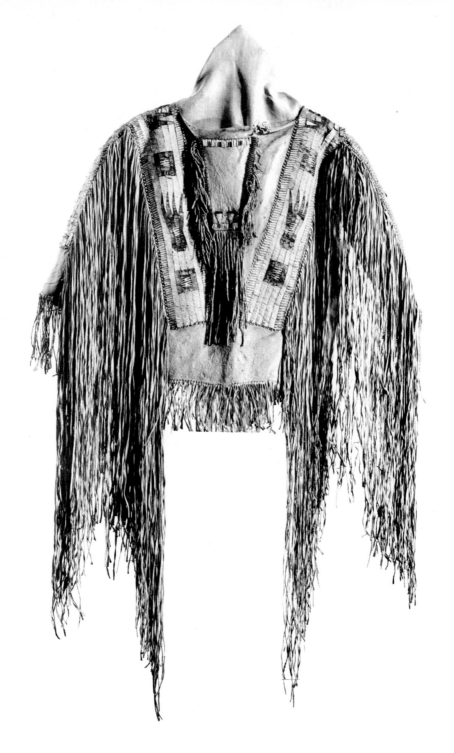

Facing page:
298
George Edward Anderson, 1860-1928
Tidwell Cabin, Sunnyside, Utah, ca. 1880-1890

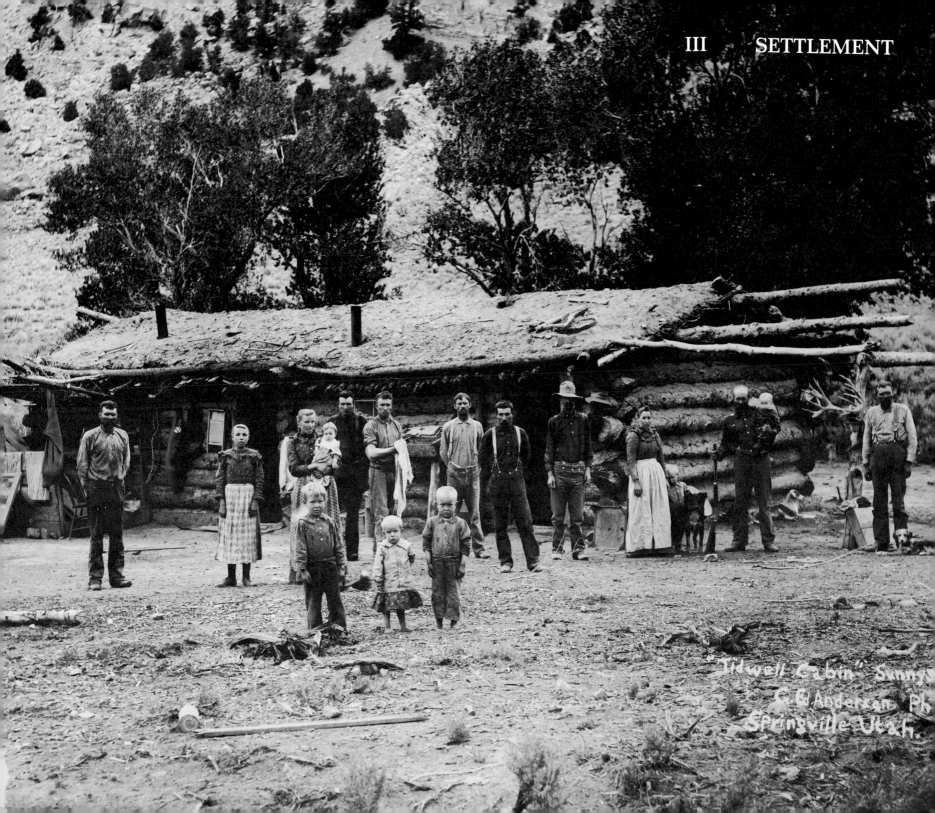

"Tidwell Cabin" Sunnys
C. E. Anderson Ph
Springville Utah.

5
Americans on the Land

1. Dr. Edwin James, botanist for Major Stephen Long's expedition along the north bank of the Platte River, 1820; quoted in Robert G. Athearn, *High Country Empire* (New York: McGraw Hill, 1960), 19.

The young American republic took less than fifty years to make its own the enormous, unknown territories from the Mississippi River to the Pacific. With the Louisiana Purchase in 1803, America acquired all the vast, rolling plains that were promptly dubbed the Great American Desert, a land of "hopeless and irreclaimable sterility."[1] Then came more verdant pastures, the rich lands of Mexico's northern provinces and the green valleys of Oregon. Americans in Texas won Texan freedom from Mexico in 1836, and the republic was annexed to the United States in 1845. California and New Mexico were prizes of the Mexican War two years later. American settlers in Oregon gradually edged out England's Hudson's Bay Company, and Oregon was admitted to the Union in 1846.

As soon as the land was theirs, and often before, Americans began moving onto it. Unlike the pioneers from countries like Spain, who established their wilderness outposts in the service of nation and church, the American went west on his own behalf. He was mobile by nature and irresistibly tempted by fertile farmland free for the asking or the golden opportunity of a quick fortune in the mines. To make his profit and his new life, he unhesitatingly exploited the land and expelled its former inhabitants. The Mexicans and British had no chance before the waves of American settlers and their expansionist government's conviction in its Manifest Destiny. Seventy-five million buffalo, irritants to the cattlemen and the military, were wiped out in one decade. Then the Indians, whose livelihood the buffalo had been for centuries, were pushed steadily west before the advancing frontier and confined to ever-shrinking reservations.

Some of the American pioneers who assaulted the unknown West were chronic frontiersmen, always ready to move on. Others needed more incentive, serious economic depression at home or the electric news of gold in the western mountains. Still others waited until trails were broken and towns laid out, until the railroad promised them a link

with the markets and mail-order houses back East.

The pioneer brought to the West cultural traditions and technical knowledge that were of little use to him in the new land. He had to adapt drastically to a totally new environment, and speedy adaptation was a matter of survival. Very few struck it rich as they had dreamed; in the beginning the land and their own wits were all they had.

Yet still they came, and for many the hardship did not, in the end, distort the dream beyond recognition. Elinore Stewart, a widow who left her job as a Denver laundress for life on a Wyoming homestead, was one of those who stayed and made it. "To me," she wrote, "homesteading is the solution of all poverty's problems . . . but persons afraid of coyotes and work and loneliness had better let ranching alone. At the same time, any woman who can stand her own company, can see the beauty of the sunset, loves growing things, and is willing to put in as much time at careful labor as she does over the washtub, will certainly succeed; will have independence, plenty to eat all the time, and a home of her own in the end."[2]

2. Elinore Pruitt Stewart, *Letters of a Woman Homesteader* (Lincoln, Nebraska: University of Nebraska Press, Bison paperback, 1961), 215.

The first surge of settlers to the West came when Mexico opened Texas to Americans in 1821. Stephen Austin settled three hundred families there in 1823, and twelve years later Texas had thirty thousand Anglo-Americans busily raising cotton, corn, and cattle. Mexican California, wealthy, indolent, and backward, came to the attention of Americans in the East when traders sailed there in the 1820's and 1830's for the hides and tallow of California cattle. Soon a number of Americans were settled on vast *ranchos,* notably John A. Sutter, whose fort became the mecca of wagon trains to California.

The principal motive for the great Oregon and California migrations of the 1840's was hunger for land, intensified by hard times in the Midwest following the depression of 1837. There was a great deal of inflated propaganda about life in the Willamette and Sacramento valleys, and

the reality was something of a shock. But most newcomers who had struggled over the Oregon Trail settled down and went to work, and more came after them in a steady stream.

At this time the Great American Desert was primarily a route to the rich lands of the Far West. Only the Mormons, for whom the remote, inhospitable desert was a haven from persecution, chose to settle there. In the late 1840's they built a successful new life through the most efficient colonization process in the history of the frontier (nos. 110-112). But a bad reputation dies slowly, and most Americans remained convinced that the treeless plains were dried up eight months of the year and unfit for human habitation.

Time and the sheer pressure of numbers moving west eventually changed this notion, and the curse of the desert yielded to the American dream that all western lands were wonderful because they were west. But at mid-century, land lying more than two hundred miles beyond the Missouri was regarded with suspicion and disfavor.

Those two hundred miles, however, had been encroached upon well before the land titles of the Oto Indian nation were extinguished and the land legally opened to settlement by the Kansas-Nebraska Act of 1854. After that, steamboats plied the treacherous Missouri with settlers, freight, and prefabricated "Cincinnati houses." Other families came by covered wagon or the miserably uncomfortable stagecoach, and the New England Emigrant Aid Company regularly left Boston shepherding large groups of westbound pioneers.

But settlement of western lands in the 1840's and 1850's was only a trickle compared to the flood that broke over plains and mountains in the wake of the great pioneering frontiers of the miner and the cattleman.

California gold was discovered in January 1848 in the tailrace of John Sutter's sawmill on the American River. By mid-June, three-

quarters of the men in San Francisco had left for the diggings, followed by hordes from the rest of California, Oregon, Mexico, Hawaii, Chile, and Australia. A San Francisco newspaper, left without readers by the end of May, mourned "The whole country . . . resounds with the sordid cry of 'gold! GOLD! GOLD!!' while the field is left half planted, the house half built, and everything neglected but the manufacture of shovels and pickaxes" (nos. 156, 157).[3]

3. *The Californian,* May 29, 1848; quoted in Ray Allen Billington, *The Far Western Frontier* (New York: Harper, 1956), 220.

The next year eighty thousand would-be millionaires poured into California from the East and from Europe. More than twenty-five guidebooks were promptly written about the unknown land, mostly by people who had never been there. Within six months, whalers and cargo ships had been converted en masse, and American vessels deserted every port in the world to carry passengers from the East Coast to the gold fields. The trip around Cape Horn averaged five or six months; the Panama route was shorter but involved an arduous overland trip and often a wait of several months for space on a Pacific Mail ship to San Francisco.

Across the plains, a wagon with three yoke of oxen managed twelve or fifteen miles a day. Gold rush pioneers had practically no knowledge of the route or its demands, and their wagons did not even possess brakes until the mid-1850's. Many miners jettisoned wagons and supplies to get over the mountains and staggered into California with nothing but the packs on their backs.

Life on the early mining frontier was miserably primitive; services were few and prices exorbitant. In San Francisco, a tent city where the population grew overnight from three to twenty thousand, a bunk without bedding cost $20 a night and a room in the best hotel $250. Laundry was sent to Hawaii or China—$8 for a dozen pieces. In the remote mining camps, romantically named Shirt Tail Canyon, You Bet, Gouge Eye, or Lousy Level, miners lived in shacks made of wooden frames with blankets and shirts tacked over them (no. 165).

But the booming gold camp was something quite new on the American frontier, an infant city thousands of miles from civilization, a thousand men clamoring for food, supplies, and transportation. The needs were urgent and money plentiful. Farmers, ranchers, town builders, merchants, saloonkeepers, whores, actors, bookkeepers, carpenters, newspapermen, freighters, and railroadmen swarmed west, and the mining frontier was almost instantly urbanized. When the mines gave out and the miners moved on, those who had been lured west by the markets of the mining frontier stayed on. The gold camp, most impermanent and careless of communities, had spawned permanence and changed the face of the wilderness.

By 1851 placer deposits dwindled in California, and industrial mining began. As miners became the hired hands of great corporations, the solitary prospector drifted on to new bonanzas. A rush for the gold and silver of the fabulous Comstock Lode in Nevada began in 1859, that to the Pikes Peak region of Colorado about the same time (nos. 159, 161). Precious metals were found in Montana, Arizona, Idaho, and finally in the Black Hills of South Dakota. Each mining rush had its own particular character, but in general methods of mining and way of life each was strikingly similar to that in California. Sudden, spectacular, and short-lived wherever it sprang up, the placer mining frontier was pretty much a thing of the past by the late 1870's.

Hard on the heels of the gold and silver miners followed the brief and colorful frontier of the cattlemen who moved in to exploit other great tracts of unclaimed western land.

The Civil War left a serious shortage of beef in the North, intensified by the industrial revolution, which lured many men off the farm and into the cities. At the same time, the meat packing industry was revolutionized. The Chicago stockyards were built in 1865, and packing plants soon opened in Kansas City, Omaha, and Denver, processing meat in the

West and shipping it to the East by rail. Stiff competition and the utilization of by-products drove prices down; people discovered they could afford to eat meat, and the market boomed.

Texas, where cattle had long been the principal industry, was ready to meet the demand. The Mexican system of land grants, which gave only a *labor* (177 acres) to a farmer but a league (4,438 acres) to a stockgrower, had encouraged the raising of cattle, and by 1860 there were close to four million head in Texas alone.

Practically destitute after the war, their farms run down from neglect, Texans in the spring of 1866 began to gather their enormous herds of range cattle for the first long treks north to market. There had been sporadic trail drives before, particularly to California during the gold rush and to the Confederate armies in the early years of the war, but nothing on the scale that now developed.

The Texas cowboy's skills, costume, and range terminology came from his ancestor the Mexican *vaquero* (no. 167). The cattle, too, had their roots in the Spanish Andalusian cattle first brought to the New World in the early sixteenth century. By the 1860's, crossbreeding with many strains had produced the Texas longhorn, a bony, sad-eyed creature with horns spreading seven feet. He was no beauty, but the longhorn was a true western pioneer with incredible adaptability and the stamina to withstand cold, heat, thirst, and hunger. He could run like a deer, climb like a goat, and eat anything.

The longhorns were trailed north in herds of up to three thousand head requiring a trail boss, a cook with his chuckwagon, about ten cowboys, and a *remuda* (relay) of sixty horses. If all went well, the cattle traveled up to five hundred miles a month. But too often there were rampaging rivers to be crossed, angry farmers to appease, days without water when the cattle went blind from thirst, and the constant threat of stampedes.

With immense herds traveling hard-packed trails two miles wide, there was inevitably friction between cowboys and the farmers along the way. To avoid the line of settlement, the railroad and the terminus of the trail drives continually moved farther west, in 1867 to Abilene, Kansas, the end of the Chisholm Trail, and then on to Ellsworth, Newton, Wichita, Dodge City, and beyond.

In the heyday of cattle trailing, herds were also driven deep into the Southwest and West into Colorado, Montana, and beyond, where soldiers, Indian reservations, mining camps, and railroad construction crews provided a ready market for beef. Booming cow towns sprang up from south Texas to the plains of Calgary: Schuyler, Kearney, and Ogallala in Nebraska; Cheyenne, Wyoming; Miles City, Montana.

Cattlemen on the northern ranges quickly discovered that the buffalo, or grama, grass was extremely nutritious even in winter because it dries into natural hay during the dry late summer. Soon, instead of simply being driven north to the railroad and on to market, cattle were established on permanent ranches all over the western plains.

Within a very short time, the open range disappeared. Rampant speculation in the ever-booming cattle market encouraged serious overgrazing of the land, and then, in the fearsome blizzards of 1886-87, the greatest die-up in the history of the West wiped out millions of cattle.

Even without these disasters, the range cattle industry was doomed by the relentless encroachment of the farmer, steadily plowing up the range and fencing off the free grass with that marvelous invention of J. F. Glidden—barbed wire. As the cowman retreated before the homesteader, the cowboy-artist Charles Russell wrote sadly, "The country is all grass side down . . . It looks like hell to me. I liked it better when it belonged to God."[4] But the cattleman himself, like the miner, had done much to bring about the permanent agrarian settlement that caused him nothing but trouble. He had lured the railroad deep into the West

4. Quoted in Athearn, *High Country Empire*, p. 201.

and shown that man could survive and prosper in the Great American Desert. Moreover, the cattle boom had turned the Midwest into a great grain-producing area, leading to the development of sophisticated farm machinery, which would help farmers deal with the prairie.

To a large extent, land speculators preceded farmers into the Kansas and Nebraska territories, and the laying out of towns preceded farms. By an 1844 act of Congress, 320 acres could be held as a town site and shares sold to all those who, with typical western optimism, were convinced that this "city" was destined to be a trade center and probably the state capital.

Some new towns did prosper, especially those along the Missouri River. Saratoga, Nebraska, within four months of its founding, had fifty-six buildings, graded streets, two omnibus lines to Omaha, and a steamship landing. More often, in spite of the maps and glamorous illustrations made of them, these towns were never more than a few dreary cabins or dugouts, a garbage-littered street, and mud. John J. Ingalls, later senator from Kansas, reflected, "Kansas mud is incomparable; in the mud line it is a perfect triumph—slippery as lard, adhesive as tar, cumulative as a miser's gold, and treacherous as hope."[5]

5. Everett Dick, *The Sod House Frontier, 1854-1890* (Lincoln, Nebraska: Johnsen, 1935), 57.

The agricultural frontier crept slowly onto the prairie west of the river cities. Where there was no wood, houses, barns, and stores were made of sod. A family's first home was usually a dugout, followed by a house of three-foot sod bricks with a roof of brush, prairie grass, and sod. The sod house was cool in summer and warm in winter; it was impervious to fire and the unceasing winds and usually lasted about six years. But it was also dark, airless, and incredibly dirty. After a good rain the sod roof dripped mud and water into the house for days (nos. 168, 319).

Especially before the coming of the railroad, life on the prairie was immensely difficult. The virgin sod was so tough that turning it required

six yoke of oxen and a large plow, with an extra man sitting on the beam just to keep the blade in the ground. Neighbors were separated by long miles, and the loneliness was crippling. Water was precious until windmills came to dot the prairie in the late 1870's. Fuel was also hard to come by; farmers had never known a land without timber before, but now a trip of forty miles to cut firewood was common. Settlers burned buffalo and cow chips, corn cobs, and "cats" of twisted hay (nos. 170-173, 313).

The 1870's saw plagues of grasshoppers, which settled up to six inches deep on the ground, ate almost every growing thing, and so polluted the water that even cattle refused to drink. Prairie fires burned for weeks, destroying everything in their path. Drought was a constant menace; in some parts of the plains there was no rain at all from June 1859 to November of the next year. In a blizzard, the ice dust blew through cracks and filled houses and barns to the ceiling; cattle became so encased in ice that it had to be knocked off with a club; people were blinded, lost, and frozen to death trying to find their way from house to barn.

Unprepared for the challenge of the land, many farmers lost their crops, went bankrupt, or went home. Those who stayed had finally to accept that all the difficulties they hoped would pass with a new season were in fact permanent characteristics of the land.

But immense rushes for western land continued through the 1870's and 1880's. Under the Homestead Act of 1862, the government had offered 160 acres to every family head or person over twenty-one. Upon filing his claim, the homesteader had six months to get on his land and begin to make improvements. He then "proved up" by digging a well, cultivating at least ten acres, and living on the land for five years before it became permanently his. Well over a million homesteads were eventually given away under this act, and the Great American Desert went under the plow.

The railroad was probably the most important single factor in bringing to a close the frontier era in the West. Penetrating to the most remote corners of plains and mountains, it created the markets that ended subsistence frontier living and brought all the trappings of civilization that permitted miners, cattlemen, farmers, and businessmen to live much like Americans anywhere else.

The first trains chugged out west of the Mississippi in 1852, but it was not until after the Civil War that the government began to show a serious interest in a transcontinental railroad. The Union Pacific tracks, California bound, started from Omaha in 1865, moving with great speed in spite of supply problems, engineering difficulties, and Indian attacks. The Kansas Pacific went west the same year, reaching Denver in 1870 with a branch line running north to connect with the Union Pacific at Cheyenne. Other lines soon followed: the Atchison, Topeka, and Santa Fe through southern Colorado and New Mexico; the Northern Pacific and Great Northern across the Dakotas and Montana to the Pacific coast.

The government granted major railroad companies from $16,000 to $48,000 per mile of track completed, depending on the difficulty of the terrain, plus alternate sections of land on either side of the right of way. By 1880 the railroads had been given 155 million acres of western land, and they worked hard to sell it. Millions of leaflets describing the glories of the plains were distributed in the East and throughout Europe; people were escorted to America and offered reduced fares west on the railroads, easy terms for railroad land, free seed, and even a place to live while getting settled.

Few could resist what looked like an easy trip to an agricultural paradise. In the 1880's more than 600,000 people moved into Nebraska alone. Whole colonies came from England, Scotland, France, Switzerland, Belgium, Scandinavia, and Iceland. In 1874 nearly two thousand

German Mennonites from Russia settled on sixty thousand acres in Kansas, lured by a Kansas law (made especially for them) that allowed a man to refuse military service on religious grounds.

As so often in the history of the West, reality harshly challenged the dream as this last wave of pioneers tried to make a living on the plains. People cried that the railroad had lied outright about this arid land and felt further betrayed by their former friend as freight rates rose steeply and prices for agricultural products declined.

Thousands who could afford to went back where they came from, but others stayed and more followed after them. Their life in the West would never be an easy one, but what Robert Athearn calls the "polyglot army of plowmen"[6] had come to stay. In 1893 the government announced that it had no more land to give away. The frontier was at an end.

GILIAN S. WOHLAUER

6. Athearn, *High Country Empire,* p. 202.

111
Frederick Piercy, 1830-1891
"Fort Laramie and Ferry of Platte River"
1853; pencil and Chinese white on gray paper, 6⅞ x 9¾ in.
Museum of Fine Arts, Boston, M. & M. Karolik Collection
(Shown in Kansas City and Milwaukee.)

A hasty sketch, clearly made in the field, this drawing shows a simple river ferry in Wyoming.

Ref.: Museum of Fine Arts, Boston, *M. & M. Karolik Collection of American Water Colors & Drawings, 1800-1875* (Boston, 1962), vol. 2, pp. 37-39.

110

Frederick Piercy, 1830-1891
Council Bluffs Ferry and Group of
Cottonwood Trees (near Omaha)
1853; watercolor, 10¼ x 7 in.
Museum of Fine Arts, Boston, M. & M.
Karolik Collection
(Shown in Kansas City and
Milwaukee.)

At the time this watercolor was made,
Council Bluffs, or Kanesville, on the
western boundary of Iowa was the
main center for outfitting Mormons
embarking for the West. The ferry
across the Missouri River marked the
beginning of the long journey.
* Commissioned by members of the*
Church of Jesus Christ of Latter-day
Saints (Mormons) to make sketches of
the trail to Utah, Piercy left Liverpool
by ship and arrived in New Orleans on
March 21, 1853. Journeying up the
Mississippi River, he took time to divert
himself with a remarkable treasury of
views of New Orleans, Baton Rouge,
Natchez, Vicksburg, Memphis, and
St. Louis before arriving in Nauvoo, the
city evacuated by Mormons in 1846.
Further to the southwest, at St. Joseph,
Piercy continued his journey on foot to
Kanesville or Council Bluffs. From
there he joined with a Mormon com-
pany heading west on the overland
trail, or Great Platte Road, to Salt Lake
City. Piercy's sketches and his narra-
tive of the journey were soon published
in a book Route from Liverpool to
Great Salt Lake Valley *(Liverpool,*
1855), which proved useful in Mormon
missionary work in England. Converts
who were hesitant about moving to
Utah territory could see and read for
themselves about the landscape and
the problems to expect.

Ref.: Museum of Fine Arts, Boston,
M. & M. Karolik Collection of American
Water Colors & Drawings, 1800-1875
(Boston, 1962), vol. 2, pp. 37-39.

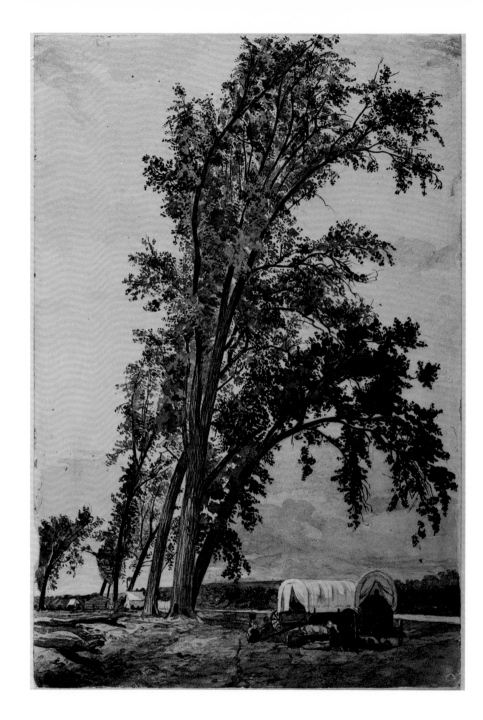

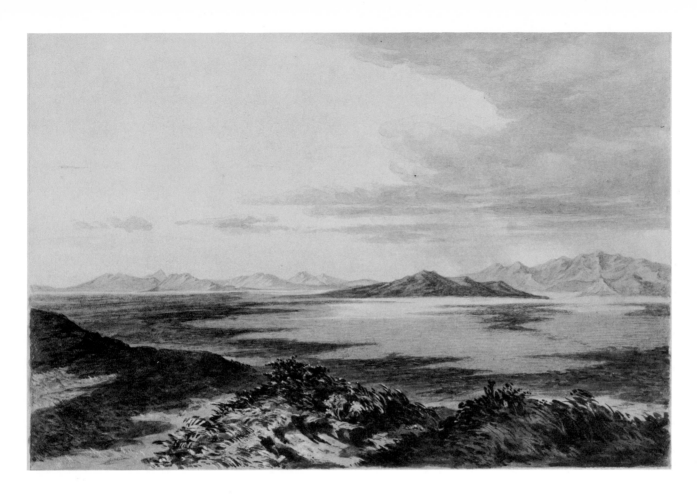

112
Frederick Piercy, 1830-1891
Great Salt Lake (Utah)
1853; pencil and brown wash,
7⅝ x 11¾ in.
Museum of Fine Arts, Boston, M. & M.
Karolik Collection
(Shown in Kansas City and
Milwaukee.)

*Piercy's drawings are objective and
precise. Even though made under the
pressure of travel, they record more
accurately than any other illustration
of the day the landscapes of the Great
Platte Trail and the Salt Lake Valley.*

156
William McIlvaine, 1813-1867
Panning for Gold, California
1849; watercolor with pencil,
18⅝ x 27½ in.
Museum of Fine Arts, Boston, M. & M.
Karolik Collection
(Shown in Boston, Denver, and San
Diego.)

*Seeking the picturesque and the scenic,
many artists traveled to the Mother
Lode of California after the discovery
of gold in 1849. William McIlvaine pub-
lished an illustrated account of his
journey in* Sketches of Scenery and
Notes of Personal Adventure in Cali-
fornia and Mexico. *This carefully com-
posed scene of panning for gold on the
Tuolumne River communicates an
idyllic vision, probably far from the
reality of the gold miner.*

Ref.: Museum of Fine Arts, Boston,
*M. & M. Karolik Collection of American
Water Colors & Drawings, 1800-1875*
(Boston, 1962), vol. 1, pp. 230-231.

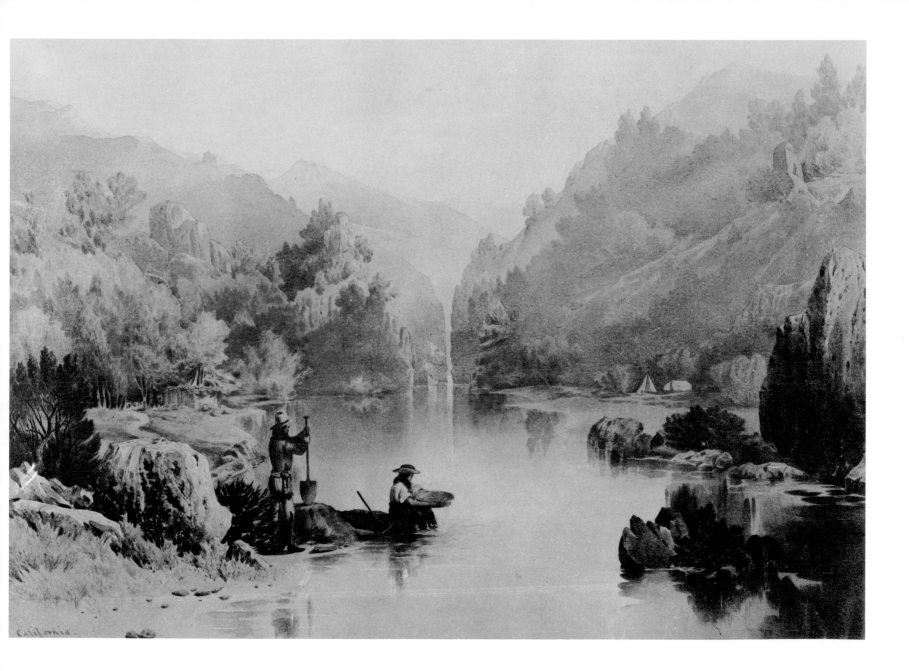

155

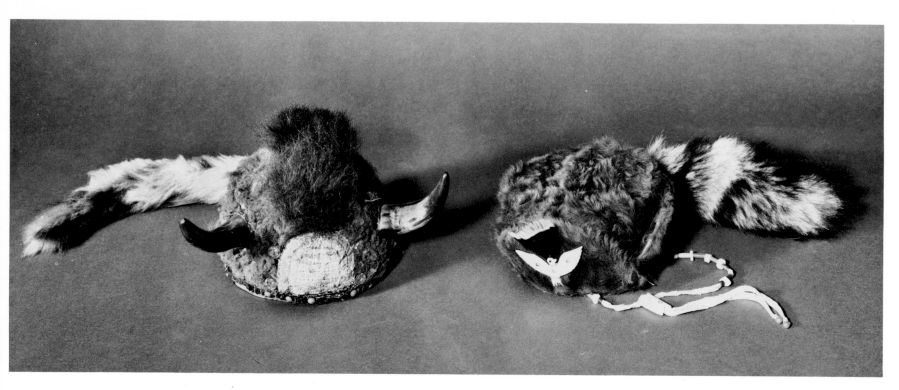

154

Trapper's hat

Ca. 1850-1870; Utah; buffalo skin with horns, l. 22½ in., diam. 7 in.

Church of Jesus Christ of Latter-day Saints, Salt Lake City

155

Trapper's hat

Ca. 1850-1870; Utah; beaver, l. 19¼ in., diam. 8½ in.

Church of Jesus Christ of Latter-day Saints, Salt Lake City

These fur hats, worn by the notorious trappers who hunted beaver in the mountain streams of the West, combine materials found also in the headdresses of the Indian: buffalo skin, horn, trade beads, and feathers. Leaving society far behind, these adventurous men adopted Indian costumes, often married Indian women, and wintered with Indian tribes. The great event of their year was the annual summer rendezvous when trappers gathered to exchange their skins for the powder, lead, rifles, knives, beaver traps, beads, blankets, and whiskey that were the necessities of their rugged life on the frontier.

157

Anonymous artist
Washing Gold, Calaveras River,
California
1853; pencil and gouache, 17 x 23½ in.
Museum of Fine Arts, Boston, M. & M.
Karolik Collection
(Shown in Kansas City and
Milwaukee.)

The Calaveras River in northern cen-
tral California flows from the foothills
of the Sierra Nevada and empties into
the San Joaquin River, Stockton. It is
in the heart of the Mother Lode coun-
try, where the gold fever started.
Towns such as Jenny Lind on the lower
Calaveras serve today as reminders of
an earlier frantic mining era. Nearby
Angel's Camp was probably the in-
spiration for Bret Harte's story The
Luck of Roaring Camp. *More famous*
today is the annual celebration at the
Calaveras County Fair of Mark Twain's
famous frog jumping contest.

Shown in this drawing are sluice
boxes through which water flowed,
forcing the earth over riffles to
separate the gold-bearing pay dirt.

Ref.: Museum of Fine Arts, Boston,
M. & M. Karolik Collection of American
Water Colors & Drawings, 1800-1875
(Boston, 1962), vol. 2, p. 16.

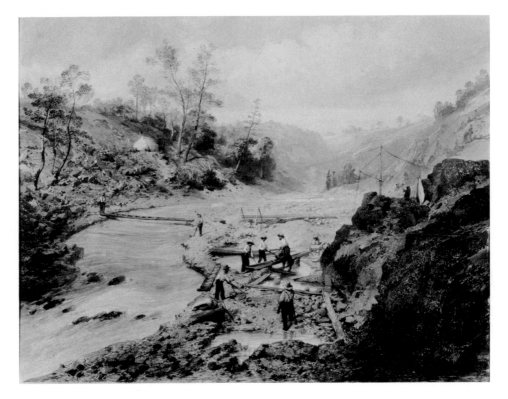

159

Gold scales
Ca. 1860; Buckskin Joe, Colorado; oak,
pine, brass, iron; box: h. 1⅛ in.,
w. 6⅝ in., d. 3¼ in.
Pioneers' Museum, Colorado Springs

Used by Reverend William Howbert
during the placer gold rush at Buck-
skin Joe, Colorado, in 1860, the scales
are well worn. Howbert was a Meth-
odist minister who came to Denver in
June 1860 from Columbus, Indiana.
He was a minister to the mining camps
of the Pikes Peak region and did some
panning on the side, although he never
struck it rich. The town of Buckskin
Joe was a famous placer mining camp
near Fairplay, Colorado. It was named
after a prospector, Joseph Higgan-
bottom, nicknamed Buckskin Joe be-
cause of his deerskin clothes. By the
1870's the town had disappeared.

161

Harry Learned, active 1880-1890
Iron Mask Mine, Gilman, Colorado
1886; oil on canvas, 24 x 36 in.
The Denver Art Museum

During the second half of the nineteenth century mining operations grew into larger, more complicated industrial endeavors. Mines employed many men, and towns flourished while the ore lasted. Iron Mask Mine was perched on the side of Battle Mountain, so called because of an Indian battle that had been fought there.

Ref.: Denver Art Museum, *American Art from the Denver Art Museum Collection* (Denver, 1969), 54.

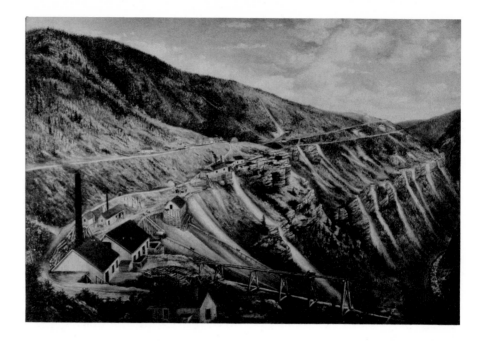

162

Anonymous artist
Montgomery Street, San Francisco
July 1851; watercolor and gouache,
18⅜ x 23 in.
Museum of Fine Arts, Boston, M. & M. Karolik Collection
(Shown in Boston, Denver, and San Diego.)

Settled in 1776, San Francisco boomed after the discovery of gold in 1848. In the last nine months of 1849 five hundred and forty-nine vessels dropped anchor in its harbor. This view of Montgomery Street, in the old mercantile quarter, was painted by an unknown visiting foreign artist two months after the fire of May 4, 1851, one of six great fires that devastated the city within four years.

Ref.: Museum of Fine Arts, Boston, *M. & M. Karolik Collection of American Water Colors & Drawings, 1800-1875* (Boston, 1962), vol. 2, p. 16.

164

George Tirrell
View of Sacramento
Ca. 1855-1860; oil on canvas, 27 x 47¾ in.
Museum of Fine Arts, Boston, M. & M.
Karolik Collection

*In tribute to the immensity of the West,
George Tirrell unveiled in 1860 "the
longest panorama ever painted"; it
covered 25,300 square feet of canvas in
four sections. With lifelike accuracy it
illustrated California from Monterey
and San Francisco to Yosemite.
Although this monumental work is now
lost, it is possible to gain some notion of
the effect of the panorama from the
luminous record Tirrell made of Sacra-
mento harbor as it appeared between
1855 and 1860.*

*Sacramento is seen from the town of
Washington (now Broderick). On the
extreme left are the city hall and
waterworks. Dominating the composi-
tion is the famous sidewheel steamship
Antelope. Built in New York in 1847,
she had run between New York and
New Brunswick, New Jersey, and then
between San Francisco and Panama.
In 1852 she was fitted as a riverboat
operating on the Sacramento River.*

Refs.: *Hutchings' California Magazine*,
February 1860; *Alta California*, April
26, 1860, p. 2; Museum of Fine Arts,
Boston, *American Paintings in the
Museum of Fine Arts, Boston* (Boston,
1969), vol. 1, p. 269.

165

W. H. Creasy
Stockton, October, 1849
1849; watercolor, 17½ x 20¾ in.
Pioneer Museum and Haggin Galleries,
Stockton, October, 1849

At the head of tidewaters on the San Joaquin River, Stockton was a wide open gold rush town, the jumping-off place for mining centers in the Mother Lode country. Bayard Taylor, the noted nineteenth century author and traveler, described it in 1849, in its great boom period: "a canvas town of a thousand inhabitants, and a port with twenty-five vessels at anchor! The mingled noises of labor around—the clink of hammers and the grating of saws—the shouts of mule drivers—the jingling of spurs—the jar and jostle of wares in the tents—almost cheated me into the belief that it was some old commercial mart—Four months had sufficed to make the place what it was." Creasy's view of the Stockton waterfront, painted in the same year, also captures the vigor of the city, with its tents, buildings under construction, boats converted into buildings with tent roofs, ships with sails down, and ox-drawn wagons.

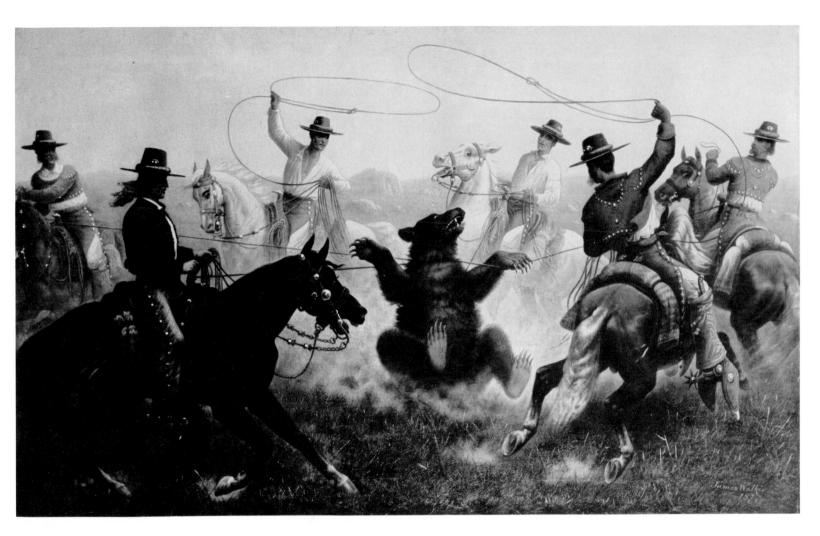

167
James Walker, 1818-1889
Cowboys Roping a Bear
1877; oil on canvas, 30 x 50 in.
The Denver Art Museum

James Walker, who had traveled in the Far West and Mexico in 1846 at the time of the Mexican War, depicted the Spanish cowboy as he had found him in California. The Spanish-California ranchers, who were great horsemen, loved the adventure of a wild bear hunt. The cowboys shown here wear the flat-brimmed hat and leather chaparreros typical of the Mexican vaquero.

Ref.: Denver Art Museum, *American Art from the Denver Art Museum Collection* (Denver, 1969), 40.

168
Sallie Cover
Homestead of Ellsworth L. Ball
Ca. 1880-1890; oil on canvas, 19½ x 23 in.
Nebraska State Historical Society, Lincoln

Sallie Cover settled in Garfield County, Nebraska, in the 1880's after the open range became available to home-steaders. Her painting of the sod house and farm of her neighbor, Ellsworth Ball, captures the strength and simplicity of the prairie dwelling.

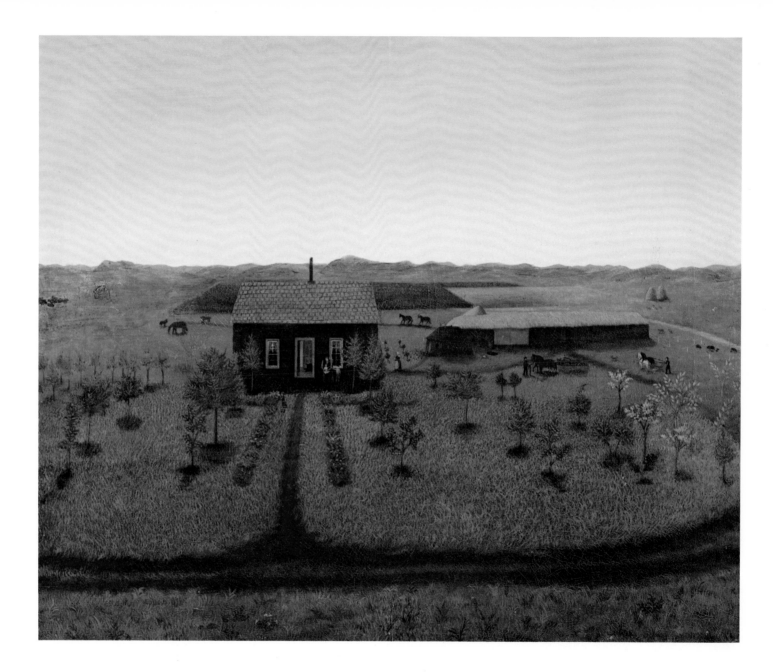

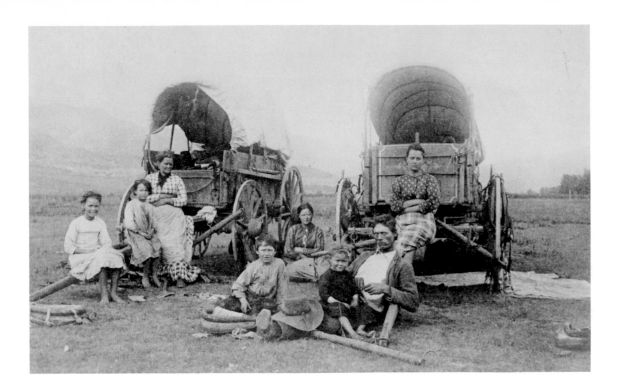

322
Anonymous photographer
Pioneer family in front of covered wagons, ca. 1870
Photograph, copy print from original print
Denver Public Library, Western History Department

This beautifully composed family portrait captures travelers on the journey west. It is a visual reminder that children made up a large part of the pioneering population. Many of them died en route. Few settlers fully realized how distant was the free land they sought. Seldom did they have the capital necessary to establish the flourishing farms they expected. But surprisingly few turned back.

319
Solomon Butcher, 1856-1927
John Curry sod house near West Union, Custer County, Nebraska, ca. 1886
Photograph, copy print from original glass plate negative
Solomon D. Butcher Collection, Nebraska State Historical Society

Butcher was a homesteader in Custer County, Nebraska, and an itinerant photographer. He photographed mainly the sod houses of Custer County and the families who lived in them. His work is a superb visual record of homestead life in the last quarter of the nineteenth century.
The Curry family, who posed for Butcher here, brought out all their most prized possessions to be included in the photograph. They owned a characteristic assortment of factory-made objects brought from the East: chairs, birdcage, tin pail, and sewing machine.

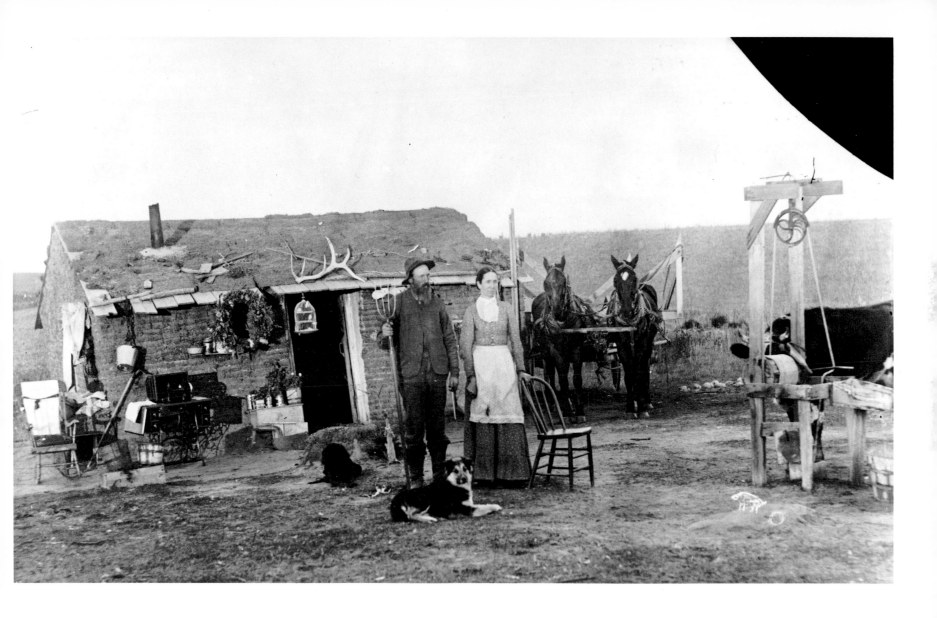

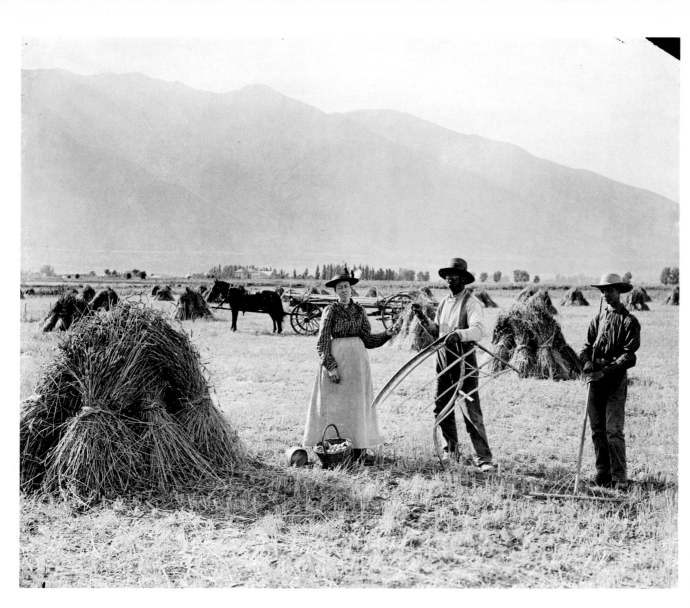

313

George Edward Anderson, 1860-1928
*Ether Blanchard Farm, Mapleton,
Utah, ca. 1900.*
Photograph, copy print from original
glass plate negative
Heritage Prints, Rell G. Francis,
Springville, Utah

*The straightforward image of life in
the West caught by frontier photog-
raphers in the nineteenth century set
a precedent for the photography of
social realism in the 1920's and 1930's.
George Edward Anderson, who had
been an apprentice to C. R. Savage, the
Salt Lake City photographer, traveled
extensively with his camera, glass
plate negatives, and portable dark-
room. He recorded scenes of rural life,
newsworthy events, and sites of early
Mormon history.*

 *Ether Blanchard, who is seen in this
photograph holding a scythe and
cradle, was both farmer and poet.
Beside him stand his wife and their
son, Achilles, a sensitive, solitary
young man who later in life became a
composer of songs, fixer of bicycles,
and antiques collector. The thirteen-
acre Blanchard farm was irrigated by
fresh mountain water from nearby
Hobble Creek Canyon. In the distance
is the Sierra Bonita, so named by the
eighteenth century Catholic priest,
Padre Escalante, who explored this
area in 1776.*

Ref.: Nelson Wadsworth, "A Village
Photographer's Dream," *Ensign*, Sep-
tember 1973, vol. 3, no. 9, pp. 40-55.

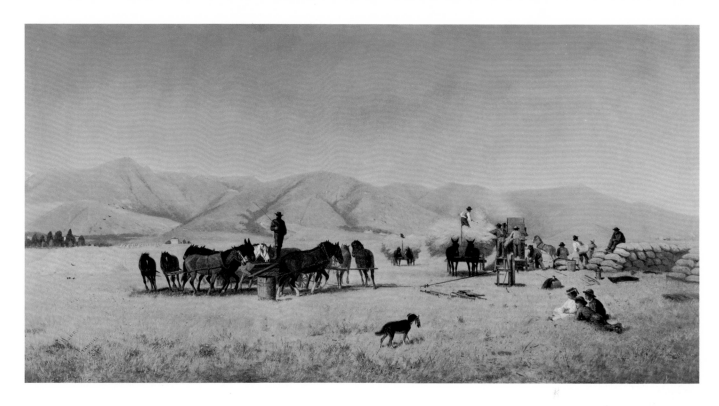

172
William Hahn, 1827-1887
Harvest Time
1875; oil on canvas, 36 x 70 in.
Fine Arts Museums of San Francisco

*This painting illustrates the threshing
of an apparently abundant California
grain field.*

*William Hahn was born in Dresden
and studied art in Düsseldorf, Paris,
Naples, and New York City. He
exhibited at the National Academy of
Design and had a studio in San Fran-
cisco in the third quarter of the nine-
teenth century.*

173
Adjustable rake
Late 19th century; Nebraska; ash and
iron, h. 74½ in., w. 18¼ in.
Stuhr Museum of the Prairie Pioneer,
Grand Island, Nebraska

169
Hayfork
Late 19th century; Nebraska; ash and
iron, h. 73½ in., w. 15 in.
Stuhr Museum of the Prairie Pioneer,
Grand Island, Nebraska

170
Pitchfork
Late 19th century; Nebraska; cotton-
wood, h. 58½ in., w. 8¾ in.
Stuhr Museum of the Prairie Pioneer,
Grand Island, Nebraska

*Large groups of covered wagons swept
into Nebraska in the 1880's, bringing
settlers who came to farm in the arid
High Plains area. Used for lifting
and raking hay, these tools from
Nebraska possess a linear elegance.
The three-pronged cottonwood pitch-
fork is whittled by hand; the iron-
tipped hayfork and adjustable rake are
of commercial manufacture.*

Ref.: Eric Sloane, *A Museum of Early
American Tools* (New York: Wilfred
Funk, 1964), 102.

171
Scythe and cradle
Late 19th century; Utah; h. 27½ in.,
w. 47½ in., d. 30 in.
Utah Pioneer Village, Salt Lake City

6
The Spanish Southwest

By the time the American Southwest became a part of the United States, in the 1840's, it was indelibly marked by three hundred years of Spanish influence. In the arts, the Mediterranean tradition had gained emotional strength during passage through Mexico and had been transformed in the lands beyond the northern frontier by non-European craftsmen and local materials. Infrequent contact with mainstreams of culture led to the development of strong regional styles in each of the huge territories that were to become the states of Arizona, California, New Mexico, and Texas.

In 1598, the Spaniards began the colonization of New Mexico, bringing their language, laws, customs, arts, crafts, and Christian religion to highly divergent Indian groups. European agricultural methods were not much more efficient than those of the Pueblo residents, but the arrival of new grains, fruits, and domestic livestock altered the economy. Spaniards introduced the techniques of ranching to the Southwest.

The plastic quality of adobe brought simplicity and ponderous grace to southwestern architecture.[1] Many variations of Old and New World methods of working with earth, wood, and stone proved practical in the extreme range of climates in the West.

In the Rio Grande Valley, Spanish colonists constructed fortified villages around a plaza, blending ancient Pueblo techniques with those of Europe and North Africa. Thick-walled, heavy-roofed adobe houses offered a refuge from summer heat and winter chill. Ceilings of stout pine logs were overlaid with a rhythmic pattern of peeled poles, covered with brush and sealed with earth. Floors were of tamped clay. Also of adobe, corner fireplaces served for heating and cooking. Corn and chili peppers were baked in outdoor beehive-shaped earthen ovens. Windows were small and high set and sometimes glazed with slabs of selenite set in wooden grilles. In the more pretentious buildings, doors and shutters were paneled and lightly carved. Adobe brick walls were protected by

1. For a discussion of adobe housing in Utah see Jonathan Fairbanks, "Shelter and Earth Crafts on the Frontier," pp. 197-209 in this catalogue.

mud plaster, and interiors whitewashed with gypsum and in some localities given a dado of orange micaceous clay.

Before the Santa Fe Trail trade with the United States became active after 1820, possessions of New Mexicans were few and generally made locally. Ordinary houses were furnished sparingly. Bedding of sheepskins and buffalo hides was rolled up to form seats. Even among the moderately well-to-do official and hacienda families, a chair or two, a table, and a cabinet *(trastero)* might be the principal pieces of furniture (nos. 184, 185). Hardwood not being available, the structural weakness of pine prompted carpenters with their primitive tools to create heavy renditions of European styles. Chests of pine and rawhide were common. Some arrived by oxcart from Mexico, packed with goods. Most were made locally in sizes from long "six-plank" storage chests to big grain bins (nos. 189, 190), and from small linen chests to tiny "life and death boxes" holding documents and jewelry. Local smiths fabricated iron hasps and hinges. Much simplified from Old World types, furniture was decorated with shallow carving, simple moldings and handhewn spindles, and a limited application of mineral paints. The uniquely New Mexican styles of furniture, which interpreted European fashions a few decades late, had the charm and substantiality of a mature folk art.

Notable buildings were erected during the early missionary period in New Mexico. Under the supervision of Franciscan priests, chapels had been established in dozens of communities between 1598 and 1630. Newly trained Indian laborers with the very minimum of tools and metal—even nails were precious—built a number of monumental mission churches. The basic materials were clay mortar and rough flagstones, as at the pueblos of Abo and Quivira, or adobe bricks and fieldstones, as at Acoma. Huge pine timbers, squared and reinforced with carved corbels, supported an earth-packed roof. The plans were bold and original; the most effective innovation consisted in constructing the

flat roof of the sanctuary slightly higher than that of the nave, so that a wide clerestory illuminated the altar. The great period of mission architecture ended abruptly when the Spaniards fled down the Rio Grande Valley to El Paso during the Pueblo Rebellion of 1680, and many of the sites were not reoccupied after Don Diego de Vargas reconquered the province in 1692. The modest village churches began to develop an intimate decorative quality, which has lasted to the present day.

Conversion of the Indians to Christianity was under way in Texas and Arizona early in the eighteenth century. Along the California coast, twenty-one Franciscan missions were built between 1769 and 1823, the nine earliest under leadership of Fray Junípero Serra. Experienced planners and craftsmen, as well as tools, materials, and works of art, were brought by ship and encouraged considerable ornamentation. Fired brick and tile, metal hardware, plaster, and refined pigments were employed. The California churches were basically of dressed timber and adobe, finished with stucco and roofed with tiles. The more celebrated mission structures, the Alamo and others in Texas, as well as San Xavier del Bac and Tumacacori in Arizona, were at their height in the late eighteenth and early nineteenth centuries. These and the California missions have been much restored in the present century, having suffered long periods of neglect.

Although open-pit copper mining took place in New Mexico, iron, tin, and copper were imported to the Southwest, often as finished objects. Very little gold and silver was discovered until after the Mexican War, but turquoise had been mined for centuries before the Spaniards came.[2] A few ironworkers created tools and household implements in characteristic local patterns. After American occupation in 1846 brought tin-coated objects and East Coast techniques, a considerable folk art in cut and punched ornamental tin emerged in New Mexico (nos. 196, 198, 199).

Sheep and the techniques of wool came to the Southwest with the

2. Eighteenth and nineteenth century silver holloware, found in the Rio Grande Valley, is in the Field Collection, University of New Mexico. Some of it is believed to have been made in New Mexico and northern Mexico. See Leona Davis Boylan, "The History of Spanish Colonial Silver in New Mexico," and "The Mary Lester Field Spanish Colonial Silver Collection in the Permanent Collection of the University Art Museum," University Art Museum, University of New Mexico, *Bulletin,* no. 4, spring 1970, pp. 18-33.

Spaniards, who made ingenious local adaptations of the European horizontal loom and wove homespun yardage and blankets, some in quite complex patterns. The most ornate textile was the New Mexican embroidery called *colcha* (bedspread), in which natural and dyed yarns were stitched to plain woven woolen ground fabric to make bed covers, wall hangings, and altar frontals (nos. 210, 211). One of the few media in which local subject matter appears, these embroideries include floral, animal, and religious motifs. Durable woolen homespun woven in long, narrow strips, called *jerga,* was used for carpeting.

In the Spanish Southwest, paintings and sculpture were almost exclusively religious in theme. Especially in New Mexico, every devout household had sacred images (*santos*). The artists (*santeros*) who made these images evolved a lively regional style during the eighteenth and nineteenth centuries. Handhewn boards coated with gesso were prepared for paintings *(retablos)* (no. 217), Christian personages and events being portrayed in homemade mineral pigments. Statues *(bultos)* (nos. 213-215) were roughed in cottonwood, the extremities glued as separate parts. The form was coated with gesso, details were carved, and the whole was painted, including the costume. Identifying attributes of wood or metal were affixed—a crown for the Virgin, a sword for St. Michael—and sometimes real clothing was added. *Bultos* were commonly about fifteen inches tall, but some, especially figures of Christ, were carved lifesize. A histrionic realism characterized New Mexican *santos,* the emotions—asceticism, tenderness, and compassion —being rendered convincingly.

Although materials and techniques concerned with food, clothing, and shelter seem to have been exchanged readily between Hispanic settlers and the Indian groups among whom they lived, designs and symbols were rarely exchanged. For each, the elements of art were sensitively associated with their respective religions.

Especially in architecture, long established regional themes are very much in use today. In original, restored, and new architecture, styles and furnishings derived from earlier Hispanic models are perpetuated in public buildings and private homes in many parts of the Southwest. Spanish continues to be the mother tongue of tens of thousands of Americans, and public interest in their heritage has surged upward in recent decades.

ROLAND F. DICKEY

180

Sword

Ca. 1750-1800; California, made in Spain; steel, l. 37 in.
de Saisset Art Gallery and Museum, Santa Clara, California

Regulation designs for cavalry swords were first promulgated in Spain in 1728 and continued into the nineteenth century. This sword belonged to Don Luis Peralta, 1754-1851, who was the original grantee of the Rancho San Antonio in 1820, which included the sites of the modern cities of Oakland and Alameda. Don Luis Peralta was the first governor of the Santa Clara Valley. An inscription engraved on both sides of the blade reads "NO · ME SACIVES · SIN RAZON/NO · ME · EVAINES SIN HONOR" ("Do not draw me without reason/Do not sheathe me without honor").

Ref.: Sidney B. Brinckerhoff and Pierce A. Chamberlain, *Spanish Military Weapons in Colonial America, 1700-1821* (Harrisburg, Pa.: Stackpole Company, 1972).

179

Henri Penelon, 1827-1885 (?)
Francisco Sepúlveda
After 1854; oil on canvas, 25 x 20 in.
Natural History Museum of Los
Angeles County, Los Angeles

*Francisco Sepúlveda, born 1790, is
seated for his portrait in traditional
Hispanic headdress with sword in
hand. He settled in the Los Angeles
region about 1815 and became a
wealthy and influential "ranchero," an
owner of fine horses and cattle. Span-
ish agricultural settlement in Califor-
nia consisted of vast tracts of land
farmed and used in ways very different
from those in other parts of the Span-
ish Southwest. Large herds of cattle
and horses fed on rich grasslands in a
temperate climate, contributing to the
great wealth of many Spanish settlers
and their descendants.*

181

Branding iron
1800-1860; Los Angeles County, Califor-
nia; wrought iron, l. 29 in.
Southwest Museum, Los Angeles

*Probably forged by the ranch black-
smith, this branding iron, which was
used at the Rancho Santa Anita in Los
Angeles County, left a heart-shaped
mark on all cattle and horses belong-
ing to the ranch.*

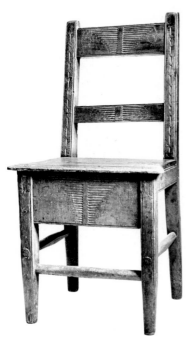

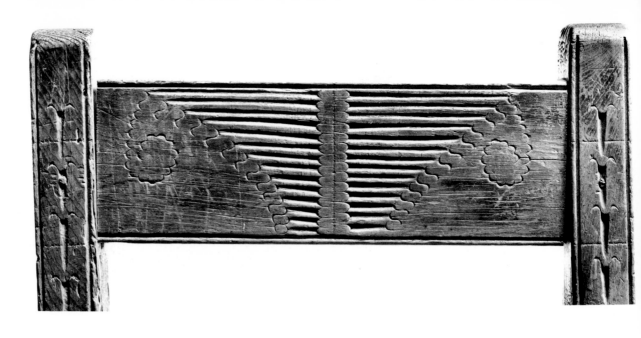

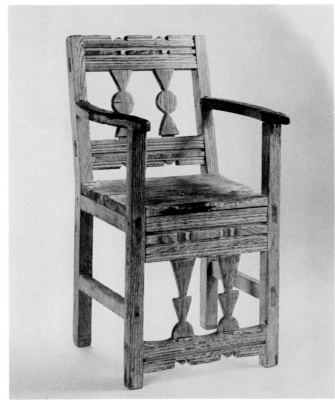

184

Side chair

Ca. 1830-1850; New Mexico; pine, h.
39 in., w. 19½ in., d. 15¾ in.
Collection of Dr. and Mrs. Ward Alan
Minge

*The simple architectonic form of this
chair is indicative of local folk crafts-
manship in a region where, for genera-
tions, few outside stylistic influences
filtered through the isolation of fron-
tier life. The form, construction, and
shallow chip carving of the chair de-
rive from Spanish influence on Mex-
ican and New Mexican craftsmanship.
New Mexican furniture is character-
ized by its construction techniques.
Chairs such as this were held together
by large mortise and tenon joints, or
the doweling of one part into another.
Iron nails were not used because they
were scarce, and fastening the thick,
soft pine boards together with nails in
the changeable New Mexican climate
tended to split the wood.*

185

Armchair

Late 18th-early 19th century; New
Mexico; pine, h. 38¾ in., w. 17¾ in.,
d. 19¾ in.
Nelson Gallery-Atkins Museum
(Nelson Fund) Kansas City, Missouri

*The paneled and carved decoration of
this armchair shows traditional Span-
ish influence. This type of chair, similar
in construction and form to seven-
teenth century New England wainscot
chairs, was a symbol of wealth and
status on the New Mexican frontier of
the early nineteenth century, much as
it had been on the seventeenth century
New England frontier. A moderately
wealthy household had only one arm-
chair, and side chairs were also un-
common. Rough benches, chests, stools,
or the floor usually served as seating.
In New Mexico the principal seat was a
roll of blankets pushed against the
wall. At night the blankets were un-
rolled for sleeping, as beds were even
rarer than chairs.*

186

Camape, or daybed
Ca. 1830-1850; New Mexico; pine,
painted blue, h. 27 in., l. 69 in.,
w. 22½ in.
Collection of Dr. and Mrs. Ward Alan
Minge

*A New Mexican craftsman's interpre-
tation of the eastern American Empire
style is evident in this daybed, with its
scroll arms and spool-turned spindles.
It was undoubtedly made for a wealthy
family determined to have the most
fashionable style in furniture locally
made.*

189

Storage chest
18th century; New Mexico; pine, h.
17½ in., w. 52½ in., d. 16¼ in.
Collection of Dr. and Mrs. Ward Alan
Minge

*The large dovetailed corners and heavy
rough-hewn pine boards of this chest
create a solid appearance, which is en-
hanced by carved rosettes and scal-
loped, incised detailing around the
edges. Found near Santa Cruz, New
Mexico, it characterizes the work of a
local carpenter, who perhaps made it to
sell at a saint's day celebration. Saint's
day festivals and fairs were promul-
gated by local authorities to stimulate
the economy as well as provide enter-
tainment and gatherings for isolated
farmers and tradesmen.*

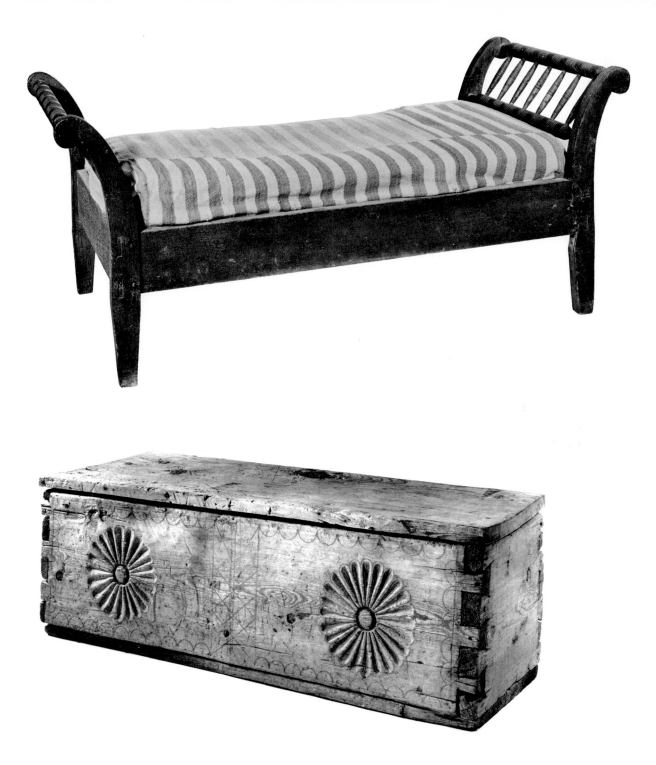

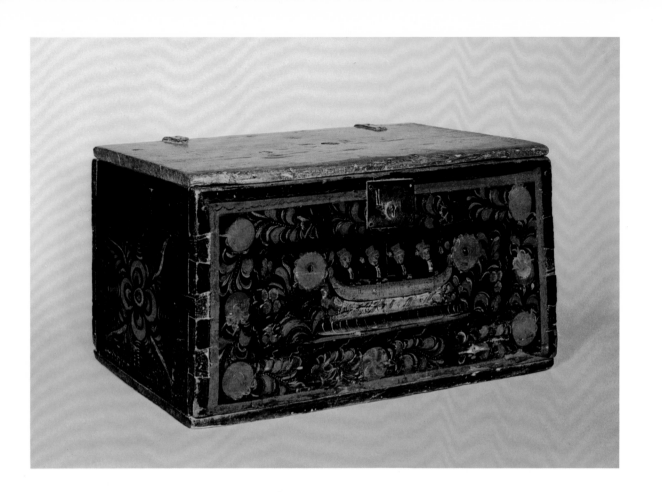

188

Chest

Ca. 1800-1830; vicinity of Santa Fe, New Mexico; painted pine, h. 12 in., w. 23¼ in., d. 11½ in.

Collection of Dr. and Mrs. Ward Alan Minge

This small painted chest is one of several examples found in the Santa Fe area. It may have been painted by an itinerant Mexican artist who settled there ca. 1800-1830. Used as dower chests, these boxes were decorated with lively genre scenes and floral motifs in white and polychrome on a traditional dark earth ground. The decoration of such chests offered the local artist one of his few chances to depict nonreligious motifs. The significance of the four men in the boat pictured here is undetermined.

190

Storage chest

18th-early 19th century; New Mexico; pine, h. 18¼ in., w. 37 in., d. 18 in.

Colorado Springs Fine Arts Center

Original iron brackets and locks, such as are on this piece, seldom survive on New Mexican furniture. Iron fastenings were often removed and reused for other purposes. The handsome lock plate is delicately shaped and punched with a pattern relating to the incised scalloping on the border of the chest.

144

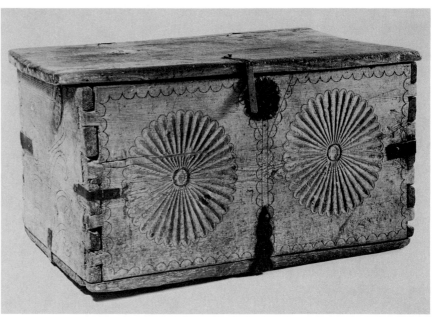

192

Table with single drawer
Late 18th-early 19th century; New Mexico; pine, h. 28½ in., w. 28 in., d. 19⅝ in.
Collection of Dr. and Mrs. Ward Alan Minge

Tables with deep drawers, such as this one, were first used in small churches and private chapels for storing vestments and other religious objects. Later, in the nineteenth century, they became a part of household furniture. This table, made by a local craftsman, probably as a commission for his church, comes from the region of Tecolotita, New Mexico. The heavy, simple frame construction of the table reflects the New Mexican craftsman's limitations in terms of tools and materials. His working tools were primitive and unrefined, and the only wood available was pine. A leather thong is used here as a drawer pull.

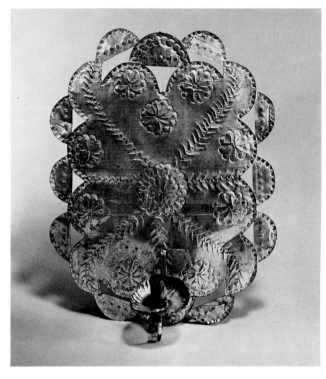

193

Cross

Ca. 1800-1850; New Mexico; pine, corn-husks, h. 19¼ in., w. 10¾ in.
Collection of Dr. and Mrs. Ward Alan Minge

Religious objects were an integral part of the Hispanic Roman Catholic culture in the Southwest: crosses, cruci-fixes, paintings and statues of special saints adorned the walls of houses, chapels, churches, and public buildings and were almost all of local Spanish manufacture. Straw or cornhusk and sticky pine pitch or tar mosaic was an effective native substitute for the more complicated wood inlay that was pro-duced in Mexico and the Philippines. Contrasts of light and dark in the na-tive materials made a jewel-like design of the floral and geometric pattern.

195

Cross

Ca. 1760; Trampas, New Mexico; wrought iron, h. 24⅛ in., w. 8 in.
Collection of Dr. and Mrs. Ward Alan Minge

Originally from the Santo Tomas church, begun about 1760 in Trampas, New Mexico, this cross may have sur-mounted the tower or gateway. Con-structed so that the arms of the cross moved with the wind, it is a traditional Spanish form dating back to the six-teenth century. Few ornamental ob-jects in New Mexico were made of iron, because it had to be imported from old Mexico. This piece is a rare survival from the eighteenth century.

196

Sconce

Ca. 1870; Cabezon, New Mexico; tinned sheet iron, h. 19½ in., w. 16 in.
Collection of Dr. and Mrs. Ward Alan Minge

One of a set of six identical sconces made for the church in Cabezon, this sconce is representative of a wide-spread craft of ornamental tinwork of the second half of the nineteenth cen-tury. Southwestern artisans eagerly utilized the shiny metal of leftover cans and packing cases of tinned sheet iron brought across the Santa Fe Trail. A rarity in New Mexico, this material was reworked into reflective sconces, mir-rors, frames, and other objects with highly decorative Spanish motifs. This sconce bears no commercial markings on the tin and may have been stamped with the dies and tools used in leather-making, as was often the case in tinwork.

198

St. John of Nepomuk

Painting: ca. 1820-1835; Mexico; oil on canvas.
Frame: ca. 1830-1850; New Mexico; tinned sheet iron, h. 28 in., w. 21¾ in.
Collection of Dr. and Mrs. Ward Alan Minge

The painting of St. John of Nepomuk is typical of religious art traded into New Mexico from Mexico. Religious painting of this type done in Mexico was relatively rare in New Mexico because of poor communication between the two areas, but it was models such as this picture that inspired the local artists who worked with native materials. Reminiscent of Empire looking glass frames of the eastern United States, with pseudo rope turnings and corner rosettes, the frame is part of a design tradition derived from the East via the Santa Fe Trail.

Ref.: E. Boyd, "Decorated Tinware East and West in New Mexico," *Antiques* 66 (1954), 203-205.

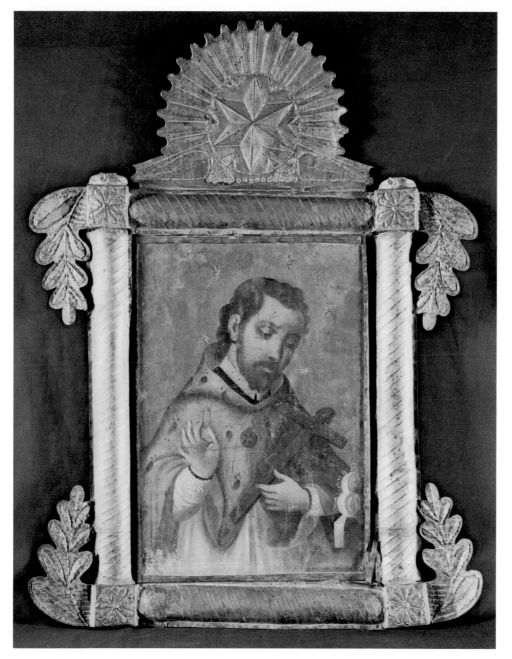

199

Chocolate pot, with stirring stick
Ca. 1830-1850; New Mexico; pot: copper, wrought iron, h. 6⅛ in., diam. (top) 3¾ in.; stick: ash, l. 17½ in.
Collection of Dr. and Mrs. Ward Alan Minge

Of hammered copper with wrought iron handle, this chocolate pot is characteristic of southwestern household items in metal. Brass, copper, and iron, as well as tin, were used by New Mexican artisans, but all had to be imported from Mexico, as New Mexico had no facilities for smelting ore.

209

Vallero blanket
Early 19th century; New Mexico; wool, l. 91 in., w. 49¼ in.
Collection of Dr. and Mrs. Ward Alan Minge

Of hand-spun natural color wool, vallero blankets were woven on simple frame looms in villagers' homes throughout New Mexico. Used as clothing or bedding, they had exceptionally bold designs, such as the brown geometric flowers on this fine example from the region of Trampas, New Mexico.

(overleaf, page 150)
213
*Niche with Our Lady of Sorrows
(Nuestra Señora de los Dolores)*
Early 19th century; New Mexico;
painted pine, h. 28 in., w. 12 in.,
d. 12½ in.
Collection of Dr. and Mrs. Ward Alan
Minge

*Symbolizing the anguish and sorrows
in the life of Mary, Our Lady of Sor-
rows, was a poignant, mournful figure
often represented by local* santeros
*("saint makers") in the early nine-
teenth century. An exceptionally
important example of New Mexican
religious sculpture, in her own carved
niche, this statue was hung in a chapel
or home as an object of devotion. The
art of the santeros flourished in the Rio
Grande and San Luis valleys of New
Mexico during the late eighteenth cen-
tury and continued into the nineteenth
century, particularly after New Mexico
slipped into isolation following Mexcio's
liberation from Spain. The Mexican
government, burdened with political
problems of its own, had little time for
this frontier outpost and stopped send-
ing the supplies, including religious
images, that the Spanish crown had
formerly provided on a limited scale.
The primitive local artist's vision and
experience combined with the cen-
turies-long traditions connected with
Roman Catholic art produced strong,
colorful devotional images in both
sculpture* (bultos) *and paintings*
(retablos).

(overleaf, page 150)
217
Attributed to Rafael Aragon, active
1836-1850
*Saint Isidore of Madrid (San Ysidro
Labrador)*
Ca. 1840; New Mexico; pine, paint on
gesso, 19 x 12 in.
Collection of Dr. and Mrs. Ward Alan
Minge

*Before the late eighteenth century, all
paintings had been imported into New
Mexico from Mexico or were the work
of priests or others who had come to
New Mexico late in life. The image
painted on this panel is Saint Isidore,
patron saint of farmers. He is shown
with his attributes—a broad-brimmed
hat, an ox-drawn plow in a wheat field,
and formalistic devices of curtain and
cross. New Mexican farmers sought his
aid as they struggled to produce crops
in their arid lands.*

(overleaf, page 151)
215
San Miguel, Archangel
19th century; New Mexico; pine, paint
on gesso, with tin scales and sword,
h. 20 in., w. 10½ in., d. 5½ in.
Marion Koogler McNay Art Institute,
San Antonio, Texas

*San Miguel, Archangel, is depicted with
all the attributes of his sainthood: mil-
itary dress, sword, the scales of justice,
and dragon under foot. As an angel of
judgment, he weighs souls to determine
who will enter heaven, and as "the
Prince Patron of the Church Militant
and Captain General of the Celestial
hosts," he fights the forces of sin and
evil.*

Refs.: Odd Halseth, "St. Michael, Arch-
angel," *El Palacio* 25 (1928), 295;
Mitchell A. Wilder and Edgar Breiten-
bach, *Santos: Religious Folk Art of
New Mexico* (Colorado Springs: Taylor
Museum of the Colorado Springs Fine
Arts Center, 1943).

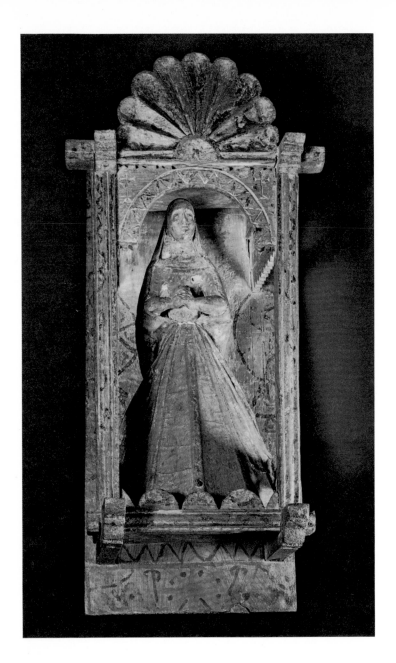

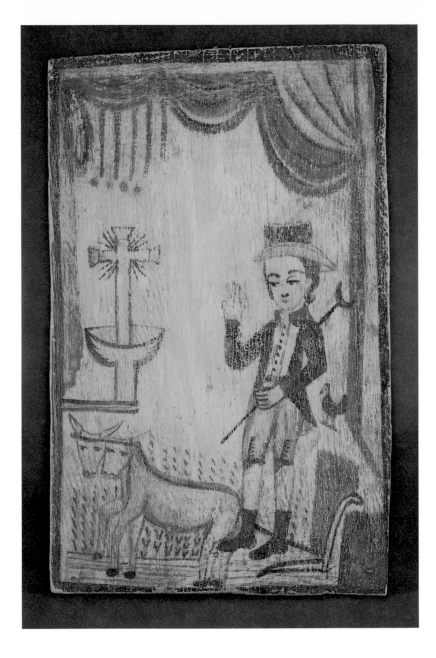

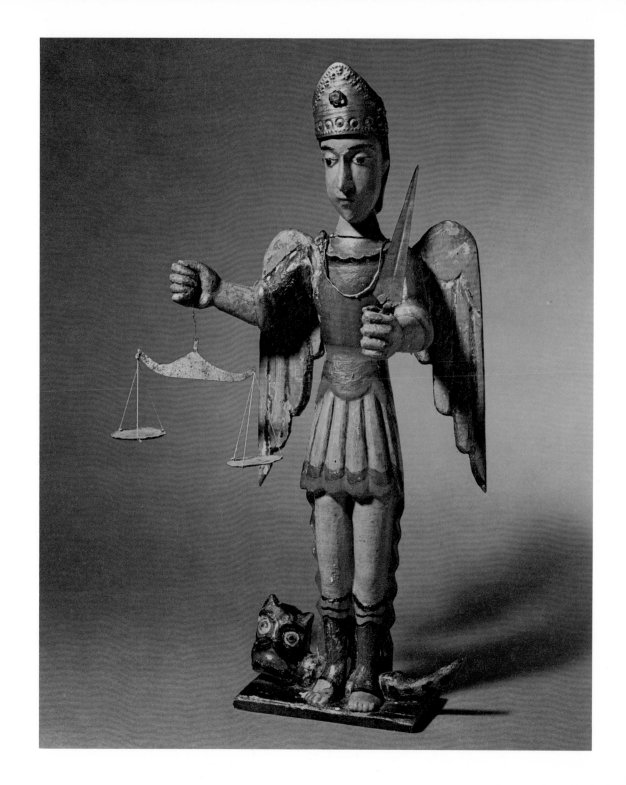

212

San Gabriel
18th century; New Mexico; painted
animal hide, 28 x 20½ in.
Marion Koogler McNay Art Institute,
San Antonio, Texas

*Paintings on buffalo, deer, and elk
hides were among the first New Mex-
ican pictures that utilized local ma-
terials and crafts. Many show a strong
European or Mexican influence deriv-
ing from pictures made by missionary
priests to illustrate their teaching of
the Gospel. Rarely in the form of a
santo, San Gabriel is usually depicted
in European paintings of the
Annunciation.*

Refs.: E. Boyd, *Saints and Saint
Makers of New Mexico* (Santa Fe: Lab-
oratory of Anthropology, 1946); Odd
Halseth, "St. Raphael, St. Michael, St.
Gabriel," *El Palacio* 26 (1929), 74.

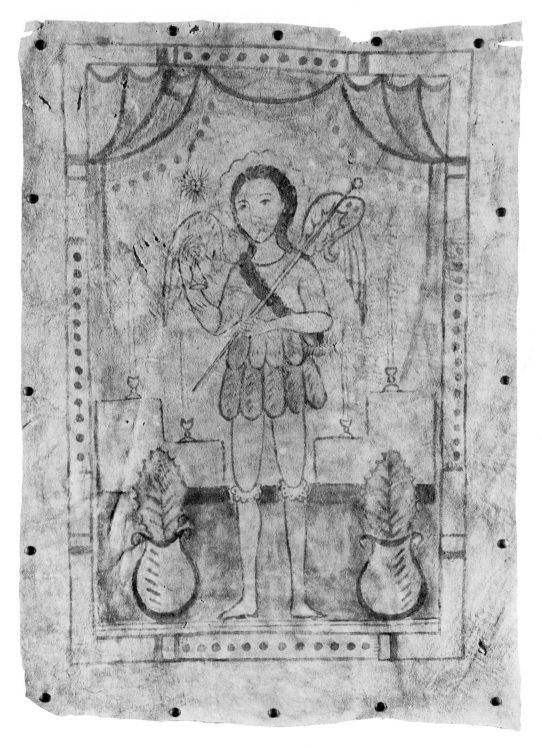

214

Our Lady of the Rosary (Nuestra Señora del Rosario)

Ca. 1800-1850; New Mexico; pine with tin and leather, h. 31 in.
Nelson Gallery-Atkins Museum (Nelson Fund), Kansas City, Missouri

The crowned Virgin probably originally held her attributes of a rosary and the holy child in her hands. The flaring, triangular skirt was a typical form for female religious sculpture. Often statues had several sets of clothing of leather or cloth, which were changed with the seasons, occasions of the year, or the whims of the owner.

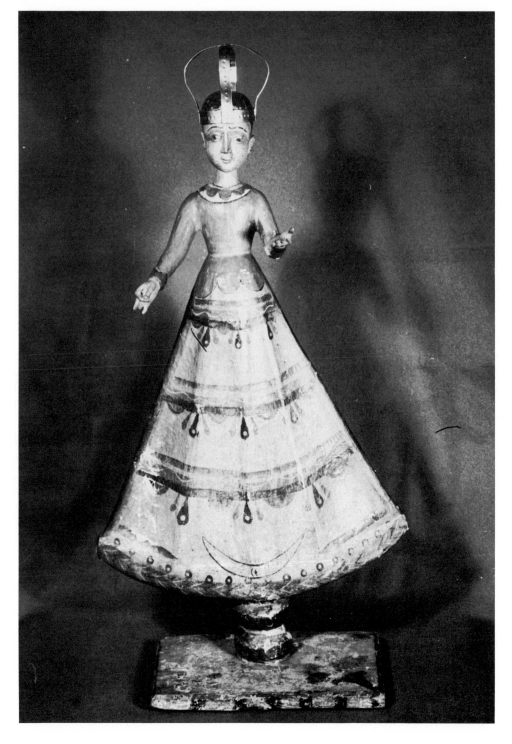

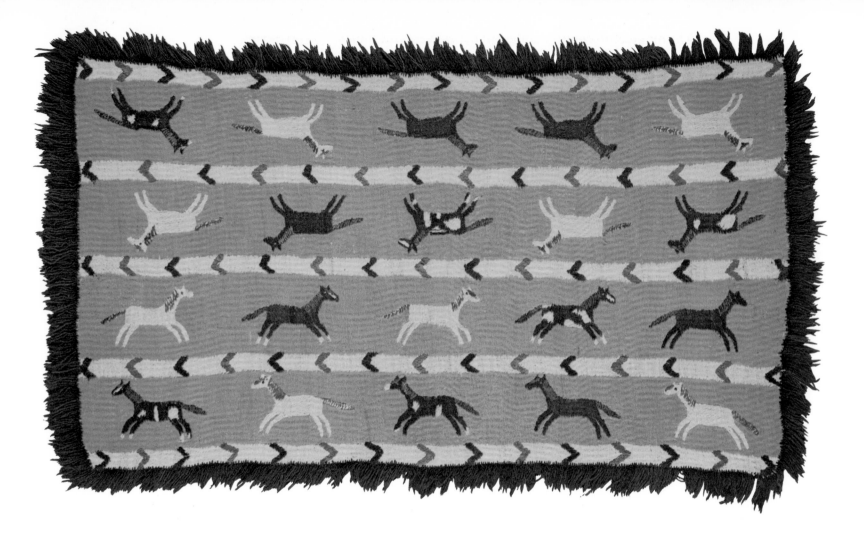

211
Colcha
Early 19th century; northern New
Mexico; wool, l. 71½ in., w. 41½ in.
Collection of Dr. and Mrs. Ward Alan
Minge

The complete covering of homespun
sabanilla *fabric by a long stitch in*
handspun wool gives the New Mexican
colcha a soft, springy texture and a
heavy weight. The long running stitch,
couched with smaller stitches at inter-
vals, made small design details un-
manageable. Soft natural and dyed
wools and bold designs based on local
flora and fauna made these colchas
colorful and practical additions to any
room.

Ref.: Hester Jones, "New Mexico Em-
broidered Bedspreads," *El Palacio* 37
(1934), 97-104.

7
Furniture
on the Frontier

1. In Oregon temporary residence and goods on credit were provided for the settlers by the Hudson's Bay Company's chief factor at Fort Vancouver.

The nineteenth century emigrant to the West saw himself as responsible for establishing the facts of his own material existence in a new land. For the most part he felt independent culturally and economically of those already living in the western territories (the Indians and the Spanish Colonials in the Southwest, for example) and responsible for providing his own shelter and goods.[1]

The first housing and furnishings in the new settlement were often crude and of a temporary nature, made by the pioneer who was, in many cases, untrained in the crafts and working with limited skill. At a later stage, when specialized craftsmen had become available, and when the desire for permanence and the fashionable could be realized, construction and design attained a higher level.

Most of the pioneers were able to bring some of their possessions with them to their new homes, the amount and type of material varying according to the route and method of transportation. Missionaries bound for Oregon in 1835, where they hoped to Christianize the Indians, could make the journey by boat from Boston. Often going by way of the Sandwich Islands, they could bring a large quantity of household furniture, boxes of cloth, agricultural, mechanical, and surgical instruments.[2]

2. Elisabeth Brigham Walton, " 'Mill Place' on the Willamette. A New Mission House for the Methodists in Oregon, 1841-44" (Master's thesis, University of Delaware, 1966), 15.
3. Ibid., p. 47.

An organizer of mission families traveling to the Willamette Valley urged settlers to bring their household furniture and to pick up their heavy goods at their point of embarkation.[3] Emigrants to Texas in the 1840's were urged, if it were possible, to "be provided with furniture, implements of industry, seed, clothing, medicine, and books, as well as materials for building, with as much work done as possible, such as morticing, tenanting, dressing boards, &c. All the above named articles are difficult to obtain in the country and carpenters' work is enormously high."[4]

4. Edward Stiff, *The Texan Emigrant* (Cincinnati: George Conclin, 1840), 189.

Those who made the trek to the West overland in a covered wagon could take far fewer possessions (nos. 220, 221). If the journey was short

and the terrain offered few challenges, functional household objects such as a chair, cradle, or table could be brought. If, however, the traveler knew that he might have to divest himself of even his wagon in the last stage of his trip and proceed by horse alone, he was warned to bring only a "few cooking utensils" and bedding consisting of "nothing more than blankets, sheets, coverlets, and pillows."[5]

For the first few months of his existence in the new land the settler's furnishings were utilitarian and often comfortless. A bed typical of the frontier homestead was described by Muir, a traveler in Texas in 1837: "In an open cabin without a floor a fork was driven into the ground, a few feet from one of the corners. Poles were laid from the fork to the openings in the logs, which were covered with clapboards. Upon this platform was strewed some moss, which together with a blanket made up the whole bed."[6]

During the first generation of settlement, a variety of methods produced the housing and furnishings necessary for survival. In some instances, the new settler, trained or not, had to build his own house and furnishings with the only tool at hand: the crudest axe. Jason Lee, an early missionary settler in Oregon, described his experiences in making a new home: "We labored under disadvantages, for we were not carpenters. We however went into the woods and cut the timber. We took the green trees and split them, and hewed out boards for our floors. If we wanted a door, a table, or a coffin, we had to do the same."[7] A Nebraska rocking chair fashioned of shaped, unstripped saplings represents this stage of hastily made furniture from the first frontier generation (no. 225).

In this early stage, each settler fended for himself and succeeded according to his ability to perform the essential tasks—particularly the task of building. The man unwilling or unable as a builder lived in the most primitive of all circumstances. A settler who did succeed was the

5. Lansford W. Hastings, *The Emigrants Guide to Oregon and California* (Cincinnati: George Conclin, 1845), 144.

6. Marilyn McAdams Sibley, *Travelers in Texas, 1761-1860* (Austin: University of Texas Press, 1967), 41.

7. *Zion's Herald* 10, February 6, 1839, p. 22.

Jesuit priest Father Ravalli, who acted as a missionary on the northwestern frontier, and who was able to create his own mission buildings, religious furnishings and objects (nos. 227, 228), and also perform his religious duties. Similarly, a group of German religious idealists, who, under the leadership of Dr. William Keil, settled the Aurora Colony in Oregon in 1856, were able to quickly create as a result of organization and determination a frontier community complete with homes, barns, and shops, which soon became well known for the quality of its furniture and textiles (nos. 230, 231).[8]

The first generation of frontier life passed quickly and, for the most part, its artifacts perished or were absorbed in new entities. Specialized laborers became available and finer artifacts made their appearance. Carpenters and cabinetmakers came early to the frontier settlements, since their skills were obviously in great demand. Some were specifically trained as cabinetmakers, others had a general background in carpentry and were able to make furniture when the need arose. Lewis Hubbell Judson, for instance, who had been trained as a wheelwright in New York State, made standard, functional furniture in the earliest days of the Willamette missionary settlement in Oregon.[9] In addition to assembling in Oregon Windsor chairs that were turned in New York, Judson made slat-back side chairs and panel and frame cabinets.

The slat-back chair and the panel and frame cabinet were standard articles of furniture produced in frontier settlements in the West. Both types had been part of the American vernacular since the seventeenth century. In the West, the slat-back chair found regional expression in the material of its seat, which was often of animal hide (nos. 232-237). The panel and frame cabinet, used for storage, received a wide range of treatment, from the simplest to the most decorative. A commonly found frontier cabinet was the kitchen safe, whose panels of punched tin allowed for ventilation and provided embellishment (nos. 240-242).

8. Clark M. Will, *The Story of Old Aurora*, n.p., 1972.

9. Walton, " 'Mill Place' on the Willamette," p. 55.

In the 1840's and 1850's, although primitive frontier housing persisted, there were settlements that took on a more permanent aspect and others that became rapidly urbanized. Contrary to myth, the material culture of the West, after the earliest period of settlement, could not be entirely characterized as rough and crude.

On the one hand, travelers described a certain stable situation throughout the West in the 1840's and 1850's of a simple log house with two rooms, furnished with beds, the ubiquitous slat-black chairs, and perhaps a table or a bookcase. In Ogden City, Utah, Captain Brown of the Nauvoo legion and territorial legislature, was described as living in a "primitive log house, with two large rooms and beds in each."[10] A log cabin in the vicinity of New Washington, Texas, was furnished about 1840 with "a bed, a table, and a few chairs, the seats of which were made by stretching a calfskin tight over them . . . In the corner of the room stood a tall cabinet" (nos. 244, 245).[11]

On the other hand, fine furniture was produced in east Texas, a region settled after 1821 by settlers from the southern states under the leadership of Stephen Austin. An elegant tripod table and desk from this area were produced perhaps with the help of slave labor (nos. 259, 260) Similarly, refinement was combined with simplicity in the homes of many German immigrants to east Texas in the 1840's. There were experienced craftsmen among them. Frederick Law Olmsted described a German home that he visited in Texas about 1848: "You are welcomed by a figure in blue flannel shirt and pendant beard, quoting Tacitus, having in one hand a long pipe, in the other a butcher's knife; Madonnas upon log-walls, coffee in tin-cups upon Dresden saucers; barrels for seats, to hear a Beethoven's symphony on the grand piano . . . a bookcase half filled with classics, half with sweet potatoes."[12]

Soon after the earliest period of settlement, furniture made throughout the western territories absorbed the stylistic features of that made

10. William Chandless, *A Visit to Salt Lake* (London: Smith, Elder & Company, 1857), 231.

11. Ferdinand Roemer, *Texas: With Particular Reference to German Immigration and the Physical Appearance of the Country, 1845-47* (San Antonio: Standard Printing Company, 1935), 60.

12. Frederick Law Olmsted, *A Journey through Texas* (New York: D. Edwards and Company, 1857), 430.

in the East. In the 1850's and 1860's chairs produced in New Mexico, California, and Texas reflected an Empire style factory-made chair. The factory-made chairs were widely distributed in the Midwest, found their way to New Mexico along the Santa Fe Trail, and also were brought into Texas. The style of these chairs was copied by local craftsmen in native woods. In the 1850's an Empire gondola chair was produced by Mormon craftsmen in Utah, organized by Brigham Young (nos. 263-266). By 1858 rococo revival furniture was made in urban San Francisco.[13]

Most of the characteristics of western furniture that distinguished it from that made in the rest of the United States were soon lost, particularly after construction of the railroad enabled furniture to be shipped easily from St. Louis and Grand Rapids. In two respects, however, furniture-making in the West was distinctive. First, furniture continued to be made by hand in the West well into the 1880's, after almost all furniture was factory-produced in the rest of the United States. Second, much western furniture retained national characteristics. Tables with Biedermeier legs and large wardrobes known as schranks continued to be made into the 1880's by German craftsmen, who were at the same time importing and assembling in their shops factory-produced furniture (nos. 277-279, 281).[14] Strong Hispanic traditions persisted in furniture made by craftsmen in New Mexico after it had become a territory of the United States, as can be seen in the chair made by Manuel Archupelata at Taos in 1850 (no. 283).

A final expression of style in western furniture was the horn chair, formed from the horns or antlers of animals native to the West (nos. 286, 287). This chair differed from earlier western furniture in that it was self-consciously regional. Before the 1880's, craftsmen in the West had not knowingly made furniture that was specifically western in style or material. Yet, western-made objects at times revealed their origin in

13. The following documentation appears to give evidence of the manufacture of Victorian furniture in San Francisco: 1) an advertisement for the Pidwell Company with an illustration of a rococo revival sofa, in the *San Francisco Directory*, 1858; 2) a label on a marble-top, serpentine-front chest, dating from ca. 1865 reads as follows: "Geo. O. Whitney & Co., Manufacturers and Importers, Fine Furniture and Upholstery Goods, Nos. 319 & 324 Pine Street, San Francisco"; see *Antiques* 89 (June 1966), 845.

14. *Early Texas Furniture and Decorative Arts* (San Antonio, Texas: Trinity University Press for the San Antonio Museum Association, 1973), 249-250. Johann Michael Jahn, a German cabinetmaker in Texas, made furniture by hand and also imported it from St. Louis and Sheboygan, Wisconsin, after 1866.

an agrarian society: a hide-seated chair, for example, or a blanket of horsehide. The horn chair continued in that regional idiom, but it was neither accidentally regional nor particularly functional. Rather, it was an object deliberately designed to evoke the romance of the untamed frontier. As such, it was considered appropriate for rooms used by men, for billiard rooms and libraries.

Within the nineteenth century, western furniture evolved from the necessarily crude to the self-consciously rough. This evolution paralleled developments from the late seventeenth to the late eighteenth century on the eastern seaboard, where within one hundred years, furniture changed from medieval European models to self-consciously American creations employing the iconography of the new nation.

ELISABETH SUSSMAN

220
Dominicus and Polly Miner Carter
Slat-back side chair
Ca. 1851; Utah; willow with rawhide thong seat, painted green at a later date, h. 32½ in., w. 17½ in., d. 13 in. Utah Pioneer Village, Salt Lake City

According to family tradition this "pioneer" chair was "whittled and put together by the hands of Dominicus and Polly Miner Carter as they crossed the plains, reaching Provo in 1851. As they rode in their 'Prairie Schooner' the framework was whittled from willows, the back was fashioned from the rims of wagon wheels and the seat was woven of ox hide."

221
Slat-back rocking chair
Ca. 1850-1870; made in Pennsylvania, brought to Nebraska ca. 1872; ash, tulip, painted, seat a later replacement, h. 41½ in., w. 21 in., d. (seat) 15¼ in. Nebraska State Historical Society, Lincoln

This simple slat-back rocker, made in Pennsylvania, is typical of the furniture carried across the country in wagons and trains by pioneers in the West. Brought to serve immediate needs, such furniture held a special place in settlers' homes as a reminder of the East Coast they had left.

160

223

Chest or trunk
Ca. 1800; made in Norway, brought to
Nebraska; pine and iron, painted,
h. 31 in., w. 44¾ in., d. 23½ in.
Stuhr Museum of the Prairie Pioneer,
Grand Island, Nebraska

*Made in Norway and transported to
Grand Island, Nebraska, in 1864, this
chest, or trunk, has been in the family
of Oscar Funru, early pioneers in the
area. A painted inscription on the front
reads, "Kari Helleksdatter/Makt 1800/
Tvetten 1864." On the back is carved,
"Kari Hellekson Sloen/Newman Grove
P.O./Madison Co. Neb./Nort Amerika."
The chest bears its original, vivid floral
decoration, known as "Rosemaling,"
which was a popular peasant art form
from the seventeenth century onward
in northern Europe and Scandinavia.
This chest is an example of the many
pieces brought by the Scandinavian
immigrants to this country in the
nineteenth century seeking open land
beyond the heavily settled eastern
seaboard.*

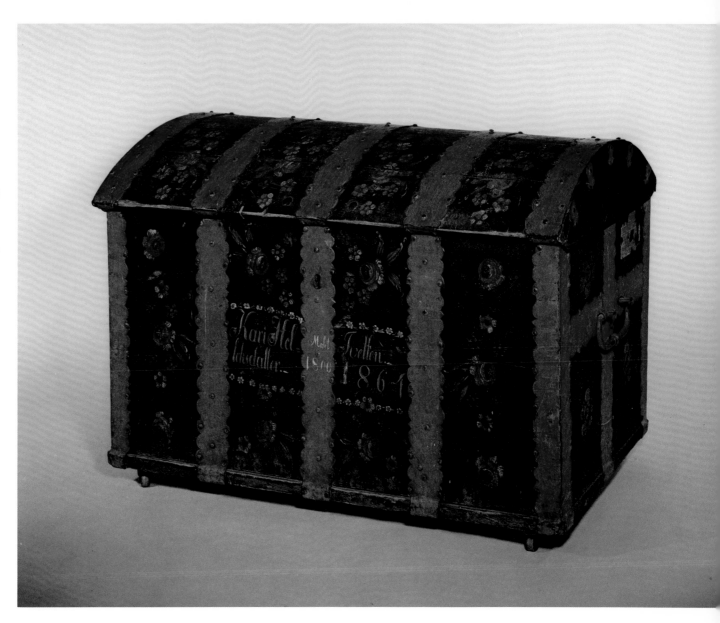

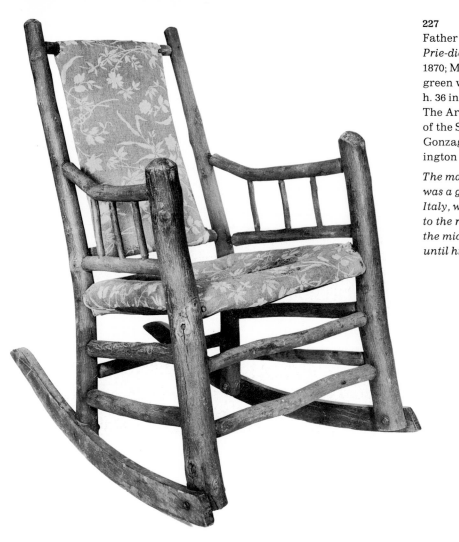

227

Father Anthony Ravalli, 1812-1884
Prie-dieu
1870; Missoula, Montana; pine, painted green with velvet upholstery,
h. 36 in., w. 20 in., d. 20 in.
The Archives of the Oregon Province of the Society of Jesus, Crosby Library, Gonzaga University, Spokane, Washington

The maker of this bench for worship was a gifted Jesuit priest from Farrara, Italy, who carried the Christian word to the remote northwest frontier from the middle of the nineteenth century until his death in 1884 at St. Mary's mission in western Montana. A mission builder, carver, mechanic, and architect-craftsman, Father Ravalli was also schooled in literature, natural sciences, philosophy, and medicine. Poignant reminders of Father Ravalli's talents and spirit are weathered mission churches in Cataldo, Idaho, and Stevensville, Montana, which he designed and constructed, complete with religious furnishings and works of art. This prie-dieu was made for the Mc-Cormick family of Missoula, Montana.

Ref.: Harold Allen, *Father Ravalli's Missions* (Chicago: School of the Art Institute of Chicago, 1972).

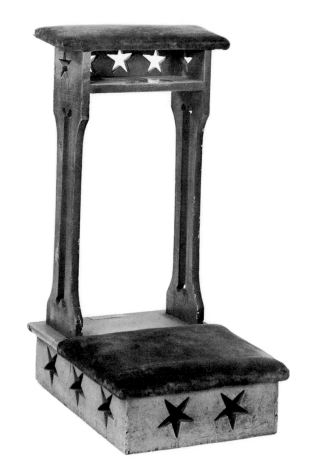

225

Armchair
Ca. 1850-1900; Grand Island, Nebraska; willow, upholstery and rockers added ca. 1900, h. 39 in., w. 25 in., d. 18½ in.
Stuhr Museum of the Prairie Pioneer, Grand Island, Nebraska

Hand hewn from unstripped willow branches, this chair characterizes the resourcefulness of early settlers in the great prairie stretches of Nebraska. Made by a member of the Stuhr family of Grand Island, the chair demonstrates the changes that are made in furniture kept in use over several generations. The rockers, of machine-sawn wood, and the upholstery of machine-woven fabric, are both later additions, probably about 1900.

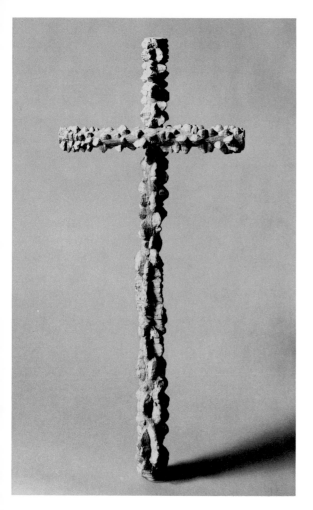

228
Father Anthony Ravalli, 1812-1884
Cross
Ca. 1860-1870; Montana; diseased cottonwood, h. 25 in., w. 11 in.
Montana Historical Society, Helena

Father Ravalli's use of natural found materials, such as the diseased cottonwood of this cross, demonstrated his artistic ingenuity and his sympathy for the untamed frontier life that surrounded him.

230
Bench
Ca. 1860; Aurora Colony, Oregon; maple and pine, h. 32 in., l. 123 in., w. 24 in.
Aurora Colony Historical Society, Aurora, Oregon

Produced in the utopian community of Aurora, in Marion County, Oregon, this bench was once communal property. The Aurora Colony was founded in 1856 by Dr. William Keil, a German religious idealist, who led his group from Pennsylvania to Bethel Community in Missouri and finally to the Willamette valley in Oregon. The spare lines of this long bench harmonized with the simplicity of the community life espoused by Dr. Keil.

Ref.: Arthur Bestor, *Backwoods Utopias* (Philadelphia: University of Pennsylvania Press, 1950), 242.

231

A. Horr
Coverlet
1840; Harmony, Indiana; wool and linen,
l. 86½ in., w. 68 in., fringe 2 in.
Collection of Leona Will Nelson on
loan to the Aurora Colony Historical
Society, Aurora, Oregon

The history of this coverlet involves
three major utopian communities on
the frontier. It was woven in Harmony,
Indiana, where Robert Owen bought
30,000 acres of land and founded a
nonreligious communitarian settle-
ment. From there the coverlet traveled
with its owners, Mr. and Mrs. Charles
Snyder, to Bethel, Missouri, the settle-
ment started by Dr. William Keil in
1844. In 1856 the Snyders went with
Dr. Keil and the first wagon train of
settlers to Aurora, Oregon.

Woven on a hand loom with
Jacquard attachment, coverlets of this
type were made chiefly in rural Penn-
sylvania, Ohio, and New York during
the mid-nineteenth century.

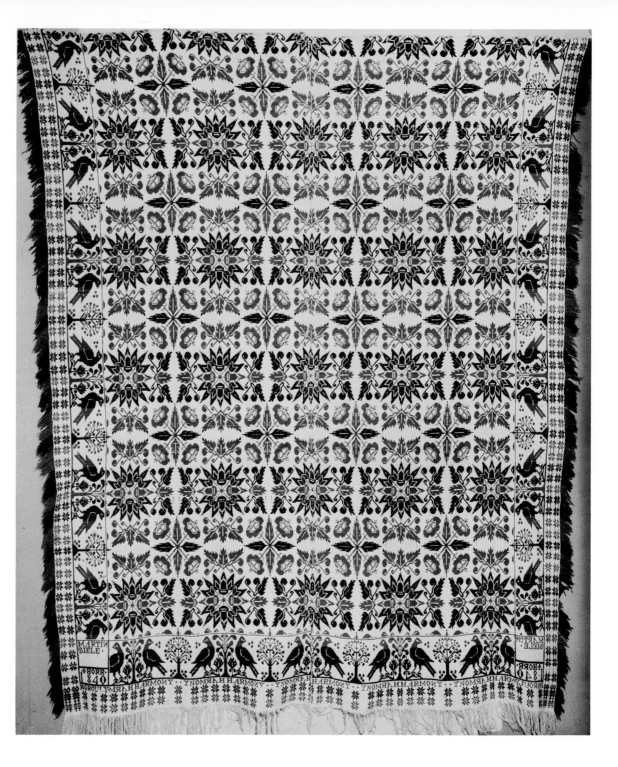

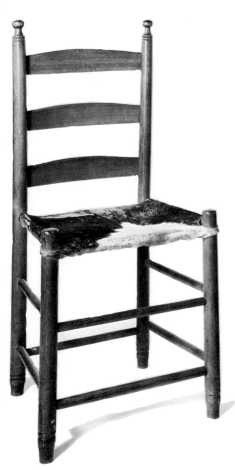

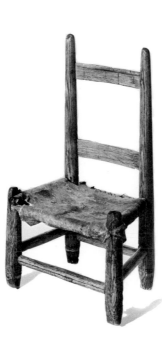

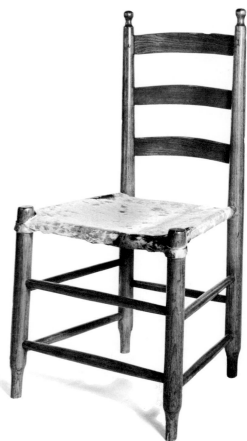

232

Side chair

1860-1870; Fayetteville, Texas; elm and ash, with cowhide seat, h. 35½ in., w. 17½ in., d. 15 in.

Collection of Mr. and Mrs. Andrew Z. Thompson

234

Child's chair

1838; Martindale, Texas; ash, with cowhide seat, h. 22½ in., w. 13 in., d. 9 in.

San Antonio Museum Association Collection, Gift of Mrs. Jesse L. Humphreys

Plain, lightweight but sturdy construction made the slat-back chair a particularly useful and flexible piece of furniture for the pioneer, who was constantly on the move. A chair type known on successive frontiers, the slat-back tradition stretches back to the very beginnings of settlement on the East Coast by western Europeans. Size, weight, and material have varied slightly through the generations to suit needs and situations, but the ubiquitous open form, based on a square post and lintel framing, has remained the same.

This chair was made for Jesse L. Humphreys, who later served in the Confederate Army.

Ref.: San Antonio Museum Association, *Early Texas Furniture and Decorative Arts* (San Antonio, 1973), pp. 4, 8, nos. 4, 11.

233

Side chair

1860-1870; Fayetteville, Texas; ash, with cowhide seat, h. 34½ in., w. 18 in., d. 14 in.

Collection of Mr. and Mrs. Andrew Z. Thompson

While East Coast slat-back chairs had seats of rushes or reeds, the most readily available strong material in the West was cowhide or rawhide. These two chairs with cowhide seats show an ingenious and typical use of native materials close at hand.

Ref.: San Antonio Museum Association, *Early Texas Furniture and Decorative Arts* (San Antonio, 1973), p. 4, no. 3.

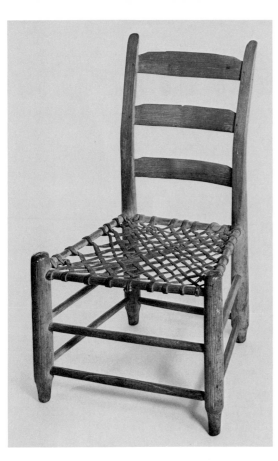

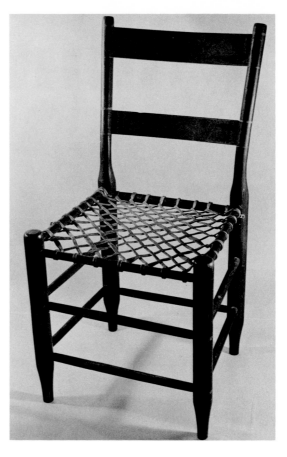

235

Side chair, slat-back
Ca. 1840; Travis County, Texas; ash,
with laced rawhide seat, h. 32¾ in.,
w. 19 in., d. 14 in.
San Antonio Museum Association Col-
lection, Gift of Mrs. Georgia Maverick
Harris

Ref.: San Antonio Museum Associa-
tion, *Early Texas Furniture and Dec-
orative Arts* (San Antonio, 1973), p. 6,
no. 5.

237

Side chair
Ca. 1850; Tumwater, Washington; pine,
painted, h. 33½ in., w. 17 in., d. 18 in.
State Capitol Museum, Olympia,
Washington

*Slat-back chairs found themselves in
uses other than domestic: this painted
chair with a woven rawhide seat was
used in the old Territorial Capitol
building completed in 1856 in Olympia.
Said to have been made by a member
of the Speakes family of Tumwater, its
existence in the northernmost reaches
of the West demonstrates the practical-
ity and versatility of this type of chair.*

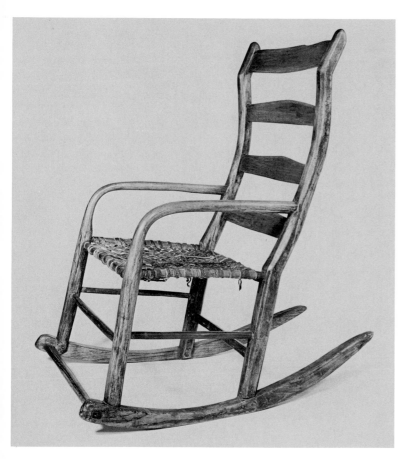

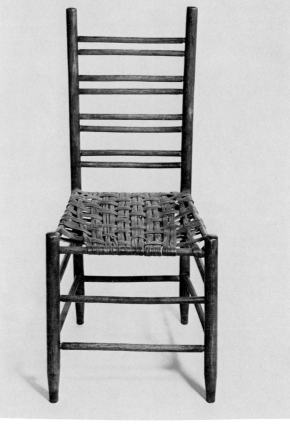

238
Rocking chair
Ca. 1840; Muldoon, Texas; elm, hickory,
ash, and rawhide, h. 38½ in., w. 20 in.,
d. (seat) 16½ in.
Collection of Mrs. Charles L. Bybee

*Bent and smoothed branches form the
continuous arms and legs of this slat-
back rocker. The back legs are hewn
posts through which the seat frame is
doweled. Rawhide, woven wet,
tightened when dry to brace the seat.*

Ref.: San Antonio Museum Associa-
tion, *Early Texas Furniture and Dec-
orative Arts* (San Antonio, 1973), p. 16,
no. 26.

239
Side chair
Ca. 1830-1845; Nacogdoches, Texas; ash,
elm with hickory bark seat, h. 39 in.,
w. 18 in., d. 14½ in.
San Antonio Museum Association Col-
lection, Gift of Mr. and Mrs. C. D.
Orchard

*The maker of this special variation on
the slat-back chair had a craftsman's
interest in contrasting the textures of
rough hickory bark seat and smooth,
turned members.*

Ref.: San Antonio Museum Associa-
tion, *Early Texas Furniture and Dec-
orative Arts* (San Antonio, 1973), p. 16,
no. 26.

240

Jelly cupboard

Ca. 1850-1860; Austin County, Texas; cedar, h. 65 in., w. 44 in., d. 19½ in. Collection of Mrs. Charles L. Bybee

A food safe, or cupboard, this piece of furniture was one of the essentials of frontier life. Continuing a tradition of fielded panel joinery a hundred years beyond the time of its popularity on the eastern seaboard, it is a reminder that conservative traditions survived and persisted in the vernacular arts on the frontier.

Ref.: San Antonio Museum Association, *Early Texas Furniture and Decorative Arts* (San Antonio, 1973), p. 98, no. 115.

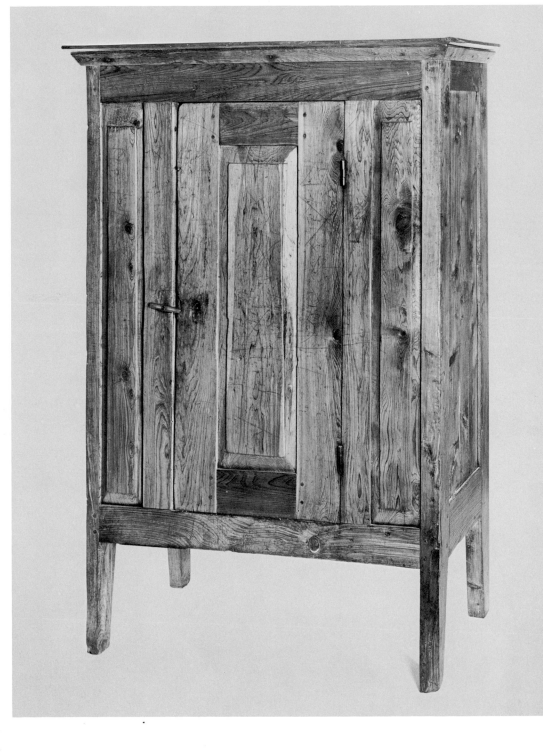

241

Pie safe

Ca. 1875; southwestern Colorado; tulip-wood, pine, and tin, h. 55⅛ in., w. 38½ in., d. 16½ in.

The State Historical Society of Colorado, Denver

Throughout the West the punched-tin pie safe was a standard piece of kitchen furniture. Examples are found in Texas, California, Utah, the Oregon territory, and elsewhere. This safe came from the Rourke Ranch on the Purgatory River in southeastern Colorado, where it was made by the ranch hands from discarded packing cases. The packing crates had originally contained factory-made parlor furniture that had been shipped from St. Louis to Colorado ranching country, where it added elegance to an otherwise rough environment. The furniture came from the "J. H. Crane Furniture Warehouse" according to the stenciled label still visible on a back board of the pie safe.

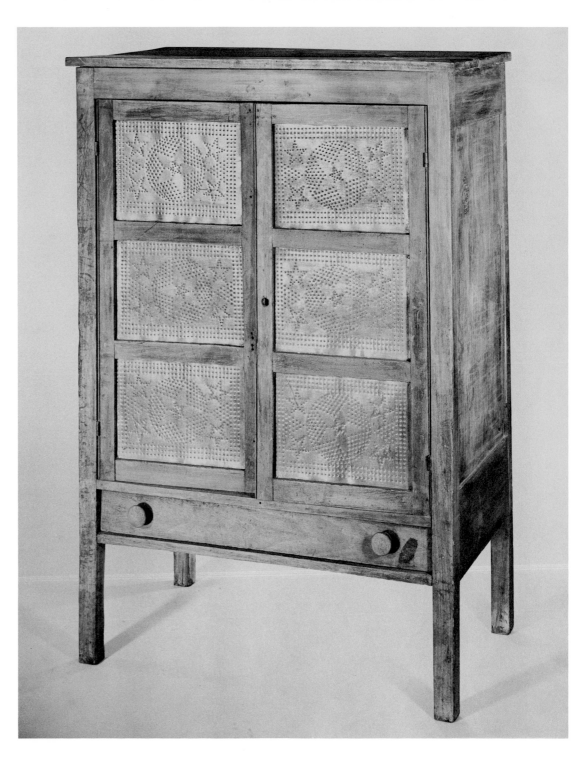

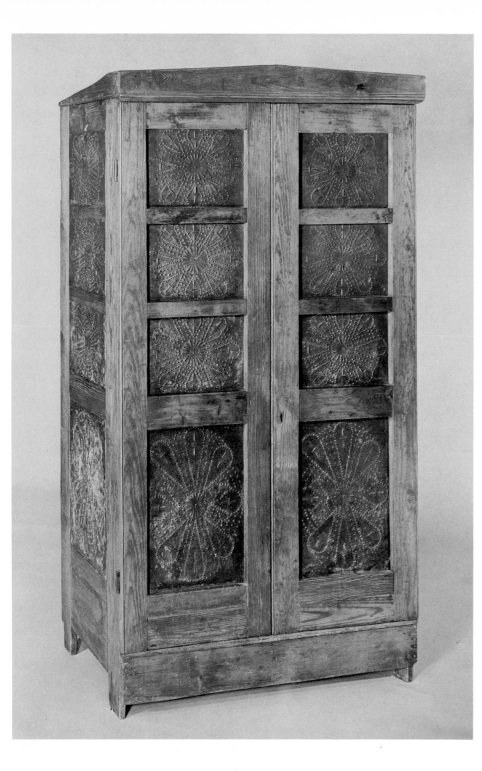

242

Food safe
Ca. 1860; Bastrop, Texas; cypress, pine,
and tin, h. 76 in., w. 40 in., d. 22½ in.
Collection of Walter Nold Mathis

*The pierced tin panels of the food safe
served both a decorative and practical
purpose. Pierced slits and holes, ar-
ranged in a variety of patterns in the
tin, let air into the safe to ventilate its
contents, which were protected from in-
sects, mice, and other pests.*

Ref.: San Antonio Museum Associa-
tion, *Early Texas Furniture and Dec-
orative Arts* (San Antonio, 1973), p. 84,
no. 101.

243

Porch bench

Ca. 1860; Washington County, Texas; pine, walnut, ash, cedar, h. 31 in., w. 83 in., d. 23¾ in.

Collection of Mrs. Charles L. Bybee

One of a pair, this bench is a Texas version of an Empire style scroll arm sofa for out-of-doors use on the porch. Its open slat construction is a familiar western idiom.

244

Daybed

Ca. 1870; Fayette County, Texas; oak, pine, and ash, traces of red brown paint, h. 32 in., l. 76 in., w. 28 in.

Collection of Mrs. Charles L. Bybee

The design of this daybed seems inspired by the familiar frontier chair, the slat-back. Its basic form is but an extended pair of slat-back chairs facing each other, with front and back rails dovetailed into the legs. The daybed served an important function in frontier life. It was a substantial piece of parlor furniture that easily provided accommodation for an expanded household when travelers arrived unexpectedly.

Ref.: San Antonio Museum Association, *Early Texas Furniture and Decorative Arts* (San Antonio, 1973), p. 48, no. 58.

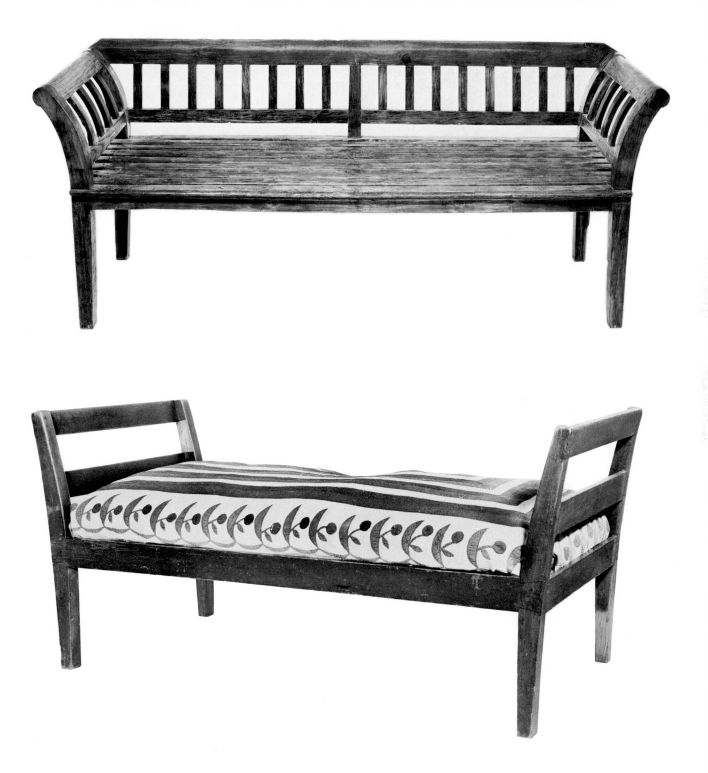

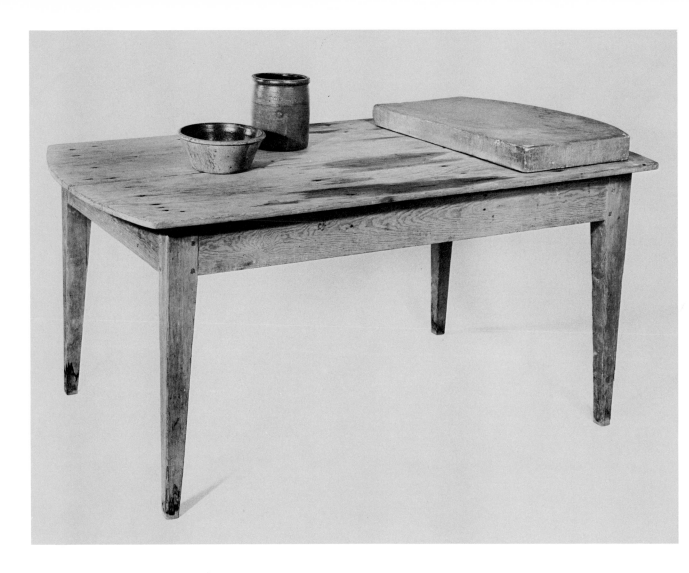

245
Kitchen table
Ca. 1857-1860; Colorado County, Texas;
pine with limestone slab, h. 30¾ in.,
l. 70 in., w. 35 in.
San Antonio Museum Association Col-
lection, Gift of Mrs. C. T. White

The spare lines of this kitchen table,
with its slightly tapering legs and
shaped top with conforming limestone
work slab, have an almost contempor-
ary appearance. The table was made
for Captain and Mrs. R. E. Stafford,
who moved from Georgia to Colorado
County in 1857. The top, made of two
broad planks joined underneath with
a wooden spline, together with other
details such as peg size and nail type,
suggest a pre-1860 date for its
construction.

Ref.: San Antonio Museum Associa-
tion, *Early Texas Furniture and Dec-
orative Arts* (San Antonio, 1973), p. 80,
no. 96.

249
John M. Wilson
Two-quart bowl
1857-1869; Seguin, Guadalupe County,
Texas; glazed stoneware, h. 4 in., diam.
(top) 10½ in.
Collection of Mrs. Georgeanna Greer

250
Hiram Wilson & Company
One-gallon open jar
Ca. 1872-1884; Seguin, Guadalupe
County, Texas; glazed stoneware, h.
8½ in., diam. (top) 7½ in.
Collection of Mr. and Mrs. Andrew Z.
Thompson

Ref.: San Antonio Museum Associa-
tion, *Early Texas Furniture and Dec-
orative Arts* (San Antonio, 1973), p. 198,
nos. 264, 268.

255
Spindle bed
Ca. 1850; La Grange, Texas; pine,
stained red brown, h. 35 in., l. 73½ in.,
w. 45½ in.
Collection of Walter Nold Mathis

*The very essence of functional simplic-
ity, this bed was made at a time when
most fashionable furniture in the East
was elaborate to the extreme. Western*
*furniture design, as exemplified in this
bed, developed organically out of the
methods and materials that best solved
the urgent needs of a mobile frontier
society.*

Ref.: San Antonio Museum Associa-
tion, *Early Texas Furniture and Dec-
orative Arts* (San Antonio, 1973), p. 118,
no. 140.

259

Slant-top desk with paneled bookcase

Ca. 1840; vicinity of Industry, Austin County, Texas; walnut, h. 67½ in., w. 43¾ in., d. 33 in.
Collection of Mrs. Charles L. Bybee

The desk is a frontier version of the secretary, an elegant piece of furniture familiar to immigrants from the South and East. There is no doubt about the close relationship of this piece in concept and design features, such as the paneling on the single door, to eastern furniture of the late eighteenth or early nineteenth century.

Ref.: San Antonio Museum Association, *Early Texas Furniture and Decorative Arts* (San Antonio, 1973), p. 30, no. 43.

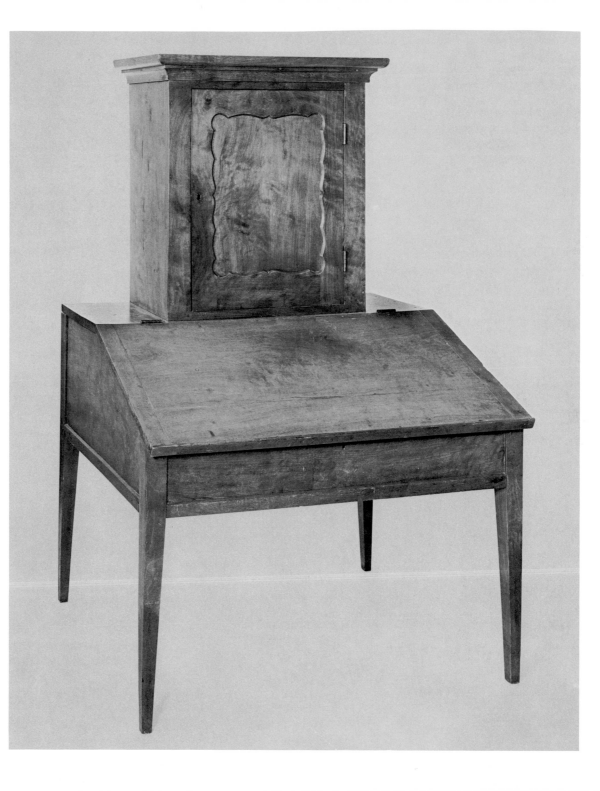

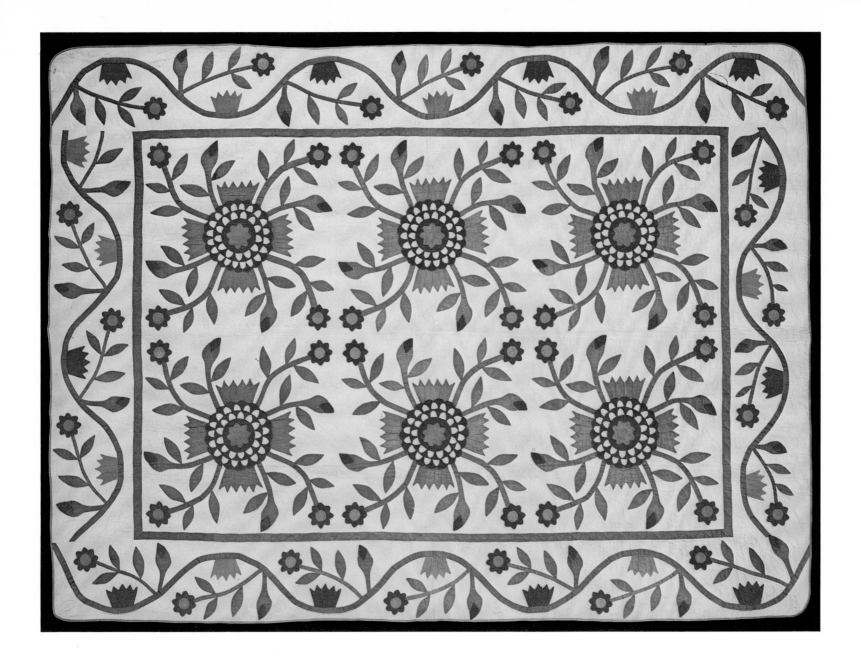

257

Matilda Hurst Irvine
Appliquéd quilt
1864-1865; Kaufman County, Texas;
cotton percale and muslin, l. 99½ in.,
w. 72½ in.
San Antonio Museum Association Collection, Gift of Mrs. J. H. Guillory

This appliquéd quilt in the "Whig Rose" pattern was made by Matilda Hurst Irvine, a settler in Kaufman County, Texas. She was the wife of Judge William Irvine, who had fought in the War for Texas Independence and actively supported the organization and advancement of the state. The quilt is a tribute to this pioneer needlewoman's artistry in design and use of color. The white muslin background is quilted in decorative motifs of stars, birds, and flowers, and appliquéd on the surface in a meandering pattern are flowers and rose vines in red, white, orange, and green percale.

Ref.: San Antonio Museum Association, *Early Texas Furniture and Decorative Arts* (San Antonio, 1973), p. 212, no. 300.

260
Tripod pedestal table
Ca. 1850; Brazos County, Texas; walnut,
h. 29¾ in., diam. (top) 35 in.
San Antonio Museum Association Collection, Endowment Fund Purchase

The tripod pedestal table had graced American parlors since the mid-eighteenth century. Elegantly finished or roughly made, tables of this type were found frequently in houses in the Far West. This example, simple in its silhouette, has a sturdy, noble form. It was made in the vicinity of great Texas cotton plantations, which reached a peak of prosperity following the Civil War.

Ref.: San Antonio Museum Association, *Early Texas Furniture and Decorative Arts* (San Antonio, 1973), p. 58, no. 69.

263

Side chair

Ca. 1830-1850; Santa Fe, New Mexico;
pine and fruitwood, h. 34 in., w. 16 in.,
d. 16½ in.

Collection of Dr. and Mrs. Ward Alan
Minge

Representing an interesting combina-
tion of local construction techniques
and outside design influences, this ex-
ample of frontier neoclassicism sug-
gests the mode of Duncan Phyfe and
demonstrates vividly the influences of
Yankee settlement in the Southwest.
Undoubtedly copying a chair brought
to New Mexico from the East, a local
carpenter carved this chair in classical
form. The large mortise and tenon
joints and wooden pegs continue tradi-
tional New Mexican construction.

264

Side chair

Ca. 1860; Mariposa, California; pine,
h. 32 in., w. 15½ in., d. 16½ in.
The Oakland Museum, Oakland,
California

A California version of the Empire
style side chair, made of wood from
Mariposa County, indicates the univer-
sality of the neoclassical style on the
frontier during the second phase of
settlement at mid-century.

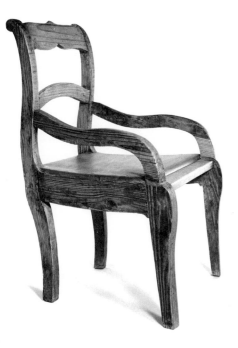

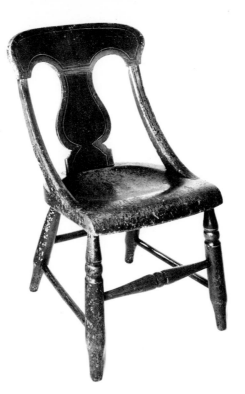

265

Scroll-back armchair
Ca. 1850; Cat Springs, Texas; pine, h.
30½ in., w. 20½ in., d. 18 in.
Collection of Mrs. Charles L. Bybee

*A Texan interpretation of neoclassical
style, the design of this armchair
makes effective use of the patterns in
the wood. As a local wood, pine was
substituted for the mahogany or rose-
wood from which a chair of this type
would have been made in the eastern
United States.*

266

William Bell, 1816-1886
Side chair
Ca. 1860-1870; Salt Lake City, Utah;
pine, painted and stenciled, h. 32¼ in.,
w. 17½ in., d. 16½ in.
Utah Pioneer Village, Salt Lake City

*As part of a public works program es-
tablished in Salt Lake City by Brigham
Young, a furniture workshop produced
grained Empire style chairs of this
type. Fashioned with generous curves,
of soft pine, these pioneer pieces were
available to an expanding market of
settlers needing useful, rugged but
stylish furniture. William Bell, who ar-
rived in Salt Lake City in 1854, worked
in Brigham Young's cabinetmaking
shop for about fifteen years. Bell is
known to have produced chairs such as*

*this, and those without the stencil
"Public Works/1856/G. S. L. City" are
believed to be of his making. Under the
seat is an inscription in pencil: "B.
Morris Young."*

267

Whipple and Kirkham
Rocking chair
Ca. 1860-1880; Lehi, Utah; pine, painted
and stenciled, h. 39 in., w. 20½ in.,
d. 18½ in.
Utah Pioneer Village, Salt Lake City

*According to local tradition, the maker
of this rocking chair was the Lehi, Utah,
firm of Whipple and Kirkham, one of
the earliest furniture manufacturers in
the Rocky Mountains. Principles in the
firm were in all probability George
Kirkham, who had worked as a car-
penter on the Mormon Temple in Salt
Lake City and Edson Whipple, a mem-
ber of a locally prominent woodwork-
ing family who settled in Lehi. This
rocking chair, of their making repre-
sents the second stage of pioneering
crafts when sufficient prosperity al-
lowed for specialization of skills and
the beginnings of mass manufacture.
During initial settlement, most pio-
neers made things for their own use.
In the second phase of settlement, they
were able to sell or barter their skills
and products for food, merchandise,
and the services of others.*

Ref.: Hamilton Gardner, *History of
Lehi* (Salt Lake City, Deseret News
Press, 1913).

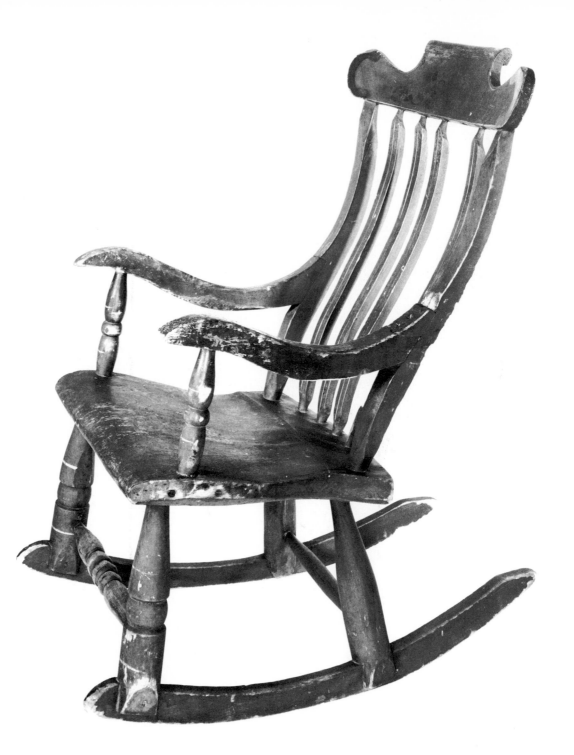

268

High post bed

Ca. 1860-1870; Salt Lake City, Utah;
pine, grained to simulate oak.
h. 78½ in., l. 68 in., w. 53¾ in.
Utah Pioneer Village, Salt Lake City

*Councillor to Brigham Young, mayor
of Salt Lake City, judge, general, peace
commissioner, and a man of means,
Daniel H. Wells, the original owner of
this bed, was also appointed superin-
tendent of Public Works of Great Salt
Lake City in 1848. It seems probable,
therefore, that the bed was made by
the furniture shop of the Public Works.
Its simulated light oak graining is
found elsewhere throughout the Salt
Lake Valley in both furniture and
architecture.*

Ref.: Hubert Howe Bancroft, *History
of Utah* (San Francisco: History Com-
pany Publishers, 1891), 698-699.

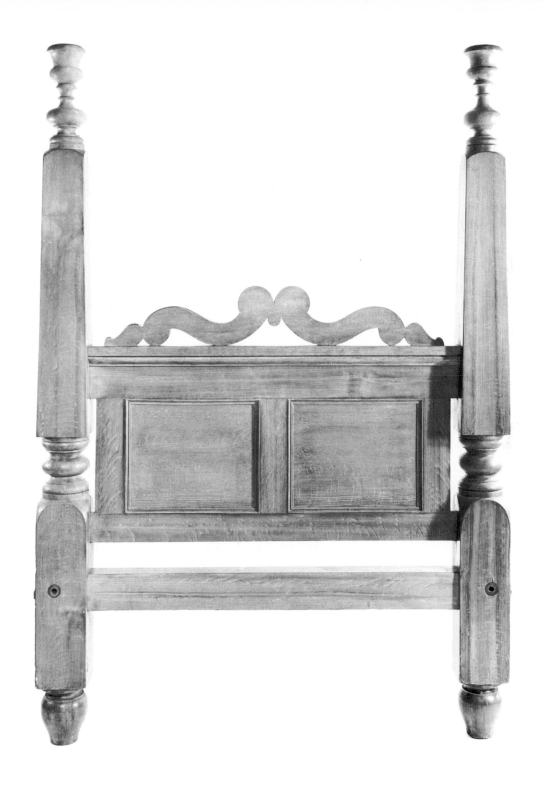

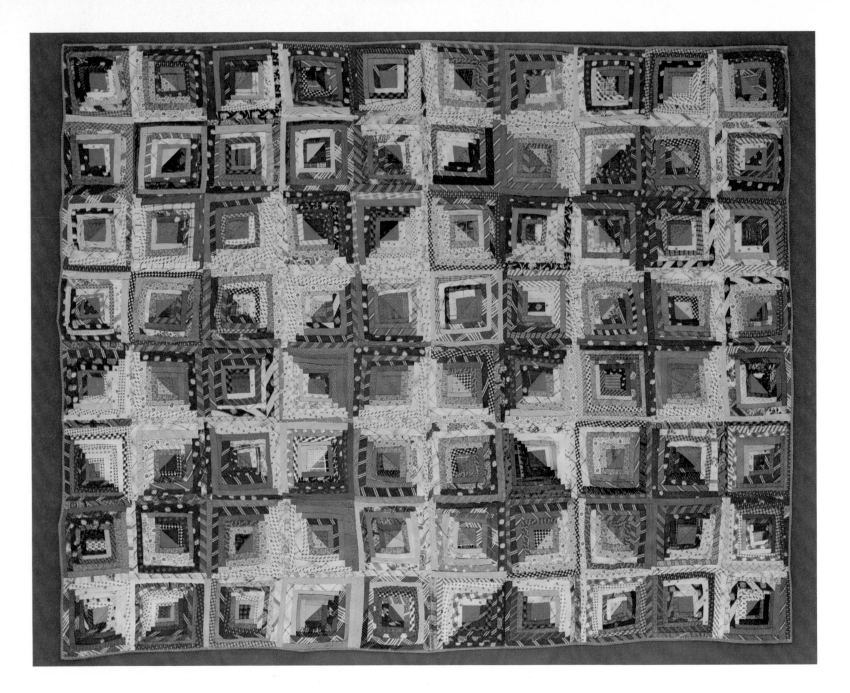

182

269

Nancy Barnes
Patchwork quilt
Ca. 1860-1870; Nebraska; cotton, wool,
and silk, l. 80¼ in., w. 64¾ in.
Stuhr Museum of the Prairie Pioneer,
Grand Island, Nebraska

*Nancy Barnes, a Civil War bride, pro-
duced this quilt in Nebraska. Narrow
strips of cotton create a decorative
pattern known as "Log Cabin." The
gradations from light to dark and the
inclusion of many bright colors make
this an extremely lively quilt.*

271

Cupboard
Ca. 1850-1860; Salt Lake City, Utah;
pine, grained to simulate rosewood,
h. 81¼ in., w. 47¼ in., d. 22¾ in.
Utah Pioneer Village, Salt Lake City

*Pine, one of the few woods available on
the frontier, was often grained with
paint to resemble the more expensive
woods.*

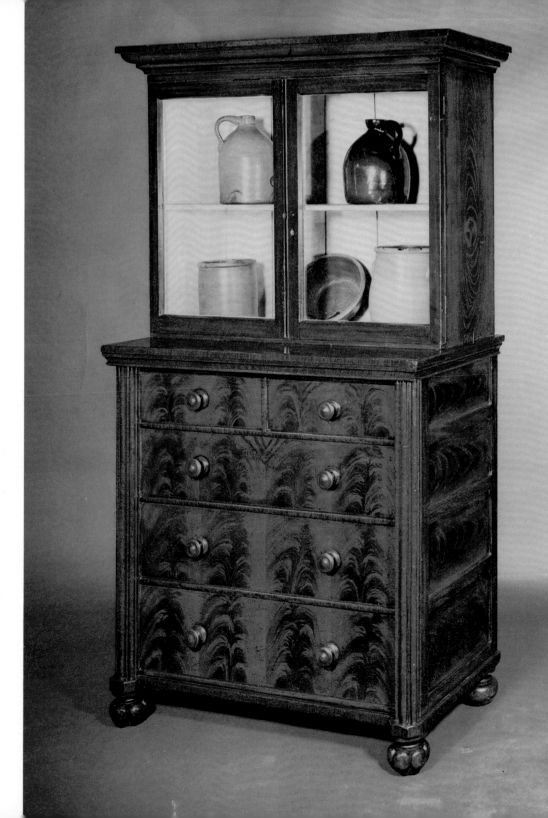

270
Low post bed
Ca. 1870; Salt Lake City, Utah; pine,
grained to simulate rosewood,
h. 48½ in., l. 83 in., w. 50½ in.
Collection of Mr. and Mrs. Avard T.
Fairbanks

*This bed belonged to the Mormon
pioneer Albert Perry Rockwood, who
was a general in Joseph Smith's
Nauvoo Legion in Illinois. In 1846 he
marched with the Mormon Batallion
foot infantry, which supported General
Kearny's Army of the West during the
Mexican War. An influential person,
Rockwood later became a legislator of
the Utah Territory and participated in
protecting Mormon interests during
the war in Utah of 1857.*

Ref.: Hubert Howe Bancroft, *History
of Utah* (San Francisco: History Com-
pany Publishers, 1891), 176, 272, 458.

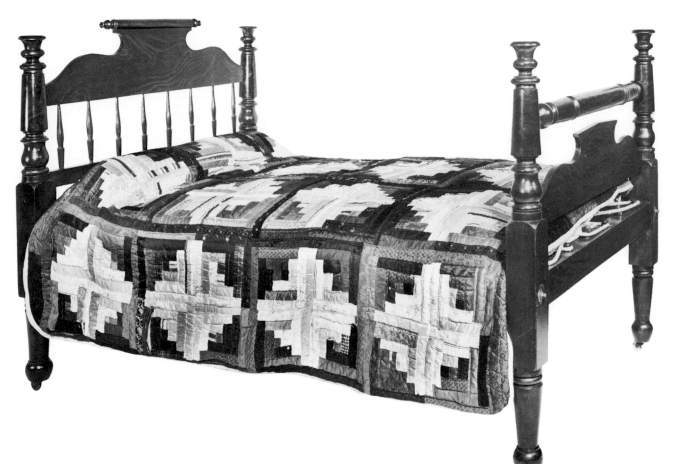

272
Settee
Ca. 1860; Belleville, Texas; pine and oak,
h. 33½ in., l. 75 in., d. 25 in.
Collection of Mrs. Charles L. Bybee

*The synthesis of stylistic influences is
a typical trait of furniture made on the
frontier. In this settee the arms follow
the classical form of Empire style
chairs, while the back has the more
fluid lines of the rococo revival. In-
tended as an important piece for the
parlor, this settee nevertheless
expresses the direct simplicity of
frontier craftsmanship.*

Ref.: San Antonio Museum Associa-
tion, *Early Texas Furniture and
Decorative Arts* (San Antonio, 1973),
p. 44, no. 53.

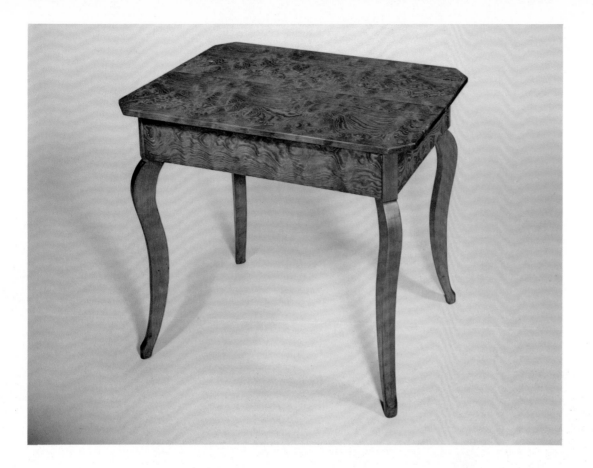

273

Side table

Ca. 1880-1883; vicinity of Shulenberg, Texas; pine, h. 29 in., w. 33¾ in., d. 22¼ in.

Collection of Mrs. Charles L. Bybee

Made at a time when ostentatious, ornamental furniture was popular in the East, this table with its simple lines and boldly figured wood is a delightful accommodation of a country craftsman's art to prevailing tastes. The table is an example of the hand-crafted furniture still produced in rural Texas in the nineteenth century to meet the needs of a local market long after machine-made furniture, shipped by rail from other parts of the country, had become available.

Ref.: San Antonio Museum Association, *Early Texas Furniture and Decorative Arts* (San Antonio, 1973), p. 70, no. 86.

277

Wardrobe

Ca. 1860-1870; Fayette County, Texas;
marked "C. W." on back in chalk;
cedar, painted and grained, h. 76½ in.,
w. 61 in., d. (at cornice) 23 in.
Collection of Mrs. Charles L. Bybee

*A traditional continental European
form, this double-door wardrobe, or
schrank, reflects Germanic arts and
skills in mid-nineteenth century Texas.
Made at a period of early prosperity in
Texan history, this wardrobe must
have once graced a substantial house-
hold. Its brilliantly decorated surface,
with large panels painted to look like
the cross section of a giant exotic tree,
constituted a huge canvas for a nine-
teenth century graining artist.*

Ref.: San Antonio Museum Associa-
tion, *Early Texas Furniture and
Decorative Arts* (San Antonio, 1973),
p. 112, no. 134.

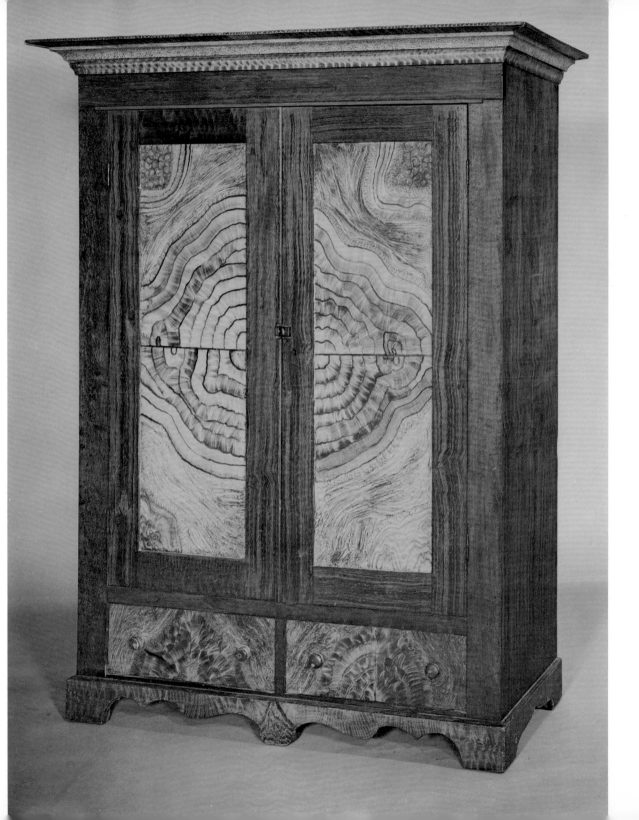

279
Dasch
Wardrobe
Ca. 1880; Columbus, Texas; cypress and
pine, painted, h. 93½ in., w. 56½ in.,
d. 29 in.
Collection of Mrs. Charles L. Bybee

*Colorfully contrasting paneling and
applied turned balustrades and mold-
ings create the vivid surface in this
wardrobe, a cherished item in the
homes of late nineteenth century
Americans.*

Ref.: San Antonio Museum Associa-
tion, *Early Texas Furniture and
Decorative Arts* (San Antonio, 1973),
p. 114, no. 136.

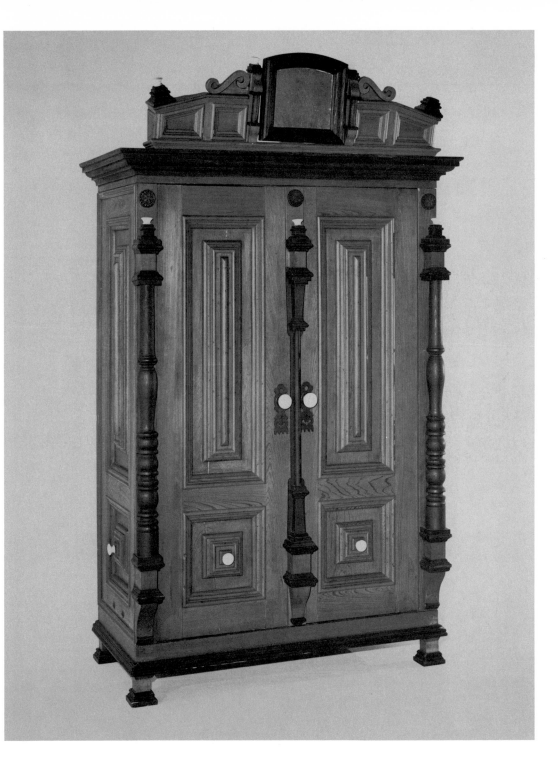

280

Corner bench (detail)
Ca. 1860-1880; Schulenberg Community, Texas; pine, h. 28¾ in., l. (in two sections) 78½ in., 80½ in., d. 16½ in.
Collection of Mrs. Charles L. Bybee

Neatly fitted together with mortise and tenon joints and wrought nails, this bench is a triumph of frontier ingenuity and simplicity. The horizontal rails of the back are joined with shaped vertical slats, suggesting budding tulips, which give the piece a strong rhythm. Adding to the charm of the bench, the surface of the wood is now weathered to an attractive gray-white color.

281

Side chair
Ca. 1860; Cat Springs, Texas; pine, h. 33¼ in., w. 18 in., d. 14½ in.
Collection of Mrs. Charles L. Bybee

Derived from a type of chair common throughout northern European peasant cultures from the seventeenth century, this plank-seated chair was probably made by a German immigrant to Texas in whose vocabulary of style the traditions of centuries survived. In both rural Pennsylvania and Ohio, where northern Europeans also settled, similar chairs are known to have been produced in the eighteenth and nineteenth centuries.

Refs.: Margarete Baur-Heinhold, *Deutsche Bauerstuben* (Königstein im Taunus: Hans Köster, 1967), 5, 21, 33, 42, 85; Illerbeuren, Bauernhofmuseum, *Kunstsinn und Erfindergeist im Bauernhof* (Memmingen, 1968).

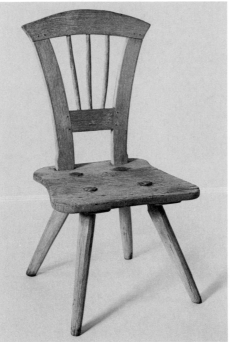

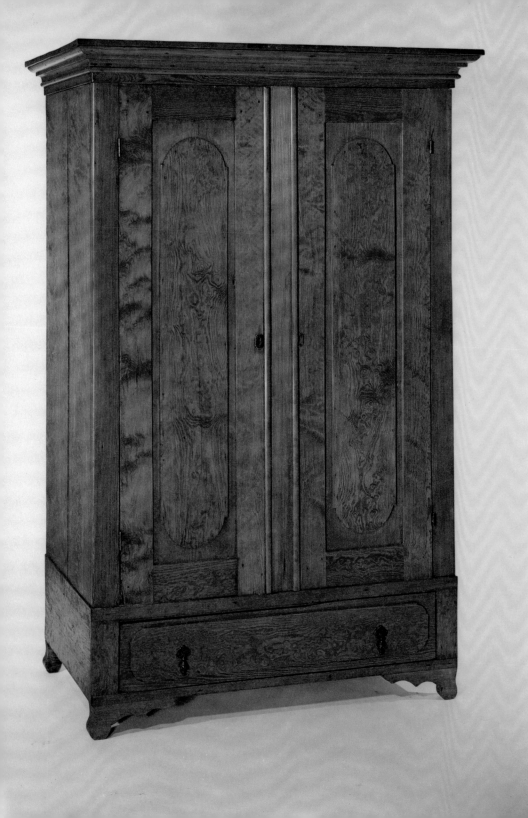

278

Demel, 1849-1932
Wardrobe
Ca. 1875-1880; Ammonsville, Texas;
pine, h. 78 in., w. 53 in., d. 22¼ in.
Collection of Mr. and Mrs. Harvin C.
Moore

Typical of many large pieces of Texas-German furniture, this paneled, curly pine wardrobe can be taken apart completely for easy transportation. The cabinetmaker, Demel, has paid attention to every design detail to achieve a total effect in this beautifully proportioned piece. Even the keyhole escutcheon plates match the form of the paneling on the doors. Demel was born in Germany in 1849 and immigrated to Ammonsville, Texas, where he died in 1932. Political disturbances in their country in the 1840's drove many Germans to new lands. Immigration societies, such as the "Society for the Protection of German Immigrants in Texas," founded in Germany in 1842, were formed to help exiles to settle in America. Within four years, more than five thousand Germans had settled in Texas at New Braunfel, Fredricksburg, and other areas. Soon after arriving, they established well-managed farms, founded their own schools, choral societies, and other social organizations.

282

Colcha
Ca. 1860-1890; New Mexico; wool, l. 84
in., w. 52 in.
The Colorado Springs Fine Arts Center

While embroidered with the traditional New Mexican long couched stitch, this colcha is more sophisticated in design and color than earlier examples, indicating the influence of eastern settlers. The brilliant colors—blue, green, red— result from aniline dyes introduced in textile manufacture in the mid-nineteenth century.

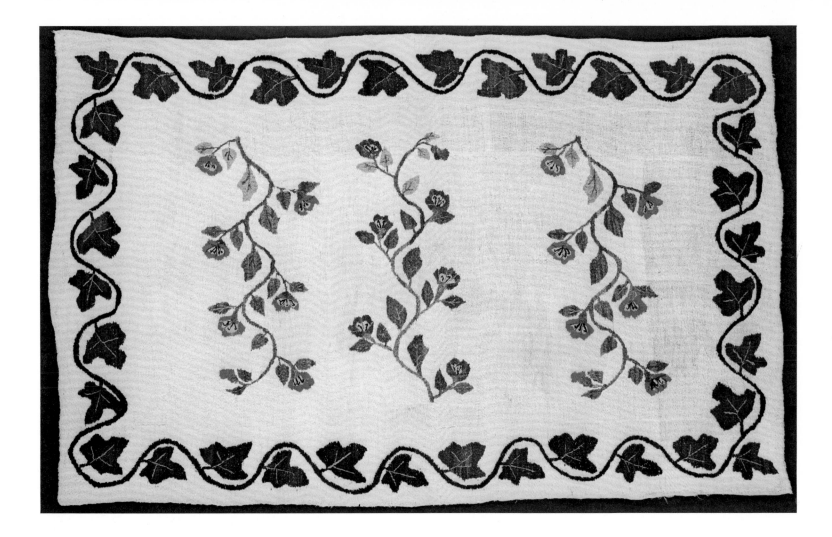

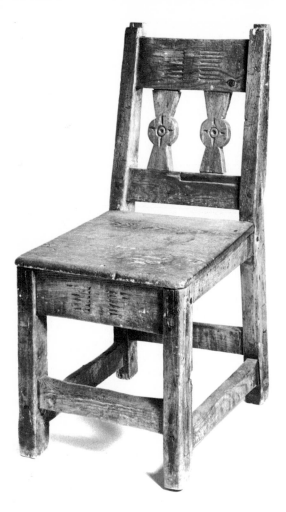

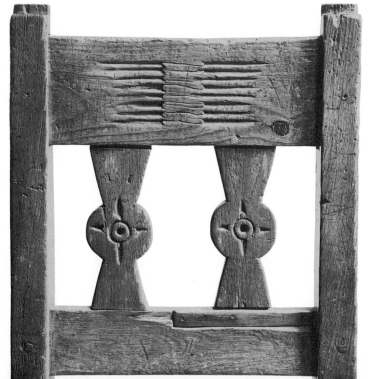

283
Manuel Archuleta
Side chair
1850-1860; Taos, New Mexico; pine,
h. 31¾ in., w. 16¼ in., d. 16¼ in.
The Colorado Springs Fine Arts Center

*Long after the Santa Fe Trail brought
Yankee settlers and their possessions
from the East, New Mexican craftsmen
persisted in their traditional design
and construction of furniture based on
Spanish models. Unusual in that it can
be traced to its maker, Manuel Arch-
uleta, this chair has the rigid form and
shallow carving found on earlier chairs
from New Mexico. It represents a style
that prevailed in Spain after the late
seventeenth century.*

Ref.: Colorado Springs Fine Arts
Center, *The Way West: American Fur-
niture in the Pikes Peak Region, 1872-
1972* (Colorado Springs, 1972).

284
George Kirkham
Parlor table
Ca. 1889-1893; Salt Lake City, Utah;
pine and mixed wood inlay, h. 29½ in.,
diam. (top) 32½ in.
Utah Pioneer Village, Salt Lake City

*During the period of 1889-1893, while
doing finish carpentry work in the
Salt Lake Temple, George Kirkham
collected scraps of moldings, banisters,
door and floor trimmings and fash-
ioned them into this table top. On it
also appear small blocks of marble and
granite. The largest piece in the table
is a trimming from the east front door
of the temple. The glass covering the
temple picture is a scrap of an acci-
dentally broken plate glass window.
A novelty, the table clearly reveals the
interests Mormons had in their own
history even as it was in the making.*

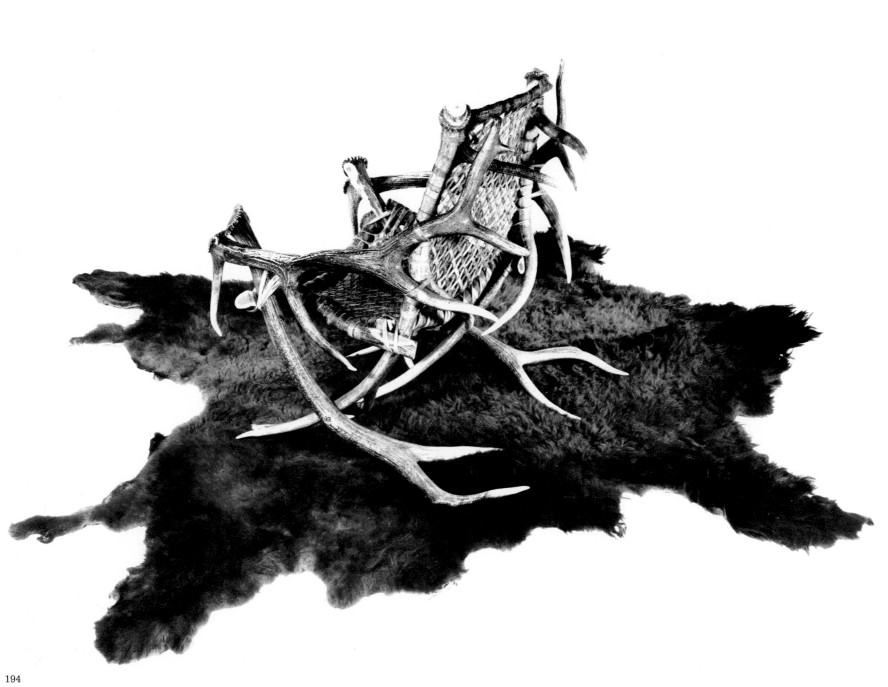

287

Armchair

Ca. 1900; Riverton or Lander, Wyoming; elk antlers with rawhide thong back and seat, h. 35 in., w. 33 in., d. 33 in.
Wyoming State Archives and Historical Department, Cheyenne

The mountainous regions of Wyoming were filled with elk and moose, which were hunted chiefly for sport. The ingenious combination of elk antlers and webbed rawhide seat in this chair make the Rocky Mountain hunter's triumphs explicit.

288

Armchair

Ca. 1900; Wyoming; elk and moose antlers, h. 33 in., w. 28¾ in., d. 18 in.
Wyoming State Archives and Historical Department, Cheyenne

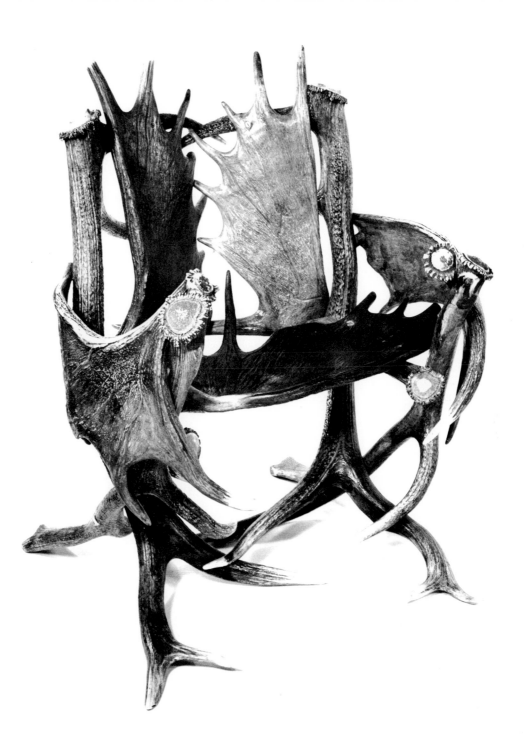

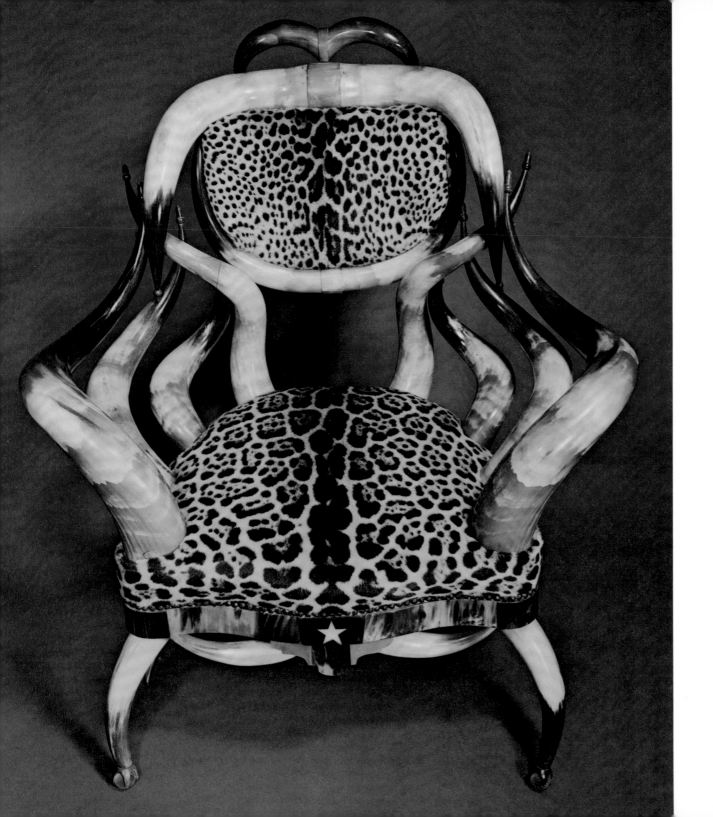

286
Wenzel Friedrich, 1827-1902
Rocking chair
Ca. 1880-1890; San Antonio, Texas;
steer horn and jaguar skin, h. 38½ in.,
w. 24 in., d. (seat) 22 in.
San Antonio Museum Association,
Gertrude and Richard Friedrich
Collection

*By the end of the nineteenth century
the frontier had been largely trans-
formed by settlement and by transpor-
tation links with the East. As the
frontier vanished, writers, artists, and
even craftsmen searched eagerly for
the rustic look of the Old West. Furni-
ture made from the horns of Texas
longhorn cattle was but one item
manufactured to meet public interest
and demand. This chair was ingeniously
cradled on iron springs for the ultimate
in rocking comfort. Today, horn furni-
ture is popularly associated with life
on the western frontier, yet much of it
was made for exhibitions, state fairs,
and for sale in the East, where it was
used in billiard rooms, libraries, and
rustic summer camps.*

Ref.: San Antonio Museum Associa-
tion, *Early Texas Furniture and Dec-
orative Arts* (San Antonio, 1973), p. 140,
no. 168.

8
Shelter on the Frontier: Adobe Housing in Nineteenth Century Utah

1. Benjamin G. Ferris, *Utah and the Mormons* (New York: Harper & Brothers, 1854), 13-15. Ferris was Secretary of the Utah Territory for six months between 1852 and 1853. While some of his observations are valuable, the woodcut illustrations in his book are not to be trusted, nor are many of his highly colored opinions.

2. At Winter Quarters, Florence, Nebraska, for example, a variety of housing was used. The diary of Hosea Stout recorded tents, log houses ("shanties," as Stout called them), and sod houses. One of the most unusual houses was that of Dr. Willard Richards: it was an octagon covered with dirt, of sufficient novelty to provoke such deriding names as "potato heap," "apple heap," "coal pit," "round house," "the doctor's den." *On the Mormon Frontier: The Diary of Hosea Stout, 1844-1861*, ed. Juanita Brook, 2 vols. (Salt Lake City: University of Utah Press, 1964), vol. 1, pp. 213, 217, 222 (hereafter referred to as *Stout Diary*).

It is a peculiar coincidence that at just the same time in the growth of this nation, in the 1840's and 1850's, a large section of American society was seeking and obtaining the ultimate in domestic comforts, by contrast, another group was sacrificing these comforts to settle the West. For many, the trials were hard; some even died from the rigors of the journey. But not all who crossed the great plains, mountains, and arid stretches found the effort overwhelming. According to a traveler in the Rocky Mountains in 1852, the experience was exhilarating: "The fatigue of traveling wears off in a very short time . . . There is a kind of cutting loose from the business regulations and customs of civilized life, which gives new freedom and elasticity to the mind . . . feelings and ideas expand in view of the boundless plains."[1] Part of the euphoria expressed in these words came from a sense of release from past constraints combined with a hope of creating a better world in the near future.

While the traveler moving west anticipated change, his basic needs remained the same and shelter was one of the most immediate of these. On the frontier, climate, defense, cheapness, and practicality were all factors that determined the forms adopted for housing. During the journey, temporary shelters were made. These are now known through drawings (no. 107), photographs, and contemporary descriptions. Tents, lean-tos, dugouts, caves, log and earth housing were used.[2] Some shelters were mobile. Wagons, Conestoga and others, were the classic movable shelters of the West; called prairie schooners, they were likened to ships on the vast sea of grassland, butte country, and turbulent mountain passes. Yet they were not considered mobile homes by their occupants. They were merely a means to an end, transporting goods, food, seed, tools, and family to new and, it was hoped, permanent homesteads. At the end of the journey, the wagon was frequently knocked apart and used for building material. Sometimes, parts of the wagon, such as the box, were attached to the pioneer's new house (fig. 1) or were used for

3. Some early log cabins have been preserved, such as the Osmyn Deuel cabin in Salt Lake City, illustrated here, which is supposed to have been built in September 1847. Other early examples in Utah are Miles Goodyear's cabin, ca. 1845, in Ogden, and one (once owned by George Lamar Wood) built in 1851 in Parowan, now moved to Cedar City.

4. Calvert Vaux, *Villas and Cottages* (New York: Harper & Brothers, 1857), 12-16, commented on and illustrated a log house "of considerable artistic treatment in a rural way." It was observed that it was a primitive expression worthy of the pioneer, who was frequently well educated, active, and energetic.

5. For an analysis of Mormon folk architecture, with an excellent study of the use of adobe, see Leon Sidney Pitman, "A Survey of Nineteenth-Century Folk Housing in the Mormon Culture Region," Ph.D. dissertation, Louisiana State University, 1973.

6. Further research may show that Mormons had built with adobe in the East. There are early adobe houses in Geneva, New York, an area from which many Mormons emigrated, but these buildings seem to date after the Mormon migration to the West.

storage and partial temporary shelter while the home was being built.

The traveler in the West today is likely to receive the impression that all shelters constructed by the pioneers were made of logs (fig. 2).[3] The popular belief in a log frontier is understandable, for even in the nineteenth century, the log house was considered a symbol of independence and self-assertion.[4] Yet, as part of a popular movement to better the lot of the working man, new experiments in housing were being explored. Since it was widely believed that good housing produced good people, there was compelling reason to develop new, practical building methods and materials for the frontier.

Traditional log, stone, frame, and brick construction required specialized skills and tools, but building with adobe (sun-dried brick made of mud and straw) could be mastered by almost anyone who had basic instructions and the simple wooden frames in which the bricks were molded. In addition, it was cheap and quick, and with care the material was durable. Adobe construction was thus well suited to frontier housing and was adopted by many settlers in the arid Far West, particularly by Mormons.[5] Study of building practices in a definable area of settlement such as the Great Basin offers insight into the nature of early settlement throughout the Far West. While many other methods of building were practiced on the frontier, they all shared certain traits in common with adobe construction. Whether the buildings were of sod, as in Nebraska and Kansas; or of *pisé* (rammed earth), as in Texas; or of sawn blocks of river clay, poured mud cement, wattle and daub, or half-timber construction with mud fill, they all had these characteristics in common: simplicity, functionalism, and use of local materials.

So far as can be determined, the Mormons first used adobe for building in Utah.[6] In their previous settlements at Nauvoo, Illinois, and elsewhere they had been skilled in the use of stone, brick, and wood. There is no record of Mormon use of adobe on the journey west.

Fig. 1
Don Loveridge house, Lehi, Utah,
1850-1855.
The earliest adobe house (now demolished) in Lehi for which a photograph survives. The wagon box is attached at right. (Photo John Hutchings Museum of Natural History, Lehi, Utah).

Fig. 2
Osmyn Deuel log house, Salt Lake
City, Utah, ca. 1847.
One of the earliest surviving log houses in Utah. A chimney of adobe bricks (not visible in the photograph) is bracketed into the log wall at right. (Photo Utah State Historical Society.)

The reasons why Mormons adopted adobe as a building material in the West seem clear. Wood was not plentiful in the arid western lands, and in the Salt Lake Valley it was conserved from the first. Since clay was abundant, the use of adobe was logical. But what was the source of the idea? Where did the Mormons learn the adobe craft? Certainly the spirit of the times nurtured the idea. For Mormons a new order of society was in the making. They were flexible and willing to try new ideas or adapt old ones to their needs. The origin of the idea is also to be found in the term "adobe," or "dobie," which was consistently used by Mormons when referring to sun-dried brick. Since the word has a Spanish derivation, the idea must have come from Spanish-Mexican contacts.

According to the Journal History of the Church, Mormons adopted the use of adobe on the advice of Colonel A. P. Rockwood and other members of the Mormon Battalion who, during a journey to Sante Fe, had seen construction with this material at Fort Pueblo and at Bent's Fort, which was built by New Mexicans on the Arkansas River. The appeal was cheapness and speed of construction. Supporting the advice of these veterans, Elder Samuel Brannan, who had sailed with a group of Mormons from New York to California, claimed that he had had his printing office in San Francisco constructed of adobe in fourteen days. The proposal to build in the Spanish mode was accepted, and in 1847 it was voted that the fort in the Salt Lake Valley would be made of adobe. This was the first recorded use of the material by Mormons.[7]

Although the idea for building in adobe came from the Spanish Southwest and from California, it is unlikely that knowledge of the craft was derived entirely in this way. The size of adobe bricks in most Mormon buildings suggests another possibility. They are significantly smaller than the Spanish-American bricks. While some variations exist between the bricks from different Mormon settlements, they generally measure about 12 in. long, 4 in. thick, and 6 in. wide. In the Spanish

7. The Journal History of the Church records that on August 2, 1847, "some of the brethren were . . . making adobes." For additional information on church manuscript sources, see Leonard J. Arrington, *Great Basin Kingdom: An Economic History of the Latter-day Saints, 1830-1900* (Cambridge: Harvard University Press, 1958), 415-420.

Southwest, bricks also vary with the makers' molds, but on the average they measure 18 in. long, 4 to 6 in. thick, and 10 in. wide. The smaller dimensions of most Mormon-made bricks correspond closely to those suggested in articles published in the East, which propagandized the use of sun-dried bricks for homes on the prairies. These articles were available to Mormons in 1846, when leaving their homes in Nauvoo, Illinois. The earliest United States publication discussing sun-dried bricks was issued as a report for the year 1843 by the first Commissioner of Patents, Henry L. Ellsworth of Washington, D.C. Information for Ellsworth's article was taken from the *British American Cultivator* of Toronto, where it was claimed that houses of sun-dried brick had already proved useful to Canadian settlers.[8]

In the next year Ellsworth reported again on the subject. This time he offered plans and elevations for an adobe house suitable for the prairies. He claimed success in putting up buildings of sun-dried brick in Washington, D.C., and in Grand Prairie, Indiana. A direct copy of Ellsworth's second report was published by John Bullock in *The American Cottage Builder* in 1854, where the plan offered by Ellsworth was entitled "The Prairie Cottage."[9] Even sixteen years later Fowler and Wells, publishers who specialized in phrenological texts and advised everyone to build octagon houses, again echoed Ellsworth's message about sun-dried bricks.[10] *The Horticulturist*, certainly one of the most influential publications of its day, did not fail to recognize a good thing. In July 1847 a design for a rural cottage was reproduced with the advice that it could be built very cheaply with "the large unburnt brick now coming into use in many parts of the country."[11]

Probably of greater consequence to the Mormons were the articles in their local newspaper, *The Nauvoo Neighbor,* in 1845 and 1846, which discussed advantages and methods of sun-dried brick construction. Also, those looking forward to heading west studied L. W. Hastings'

8. U.S. Commissioner of Patents, *Annual Report,* 1843 (Washington, D.C., 1844), 239-241; idem, *Annual Report,* 1844 (Washington, D.C., 1845), 450-454.

9. John Bullock, *The American Cottage Builder: A Series of Designs, Plans, and Specifications from $200 to $20,000. For Homes for the People* (New York: Stringer & Townsend, 1854), 37-41.
10. *The House: A Pocket Manual of Rural Architecture* (New York: Fowler and Wells, 1859), 160.

11. *The Horticulturist,* July 1847, pp. 18-20.

12. For additional analysis of possible sources see Pitman, pp. 47-48.

Emigrant's Guide, which contained a description of adobe buildings by Mexicans in California.[12] The opportunities for Mormons to know about adobe buildings were therefore many. Even on the trail they passed Fort Laramie as well as other old adobe forts on the North Platte.

To what extent the writings on adobe were noticed is difficult to guess, but the buildings themselves were observed. And the Mormon leaders, who were good planners, undoubtedly collected all the useful information available as they headed west into what was then Mexican territory. From the evidence gathered, it would seem, then, that this practice came about through a convergence of ideas from the Spanish Southwest and Spanish California, from experiences on the trail, and from publications from the East.

The first building erected by the Mormons after arriving in the Salt Lake Valley in 1847 was the fort (no longer standing). It consisted of a series of small one-story houses that faced into the courtyard, their outside walls forming the walls of the fort. Three sides of the fort were made of adobe. The east side was made of logs.[13] Within a year there were two and a half fortress blocks of this type in the new settlement. But it was clear from the original plan for the projected city that fortresses were only a small part of the whole. It was planned that the city would contain fifteen to twenty thousand church members.

13. *Stout Diary,* vol. 2, p. 326.

Although some early Mormon homes were of wattle and daub, or of frame, log, or stone, the most typical and recognizable early Mormon house was of adobe. Symmetrical in appearance from the front, the earliest single adobe homes were usually one story in height and rectangular in plan. The central doorway was flanked by windows balanced on each side with corresponding chambers almost equally divided within. The back of the house usually had an attached wing, forming an "L." This early, simple house probably echoed the general pattern established by the individual house unit of the early forts.

14. Interviews with John Hutchings, in 1958, and information in Hamilton Gardner, *History of Lehi* (Salt Lake City: Deseret News Press, 1913), formed the basis of my study of adobe buildings in that city.

To see today surviving buildings typical of early settlement, one must turn to an undisturbed rural Mormon village such as Lehi, about thirty miles south of Salt Lake City (figs. 3, 4).[14] The William H. Winn house, still in use, belongs to a class of dwelling built for a moderately successful community leader. With stuccoed walls, it would hardly be suspected by the casual observer as being an early adobe house. The earliest homes, usually built with the owner's own hands, have a certain honest simplicity. The use of local materials and the handmade quality of these buildings attest to resourcefulness, self-help, and prag- matism—characteristics typical of the crafts during the first phase of settlement. More than one pioneer proudly recorded how he or she put up an adobe house with little or no help, no elaborate tools, few nails, and a minimum of purchased lumber, glass, and manufactured goods. Those willing to barter goods or services usually had their home con- structed for almost no cash outlay.

After the initial phase of colonization, the character of most adobe buildings changed. Trained builders found that their skills were in steady demand in the settlements; hence it was possible to produce more advanced buildings, better made, with ornamental detail that surpassed the talents of the average settler. Consistency of workmanship and imaginative detail may be found in certain Utah villages that point to local builders or a team of builders who were popular in the area. In Lehi, for example, a group of adobe homes shows a flair for the carved bargeboard (fig. 5) reminiscent of designs published by eastern taste- makers A. J. Downing and Calvert Vaux.

Prosperity and increased families caused many Mormons to move from their earliest homes to more developed housing. The improvements that took place in Brigham Young's household, for example, in less than a decade may be seen by comparing his first adobe home with his later, more famous, adobe villa called the Beehive House (figs. 6, 7).

Fig. 3
Hans Hammer house, Lehi, Utah,
1855-1858. Stucco over adobe.
From these quarters, Hammer, who
came to this country from Denmark in
1853, conducted a mercantile store,
hotel, livery stable, barber shop, and
delivery business. Part of the back of
the house was used as a shop by a
silversmith and goldsmith, Abe
Gudmunsen.

Fig. 4
William H. Winn house, Lehi, Utah, ca.
1859. Stucco over adobe with stone base.

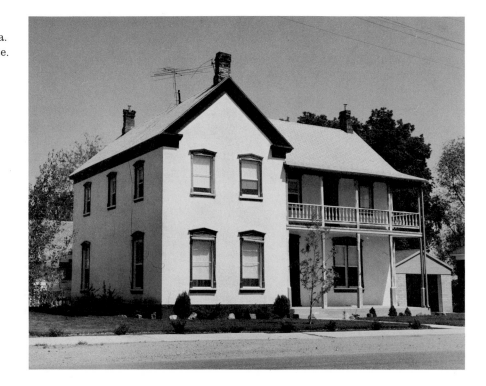

Fig. 5
Thomas Smith house, Lehi, Utah,
1860-1880. Unsurfaced adobe.
This house, which resembles several
others in the area, was the work of a
skilled builder and marks the second
phase of pioneer construction in adobe.
Picturesque in external appearances, it
is severely symmetrical in plan. The
walls have a thickness of three adobe
bricks.

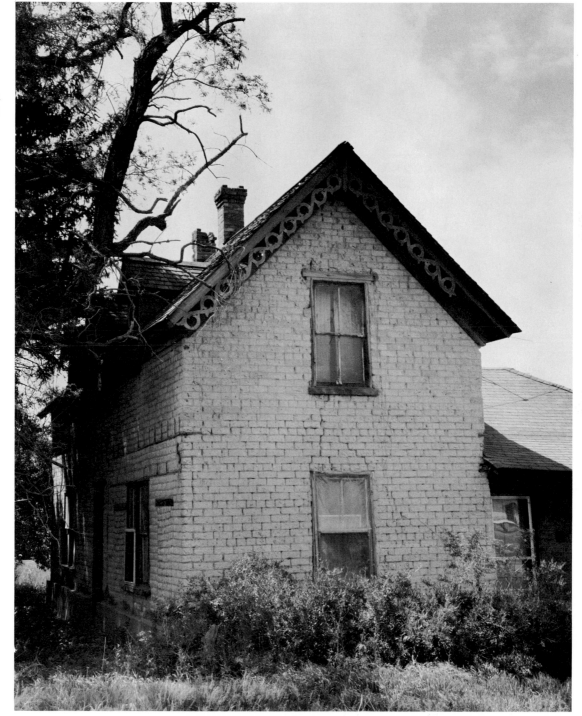

A vivid, contemporary description of Salt Lake City and its adobe houses appears in the writings of the famous British explorer Richard Burton (best known, perhaps, for his expedition in search of the source of the Nile):

"At a little distance the aspect was somewhat Oriental, and in some points it reminded me of modern Athens—without the Acropolis. None of the buildings, except the Prophet's house, were whitewashed. The material—the thick, sun-dried adobe, common to all parts of the Eastern world—was of a dull leaden blue, deepened by the atmosphere to a grey, like the shingles of the roofs . . . The houses are almost all of one pattern—a barn shape, with wings and lean-tos, generally facing, sometimes turned endways to, the street, which gives a suburban look to the settlement; and the diminutive casements show that window-glass is not yet made in the Valley. In the best abodes the adobe rests upon a few courses of sandstone, which prevent undermining by water or ground-damp, and it must always be protected by a coping from the rain and snow. The poorer are small, low, and hut-like; others are long single-storied buildings, somewhat like stables, with many entrances."[15]

15. Richard F. Burton, *The City of the Saints and across the Rocky Mountains to California* (London: Longman, Green, Longman and Roberts, 1861), 244, 246.

While there were others on the frontier who built with adobe earlier than 1847, it was the Mormons who became the first of the Anglo-American subcultures to fully incorporate adobe as an integral part of their material folk tradition. For Mormons, adobe became accepted as the way to build almost from the moment of settlement, irrespective of the settler's former background. Barns, chicken pens, lean-tos, saw mills, outbuildings, and blacksmiths' shops (no. 297)—every type of building was made of adobe. Because it was so practical and cheap, its use lingered in the face of progress. Even when new building materials and techniques were adopted, some Mormons remembered the insulating qualities of adobe and used it to line their new brick homes.

In Brigham Young's opinion, adobe was the perfect building ma-

Fig. 6
The first two adobe homes of Brigham
Young, Salt Lake City, Utah, 1849.
(Photo Utah State Historical Society).

Fig. 7
The Beehive House, Salt Lake City,
Utah, 1853-1855. Architect: Truman O.
Angell.
*Of stucco and adobe on a sandstone
base, this house was the official resi-
dence of Brigham Young. At right is
the gate with wooden eagle carved by
Ralph Ramsay in 1859. The eagle is now
in the museum of the Daughters of
Utah Pioneers. Photographed prior
to restoration. (Photo Utah State
Historical Society.)*

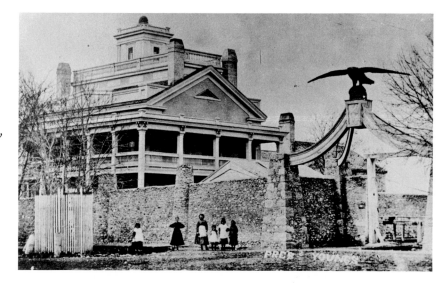

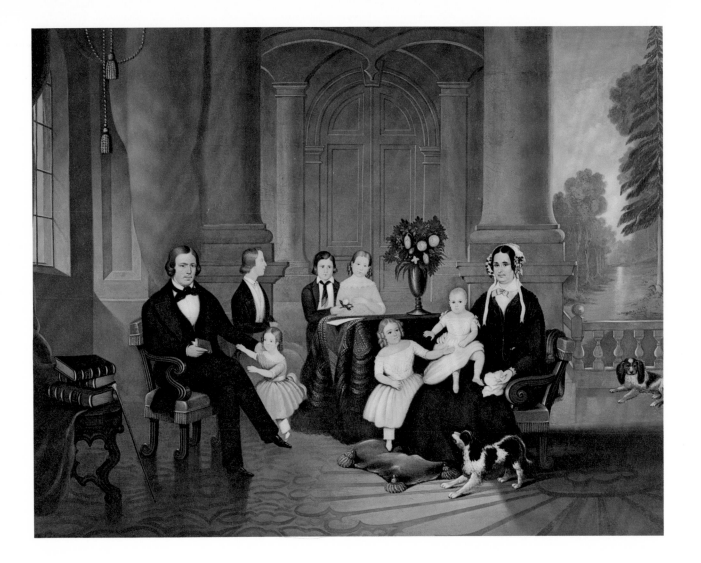

292

William Warner Major, 1804-1854
Brigham Young's Family
1840-1850; Salt Lake City, Utah; oil on
canvas, 25 x 33 in. (unframed)
Church of Jesus Christ of Latter-day
Saints, Salt Lake City

*This idealized portrait of the Brigham
Young family was made by an English
artist, William Warner Major, who
joined the Mormon Church in Nauvoo
in 1844. He sketched and painted dur-
ing the journey across the continent to
Utah from 1846 to 1848. Called on a
Church mission to England in 1853,
Major died in London the following
year.*

terial. He believed that it would outlast any stone—marble, sandstone, or limestone. He reasoned that adobe was immature stone and that stone, having reached its zenith of maturity must, of necessity, decay. But adobe, he felt, would harden with the ages to become stone and hence would have greater longevity. Using this "chemical argument," he made a long and picturesque address to the General Conference of members of the Church in Salt Lake City urging a decision to construct the Salt Lake Temple building of adobe rather than stone.[16] The walls surrounding the temple block were built of adobe facing a core of sandstone. They stand to this day. The temple itself, however, despite Young's advice, was built of granite (no. 328). Cut from the mouth of Little Cottonwood Canyon, the building of the Salt Lake Temple was the work of a younger generation.

By the third quarter of the nineteenth century, building crafts using local materials and hand labor were making way for modern technology in many urban centers of the West. In Salt Lake City the monumental façade of Zion's Cooperative Mercantile Institution of 1876 (no. 294) signaled the triumph of cast iron over alluvial clay.

JONATHAN L. FAIRBANKS

16. Brigham Young, *Journal of Discourses* (London: F. D. and S. W. Richards, 1854), vol. 1, p. 220.

107

Frederick Piercy, 1830-1891
Elk Horn River Ferry (Nebraska)
1853; pencil and brown wash;
6½ x 10⅛ in.
Museum of Fine Arts, Boston, M. & M.
Karolik Collection
(Shown in Boston, Denver, and San
Diego.)

*A broken wheel delayed the Mormon
wagon train accompanied by Frederick
Piercy on the trail heading west. While
the wheel was being repaired, the artist
sketched this view showing two differ-
ent types of tents. The canvas tent was
easily removed from site to site. The
other, more cumbersome shelter made
of skins, poles, and perhaps oilcloth
seems less temporary. Behind the latter
can be seen poles that secured the tow
rope for the ferry boat, which carried
wagons across the river. Animals in
the wagon train, according to Piercy's
account, reluctantly swam the nine-
rod river.*

*Illustrated guidebooks such as
Piercy's were of assistance to emi-
grants traveling across the country in
search of a new home.*

Refs.: Frederick Hawkins Piercy, *Route
from Liverpool to Great Salt Lake
Valley* (Liverpool, 1855; reprint ed.,
Cambridge: Harvard University Press,
1962), p. 801, pl. XXII; Museum of Fine
Arts, Boston, *M. & M. Karolik Collec-
tion of American Water Colors &
Drawings, 1800-1875* (Boston, 1962),
vol. 2, pp. 37-39.

108

Frederick Piercy, 1830-1891
View of Great Salt Lake City
1853; pencil, 6⅞ x 10⅜ in.
Museum of Fine Arts, Boston, M. & M.
Karolik Collection

This view of Salt Lake City, looking south, was made six years after the Mormons had entered the valley. It shows buildings chiefly made of adobe. The view is from the north bench of the city, above Heber C. Kimball's house, which can be seen in the foreground, left of East Temple Street. The picture was made with a camera lucida, a viewing device helpful in making accurate renderings. Pleased with the drawing, Piercy claimed that "it may be presented as a faithful portrait of Great Salt Lake City in 1853."

Refs.: Frederick Hawkins Piercy, *Route from Liverpool to Great Salt Lake Valley* (Liverpool, 1855; reprint ed., Cambridge: Harvard University Press, 1962), p. 128, pl. XXXIII; Museum of Fine Arts, Boston, *M. & M. Karolik Collection of American Water Colors & Drawings, 1800-1875* (Boston, 1962), vol. 2, pp. 37-39.

115

Peter Petersen Tofft, 1825-1901
My Cabin on Elk Creek, Montana Territory
1866; watercolor, 8⅝ x 10⅝ in.
Museum of Fine Arts, Boston, M. & M. Karolik Collection
(Shown in Boston, Denver, and San Diego.)

Born in Denmark, Peter Tofft was an itinerant artist who traveled in the American Northwest from 1865 through 1867. His many views of the Montana Territory were intended to illustrate a series for Harper's *magazine, "Rides through Montana" by Thomas Francis Meagher, acting governor of the state. This watercolor of the artist's cabin is an invaluable, candid record of the unrefined interiors of early frontier housing.*

Ref.: Museum of Fine Arts, Boston, *M. & M. Karolik Collection of American Water Colors & Drawings 1800-1875* (Boston, 1962), vol. 2, p. 46.

297

George Edward Anderson, 1860-1928
Joseph Thurber, blacksmith, Richfield, Utah, ca. 1880-1890
Photograph, modern enlargement made from original glass plate negative
Harold B. Lee Library, Brigham Young University, Provo, Utah

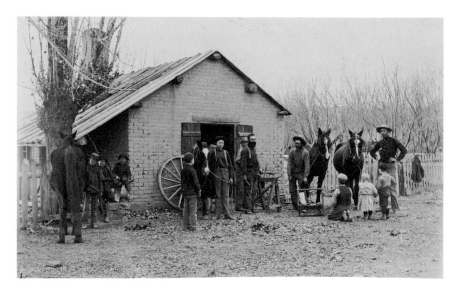

Checklist

Titles of pictorial works in quotation marks are those assigned by the artist or photographer. For drawings and watercolors, description of paper is given only when it is other than white. Dimensions are to the nearest one-eighth inch. An asterisk signifies that the work is illustrated in the catalogue.

1*
Palette
Ca. A.D. 700-900; Hohokam, Kinishba Ruin, southern Arizona; slate, h. 7 in., w. 3 in.
Arizona State Museum, Tucson

2*
Stele
Prehistoric; Sauvie Island, Columbia River, Oregon; granite with traces of red and white paint, h. 30 in., w. 11 in., d. 9 in.
Oregon Historical Society, Portland

3-6*
Four figurines
Ca. A.D. 1000; Fremont-Provo culture area, Hinckley Farm site, Utah Lake; unbaked clay, h. 3⅜ in., 3¼ in., 2¾, 2⅛ in.
Brigham Young University, Provo, Utah

7*
Figurine in twined rod cradle
Ca. A.D. 950-1200; Fremont-Provo culture area, Wayne County, Utah; bark strands, reeds, clay, skins, cloth, and twine, h. 5 in., w. 9 in., l. 16½ in.
The Church of Jesus Christ of Latter-day Saints, Salt Lake City

8*
Pelican
Ca. A.D. 800-1000; southern California Indian; steatite, h. 3½ in., w. 2¼ in., d. 2½ in.
Southwest Museum, Los Angeles

9*
Whale
Ca. A.D. 800-1000; southern California Indian; steatite, h. 4¼ in., w. 6⅜ in., d. 2¼ in.
Peabody Museum of Archaeology and Ethnology, Harvard University

10
Boat
Prehistoric; Santa Barbara, California Indian; steatite, h. 2⅞ in., w. 6¾ in., d. 3¼ in.
Southwest Museum, Los Angeles

11*
Jar
Ca. A.D. 900-1200; Hohokam, Snaketown site, Arizona; red earthenware with red and white slip, h. 5 in., diam. (top) 7½ in.
Arizona State Museum, Tucson

12
Censer
Ca. A.D. 900-1200; Hohokam, Snaketown site, Arizona; red earthenware with red and white slip, h. 1¾ in., diam. (top) 4¼ in.
Arizona State Museum, Tucson

13
Bowl
Ca. A.D. 1200-1400; Hohokam, Las Acequias site, lower Salado Valley, Arizona; red earthenware with white, black, and red slip, h. 3½ in., diam. (top) 6½ in.
Peabody Museum of Archaeology and Ethnology, Harvard University

14
Bowl
Ca. A.D. 1000-1200; Mogollon culture, Mimbres Valley, Grant County, New Mexico; gray earthenware with black and white slip, h. 4½ in., diam. (top) 8½ in.
Peabody Museum of Archaeology and Ethnology, Harvard University

15*
Bowl
Ca. A.D. 1000-1200; Mogollon culture, Mimbres Valley, southwest New Mexico; red earthenware with white and black slip; h. 3½ in., diam. (top) 7¾ in.
The Denver Art Museum

16*
Vessel in human form
Ca. A.D. 1050-1350; Anasazi culture, Pueblo III, Chaco Canyon, New Mexico; gray earthenware with white and black slip, h. 7¼ in., w. 4½ in., d. 5 in.
Peabody Museum of Archaeology and Ethnology, Harvard University

17
Mug
Ca. A.D. 1050-1350; Anasazi culture, Pueblo III, La Plata Valley, New Mexico; gray earthenware with black and white slip, h. 3½ in., diam. (top) 4 in. (without handle)
Peabody Museum of Archaeology and Ethnology, Harvard University

18*
Blade
Ca. A.D. 1050-1350; Anasazi culture, Pueblo III, Poncho House, Utah, Kayenta region; limestone, inlaid with turquoise, h. 4½ in., w. 2¼ in.
Peabody Museum of Archaeology and Ethnology, Harvard University

19
Jar in bird form
Ca. A.D. 1200; Anasazi culture, Socorro County, New Mexico; gray earthenware with black and white slip, h. 7¾ in., d. 5¼ in., w. 8 in.
Museum of the American Indian, Heye Foundation, New York

20
Jar
Ca. A.D. 1050-1300; Anasazi culture, Pueblo III, northeast Arizona, Kayenta region; gray earthenware with black and white slip, h. 3½ in., diam. (top) 4 in.
Museum of Northern Arizona, Flagstaff

21

Bowl
Ca. A.D. 1050-1300; Anasazi culture,
Pueblo III, northeast Arizona; gray
earthenware with black and white slip,
h. 2¼ in., diam. 5¾ in.
Museum of Northern Arizona,
Flagstaff

22

Bowl
Ca. 1630-1700; Pueblo culture, Spanish
Mission period, Antelope Mesa, Awa-
tovi, Arizona; gray earthenware with
polychrome slip, h. 4¾ in., diam. (top)
13¼ in.
Peabody Museum of Archaeology and
Ethnology, Harvard University

23

Bowl
Ca. A.D. 1400-1630; Pueblo IV culture,
Sikyatki style, northern Arizona; red
earthenware with white, black, and
red slip, h. 4½ in., diam. (top) 11 in.
Peabody Museum of Archaeology and
Ethnology, Harvard University

24*

Titian Ramsay Peale, 1799-1855
American bison bull
Ca. 1819; watercolor, 6⅛ x 8¼ in.
Kennedy Galleries, Inc., New York

25

Titian Ramsay Peale, 1799-1855
Bobcat
1819; watercolor, 4¼ x 6⅜ in.
Kennedy Galleries, Inc., New York

26*

Samuel Seymour, 1797-1822
*"View near the base of the Rocky
Mountains"*
1820; watercolor, 5½ x 8¼ in.
The Beinecke Rare Book and Manu-
script Library, Yale University
(Shown in Boston only.)

27

Samuel Seymour, 1797-1822
*"Indian Record of a battle between the
Pawnees and Konzas, being a Facsimile
of a delineation upon a Buffalo Robe"*
Ca. 1820; watercolor, 5½ x 7⅜ in.
The Beinecke Rare Book and Manu-
script Library, Yale University
(Shown in Boston only.)

28*

Samuel Seymour, 1797-1822
"Kaskaia, Shienne Chief, Arrappaho"
1820; watercolor, 4¾ x 6 in.
The Beinecke Rare Book and Manu-
script Library, Yale University
(Shown in Boston only.)

29*

Peter Rindisbacher, 1806-1834
*"A Party of Indians—Aesseneboines
[sic]"*
Ca. 1821-1824; watercolor, 7⅞ x 9⅞ in.
The Denver Art Museum

30

George Catlin, 1796-1872
*Big Bend on the Upper Missouri, 1900
Miles above St. Louis*
1832; oil on canvas, 11⅛ x 14⅜ in.
National Collection of Fine Arts,
Washington, D.C.

31*

George Catlin, 1796-1872
*Back View of Mandan Village, Show-
ing Cemetery*
1832; oil on canvas, 11⅛ x 14⅜ in.
National Collection of Fine Arts,
Washington, D.C.

32*

George Catlin, 1796-1872
Old Bear, A Mandan Medicine Man
1832; oil on canvas, 29 x 24 in.
National Collection of Fine Arts,
Washington, D.C.

33

George Catlin, 1796-1872
*Buffalo Chase: A Surround by the
Hidatsa*
1832; oil on canvas, 22⅝ x 27⅝ in.
National Collection of Fine Arts,
Washington, D.C.

34

George Catlin, 1796-1872
*Bear Dance: Preparing for a Bear
Run*
1832; oil on canvas, 19½ x 27½ in.
National Collection of Fine Arts,
Washington, D.C.

35

George Catlin, 1796-1872
White Buffalo
1832; oil on canvas, 29 x 24 in.
National Collection of Fine Arts,
Washington, D.C.

36*

I. Hurlimann after Karl Bodmer,
1809-1893
Mato-Tope
1842-1844; hand-colored engraving,
16⅝ x 11¾ in. (plate), 23⅝ x 17½ in.
(overall)
Museum of Fine Arts, Boston, M. & M.
Karolik Collection
(Shown in Boston, Denver, and San
Diego.)

37

P. Legrand after Karl Bodmer,
1809-1893
Snake and Cree Indian Women
1842-1844; hand-colored engraving,
14½ x 18⅜ in. (plate), 17½ x 23¾ in.
(overall)
Museum of Fine Arts, Boston, M. & M.
Karolik Collection
(Shown in Kansas City and
Milwaukee.)

38*

Alfred Jacob Miller, 1810-1874
The Indian Guide
1837; pen and ink with gray wash on
buff card, 9 x 11 in.
The Denver Art Museum

39

Alfred Jacob Miller, 1810-1874
"Beating a Retreat"
After 1842; oil on canvas, 29 x 36 in.
Museum of Fine Arts, Boston, M. & M.
Karolik Collection

40*

Alfred Jacob Miller, 1810-1874
Fort Laramie
1836-1837; watercolor, 7½ x 11⅝ in.
The Beinecke Rare Book and Manu-
script Library, Yale University
(Shown in Boston only.)

41*

Alfred Jacob Miller, 1810-1874
Indians Fording a River, Oregon
Ca. 1837; pencil and brown wash,
6 x 9⅝ in.
Museum of Fine Arts, Boston, M. & M.
Karolik Collection
(Shown in Boston, Denver, and San
Diego.)

42

Alfred Jacob Miller, 1810-1874
*"Snake Indian Pursuing Crow Horse
Thief*
1837; watercolor and gouache,
7½ x 10⅞ in.
Museum of Fine Arts, Boston, M. & M.
Karolik Collection
(Shown in Kansas City and
Milwaukee.)

43*

James William Abert, 1820-1871
*Creek Indian Family on the Upper
Arkansas*
1845; wash drawing, 8⅜ x 10½ in.
The Amon Carter Museum, Fort
Worth, Texas

44*

Paul Kane, 1810-1871
A Sketch on the Pelouse
1847; oil on canvas, 20¾ x 30 in.
Royal Ontario Museum, Toronto

45*
Paul Kane, 1810-1871
Medicine Mask Dance
1847; oil on canvas, 17½ x 28¾ in.
Royal Ontario Museum, Toronto

46
Paul Kane, 1810-1871
Half Breeds Running Buffalo
1846; oil on canvas, 19¾ x 29¾ in.
Royal Ontario Museum, Toronto

47
Paul Kane, 1810-1871
Return of a War Party
1847; oil on canvas, 19¾ x 29¼ in.
Royal Ontario Museum, Toronto

48*
Seth Eastman, 1808-1875
*"Front View of the Mission Chapel of
San José, 5 miles from San Antonio,
Texas, Nov. 1848"*
1848; pencil on paper, 4¾ x 7¾ in.
Marion Koogler McNay Art Institute,
San Antonio, Texas

49
Seth Eastman, 1808-1875
San Antonio
1849; watercolor, 5 x 7⅞ in.
Museum of Fine Arts, Boston, M. & M.
Karolik Collection
(Shown in Boston, Denver, and San
Diego.)

50*
John Mix Stanley, 1814-1872
Chain of Spires along the Gila River
Ca. 1848; oil on canvas, 31 x 42 in.
Phoenix Art Museum, Museum Pur-
chase 68/20, Phoenix, Arizona

51
Richard Kern, 1821-1853
*"Hos-Ta (The Lightning). Governor of
the Pueblo at Jémez. Aug. 20."*
1849; watercolor, 8¾ x 5¾ in.
The Academy of Natural Sciences of
Philadelphia

52*
Richard Kern, 1821-1853
*"North west view of the Ruins of the
Pueblo Pintado in the Valley of the Rio
Chaco. No. 1 Aug. 26."*
1849; ink and wash, 6 x 9½ in.
The Academy of Natural Sciences of
Philadelphia

53*
Richard Kern, 1821-1853
*"Ruins of an Old Pueblo in the Cañon
of Chelly. Sept. 8th"*
1849; ink and wash, 9¼ x 5 in.
The Academy of Natural Sciences of
Philadelphia

54*
William Birch McMurtrie, 1816-1872
*Mt. Saint Helen's from the Mouth of
the Columbia River*
Ca. 1850; watercolor, 9⅛ x 13 in.
Museum of Fine Arts, Boston, M. &. M.
Karolik Collection
(Shown in Kansas City and
Milwaukee.)

55
William Birch McMurtrie, 1816-1872
Mt. Baker from Puget Sound
Ca. 1850; watercolor, 7⅜ x 12⅞ in.
Museum of Fine Arts, Boston, M. & M.
Karolik Collection
(Shown in Boston, Denver, and San
Diego.)

56
William Birch McMurtrie, 1816-1872
Shoshone Falls, Snake River, Idaho
Ca. 1850; pencil and watercolor washes,
7⅛ x 10½ in.
Museum of Fine Arts, Boston, M. & M.
Karolik Collection
(Shown in Boston, Denver, and San
Diego.)

57
William Birch McMurtrie, 1816-1872
Sand Bar, Oregon
Ca. 1850; watercolor, 8⅝ x 11½ in.
Museum of Fine Arts, Boston, M. & M.
Karolik Collection
(Shown in Kansas City and
Milwaukee.)

58*
Rudolph Friedrich Kurz, 1818-1871
"Crow Family Crossing the Missouri"
1851; ink and wash drawing,
10 x 14⅛ in.
Museum of Fine Arts, Boston, M. & M.
Karolik Collection
(Shown in Boston, Denver, and San
Diego.)

59*
Rudolph Friedrich Kurz, 1818-1871
"Herantsa Children Playing"
1851; pencil and pen, 10½ x 14¼ in.
Museum of Fine Arts, Boston, M. & M.
Karolik Collection
(Shown in Kansas City and
Milwaukee.)

60
Rudolph Friedrich Kurz, 1818-1871
Herd of Buffalo Fording a River
1851; charcoal drawing, 12⅛ x 18⅝ in.
Museum of Fine Arts, Boston, M. & M.
Karolik Collection
(Shown in Boston, Denver, and San
Diego.)

61
Gustav Sohon, 1825-1903
Gate of the Columbia
Ca. 1854; pencil drawing on toned chalk
ground, 10 x 14 in.
National Archives, Washington, D.C.
(Shown in Boston only.)

62
Gustav Sohon, 1825-1903
*" 'Bird Tail Rock.' as seen from the
East. 'Bird Tail Rock' as seen from the
West"*
Ca. 1854; pencil on toned chalk ground,
10 x 14 in.
National Archives, Washington, D.C.
(Shown in Boston only.)

63
Henry Cheever Pratt, 1803-1880
View in the Canyon of the Coppermine
1855; oil on canvas, 30 x 44 in.
Vose Galleries of Boston, Inc., Boston

64
Henry Cheever Pratt, 1803-1880
Old Fort at El Paso
1853; oil on canvas, 30 x 50 in.
Texas Memorial Museum, University
of Texas, Austin

65
James M. Alden, 1810-1877
*"Castle Rock or 'McLeod's Castle,'
right bank of the Columbia River.
(Cascades of the Columbia)"*
1857-1862; watercolor over pencil,
9⅜ x 12⅛ in.
National Archives, Washington, D.C.
(Shown in Boston only.)

66
James M. Alden, 1810-1877
*" 'Mt. Kirby' from 'Mt. Spence' (the 2
peaks of Kishnehnehna Mountain)
looking N."*
1857-1862; watercolor, 9 x 12 in.
National Archives, Washington, D.C.
(Shown in Boston only.)

67
James M. Alden, 1810-1877
*"Cascade of the left bank of the Colum-
bia River (Cascades of the Columbia)."*
1857-1862; watercolor and pencil,
9⅜ x 12⅛ in.
National Archives, Washington, D.C.
(Shown in Boston only.)

68
James M. Alden, 1810-1877
" 'Aspen Camp' (27 miles from Cow
Creek) looking N. trail from Palouse R.
to Plank' Crossing on the Spokane."
1857-1862; watercolor, 10½ x 17 in.
National Archives, Washington, D.C.
(Shown in Boston only.)

69*
Joseph Heger, 1835-1897
"Camp Floyd, Ceder Valley, Utah,
July, 1858"
1858; pencil, 5⅞ x 10½ in.
The Beinecke Rare Book and Manu-
script Library, Yale University
(Shown in Boston only.)

70*
Albert Bierstadt, 1830-1902
Indians near Fort Laramie
1858; oil and paper mounted on card-
board, 13½ x 19½ in.
Museum of Fine Arts, Boston, M. & M.
Karolik Collection

71*
Albert Bierstadt, 1830-1902
View from the Wind River Mountains,
Wyoming
1860; oil on canvas, 30¼ x 48¼ in.
Museum of Fine Arts, Boston, M. & M.
Karolik Collection

72*
Albert Bierstadt, 1830-1902
The Rocky Mountains, Lander's Peak
1863; oil on canvas, 44⅝ x 36½ in.
Fogg Art Museum, Harvard University

73
Albert Bierstadt, 1830-1902
Yosemite Valley, Glacier Point Trail
After 1872; oil on canvas, 54 x 84⅝ in.
Yale University Art Gallery, Gift of
Mrs. Vincenzo Ardenghi

74*
Antoin Schonborn
"Red Buttes of Powder River"
Ca. 1859-1860; watercolor, 7 x 9⅞ in.
The Beinecke Rare Book and Manu-
script Library, Yale University
(Shown in Boston only.)

75
Worthington Whittredge, 1820-1910
Long's Peak, Colorado
1865; oil on canvas, 14½ x 22 in.
Museum of Fine Arts, Boston, M. & M.
Karolik Collection

76*
Timothy O'Sullivan, 1840-1882
Expedition Exploring Boat, Truckee
River
Geological Exploration of the Fortieth
Parallel. Clarence King, Geologist in
charge.
1867; photograph, 8 x 10⅝ in. (image),
16¾ x 21¾ in. (overall)
The Library of Congress, Washington,
D.C.
(Shown in Boston only. Copy print to
travel.)

77*
Timothy O'Sullivan, 1840-1882
Pyramid Lake, Nevada
U.S. Engineer Department Geological
Exploration Fortieth Parallel
1867; photograph, 7¾ x 10⅝ in.
(image), 18 x 24 in. (overall)
The Beinecke Rare Book and Manu-
script Library, Yale University
(Shown in Boston only. Copy print to
travel.)

78
Timothy O'Sullivan, 1840-1882
Calcareous Tufa, Pyramid Island,
Pyramid Lake
U.S. Engineer Department Geological
Exploration Fortieth Parallel
1867; photograph, 7¾ x 10⅝ in.
(image), 18 x 24 in. (overall)
The Beinecke Rare Book and Manu-
script Library, Yale University
(Shown in Boston only. Copy print to
travel.)

79*
Timothy O'Sullivan, 1840-1882
Shoshone Falls
U.S. Engineer Department Geological
Exploration Fortieth Parallel
1867; photograph, 7¾ x 10⅝ in.
(image), 18 x 24 in. (overall)
The Beinecke Rare Book and Manu-
script Library, Yale University
(Shown in Boston only. Copy print to
travel.)

80*
Timothy O'Sullivan, 1840-1882
Sand Dune near Sand Springs, Nevada
U.S. Engineer Department Geological
Exploration Fortieth Parallel
1867; photograph, 7⅞ x 10⅝ in.
(image), 18 x 24 in. (overall)
The Beinecke Rare Book and Manu-
script Library, Yale University
(Shown in Boston only. Copy print to
travel.)

81
Timothy O'Sullivan, 1840-1882
Witches Rocks, Utah
Geological Exploration of the Fortieth
Parallel. Clarence King Geologist in
charge.
Ca. 1867; photograph, 7⅞ x 10⅝ in.
(image), 16¾ x 22 in. (overall)
The Library of Congress, Washington,
D.C.
(Shown in Boston only. Copy print to
travel.)

82*
Timothy O'Sullivan, 1840-1882
Natural Column, Washiki Badlands
Geological Exploration of the Fortieth
Parallel. Clarence King Geologist in
charge.
Ca. 1867; photograph, 10⅝ x 8 in.
(image), 21¾ x 16¾ in. (overall)
The Library of Congress, Washington,
D.C.
(Shown in Boston only. Copy print to
travel.)

83
Timothy O'Sullivan, 1840-1882
Washiki Badlands
Geological Exploration of the Fortieth
Parallel. Clarence King Geologist in
charge.
Ca. 1867; photograph, 8 x 10⅝ in.
(image), 16¾ x 21¾ in. (overall)
The Library of Congress, Washington,
D.C.
(Shown in Boston only. Copy print to
travel.)

84
Timothy O'Sullivan, 1840-1882
Grand Canyon, Colorado River
War Department Corps of Engineers,
U.S. Army Geographical Explorations
and Surveys West of the 100th Merid-
ian Expedition of 1872 under command
of Lieut. Geo. M. Wheeler, Corps of
Engrs.
1872; photograph, 10⅝ x 7⅞ in.
(image)
Museum of Fine Arts, Boston
(Shown in Boston only. Copy print to
travel.)

85
Timothy O'Sullivan, 1840-1882
Pyramid Lake, Nevada
U.S. Engineer Department Geological
Exploration Fortieth Parallel
1867; photograph, 7¾ x 10⅝ in.
(image), 18 x 24 in. (overall)
The Beinecke Rare Book and Manu-
script Library, Yale University
(Shown in Boston only. Copy print to
travel.)

86
C. E. Watkins, 1825-1916
Rock Formation
U.S. Engineer Department Geological
Exploration Fortieth Parallel
Ca. 1867; photograph, 8⅛ x 12¼ in.
(image), 18 x 24 in. (overall)
The Beinecke Rare Book and Manu-
script Library, Yale University
(Shown in Boston only. Copy print to
travel.)

87*
John Henry Hill, 1839-1922
Yosemite Falls
Ca. 1868; watercolor, 12 x 16 in.
Washburn Gallery, New York

88
William Henry Jackson, 1843-1942
The Hayden Survey at Red Butte
1870; photograph, copy print from
original photograph, 16 x 20 in.
The Denver Public Library, Western
History Department

89*
William Henry Jackson, 1843-1942
*Castellated Rocks on the Chugwater,
S. R. Gifford, Artist*
1870; photograph, copy print, 8 x 10 in.
Amon Carter Museum, Fort Worth,
Texas
(Courtesy U.S. Geological Survey.)

90*
Sanford Robinson Gifford, 1823-1880
Valley of the Chugwater
1870; oil on canvas, 8¼ x 13⅜ in.
Amon Carter Museum, Fort Worth,
Texas

91
John Frederick Kensett, 1816-1872
Sioux Indians
1870; pencil and watercolor, 8¼ x 8⅞ in.
Museum of Fine Arts, Boston, M. & M.
Karolik Collection
(Shown in Boston, Denver, and San
Diego.)

92*
Thomas Moran, 1837-1936
*"Beaver Head Canon, Montana
July 4, 1871"*
1871; watercolor and Chinese white on
yellow-gray paper, 10⅜ x 14⅛ in.
Museum of Fine Arts, Boston, M. & M.
Karolik Collection
(Shown in Boston, Denver, and San
Diego.)

93*
William Henry Jackson, 1843-1942
*"Mammoth Hot Springs on Gardiner's
River"*
1871; photograph, 9⅞ x 12¾ in.
(image), 16 x 20 in. (overall)
Boston Public Library
(Shown in Boston only. Copy print to
travel.)

94*
Henry Wood Elliott, 1846-1930
Yellowstone Lake
1871; watercolor, 10 x 19¼ in.
Kennedy Galleries, Inc., New York

95*
Thomas Moran, 1837-1936
"The Devils Den, Yellowstone. 1871"
1871; pencil, 4⅞ x 8 in.
The Cooper-Hewitt Museum of Decora-
tive Arts and Design, Smithsonian
Institution, New York

96*
Thomas Moran, 1837-1936
Mammoth Hot Springs, Yellowstone
1872; watercolor, 14¼ x 10⅜ in.
National Collection of Fine Arts,
Washington, D.C.
(Shown in Boston only.)

97
Thomas Moran, 1837-1936
*"West Wall of Canon from the edge of
the Lower fall of the Yellowstone.*
1872; pencil, 9⅞ x 7⅞ in.
The Cooper-Hewitt Museum of Decora-
tive Arts and Design, Smithsonian
Institution, New York

98
Thomas Moran, 1837-1936
"In the Canon" (Yellowstone)
1871; pencil, 5⅛ x 7¾ in.
Jefferson National Expansion Memo-
rial Historic Site, St. Louis, Missouri

99
Thomas Moran, 1837-1936
"Yellowstone Lake Aug 4th 1871"
1871; pencil, 5⅛ x 7¾ in.
Jefferson National Expansion Memo-
rial Historic Site, St. Louis, Missouri

100
Thomas Moran, 1837-1936
*Hot Springs of Gardiner's River,
Yellowstone*
1871; chromolithograph by L. Prang
& Co., Boston, 1876, after Moran's
painting, published in *The Yellowstone
National Park . . .*, 9¾ x 14⅛ in.
Museum of Fine Arts, Boston, M. & M.
Karolik Collection
(Shown in Kansas City and
Milwaukee.)

101
Thomas Moran, 1837-1936
Cliffs, Green River, Utah
1872; gouache, 6¼ x 11¾ in.
Museum of Fine Arts, Boston, M. & M.
Karolik Collection
(Shown in Kansas City and
Milwaukee.)

102
Timothy O'Sullivan, 1840-1882
"Cereus Giganteus, Arizona."
1873; photograph, 10¾ x 7⅞ in.
(image), 20 x 16 in. (overall)
Boston Public Library
(Shown in Boston only. Copy print to
travel.)

103*
John K. Hillers
*"Ruins of Cliff Dwellings in De Chelley
Cañon."*
1872-1878; photograph, 9¾ x 12⅞ in.
(image), 11 x 14 in. (overall)
Peabody Museum of Archaeology and
Ethnology, Harvard University
(Shown in Boston only. Copy print to
travel.)

104
Frederick Piercy, 1830-1891
*"Near Linden on the Kanesville Rd."
(Missouri)*
1853; watercolor, 10¼ x 7 in.
Museum of Fine Arts, Boston, M. & M.
Karolik Collection
(Shown in Boston, Denver, and San
Diego.)

105
Frederick Piercy, 1830-1891
Independence Rock (Wyoming)
1853; brown wash, 4¼ x 6½ in.
Museum of Fine Arts, Boston, M. & M.
Karolik Collection
(Shown in Boston, Denver, and San
Diego.)

106
Frederick Piercy, 1830-1891
*Fort Laramie from the South
(Wyoming)*
1853; pencil and white on gray paper,
7 x 10⅜ in.
Museum of Fine Arts, Boston, M. & M.
Karolik Collection
(Shown in Boston, Denver, and San
Diego.)

107*
Frederick Piercy, 1830-1891
Elk Horn River Ferry (Nebraska)
1853; pencil and brown wash,
6½ x 10⅛ in.
Museum of Fine Arts, Boston, M. & M.
Karolik Collection
(Shown in Boston, Denver, and San
Diego.)

108*
Frederick Piercy, 1830-1891
View of Great Salt Lake City
1853; pencil, 6⅞ x 10⅜ in.
Museum of Fine Arts, Boston, M. & M.
Karolik Collection

109
Frederick Piercy, 1830-1891
Devil's Gate
1853; wash, 4¼ x 5 in.
Museum of Fine Arts, Boston, M. & M.
Karolik Collection
(Shown in Kansas City and
Milwaukee.)

110*
Frederick Piercy, 1830-1891
*Council Bluffs Ferry and Group of
Cottonwood Trees (near Omaha)*
1853; watercolor, 10¼ x 7 in.
Museum of Fine Arts, Boston, M. & M.
Karolik Collection
(Shown in Kansas City and
Milwaukee.)

111*
Frederick Piercy, 1830-1891
*"Fort Laramie and Ferry of Platte
River" (Wyoming)*
1853; pencil and Chinese white on gray
paper, 6⅞ x 9¾ in.
Museum of Fine Arts, Boston, M. & M.
Karolik Collection
(Shown in Kansas City and
Milwaukee.)

112*
Frederick Piercy, 1830-1891
Great Salt Lake (Utah)
1853; pencil and brown wash,
7⅝ x 11¾ in.
Museum of Fine Arts, Boston, M. & M.
Karolik Collection
(Shown in Kansas City and
Milwaukee.)

113*
Frederick Piercy, 1830-1891
*Entrance to Kanesville from the
Keokuk Road*
1853; pencil touched with white,
7 x 10⅜ in.
Museum of Fine Arts, Boston, M. & M.
Karolik Collection
(Shown in Kansas City and
Milwaukee.)

114
Peter Petersen Tofft, 1825-1901
*My Cabin on Elk Creek, Montana
Territory*
1866; watercolor, 8⅞ x 5⅞ in.
Museum of Fine Arts, Boston, M. & M.
Karolik Collection
(Shown in Kansas City and
Milwaukee).

115*
Peter Petersen Tofft, 1825-1901
*My Cabin on Elk Creek, Montana
Territory (interior)*
1866; watercolor, 8⅝ x 10⅝ in.
Museum of Fine Arts, Boston, M. & M.
Karolik Collection
(Shown in Boston, Denver, and San
Diego.)

116
Peter Petersen Tofft, 1825-1901
*"St. Ignatius Mission Rocky Mountains
—Founded by Jesuits 1845, Montana
Terr."*
1866; watercolor, 10⅛ x 13 in.
Museum of Fine Arts, Boston, M. & M.
Karolik Collection
(Shown in Kansas City and
Milwaukee.)

117*
Robe
1797; Mandan, North Dakota;
buffalo hide, 8 x 6 ft. (approx.)
Peabody Museum of Archaeology and
Ethnology, Harvard University
(Shown in Boston only.)

118*
Silver Horns
Young Kiowa Brave
Ca. 1887; crayon and pencil,
9¼ x 13¾ in.
Marion Koogler McNay Art Institute,
San Antonio, Texas

119*
Herman Stieffel, 1826-1882
*"Attack on General Marcy's Train,
escorted by Comp: K. 5th U. S. Infantry,
Br. Major Brotherton commanding,
near Pawne-Fort Kansas, September
23th 1867"*
1867; watercolor, 16⅛ x 23¾ in.
The Beinecke Rare Book and Manu-
script Library, Yale University
(Shown in Boston only.)

120*
Felix Octavius Carr Darley, 1822-1888
Indian Attack on an Emigrant Train
Ca. 1860-1870; watercolor, 13⅛ x 18⅛ in.
Museum of Fine Arts, Boston, M. & M.
Karolik Collection
(Shown at Kansas City and
Milwaukee.)

121*
William Simpson, 1823-1903
The Modoc Indians in Lava Beds
1873; California; watercolor, 15 x 21 in.
Peabody Museum of Archaeology and
Ethnology, Harvard University

122
Saddle
1880-1900; Sioux, North Dakota; bone,
leather, and wood, h. 12¾ in., w. 15 in.,
d. 20½ in.
Utah Pioneer Village, Salt Lake City

123*
Saddle
1880-1900; Navajo, northern Arizona;
bone, leather, and wood, h. 15¼ in.,
w. 14¾ in., d. 21½ in.
Utah Pioneer Village, Salt Lake City

124
Englebert Krauskopf
Half-stock percussion plains rifle
Ca. 1850; Fredericksburg, Texas; steel,
walnut, and German silver, l. 52 in.
Collection of Oscar Krauskopf

125
Frederic Remington, 1861-1909
A Dash for the Timber
1889; oil on canvas, 48¼ x 84⅛ in.
Amon Carter Museum, Fort Worth,
Texas
(Shown in Boston only.)

126*
Needlework case
Ca. 1880; Omaha, northeastern Ne-
braska; wool and silk, h. 18 in., w. 5½ in.
Peabody Museum of Archaeology and
Ethnology, Harvard University

127*
Calumet
Ca. 1850; Osage, Oklahoma; wood, duck-
bill, feathers, horsehair, wool, l. 33½ in.
Museum of the American Indian,
Heye Foundation, New York

128
Bow and seven arrows
Ca. 1845; Plains Indian; wood wrapped
with cloth and rawhide; bow: l. 27 in.;
arrows: l. 26⅞ in. (approx.)
The Colonial Society of Massachusetts,
Boston

129*
Man's shirt
19th century; Tlinglit, Alaskan
coast; wool, l. 44½ in., w. 28½ in.
The Denver Art Museum

130
Copper knife
Ca. 1850-1900; Tlinglit, northwest coast;
l. 25¾ in., w. 4¾ in.
The Denver Art Museum

131*
White Bird
*Reno's Retreat: The Battle of Little
Big Horn*
1894-1895; Northern Cheyenne, Wyom-
ing; ink and watercolor on muslin,
30½ x 25½ in.
West Point Museum, United States
Military Academy, West Point,
New York

132
White Bird
*Custer's Last Fight, The Battle of
Little Big Horn*
1894-1895; Northern Cheyenne, Wyom-
ing; painted on muslin, 30 x 26 in.
West Point Museum, United States
Military Academy, West Point,
New York

133
Blanket
Ca. 1850-1900; Navajo, New Mexico;
wool, 70 x 49 in.
Maxwell Museum of Anthropology,
Albuquerque, New Mexico
(Shown in Boston only.)

134
Blanket
Ca. 1850-1900; Navajo, New Mexico;
wool, 74 x 52½ in.
Maxwell Museum of Anthropology,
Albuquerque, New Mexico
(Shown in Boston only.)

135*
Hand adze
Ca. 1890; Cowichan, Vancouver Island,
British Columbia; pine and iron,
h. 3¼ in., w. 10½ in., d. 1¾ in.
Museum of the American Indian,
Heye Foundation, New York

136
Spear with iron tip
Ca. 1850-1860; Arikara, North Dakota;
l. 75 in.
Museum of the American Indian,
Heye Foundation, New York

137*
Headdress
Ca. 1890; Crow, Montana; eagle
feathers, h. 22 in., w. 16 in. (approx.)
Museum of the American Indian,
Heye Foundation, New York

138
Headdress
Ca. 1860-1880; Crow, Montana; feathers,
h. 20½ in., w. 8 in. (approx.)
Museum of the American Indian,
Heye Foundation, New York
(Shown in Boston only.)

139
Beads
Ca. 1850-1900; Crow, Montana; bone and
brass on rawhide, l. (of strand) 19 in.,
diam. (of bead) ¼ in.
State Historical Society of Colorado,
Denver

140*
Cross
Ca. 1890; Cheyenne; Oklahoma; German
silver, h. 8 in., w. 6 in.
Museum of the American Indian,
Heye Foundation, New York

141*
Breast ornament
Ca. 1890; Osage, Oklahoma; German
silver, h. 4½ in., w. 3 in.
Museum of the American Indian,
Heye Foundation, New York

142*
Peace medal
1845; silver, made by the U. S. Mint,
diam. 3 in.
Museum of the American Indian,
Heye Foundation, New York

143*
Courting flute, made from a gun barrel
Ca. 1900; White Mountain Apache,
Cibique, Arizona; steel, l. 23⅛ in.,
diam. ¾ in.
Museum of the American Indian,
Heye Foundation, New York

144*
Button blanket
Ca. 1910; Kwakiutl, Cape Mudge, Van-
couver Island, British Columbia;
wool, h. 74 in., w. 53½ in.
Museum of the American Indian,
Heye Foundation, New York

145*
Mirror board
Ca. 1890; Caddo, Oklahoma; pine,
h. 11½ in., w. 4⅛ in., d. ¾ in.
Museum of the American Indian,
Heye Foundation, New York

146
Buffalo hide shirt
Ca. 1825-1850; southern Ute, Colorado;
h. 23 in., w. 25½ in. (excluding fringe)
Museum of the American Indian,
Heye Foundation, New York

147*
Burden basket
Ca. 1850-1900; Apache, Arizona;
h. 14 in., diam. 17 in.
Heard Museum, Phoenix, Arizona

148
Burden basket
Ca. 1850-1900; Apache, Arizona;
h. 11½ in., diam. 12 in.
Heard Museum, Phoenix, Arizona

149*
Shirt
Ca. 1800-1825; Mandan, North Dakota;
buckskin, l. 22 in., w. 20 in. (excluding
fringe)
Museum of the American Indian,
Heye Foundation, New York

150
Shield, painted by George Catlin
Ca. 1850; Mandan, North Dakota; hide,
diam. 22½ in.
Museum of the American Indian,
Heye Foundation, New York

151
Shield, with deerskin cover
Ca. 1850-1875; probably Mandan, North
Dakota; hide, diam. 19¼ in.
Museum of the American Indian,
Heye Foundation, New York
(Shown in Boston only.)

152
Horse mask made of buffalo hide
Ca. 1850; Sioux, North Dakota; h. 19 in.,
w. 29 in.
Museum of the American Indian,
Heye Foundation, New York
(Shown in Boston only.)

153
John Burgum
Thirty Coaches
1868; oil on canvas, 20 x 40 in.
New Hampshire Historical Society,
Concord
(Shown in Boston only.)

154*
Trapper's hat
Ca. 1850-1870; Utah; buffalo skin with
horns, l. 22½ in., diam. 7 in.
Church of Jesus Christ of Latter-day
Saints, Salt Lake City

155*
Trapper's hat
Ca. 1850-1870; Utah; beaver, l. 19¼ in.,
diam. 8½ in.
Church of Jesus Christ of Latter-day
Saints, Salt Lake City

156*
William McIlvaine, 1813-1867
Panning for Gold, California
1849; watercolor with pencil,
18⅝ x 27½ in.
Museum of Fine Arts, Boston, M. & M.
Karolik Collection
(Shown in Boston, Denver, and San
Diego.)

157*
Anonymous artist
Washing Gold, Calaveras River,
California
1853; pencil and gouache, 17 x 23½ in.
Museum of Fine Arts, Boston, M. & M.
Karolik Collection
(Shown in Kansas City and
Milwaukee.)

158
Emanuel G. Leutze, 1816-1868
Gold Mining, Gregory Extension,
Central City, Colorado Territory
1861; watercolor, 14 x 10¼ in.
Museum of Fine Arts, Boston, M. & M.
Karolik Collection
(Shown in Boston, Denver, and San
Diego.)

159*
Gold scales
Ca. 1860; Buckskin Joe, Colorado; oak,
pine, brass, iron; box: h. 1⅛ in.,
w. 6⅝ in., d. 3¼ in.
Pioneers' Museum, Colorado Springs

160
Gold pan (batea)
Ca. 1850-1860; Mexican, used in Cali-
fornia; pine, diam. 24 in.
The Oakland Museum, Oakland,
California

161*
Harry Learned, active 1880-1890
Iron Mask Mine, Gilman, Colorado
1886; oil on canvas, 24 x 36 in.
The Denver Art Museum

162*
Anonymous artist
Montgomery Street, San Francisco
July 1851; watercolor and gouache,
18⅜ x 23 in.
Museum of Fine Arts, Boston, M. & M.
Karolik Collection
(Shown in Boston, Denver, and San
Diego.)

163
B. C. Turnbull
"View of Driscoll's Stone Building that
Checked the Great Fire in Virginia
City, October 26th 1875" (Nevada)
1875; pencil, pen, watercolor,
15½ x 20⅞ in.
Museum of Fine Arts, Boston, M. & M.
Karolik Collection
(Shown in Kansas City and
Milwaukee.)

164*
George Tirrell
View of Sacramento
Ca. 1855-1860; oil on canvas, 27 x 47¾ in.
Museum of Fine Arts, Boston, M. & M.
Karolik Collection

165*
W. H. Creasy
Stockton, October, 1849
1849; watercolor, 17½ x 20¾ in.
Pioneer Museum and Haggin Galleries,
Stockton, California

166
Charles M. Russell, 1864-1926
Cowboy Camp during the Roundup
Ca. 1887; oil on canvas, 33½ x 47¼ in.
Amon Carter Museum, Fort Worth,
Texas

167*
James Walker, 1818-1889
Cowboys Roping a Bear
1877; oil on canvas, 30 x 50 in.
The Denver Art Museum

168*
Sallie Cover
Homestead of Ellsworth L. Ball
Ca. 1880-1890; oil on canvas, 19½ x 23 in.
Nebraska State Historical Society,
Lincoln

169*
Hayfork
Late 19th century; Nebraska; ash and
iron, h. 73½ in., w. 15 in.
Stuhr Museum of the Prairie Pioneer,
Grand Island, Nebraska

170*
Pitchfork
Late 19th century; Nebraska; cotton-
wood, h. 58½ in., w. 8¾ in.
Stuhr Museum of the Prairie Pioneer,
Grand Island, Nebraska

171*
Scythe and cradle
Late 19th century; Utah; h. 27½ in.,
w. 47½ in., d. 30 in.
Utah Pioneer Village, Salt Lake City

172*
William Hahn, 1827-1887
Harvest Time
1875; oil on canvas, 36 x 70 in.
Fine Arts Museums of San Francisco

173*
Adjustable rake
Late 19th century; Nebraska; ash and
iron, h. 74½ in., w. 18¼ in.
Stuhr Museum of the Prairie Pioneer,
Grand Island, Nebraska

174
Broom
Late 19th century; Nebraska; cotton-
wood, h. 60¼ in., w. 5½ in.
Stuhr Museum of the Prairie Pioneer,
Grand Island, Nebraska

175
Lariat
Late 19th century; Colorado; braided
horsehair, l. 26 ft.
The State Historical Society of
Colorado, Denver

176
Rope reel
Ca. 1880-1900; vicinity of Round Top,
Texas; pine, h. 10 ft., w. 37 in., d. 23½ in.
Collection of Mrs. Charles L. Bybee
(Shown in Boston only.)

177
Gate post
Late 19th century, Paguate, New Mex-
ico; juniper, h. 8 ft. 5 in., w. 16 in., d. 9 in.
Collection of Dr. and Mrs. Ward Alan
Minge
(Shown in Boston only.)

178
Camera, owned by Charles Ellis
Johnson, Salt Lake City
1902; Eastman Kodak, Rochester, New
York; mahogany, h. 50 in., w. 24 in.,
l. 37 in.
Collection of Mr. and Mrs. Avard T.
Fairbanks

179*
Attributed to Henri Penelon, 1827-1885
Francisco Sepúlveda
After 1854; oil on canvas, 25 x 20 in.
Natural History Museum of Los
Angeles County, Los Angeles

180*
Sword
Ca. 1750-1800; California, made in
Spain; steel, l. 37 in.
de Saisset Art Gallery and Museum,
Santa Clara, California

181*
Branding iron
1800-1860; Los Angeles County, Cali-
fornia; wrought iron, l. 29 in.
Southwest Museum, Los Angeles

182
Branding iron
1800-1860; California; wrought iron,
l. 15 in.
Natural History Museum of Los
Angeles County, Los Angeles

183

Spanish stirrup
17th century; Mexico; wrought
iron, h. 12⅜ in., w. 8 in., d. 3¼ in.
San Antonio Museum Association
Collection, San Antonio, Texas

184*

Side chair
Ca. 1830-1850; New Mexico; pine,
h. 39 in., w. 19½ in., d. 15¾ in.
Collection of Dr. and Mrs. Ward Alan
Minge

185*

Armchair
Late 18th-early 19th century; New Mex-
ico; pine, h. 38¾ in., w. 17¾ in.,
d. 19¾ in.
Nelson Gallery-Atkins Museum
(Nelson Fund), Kansas City, Missouri

186*

Camape, or daybed
Ca. 1830-1850; New Mexico; pine,
painted blue, h. 27 in., l. 69 in.,
w. 22½ in.
Collection of Dr. and Mrs. Ward Alan
Minge

187

Trastero
Ca. 1800-1820; New Mexico; pine,
h. 65 in., w. 21 in., d. 14¼ in.
Collection of Dr. and Mrs. Ward Alan
Minge

188*

Chest
Ca. 1800-1830; vicinity of Santa Fe,
New Mexico; painted pine, h. 12 in.,
w. 23¼ in., d. 11½ in.
Collection of Dr. and Mrs. Ward Alan
Minge

189*

Storage chest
18th century; New Mexico; pine,
h. 17½ in., w. 52½ in., d. 16¼ in.
Collection of Dr. and Mrs. Ward Alan
Minge

190*

Storage chest
18th-early 19th century; New Mexico;
pine, h. 18¼ in., w. 37 in., d. 18 in.
Colorado Springs Fine Arts Center

191

Chest on legs
Late 18th-early 19th century; New
Mexico; pine, h. 26¾ in., w. 52½ in.,
d. 17½ in.
Nelson Gallery-Atkins Museum
(Nelson Fund), Kansas City, Missouri

192*

Table with single drawer
Late 18th-early 19th century; New
Mexico; pine, h. 28½ in., w. 28 in.,
d. 19⅝ in.
Collection of Dr. and Mrs. Ward Alan
Minge

193*

Cross
Ca. 1800-1850; New Mexico; pine, corn-
husks, h. 19¼ in., w. 10¾ in.
Collection of Dr. and Mrs. Ward Alan
Minge

194

Box
Ca. 1800-1850; New Mexico; pine decor-
ated with pitch and cornhusk mosaic,
h. 4¼ in., w. 9⅜ in., d. 3¾ in.
Collection of Dr. and Mrs. Ward Alan
Minge

195*

Cross
Ca. 1760; Trampas, New Mexico;
wrought iron, h. 24⅛ in., w. 8 in.
Collection of Dr. and Mrs. Ward Alan
Minge

196*

Sconce
Ca. 1870; Cabezon, New Mexico; tinned
sheet iron, h. 19½ in., w. 16 in.
Collection of Dr. and Mrs. Ward Alan
Minge

197

Sconce
Ca. 1850-1870; New Mexico; tinned
sheet iron, h. 10½ in., w. 6 in.
Collection of Dr. and Mrs. Ward Alan
Minge

198*

St. John of Nepomuk
Painting: ca. 1820-1835; Mexico; oil on
canvas
Frame: ca. 1830-1850; New Mexico;
tinned sheet iron, h. 28 in., w. 21¾ in.
Collection of Dr. and Mrs. Ward Alan
Minge

199*

Chocolate pot, with stirring stick
Ca. 1830-1850; New Mexico; copper,
wrought iron, h. 6½ in., diam. (top)
3¾ in. stick: ash, l. 17½ in.
Collection of Dr. and Mrs. Ward Alan
Minge

200

Spit
Early 19th century; New Mexico;
wrought iron, l. 38¼ in.
Collection of Dr. and Mrs. Ward Alan
Minge

201

Spoon
Early 19th century; New Mexico;
wrought iron, l. 16½ in.
Collection of Dr. and Mrs. Ward Alan
Minge

202

Tongs
Early 19th century; Mexico or New
Mexico; wrought iron, l. 13½ in.
Collection of Dr. and Mrs. Ward Alan
Minge

203

Oija, or pot
Ca. 1820-1850; New Mexico; copper,
h. 11 in., diam. 14½ in.
Collection of Dr. and Mrs. Ward Alan
Minge

204-208

5 tobacco holders
18th and early 19th century; New
Mexico; silver, copper, and leather
Collection of Dr. and Mrs. Ward Alan
Minge

209*

Vallero blanket
Early 19th century; New Mexico; wool,
l. 91 in., w. 49¼ in.
Collection of Dr. and Mrs. Ward Alan
Minge

210

Colcha
Early 19th century; Sante Fe, New
Mexico; wool, l. 72 in., w. 41½ in.
Collection of Dr. and Mrs. Ward Alan
Minge

211*

Colcha
Early 19th century; northern New
Mexico; wool, l. 71½ in., w. 41½ in.
Collection of Dr. and Mrs. Ward Alan
Minge

212*

San Gabriel
18th century; New Mexico; painted
animal hide, 28 x 20½ in.
Marion Koogler McNay Art Institute,
San Antonio, Texas

213*

*Niche with Our Lady of Sorrows
(Nuestra Señora de los Dolores)*
Early 19th century; New Mexico;
painted pine, h. 28 in., w. 12 in.,
d. 12½ in.
Collection of Dr. and Mrs. Ward Alan
Minge

214*

*Our Lady of the Rosary (Nuestra
Señora del Rosario)*
Ca. 1800-1850, Santa Cruz valley, New
Mexico; pine with tin and leather,
h. 31 in.
Nelson Gallery-Atkins Museum
(Nelson Fund), Kansas City, Missouri

215*

San Miguel, Archangel
19th century; New Mexico; pine, paint on gesso, with tin scales and sword, h. 20 in., w. 10½ in., d. 5½ in.
Marion Koogler McNay Art Institute, San Antonio, Texas

216*

Pedro Antonio Fresquis, 1749-1831
Saint Acacius (San Acacio)
Ca. 1820; New Mexico; pine, paint on gesso, 10 x 9 in.
Collection of Dr. and Mrs. Ward Alan Minge

217*

Attributed to Rafael Aragon, active 1836-1850
Saint Isidore of Madrid (San Ysidro Labrador)
Ca. 1840; New Mexico; pine, paint on gesso, 19 x 12 in.
Collection of Dr. and Mrs. Ward Alan Minge

218

Rafael Aragon, active 1836-1850
Holy Child of Atocha (Santo Niño de Atocha)
Ca. 1840-1850; New Mexico; pine, paint on gesso, 8¼ x 6½ in.
Collection of Dr. and Mrs. Ward Alan Minge

219

San José
Ca. 1820-1850; New Mexico; pine, paint on gesso, 10⅝ x 7¾ in.
Collection of Dr. and Mrs. Ward Alan Minge

220*

Dominicus and Polly Miner Carter
Slat-back side chair
Ca. 1851; Utah; willow with rawhide thong seat, painted green at a later date, h. 32½ in., w. 17½ in., d. 13 in.
Utah Pioneer Village, Salt Lake City

221*

Rocking chair, slat-back
Ca. 1850-1870; made in Pennsylvania, brought to Nebraska ca. 1872; ash, tulip, painted, seat a later replacement, h. 41½ in., w. 21 in., d. (seat) 15¼ in.
Nebraska State Historical Society, Lincoln

222

Cradle
Ca. 1840; made in Illinois, brought to Missouri ca. 1870; pine and walnut, h. 24 in., w. 39 in., d. 16½ in.
Nebraska State Historical Society, Lincoln

223*

Chest or trunk
Ca. 1800; made in Norway, brought to Nebraska; pine and iron, painted, h. 31 in., w. 44¾ in., d. 23½ in.
Stuhr Museum of the Prairie Pioneer, Grand Island, Nebraska

224

Kettle
Ca. 1850-1880; Sweden, brought to Nebraska; tin and copper, h. 11¼ in., diam. 15¾ in.
Nebraska State Historical Society, Lincoln

225*

Armchair
Ca. 1850-1900; Grand Island, Nebraska; willow, upholstery and rockers added ca. 1900, h. 39 in., w. 25 in., d. 18½ in.
Stuhr Museum of the Prairie Pioneer, Grand Island, Nebraska

226

Albert Osgood, 1854-1929
Parlor table
Ca. 1900; Nebraska; walnut with mixed wood inlay, h. 29 in., diam. 32½ in.
Nebraska State Historical Society, Lincoln

227*

Father Anthony Ravalli, 1812-1884
Prie-dieu
1870; Missoula, Montana; pine, painted green with velvet upholstery, h. 36 in., w. 20 in., d. 20 in.
The Archives of the Oregon Province of the Society of Jesus, Crosby Library, Gonzaga University, Spokane, Washington

228*

Father Anthony Ravalli, 1812-1884
Cross
Ca. 1860-1870; Montana; diseased cottonwood, h. 25 in., w. 11 in.
Montana Historical Society, Helena

229

Father Anthony Ravalli, 1812-1884
Skull and crossbones, sculpture
Ca. 1860-1870; Montana; pine, h. 5½ in., w. 10½ in., d. 6 in.
Montana Historical Society, Helena

230*

Bench
Ca. 1860; Aurora Colony, Oregon; maple and pine, h. 32 in., l. 123 in., w. 24 in.
Aurora Colony Historical Society, Aurora, Oregon

231*

A. Horr
Coverlet
1840; Harmony, Indiana; wool and linen, l. 86½ in., w. 68 in., fringe 2 in.
Collection of Leona Will Nelson, on loan to the Aurora Colony Historical Society, Aurora, Oregon

232*

Side chair, slat-back
1860-1870; Fayetteville, Texas; elm and ash, with cowhide seat, h. 35½ in., w. 17½ in., d. 15 in.
Collection of Mr. and Mrs. Andrew Z. Thompson

233*

Side chair, slat-back
1860-1870; Fayetteville, Texas; ash, with cowhide seat, h. 34½ in., w. 18 in., d. 14 in.
Collection of Mr. and Mrs. Andrew Z. Thompson

234*

Child's chair, made for Jesse L. Humphreys
1838; Martindale, Texas; ash, with cowhide seat, h. 22½ in., w. 13 in., d. 9 in.
San Antonio Museum Association Collection, Gift of Mrs. Jesse L. Humphreys

235*

Side chair, slat-back
Ca. 1840; Travis County, Texas; ash, with laced rawhide seat, h. 32¾ in., w. 19 in., d. 14 in.
San Antonio Museum Association Collection, Gift of Mrs. Georgia Maverick Harris

236

Side chair, slat-back
Ca. 1840-1850; New Braunfels, Texas; walnut with rawhide seat, h. 36¼ in., w. 17¼ in., d. 14¼ in.
Collection of Mrs. Charles L. Bybee

237*

Side chair, slat-back
Ca. 1850; Tumwater, Washington; pine, painted, h. 33½ in., w. 17 in., d. 18 in.
State Capitol Museum, Olympia, Washington

238*

Rocking chair
Ca. 1840; Muldoon, Texas; elm, hickory, ash, and rawhide, h. 38½ in., w. 20 in., d. 16½ in. (seat)
Collection of Mrs. Charles L. Bybee

239*
Side chair
Ca. 1830-1845; Nacogdoches, Texas; ash, elm with hickory bark seat, h. 39 in., w. 18 in., d. 14½ in.
San Antonio Museum Association Collection, Gift of Mr. and Mrs. C. D. Orchard

240*
Jelly cupboard
Ca. 1850-1860; Austin County, Texas; cedar, h. 65 in., w. 44 in., d. 19½ in.
Collection of Mrs. Charles L. Bybee

241*
Pie safe
Ca. 1875; southwestern Colorado; tulipwood, pine, and tin, h. 55⅛ in., w. 38½ in., d. 16½ in.
The State Historical Society of Colorado, Denver

242*
Food safe
Ca. 1860; Bastrop, Texas; cypress, pine, and tin, h. 76 in., w. 40 in., d. 22½ in.
Collection of Walter Nold Mathis

243*
Porch bench
Ca. 1860; Washington County, Texas; pine, walnut, ash, cedar, h. 31 in., w. 83 in., d. 23¾ in.
Collection of Mrs. Charles L. Bybee

244*
Daybed
Ca. 1870; Fayette County, Texas; oak, pine, and ash, traces of red brown paint, h. 32 in., l. 76 in., w. 28 in.
Collection of Mrs. Charles L. Bybee

245*
Kitchen table
Ca. 1857-1860; Colorado County, Texas; pine with limestone slab, h. 30¾ in., l. 70 in., w. 35 in.
San Antonio Museum Association Collection, Gift of Mrs. C. T. White

246
Mortar and pestle
Ca. 1850-1860; Round Top, Texas; pine, mortar, h. 17½ in., diam. (top) 7¼ in., pestle, h. 16 in.
Collection of Mrs. Charles L. Bybee

247
Washtub
Ca. 1880-1900; vicinity of Round Top, Texas; tin h. 9½ in., diam. (top) 20¼ in.
Collection of Mrs. Charles L. Bybee

248
Sausage stuffer
Ca. 1860-1890; Grapevine Community, Latchum, Texas; tinned iron and pine, l. 46½ in., h. 11 in., w. 10½ in.
Collection of Mrs. Charles L. Bybee

249*
John M. Wilson
Two-quart bowl
1857-1869; Seguin, Guadalupe County, Texas; glazed stoneware, h. 4 in., diam. (top) 10½ in.
Collection of Mrs. Georgeanna Greer

250*
Hiram Wilson & Company
One-gallon open jar
Ca. 1872-1884; Seguin, Guadalupe County, Texas; glazed stoneware, h. 8½ in., diam. (top) 7½ in.
Collection of Mr. and Mrs. Andrew Z. Thompson

251
John M. Wilson,
The Guadalupe Pottery
Five-gallon storage jar
1857-1869; Seguin, Guadalupe County, Texas; glazed stoneware, h. 16 in., diam. (top) 8½ in.
San Antonio Museum Association Collection, Gift of Miss Ruth Lawler

252
Pie box
Ca. 1870-1890; vicinity of Round Top, Texas; walnut, h. 8⅜ in., w. 17¼., d. 11⅜ in.
Collection of Mrs. Charles L. Bybee

253
Joseph Wolfe & Co.
One-gallon storage jar
Ca. 1860-1870; Rock Creek, Boulder, Colorado; glazed stoneware, h. 10 in., diam. (top) 7 in.
Pioneer's Museum, Colorado Springs

254
Wenzel Friedrich, 1827-1902
Draw-leaf extension table
Ca. 1860; San Antonio, Texas; pine and oak, h. 28¾ in., w. (closed) 44½ in., d. 38¾ in.
San Antonio Museum Association Collection, Gift of Miss Lena Friedrich

255*
Spindle bed
Ca. 1850; La Grange, Texas; pine, stained red brown, h. 35 in., l. 73½ in., w. 45½ in.
Collection of Walter Nold Mathis

256*
Three-quarter high post bed
Ca. 1850; Tarrant County, Texas; elm and ash with blackberry stain, h. 52½ in., l. 73¾ in., w. 53 in.
Collection of Mrs. Charles L. Bybee

257*
Matilda Hurst Irvine
Appliquéd quilt
1864-1865; Kaufman County, Texas; cotton percale and muslin, l. 99½ in., w. 72½ in.
San Antonio Museum Association Collection, Gift of Mrs. J. H. Guillory

258*
Attributed to Franz Wurzbach
Crib
Ca. 1850-1860; Rio Medina, Texas; cypress, h. 24¾ in., l. 40 in., w. 24 in.
Collection of Mr. Robert Quill Johnson

259*
Slant-top desk with paneled bookcase
Ca. 1840; vicinity of Industry, Austin County, Texas; walnut, h. 67½ in., w. 43¾ in., d. 33 in.
Collection of Mrs. Charles L. Bybee

260*
Tripod pedestal table
Ca. 1850; Brazos County, Texas; walnut, h. 29¾ in., diam. (top) 35 in.
San Antonio Museum Association Collection, Endowment Fund Purchase

261
Tripod tilt-top table
Ca. 1860; Fayetteville, Texas; walnut, h. 30½ in., diam. (top) 36 in.
Collection of Mrs. Charles L. Bybee

262
Tripod table
Ca. 1860; Round Top, Texas; pine, h. 30 in., diam. (top) 23 in.
Collection of Mrs. Charles L. Bybee

263*
Side chair
Ca. 1830-1850; Santa Fe, New Mexico; pine and fruitwood, h. 34 in., w. 16 in., d. 16½ in.
Collection of Dr. and Mrs. Alan Ward Minge

264*
Side chair
Ca. 1860; Mariposa, California; pine, h. 32 in., w. 15½ in., d. 16½ in.
The Oakland Museum, Oakland, California

265*
Scroll-back armchair
Ca. 1850; Cat Springs, Texas; pine, h. 30½ in., w. 20½ in., d. 18 in.
Collection of Mrs. Charles L. Bybee

266*
William Bell, 1816-1886
Side chair
Ca. 1854-1870; Salt Lake City, Utah;
pine, painted and stenciled, h. 32¼ in.,
w. 17½ in., d. 16½ in.
Utah Pioneer Village, Salt Lake City

267*
Whipple and Kirkham
Rocking chair
Ca. 1860-1880; Lehi, Utah; pine, painted
and stenciled, h. 39 in., w. 20½ in.,
d. 18½ in.
Utah Pioneer Village, Salt Lake City

268*
High post bed
Ca. 1860-1870; Salt Lake City, Utah;
pine, grained to simulate oak, h. 78½
in., l. 68 in., w. 53¾ in.
Utah Pioneer Village, Salt Lake City

269*
Nancy Barnes
Patchwork quilt
Ca. 1860-1870; Nebraska; cotton, wool,
and silk, l. 80¼ in., w. 64¾ in.
Stuhr Museum of the Prairie Pioneer,
Grand Island, Nebraska

270*
Low post bed, owned by Albert P.
Rockwood
Ca. 1850-1870; Salt Lake City, Utah; pine,
grained to simulate rosewood, h. 48½
in., w. 50½ in., l. 83 in.
Collection of Mr. and Mrs. Avard T.
Fairbanks

271*
Cupboard
Ca. 1850-1860; Salt Lake City, Utah;
wood, grained to simulate rosewood,
h. 81¼ in., w. 47¼ in., d. 22¾ in.
Utah Pioneer Village, Salt Lake City

272*
Settee
Ca. 1860; Belleville, Texas; pine and
oak, h. 33½ in., d. 25 in., l. 75 in.
Collection of Mrs. Charles L. Bybee
224

273*
Side table
Ca. 1880-1883; vicinity of Schulenberg,
Texas; pine, h. 29 in., w. 33¾ in.,
d. 22¼ in.
Collection of Mrs. Charles L. Bybee

274
Chest of drawers
Ca. 1885; High Hill, Texas; pine and
cypress, h. 28½ in., w. 29 in., d. 17¾ in.
Collection of Miss Selma Klatt

275
Writing table
Ca. 1873; Austin, Texas; pine, h. 30¼ in.,
w. 28⅝ in., d. 27⅜ in.
Collection of Mrs. Charles L. Bybee

276
Mirror
Ca. 1860-1870; Fayetteville, Texas; pine
and veneer, painted graining, h. 41 in.,
w. 20 in.
Collection of Mrs. Charles L. Bybee

277*
Wardrobe
Ca. 1860-1870; Fayette County, Texas;
marked "C. W." on back in chalk;
cedar, painted and grained, h. 76½ in.,
w. 61 in., d. (at cornice) 23 in.
Collection of Mrs. Charles L. Bybee

278*
Demel, 1849-1932
Wardrobe
Ca. 1875-1880, Ammonsville, Texas;
h. 78 in., w. 53 in., d. 22¼ in.
Collection of Mr. and Mrs. Harvin C.
Moore

279*
Dasch
Wardrobe
Ca. 1880; Columbus, Texas; cypress and
pine, painted, h. 93½ in., w. 56½ in.,
d. 29 in.
Collection of Mrs. Charles L. Bybee

280*
Corner bench
Ca. 1860-1880; Schulenberg Community,
Texas; pine, h. 28¾ in., l. (in two sec-
tions) 78½ in., 80½ in., d. 16½ in.
Collection of Mrs. Charles L. Bybee

281*
Chair, plank seat
Ca. 1860; Cat Springs, Texas; pine,
h. 33¼ in., w. 18 in., d. 14½ in.
Collection of Mrs. Charles L. Bybee

282*
Colcha
Ca. 1860-1890; New Mexico; wool,
l. 84 in., w. 52 in.
The Colorado Springs Fine Arts Center

283*
Manuel Archuleta
Side chair
1850-1860; Taos, New Mexico; pine,
h. 31¾ in., w. 16¼ in., d. 16¼ in.
The Colorado Springs Fine Arts Center

284*
George Kirkham
*Parlor table, with moldings from the
Great Salt Lake Temple*
Ca. 1880; Salt Lake City, Utah; pine
and mixed wood inlay, h. 29½ in.,
diam. (top) 32½ in.
Utah Pioneer Village, Salt Lake City

285
Horsehide blanket with wool backing
Ca. 1850-1880; Nebraska; wool and
horsehide, l. 71½ in., w. 66¾ in.
Stuhr Museum of the Prairie Pioneer,
Grand Island, Nebraska

286*
Wenzel Friedrich, 1827-1902
Rocking chair
Ca. 1880-1890; San Antonio, Texas; steer
horn and jaguar skin, h. 38½ in.,
w. 24 in., d. (seat) 22 in.
San Antonio Museum Association,
Gertrude and Richard Friedrich
Collection

287*
Armchair
Ca. 1900; Riverton or Lander, Wyoming;
elk antlers with rawhide thong back
and seat, h. 35 in., w. 33 in., d. 33 in.
Wyoming State Archives and
Historical Department, Cheyenne

288
Armchair
Ca. 1900; Wyoming; elk and moose
antlers, h. 33 in., w. 28¾ in., d. 18 in.
Wyoming State Archives and
Historical Department, Cheyenne

289
Jerga
Ca. 1800-1850; New Mexico; wool,
l. 192½ in., w. 56 in.
Collection of Dr. and Mrs. Alan Ward
Minge

290
Floor covering
Ca. 1880-1900; vicinity of Round Top,
Texas; cotton and wool, l. 148 in.,
w. 104 in.
Collection of Mrs. Charles L. Bybee

291
Buffalo robe
Ca. 1890-1900; Utah; buffalo hide, l. 84
in., w. 70 in.
Utah State Park Service, Salt Lake City

292*
William Warner Major, 1804-1854
Brigham Young's Family
1840-1850; Salt Lake City, Utah; oil on
canvas, 25 x 33 in. (unframed)
Church of Jesus Christ of Latter-day
Saints, Salt Lake City

293*
Cyrus Dallin, 1861-1944
The Protest
1904; bronze, h. 20½ in., w. 17 in.
Museum of Fine Arts, Boston

294

Zion's Cooperative Mercantile Institution. Façade section, three bays, north wing, second story
1901-1902; Salt Lake City, Utah; tin,
h. 15 ft. 10 in., w. 21 ft. 3 in.
Architects: Obed Taylor and William H. Folsom [Young]
Superintendent of Construction:
Henry Grow
Zion's Cooperative Mercantile Institution
(Shown in Boston only.)

All photographs listed in the following section of the catalogue are modern enlargements made from original glass plate negatives or original photographs.

295

George Edward Anderson, 1860-1928
The Schofield School, Schofield, Utah, ca. 1899
Harold B. Lee Library, Brigham Young University, Provo, Utah

296

George Edward Anderson, 1860-1928
Charles Otteson Ranch, Huntington, Utah, ca. 1890
Harold B. Lee Library, Brigham Young University, Provo, Utah

297*

George Edward Anderson, 1860-1928
Joseph Thurber, blacksmith, Richfield, Utah, ca. 1880-1890
Harold B. Lee Library, Brigham Young University, Provo, Utah

298

George Edward Anderson, 1860-1928
Tidwell cabin, Sunnyside, Utah, ca. 1880-1890
Harold B. Lee Library, Brigham Young University, Provo, Utah

299

George Edward Anderson, 1860-1928
John Westenskow's family, Sunnyside, Utah, ca. 1880-1890
Harold B. Lee Library, Brigham Young University, Provo, Utah

300

George Edward Anderson, 1860-1928
Pioneer family, near Laurence, Utah, ca. 1880-1890
Harold B. Lee Library, Brigham Young University, Provo, Utah

301

George Edward Anderson, 1860-1928
Drugstore and harness shop, Ephraim, Utah, ca. 1890
Harold B. Lee Library, Brigham Young University, Provo, Utah

302

George Edward Anderson, 1860-1928
Syrett house and store, Emery County, Utah, ca. 1890
Harold B. Lee Library, Brigham Young University, Provo, Utah

303

George Edward Anderson, 1860-1928
Richfield store, Richfield, Utah, ca. 1890
Harold B. Lee Library, Brigham Young University, Provo, Utah

304

George Edward Anderson, 1860-1928
Mercer Mills, Utah, 1893
Harold B. Lee Library, Brigham Young University, Provo, Utah

305

George Edward Anderson, 1860-1928
Aldredge family, believed to be at Oak Creek, Utah, near Schofield, ca. 1890
Harold B. Lee Library, Brigham Young University, Provo, Utah

306

George Edward Anderson, 1860-1928
Coal mine, Huntington Canyon, Emery County, Utah, October 23, 1901
Harold B. Lee Library, Brigham Young University, Provo, Utah

307

George Edward Anderson, 1860-1928
Beason Lewis and family, Emery County, Utah, ca. 1890
Harold B. Lee Library, Brigham Young University, Provo, Utah

308

George Edward Anderson, 1860-1928
Tim Evans and David Eccles store, Schofield, Utah, ca. 1890
Harold B. Lee Library, Brigham Young University, Provo, Utah

309

George Edward Anderson, 1860-1928
Ashmand and Carland team, Emery County, Utah, ca. 1890-1900
Harold B. Lee Library, Brigham Young University, Provo, Utah

310

George Edward Anderson, 1860-1928
Joseph Leavitt and family, White Pine County, Utah, ca. 1890
Harold B. Lee Library, Brigham Young University, Provo, Utah

311

George Edward Anderson, 1860-1928
Moses Burdick and family, near Sunnyside, Utah, ca. 1890
Harold B. Lee Library, Brigham Young University, Provo, Utah

312

George Edward Anderson, 1860-1928
Children of Moses Burdick, near Sunnyside, Utah, ca. 1890
Harold B. Lee Library, Brigham Young University, Provo, Utah

313*

George Edward Anderson, 1860-1928
Ether Blanchard Farm, Mapleton, Utah, ca. 1900
Heritage Prints, Rell G. Francis, Springville, Utah

314

George Edward Anderson, 1860-1928
Lewis Perry threshing crew, Mapleton, Utah, ca. 1900
Heritage Prints, Rell G. Francis, Springville, Utah

315

Albert Bierstadt, 1830-1902
St. Joseph, Missouri, 1859
Kansas State Historical Society, Topeka

316

Solomon D. Butcher, 1856-1927
C. H. Peter's drugstore, West Union, Custer County, Nebraska, ca. 1886
Solomon D. Butcher Collection, Nebraska State Historical Society, Lincoln

317

Solomon D. Butcher, 1856-1927
Shores family in Custer County, Nebraska, near Westerville, ca. 1887
Solomon D. Butcher Collection, Nebraska State Historical Society, Lincoln

318

Solomon D. Butcher, 1856-1927
Sod dugout on South Loup, Custer County, Nebraska, 1892
Solomon D. Butcher Collection, Nebraska State Historical Society, Lincoln

319*

Solomon D. Butcher, 1856-1927
John Curry sod house, near West Union, Custer County, Nebraska, ca. 1886
Solomon D. Butcher Collection, Nebraska State Historical Society, Lincoln

320
Solomon D. Butcher, 1856-1927
Sod house of Gideon Haumont, north of Broken Bow, Nebraska, 1884-1885
Solomon D. Butcher Collection, Nebraska State Historical Society, Lincoln

321
Anonymous photographer
Leadville, Colorado, ca. 1890
Denver Public Library, Western History Department

322
Anonymous photographer
Pioneer family in front of covered wagons, ca. 1870
Denver Public Library, Western History Department

323
Anonymous photographer
Ore wagon train in Nevada, ca. 1880-1900
Denver Public Library, Western History Department

324
Anonymous photographer
Lynching in Montana, ca. 1870-1900
Denver Public Library, Western History Department

325
Anonymous photographer
Panning for gold, ca. 1880
Denver Public Library, Western History Department

326
Charles Ellis Johnson, 1857-1926
In the mountains near Salt Lake City, Utah, ca. 1890-1900
Anonymous lender

327
Charles Ellis Johnson, 1857-1926
Railroad pass, Castledale, Utah, ca. 1890-1900
Anonymous lender

328
Sainsbury and Johnson
Mormon Temple, Salt Lake City, Utah, ca. 1880
Anonymous lender

329
Sainsbury and Johnson
Gardo House or "Amelia Palace," Salt Lake City, ca. 1880
Anonymous lender

330
Charles Ellis Johnson, 1857-1926
Saltair Pavilion, Great Salt Lake, Utah, ca. 1880
Anonymous lender

331
Charles Ellis Johnson, 1857-1926
Photographer's bedroom and studio, Salt Lake City, ca. 1890
Anonymous lender

332
Charles Ellis Johnson, 1857-1926
Charles E. Johnson's drug display featuring Valley Tan Remedy, ca. 1888
Anonymous lender

333
Charles Ellis Johnson, 1857-1926
St. George Co-operative Mercantile Institution, St. George, Utah, ca. 1880
Anonymous lender

334
Charles Ellis Johnson, 1857-1926
"Dr. and Mrs. Heber John Richards, Salt Lake City, ca. 1890
Anonymous lender

335
Frederike Michaelis Recknagel, 1860-1956
Eduard and Louisa Recknagel at Christmas, Round Top, Texas, ca. 1895
Collection of Mrs. Charles L. Bybee

336
Frederike Michaelis Recknagel, 1860-1956
Eduard and Louisa Recknagel in the snow, Round Top, Texas, ca. 1895
Collection of Mrs. Charles L. Bybee

337
Frederike Michaelis Recknagel, 1860-1956
Eduard Recknagel and a chemistry experiment, Round Top, Texas, ca. 1895
Collection of Mrs. Charles L. Bybee

338
Frederike Michaelis Recknagel, 1860-1956
Louisa Recknagel on her tricycle, Round Top, Texas, ca. 1895
Collection of Mrs. Charles L. Bybee

339
Frederike Michaelis Recknagel, 1860-1956
Eduard Recknagel and a friend in the backyard, Round Top, Texas, ca. 1895
Collection of Mrs. Charles L. Bybee

340
Frederike Michaelis Recknagel, 1860-1956
Eduard, Louisa, and Frederike Recknagel looking at her photographs, Round Top Texas, ca. 1895
Collection of Mrs. Charles L. Bybee

341
Frederike Michaelis Recknagel, 1860-1956
Louisa Recknagel and a servant, Round Top, Texas, ca. 1895
Collection of Mrs. Charles L. Bybee

342
Frederike Michaelis Recknagel, 1860-1956
Family portrait, Round Top, Texas, ca. 1895
Collection of Mrs. Charles L. Bybee

343
Frederike Michaelis Recknagel, 1860-1956
Portrait, Round Top, Texas, ca. 1895
Collection of Mrs. Charles L. Bybee

344
Frederike Michaelis Recknagel, 1860-1956
Family portrait, Round Top, Texas, ca. 1895
Collection of Mrs. Charles L. Bybee

345
Frederike Michaelis Recknagel, 1860-1956
Two-story dogtrot house, near Round Top, Texas, ca. 1895-1900
Collection of Mrs. Charles L. Bybee

346
Frederike Michaelis Recknagel, 1860-1956
Cabin, near Round Top, Texas, ca. 1895-1900
Collection of Mrs. Charles L. Bybee

347
Frederike Michaelis Recknagel, 1860-1956
House, near Round Top, Texas, ca. 1895-1900
Collection of Mrs. Charles L. Bybee

348
Frederike Michaelis Recknagel, 1860-1956
Class and teachers in front of school house, near Round Top, Texas, ca. 1895
Collection of Mrs. Charles L. Bybee

349
Frederike Michaelis Recknagel, 1860-1956
Round Top, Texas, ca. 1895-1900
Collection of Mrs. Charles L. Bybee

350
Frederike Michaelis Recknagel, 1860-1956
Family in a garden, near Round Top, Texas, ca. 1895-1900
Collection of Mrs. Charles L. Bybee

351
Frederike Michaelis Recknagel,
1860-1956
*Stone house, near Round Top, Texas,
ca. 1900-1910*
Collection of Mrs. Charles L. Bybee

352
Frederike Michaelis Recknagel,
1860-1956
*Henkel Square, Round Top, Texas,
ca. 1895-1900*
Collection of Mrs. Charles L. Bybee

353
Frederike Michaelis Recknagel,
1860-1956
*Mail delivery, Round Top, Texas, ca.
1900*
Collection of Mrs. Charles L. Bybee

354
Frederike Michaelis Recknagel,
1860-1956
*House, near Round Top, Texas, ca.
1895-1900*
Collection of Mrs. Charles L. Bybee

355
Frederike Michaelis Recknagel,
1860-1956
*Mexican family, near Round Top,
Texas, ca. 1900-1910*
Collection of Mrs. Charles L. Bybee

356
Charles Savage
In Corrill at Coalville, 1866 (Utah)
Church Archives, The Church of Jesus
Christ of Latter-day Saints

357
Anonymous photographer
*Headquarters, Department of Utah,
Camp Scott, Utah, 1857-1858*
Pioneer Craft House, Salt Lake City

358
C. W. Carter
*Mormons crossing the plains through
Echo Canyon, 1867*
Pioneer Craft House, Salt Lake City

359
Anonymous photographer
*W. C. Standley and family from Wells
Point, Texas, 5 months en route,
September 5, 1888*
Pioneer Craft House, Salt Lake City

360
Lawrence & Houseworth
*Emigrant train, Strawberry Valley,
California, going East, Copyright 1866*
Pioneer Craft House, Salt Lake City

361
C. W. Carter
Emigrants in Echo Canyon, Utah, 1866
Pioneer Craft House, Salt Lake City

Selected Bibliography

Included in the following list are major works consulted in the preparation of this catalogue and additional references considered useful in the study of the material culture of the Far West in the nineteenth century.

Adams, Eleanor B., and Chavez, Fray Angelico, trans.
The Missions of New Mexico, 1776: A Description by Fray Atanasio Dominquez.
Albuquerque: University of New Mexico Press, 1956.

Alexander, Drury.
Texas Homes of the Nineteenth Century.
Austin: University of Texas Press, 1966.

Allen, Harold.
Father Ravalli's Missions.
Chicago: School of the Art Institute of Chicago, 1972.

"American Colonies under the Flag of Mexico: Texas."
Antiques 53 (June 1948), 439-40.

American Paintings in the Museum of Fine Arts, Boston.
2 vols. Boston: Museum of Fine Arts, 1969.

Amon Carter Museum of Western Art.
Santos.
Essay by George Kubler. Fort Worth, 1964.

Amsden, Charles.
Navaho Weaving.
Santa Ana, Calif.: Fine Arts Press, 1934.

Andrew, David S., and Blank, Laurel B.
"The Four Mormon Temples in Utah."
Journal of the Society of Architectural Historians 30, no. 1 (March 1971), 51-66.

Arrington, Leonard J.
Great Basin Kingdom: An Economic History of the Mormons, 1830-1900.
Cambridge: Harvard University Press, 1958.

Athearn, Robert G.
Forts of the Upper Missouri.
Englewood, N.J.: Prentice-Hall, 1967.

Athearn, Robert G.
High Country Empire.
New York: McGraw Hill, 1960.

Bancroft, Hubert Howe.
History of Utah.
San Francisco: History Company Publishers, 1891.

Bartlett, Richard.
Great Surveys of the American West.
Norman: University of Oklahoma Press, 1962.

Billington, Ray Allen.
America's Frontier Heritage.
Histories of the American Frontier. New York: Holt, Rinehart and Winston, 1966.

Billington, Ray Allen.
The Far Western Frontier, 1830-1860.
New York: Harper and Row, 1956.

Billington, Ray Allen, ed.
Peoples of the Plains and Mountains.
Westport, Conn.: Greenwood Press, 1973.

Boyd, E.
"Antiques in New Mexico."
Antiques 44 (August 1943), 58-62.

Boyd, E.
"Arts of the Southwest."
Concise Encyclopedia of American Antiques.
Edited by Helen Comstock. Vol. 2, pp. 518-528.
New York: Hawthorne Books, 1958.

Boyd, E.
"Decorated Tinware East and West in New Mexico."
Antiques 66 (September 1954), 203-205.

Boyd, E.
The New Mexican Santero.
Santa Fe: Museum of New Mexico, 1969.

Boyd, E.
New Mexico Santos: How to Name Them.
Santa Fe: International Folk Art Foundation, 1966.

Boyd, E.
Popular Arts of Spanish New Mexico.
Santa Fe: Museum of New Mexico, 1974.

Boyd, E.
Saints and Saint Makers of New Mexico.
Santa Fe: Laboratory of Anthropology, 1946.

Brewster, Sir David.
The Stereoscope: Its History, Theory, and Construction.
London: John Murray, 1856.

Brinckerhoff, Sidney B., and Chamberlain, Pierce A.
Spanish Military Weapons in Colonial America 1700-1821.
Harrisburg, Pa.: Stackpole Company, 1972.

Burton, Richard F.
The City of the Saints and across the Rocky Mountains to California.
London: Longman, Green, Longman, and Roberts, 1861.

Carvalho, Solomon Nunes.
Incidents of Travel and Adventure in the Far West.
1857. Reprint. Philadelphia: Jewish Publication Society of America, 1954.

Catlin, George.
The Manners, Customs, and Condition of the North American Indians.
2 vols. London: Egyptian Hall, 1841.

Chapman, Kenneth.
The Pottery of San Ildefonso Pueblo.
Albuquerque: University of New Mexico Press for School of American Research, 1970.

"Cooperstown: The Crafts."
Antiques 75, no. 2 (February 1959), 192.

Curry, Larry.
The American West.
New York: Viking Press in association with the Los Angeles County Museum of Art, 1972.

de Jonge, Eric, ed.
Country Things from the Pages of the Magazine Antiques.
Princeton, N.J.: Pyne Press, 1972.

Dellenbaugh, Frederick S.
Fremont and '49.
New York: G. P. Putnam's Sons, Knickerbocker Press, 1914.

Denver Art Museum.
American Art from the Denver Art Museum Collection.
Denver, 1969.

DeVoto, Bernard.
Across the Wide Missouri.
Boston: Houghton Mifflin Company, 1947.

Dick, Everett.
The Sod House Frontier, 1854-1890.
New York: Appleton-Century, 1937.

Dick, Everett.
Tales of the Frontier from Lewis and Clark to the Last Roundup.
Lincoln: University of Nebraska Press, 1964.

Dickey, Roland F.
New Mexico Village Arts.
Albuquerque: University of New Mexico Press, 1970.

Dockstader, Frederick J.
Indian Art in America.
Greenwich, Conn.: New York Graphic Society, 1960.

Dozier, Edward.
The Pueblo Indians of North America.
New York: Holt, Rinehart and Winston, 1970.

Drucker, Philip.
Indians of the Northwest Coast.
New York: McGraw-Hill Book Company for the American Museum of Natural History, 1955.

Dunn, Dorothy.
American Indian Painting.
Albuquerque: University of New Mexico Press, 1968.

Dunton, Nellie.
The Spanish Colonial Ornament.
Philadelphia: H. C. Perleberg, 1935.

Dutton, Bertha.
Sun Father's Way: The Kiva Murals of Kuaua.
Albuquerque: University of New Mexico Press for the School of American Research, Museum of New Mexico, 1963.

Eastman, Seth.
A Seth Eastman Sketchbook, 1848-1849.
Austin: University of Texas Press, 1961.

Espinosa, Jose E.
Saints in the Valleys.
Albuquerque: University of New Mexico Press, 1960.

Ewers, John C.
Artists of the Old West.
Garden City, N.Y.: Doubleday and Company, 1973.

Ewers, John C.
"George Catlin, Painter of Indians and the West."
Smithsonian Institution. *Annual Report,* 1955, pp. 483-528.

Ewers, John C.
Plains Indian Painting.
Stanford, Calif.: Stanford University Press, 1939.

Fife, Austin.
"Stone Houses of Northern Utah."
Utah Historical Quarterly 40, no. 1 (winter 1972), 6-23.

Flanders, Robert Bruce.
Nauvoo: Kingdom on the Mississippi.
Urbana: University of Illinois, 1965.

George Eastman House, Rochester, in collaboration with the Amon Carter Museum of Western Art.
T. H. O'Sullivan, Photographer.
Text by Beaumont and Nancy Newhall, with an appreciation by Ansel Adams.
Rochester, 1966.

Gladwin, Harold, et al.
Excavations at Snaketown: Material Culture.
Tucson: University of Arizona Press for Arizona State Museum, 1965.

Glassie, Henry.
Pattern in the Material Folk Culture of the Eastern United States.
Philadelphia: University of Pennsylvania Press, 1968.

Goddard, Pliny Earle.
Indians of the Southwest.
New York: American Museum Press, 1931.

Goetzmann, William H.
Army Exploration in the American West, 1803-1863.
New Haven: Yale University Press, 1959.

Goetzmann, William H.
Exploration and Empire.
New York: Vintage Books, 1966.

González, Nancie L.
The Spanish-Americans of New Mexico: A Heritage of Pride.
Albuquerque: University of New Mexico Press, 1967.

Halseth, Odd.
"St. Michael, Archangel."
El Palacio 25 (1928), 295.

Halseth, Odd.
"St. Raphael, St. Michael, St. Gabriel."
El Palacio 26 (1929), 74.

Harper, J. Russell, ed.
Paul Kane's Frontier.
Austin: University of Texas Press, 1971.

Hassrick, Royal B.
Cowboys: The Real Story of Cowboys and Cattlemen.
London: Octopus Books, 1974.

Hastings, Lansford.
The Emigrant's Guide to Oregon and California.
Cincinnati: George Conclin, 1845.

Hawgood, John A.
America's Western Frontiers: The Exploration and Settlement of the Trans-Mississippi West.
New York: Alfred A. Knopf, 1967.

Hendricks, Gordon.
Bierstadt.
Fort Worth, Texas: Amon Carter Museum, 1972.

Hendricks, Gordon.
"The First Three Western Journeys of Albert Bierstadt."
Art Bulletin 46 (1964), 333-365.

"Henry Ford Museum: The Other Metals."
Antiques 73, no. 2 (February 1958), 178-181.

Hine, Robert V.
Bartlett's West.
New Haven: Yale University Press, 1968.

Hine, Robert V.
Edward Kern and American Expansion.
New Haven: Yale University Press, 1962.

Hodge, Frederick Webb, ed.
Handbook of American Indians.
2 vols. Washington: Smithsonian Institution, Bureau of American Ethnology, 1907-1910.

Howell, Edgar M.
"Hermann Stieffel: 'Soldier Artist of the West.'"
United States National Museum. *Bulletin* no. 225, 1960, pp. 3-16.

Irving, Washington.
The Adventures of Captain Bonneville, U.S.A. in the Rocky Mountains and the Far West, Digested from his Journals Washington Irving.
Edited and with an introduction by Edgeley W. Todd. 1849. Reprint. Norman: University of Oklahoma, 1961.

Irving, Washington.
Astoria.
Philadelphia: Carey, Lea & Blanchard, 1836.

Jackson, William Henry.
Time Exposure: The Autobiography of William Henry Jackson.
1941. Reprint. New York: Cooper Square Publishers, 1970.

Jones, Hester.
"New Mexico Embroidered Bedspreads."
El Palacio 37 (1934), 97-104.

Josephy, Alvin, Jr.
The Artist Was a Young Man: The Life Story of Peter Rindisbacher.
Fort Worth, Texas: Amon Carter Museum, 1961.

King, Clarence.
"The Falls of the Shoshone."
Overland Monthly 5 (October 1870), 379-385.

Kubler, George.
The Religious Architecture of New Mexico in the Colonial Period and since the American Occupation.
Colorado Springs: Taylor Museum, 1940.

Kurz, Rudolf Friedrich.
"Journal of Rudolf Friedrich Kurz."
Smithsonian Institution, Bureau of American Ethnology. *Bulletin* no. 115, 1937, p. 2.

Lillibridge, Robert.
"Architectural Currents on the Mississippi River Frontier: Nauvoo, Illinois."
Journal of the Society of Architectural Historians 19, no. 3 (October 1960), 109-115.

Lillie, L. C.
"Two Phases of American Art: Thomas Cole and John W. Hill."
Harper's New Monthly Magazine, January 1890, pp. 206-216.

Lindquist-Cock, Elizabeth.
"Stereoscopic Photography and the Western Paintings of Albert Bierstadt."
Art Quarterly 33 (winter 1970), 360-378.

Los Angeles County Museum of History, Science, and Art.
The Mission Trail.
Los Angeles, 1940.

Lyford, Carrie A.
Quill and Beadwork of the Western Sioux.
Washington, D.C.: U.S. Department of the Interior, Bureau of Indian Affairs, Division of Education, 1940.

McCracken, Harold.
George Catlin and the Old Frontier.
New York: Dial Press, 1959.

McCracken, Harold.
Portrait of the Old West.
New York: McGraw-Hill Book Company, 1952.

McDermott, John Francis.
Frenchmen and French Ways in the Mississippi Valley.
Urbana: University of Illinois Press, 1969.

McDermott, John Francis.
"Samuel Seymour, Pioneer Artist of the Plains and the Rockies."
Smithsonian Institution, *Annual Report,* 1950, pp. 497-509.

McDermott, John Francis, ed.
The Spanish in the Mississippi Valley 1762-1804.
Urbana: University of Illinois, 1974.

Mallery, Garrick.
"Picture Writing of the American Indians."
U.S. Bureau of American Ethnolgy, *Annual Report,* no. 10, 1893.

Metropolitan Museum of Art, New York.
Masterworks from the Museum of the American Indian, Heye Foundation.
Introduction by Frederick J. Dockstader. New York, 1973.

Martin, Paul S., Quimby, George I., and Collier, Donald.
Indians before Columbus.
Chicago: University of Chicago Press, 1947.

Miles, Charles.
Indian and Eskimo Artifacts of North America.
Chicago: Henry Regnery Company, 1963.

Mills, George.
The People of the Saints.
Colorado Springs: Taylor Museum, Colorado Springs Fine Arts Center, n.d.

Monaghan, Jay, et al.
The Book of the American West.
New York: Bonanza Books, 1963.

Monroe, Robert D.
"William Birch McMurtrie, A Painter Partially Restored."
Oregon Historical Quarterly, 60, no. 3 (September 1959), 352-374.

Moody, Ralph.
The Old Trails West.
New York: Thomas Y. Crowell Company, 1963.

Morgan, Lewis H.
Houses and House-Life of the American Aborigines.
1881. Reprint. Chicago: University of Chicago Press, Phoenix Books, 1965.

Mortenseh, A. Russell.
Early Utah Sketches: Historic Buildings and Scenes in Mormon Country.
Salt Lake City: University of Utah Press, 1969.

Museum of Fine Arts, Boston.
M. and M. Karolik Collection of American Paintings, 1815 to 1865.
Cambridge: Harvard University Press for Museum of Fine Arts, Boston, 1949.

Museum of Fine Arts, Boston.
M. & M. Karolik Collection of American Water Colors & Drawings, 1800-1875.
2 vols. Boston, 1962.

Nash, Roderick.
Wilderness and the American Mind.
New Haven: Yale University Press, 1967.

National Collection of Fine Arts, Washington.
National Parks and the American Landscape.
Essay by William Truettner and Robin Bolton-Smith. Washington, 1972.

Nelson, Lowry.
The Mormon Village, A Pattern and Technique of Land Settlement.
Salt Lake City: University of Utah Press, 1952.

New Mexico. Department of Vocational Education.
New Mexico Tin Craft.
Santa Fe, 1937.

Novak, Barbara.
"Grand Opera and the Small Still Voice."
Art in America 59 (March-April 1971), 64-73.

Olmsted, Frederick Law.
A Journey through Texas.
New York: D. Edwards and Company, 1857.

Ortiz, Alfonso, ed.
New Perspectives on the Pueblos.
Albuquerque: University of New Mexico Press for School of American Research, 1972.

O'Sullivan, T. H. [Sampson, John].
"Photographs from the High Rockies."
Harper's New Monthly Magazine 39 (1869), 465-475.

Parkman, Francis.
The Oregon Trail.
1849. Reprint. Philadelphia: John C. Winston Company, 1931.

Piercy, Frederick.
Route from Liverpool to Great Salt Lake Valley.
1855. Reprint. Cambridge: Harvard University Press, 1962.

Pinckney, Pauline.
"Johann Michael Jahn, Texas Cabinetmaker."
Antiques 75, no. 5 (May 1959), 462-463.

Pinckney, Pauline.
Painting in Texas.
Austin: University of Texas Press, 1967.

Pitman, Leon Sidney.
"A Survey of Nineteenth Century Folk Housing in the Mormon Culture Region."
Ph.D. dissertation, Louisiana State University, 1973.

Poesch, Jessie.
Titian Ramsay Peale and His Journals of the Wilkes Expedition.
Philadelphia: American Philosophical Society, 1961.

Portland Art Museum.
Art in the Life of the Northwest Coast Indians.
Catalogue entries by Erna Gunther. Portland, 1966.

Quinn, Robert.
"Spanish Colonial Style: The Architectural Origins of the Southwestern Missions."
The American West 3, no. 3 (summer 1966), 55-66.

Rathbone, Perry.
Westward the Way.
St. Louis: City Art Museum of St. Louis, 1954.

Roach, Ruth.
"Midwestern Silversmiths in the Trinket Trade."
Antiques 74, no. 1 (July 1958), 60-61.

Roemer, Ferdinand.
Texas: With Particular Reference to German Immigration and the Physical Appearance of the Country, 1845-47.
San Antonio: Standard Printing Company, 1935.

Ross, Marvin C.
The West of Alfred Jacob Miller.
Norman: University of Oklahoma Press, 1951.

Rossi, Paul A., and Hunt, David C.
The Art of the Old West.
New York: Alfred A. Knopf, 1973.

San Antonio Museum Association.
Early Texas Furniture and Decorative Arts.
San Antonio: Trinity University Press, 1973.

Saum, Lewis O.
The Fur Trader and the Indian.
Seattle: University of Washington Press, 1965.

Sheldon, G. W.
American Painters.
New York: D. Appleton, 1881.

Shuffler, R. Henderson.
"Winedale Inn."
Texas Quarterly, summer 1965, pp. 1-32.

Sibley, Marilyn McAdams.
Travelers in Texas, 1761-1860.
Austin: University of Texas Press, 1967.

Sloane, Eric.
A Museum of Early American Tools.
New York: Wilfred Funk, 1964.

Spencer, Robert, et al.
The Native Americans.
New York: Harper and Row, 1965.

Stansbury, Howard.
Exploration and Survey of the Valley of the Great Salt Lake of Utah.
Philadelphia: Lippincott, Grambo, and Company, 1852.

Stegner, Wallace.
The Gathering of Zion: The Story of the Mormon Trail.
New York: McGraw-Hill Book Company, 1964.

Stewart, Elinore Truitt.
Letters of a Woman Homesteader.
Lincoln: University of Nebraska Press, 1961.

Stiff, Edward.
The Texan Emigrant.
Cincinnati: George Conclin, 1840.

Stout, Hosea.
On the Mormon Frontier: The Diary of Hosea Stout 1844-1861.
Edited by Juanita Brook. 2 vols. Salt Lake City: University of Utah Press, 1964.

Swanton, John R.
The Indian Tribes of North America.
Washington: Smithsonian Institution Press, 1952.

Taft, Robert.
Artists and Illustrators of the Old West.
New York: Charles Scribner's Sons, 1953.

Taft, Robert.
Photography and the American Scene.
New York: Macmillan Company, 1938.
"A Texas Frontier Home."
Antiques 42 (November 1942), 242-243.
"Texas in the Union."
Antiques 52 (June 1948), 447-452.

Thayer, William M.
Marvels of the New West.
Norwich, Conn.: Henry Bill Publishing Company, 1892.

Tuckerman, Henry T.
Book of the Artists.
New York: James F. Carr, 1966.

U.S. Work Projects Administration, Writers' Program.
California.
New York: Hastings House, 1943.

Vanderbilt, Paul, comp.
Guide to the Special Collections of Prints and Photographs in the Library of Congress.
Washington: Library of Congress, 1955.

Walker Art Center, Minneapolis, Indian Art Association, and the Minneapolis Institute of Arts.
American Indian Art: Form and Tradition.
New York: Dutton, 1972.

Walton, Elisabeth Brigham.
"Mill Place on the Willamette. A New Mission House for the Methodists in Oregon, 1841-44."
Master's thesis, University of Delaware, 1966.

Washburn Gallery, New York.
John William Hill, John Henry Hill.
New York, 1973.

Webb, Walter Prescott.
The Great Plains.
New York: Grosset and Dunlap, 1931.

Weitenkampf, Frank.
"Early Pictures of North American
Indians."
New York Public Library. *Bulletin* 53,
no. 12 (December 1949), 591-613.

Wheat, Carl Irving.
*The Maps of the California Gold
Region 1848-1857.*
San Francisco: Grabhern Press, 1942.

Whittredge, Worthington.
*The Autobiography of Worthington
Whittredge, 1820-1910.*
Edited by John I. Bauer. 1942. Reprint.
New York: Arno Press, 1969.

Wilder, Mitchell A., and Breitenbach,
Edgar.
*Santos: Religious Folk Art of
New Mexico.*
Colorado Springs: Taylor Museum of
the Colorado Springs Fine Arts Center,
1943.

Will, Clark M.
The Story of Old Aurora . . . 1856-1883.
n.p., 1972.

Willoughby, Charles C.
"A Few Ethnological Specimens
Collected by Lewis and Clark."
American Anthropologist 7; no. 4
(1905), 633-641.

Wormington, H. M.
Prehistoric Indians of the Southwest.
Denver: Denver Museum of Natural
History, 1959.

Wright, Louis B.
Life on the American Frontier.
New York: Capricorn Books, 1971.